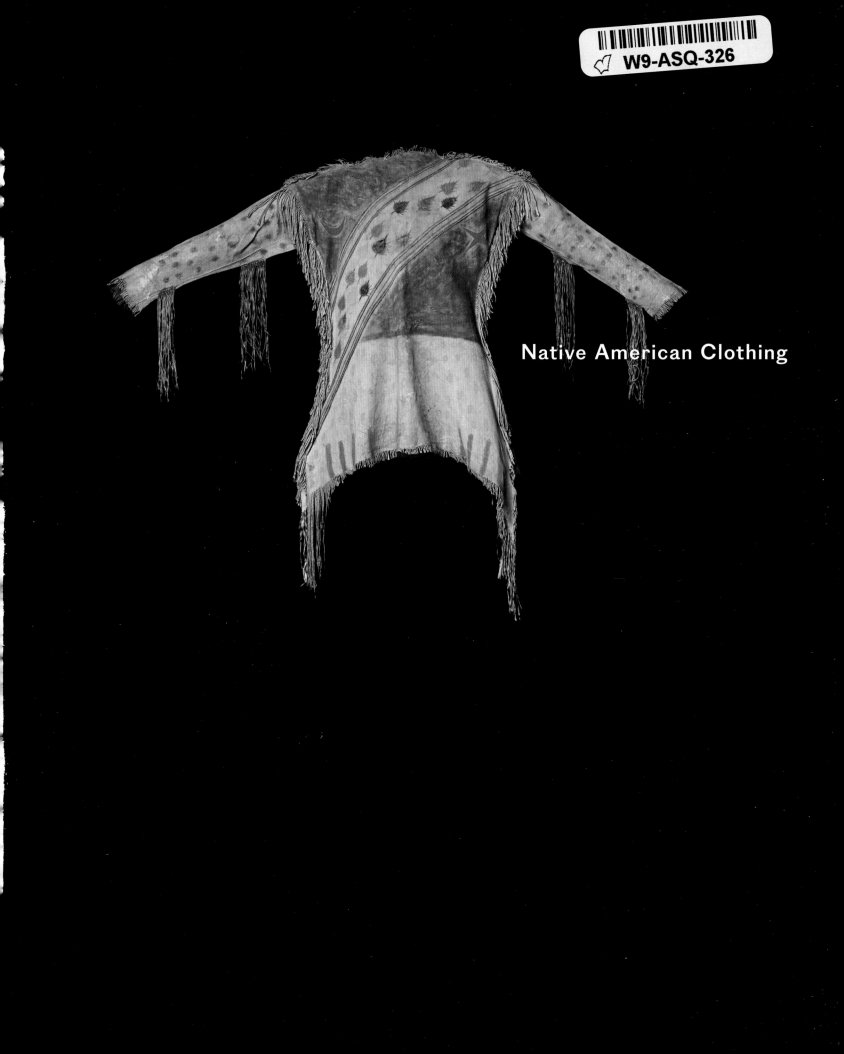

Native American Clothing

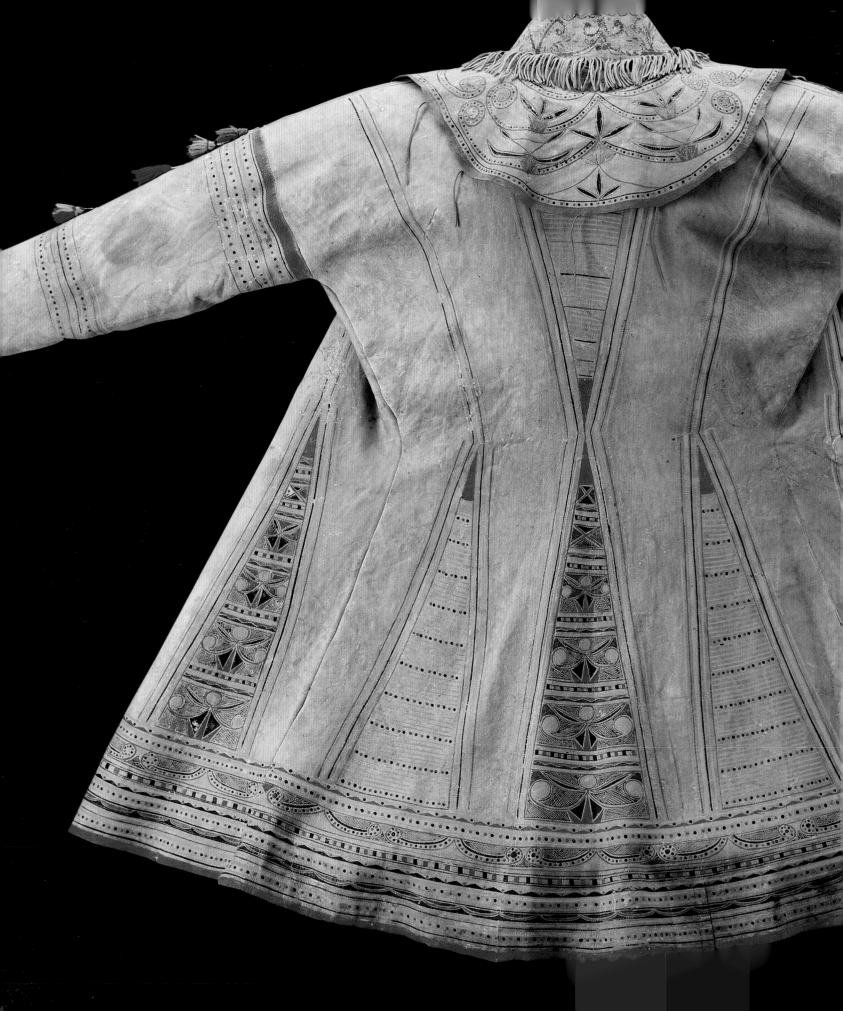

Native American Clothing

An Illustrated History

Theodore Brasser

FIREFLY BOOKS

A FIREFLY BOOK

Published by Firefly Books Ltd. 2009
Copyright © 2009 Firefly Books Ltd.
Text copyright © 2009 Theodore Brasser
Images copyright as noted in credits
All rights reserved.

First printing

Cover and text design: Counterpunch Inc./Linda Gustafson
Cartography: George A. Walker
Photo Editor: Nicole Caldarelli

The publisher gratefully acknowledges the financial support for our publishing program by the Government of Canada through the Book Publishing Industry Development Program.

Page 1: Man's shirt, southern Cheyenne or Arapaho, southern Plains, circa 1890
Courtesy Donald Ellis Gallery, Dundas, ON, New York, NY
Pages 2–3: Coat, Naskapi, circa 1840
Courtesy Donald Ellis Gallery, Dundas, ON, New York, NY
(see page 98)
Page 5: Poncho, southern Arapaho, circa 1890
Courtesy Donald Ellis Gallery, Dundas, ON, New York, NY
Page 6: Man's leggings, Creek or Seminole, circa 1840
Courtesy John and Marva Warnock Collection /
www.splendidheritage.com
Page 8: Sioux woman's dress, circa 1880
Courtesy David Cook Fine American Art, Denver, Colorado
Page 9: NezPerce war shirt, circa 1865–70
Courtesy H.M. Grimmer

Printed in China

Publisher Cataloging-in-Publication Data (U.S.)
Brasser, Theodore.
 Native American clothing : an illustrated history/Theodore Brasser.
[368] p. : ill., photos. (chiefly col.), maps ; cm.
Includes bibliographical references and index.
Summary: A collection of photographs from museums, collectors and private dealers that documents five centuries of Native American artistry.

ISBN-13: 978-1-55407-433-4
ISBN-10: 1-55407-4339

1. Indians of North America – Clothing. 2. Indians of North America – Clothing – Exhibitions. I. Title.

391.008997 DC22 E98.C8B7377 2009

Library and Archives Canada Cataloguing in Publication
Brasser, Ted J.
Native American clothing : an illustrated history/Theodore Brasser.

Includes bibliographical references and index.
ISBN-13: 978-1-55407-433-4
ISBN-10: 1-55407-433-9

 1. Indians of North America--Clothing. 2. Indians of North America – Clothing – Pictorial works. 3. Indians of North America – Antiquities. 4. Indians of North America – History. I. Title.

E98.C8B73 2009 391.0089'97 C2009-901917-5

Published in the United States by
Firefly Books (U.S.) Inc.
P.O. Box 1338, Ellicott Station
Buffalo, New York 14205

Published in Canada by
Firefly Books Ltd.
66 Leek Crescent
Richmond Hill, Ontario L4B 1H1

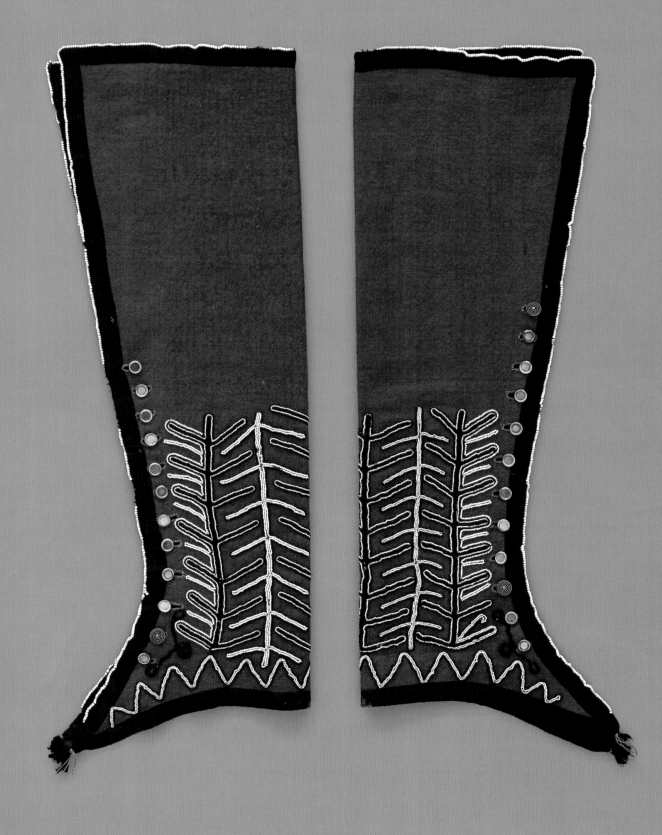

Contents

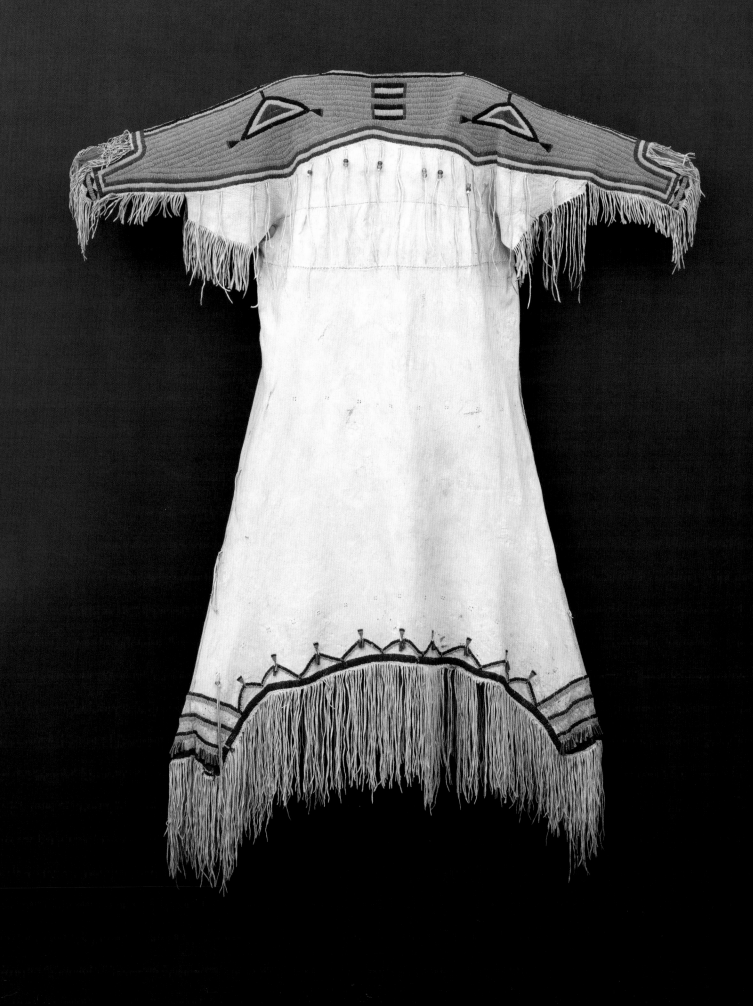

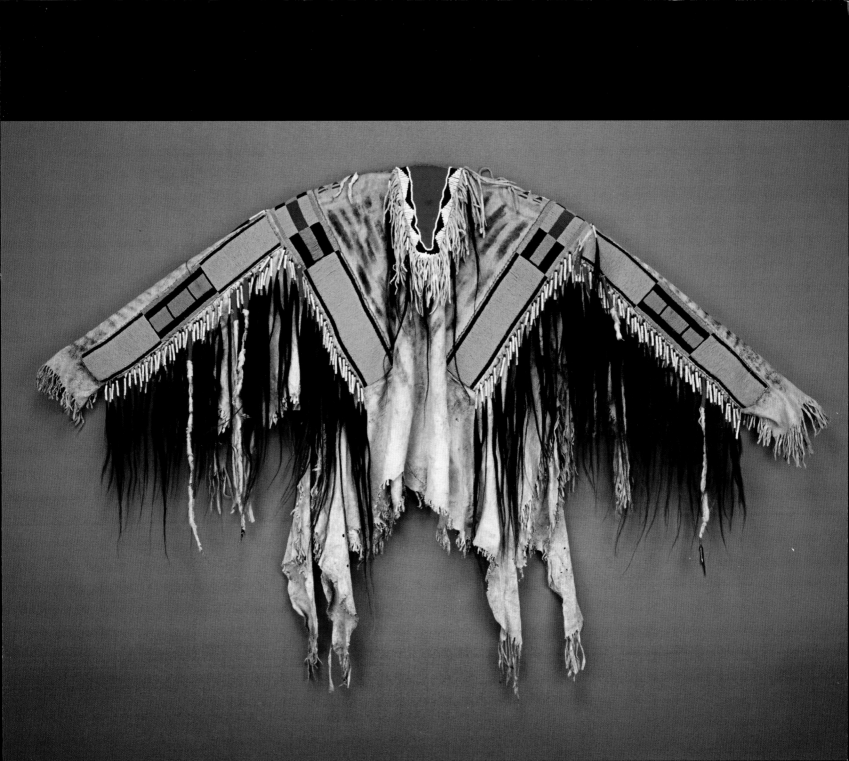

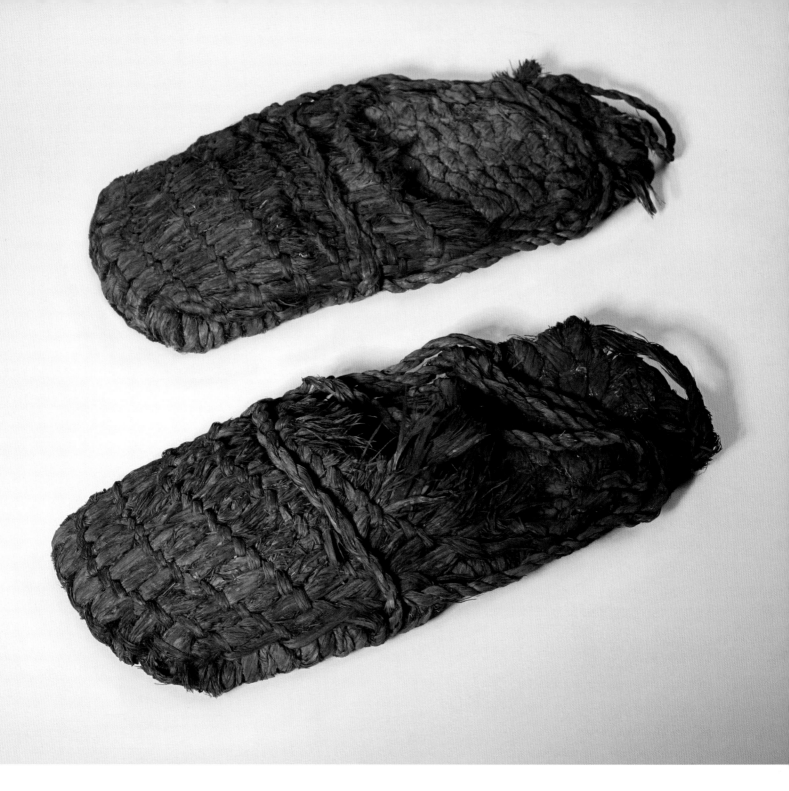

Sandals, Fort Rock Cave, South-Central Oregon.
Almost one hundred pairs of these sandals, twined of shredded
sagebrush, were found in Fort Rock Cave in south-central
Oregon. They have been radiocarbon-dated as more than
9,000 years old. Twining is the oldest weaving technique in the
Americas and is still used today by Indian basket makers.
Courtesy University of Oregon Museum of Natural and Cultural
History. Photo by Jack Liu.

Introduction | Crossing Beringia

Climate change has forced itself upon us, more than we might ever have imagined in our wildest dreams. But climate change is not something new, though it has previously run its course beyond the time frames of our human experience. Some 40,000 years ago, as the last ice age was slowly coming to an end, enormous glaciers were retreating northward, followed by large herds of mammoths, wild horses and reindeer. Always following the game, mankind was spreading into Asia from its original residence in warmer regions. Most probably these people protected themselves against the hot sun and windburn by rubbing their bodies with animal grease mixed with red ocher. This ancient means of body protection survived for untold centuries in many parts of the world. Stimulated by a psychological need that animals do not experience, these people adopted various types of body adornment. Body painting and tattooing satisfied vanity and denoted status and prestige long before these roles were taken over by garments.

Vaguely noticeable in the shadows of the past, these people gradually spread northward. The need for protection from the cold climate is what first brought about the invention of clothing. Bone awls and needles found in ancient campsites are evidence of the tailored clothing of the hardy hunters. In order to survive on the northern tundra, they wore furs and tanned hides that were sewn with waterproof seams. The need for protection from the cold climate initiated the invention of clothing. Secondary reasons played a role in much later cultural developments. The construction of garments was undoubtedly the work of women, who took care of the camp while the men were out hunting. This gender-based division of labor in daily occupations may have led to the differences in dress between men and women.

The nomadic bands, widely scattered in the vast expanse of new land, gradually developed the cultural equipment to survive in the sub-arctic environment of Siberia. While they gathered and dispersed with the seasonal movements of the game herds, some of these people moved east over the course of many generations. Following the game, they entered a wide valley, later called Beringia by our archaeologists. Beringia does not exist anymore; about 14,000 years ago the rising temperatures started to melt the glacial ice, causing the ocean levels to rise. The submerged valley separated Siberia from Alaska and became the present-day Bering Strait. From Siberia, the New World is visible some 55 miles in the distance.

As single families and in small bands, people found their way across Beringia, first across the dry land, followed by others across the ice during the long winters, and in later times, in skin-covered boats. For thousands of years the wandering hunters kept coming, unaware they were entering another continent. They merely remembered that their ancestors had once lived in a more eastern valley or beyond the distant mountains. These migrations involved various groups of different physical types who would have been strangers to each other. The earliest immigrants may have represented mankind before the emergence of the modern races; Mongolian features increased among later arrivals

It was probably about 25,000 years ago that the first trickle of these people crossed Beringia, to remain in the ice-free parts of western Alaska for a long time. The interior and all of Canada was still covered by glacial ice. However, about 14,000 years ago, an ice-free route opened up along the Pacific coast, followed by a similar corridor along the eastern flanks of the Rocky Mountains. Along these two routes, the first immigrants moved south. Some daring pioneers appear to have reached present-day Pennsylvania 16,000 years ago; 6,000 years after that, people had reached the southern tip of South America. As periodic markers along this endless river of time, these people left us their stone and bone tools, bark sandals in an Oregon cave, fragments of basketry, and their own bones. These clues tell an increasingly detailed story of a diversity of intelligent ways of life.

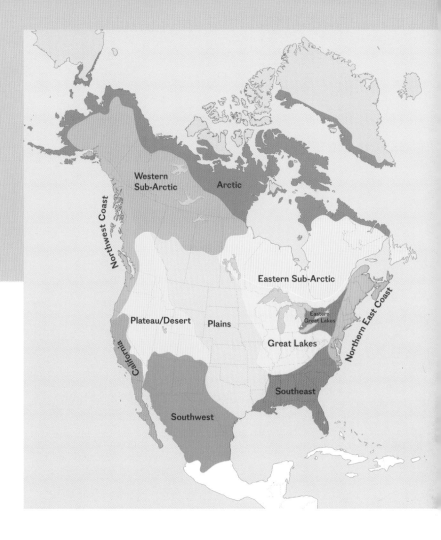

By 10,000 years ago, scattered populations lived in every corner of North America. The big game of the ice age had vanished and caribou, buffalo, sea mammals and fish became major food sources. While gathering edible wild plants, roots, berries and seeds, some women discovered the germination of such seeds and the growing of plants for food. Horticulture of squash, maize and beans emerged in Central America about 5,000 years ago and spread into the southern parts of North America, enabling the people to settle in permanent villages. The impact of these economic developments is apparent in the garments they wore, particularly in the predominant use of hide clothing by the nomadic hunters and in the woven fiber materials used by the farming people.

Europeans may have "discovered" North America several times before Christopher Columbus came ashore, believing he had arrived in India. As a result, we still identify the aboriginal people of North America as "Indians," which is a term equivalent in its generality as the terms "Europeans" or "Africans." With each of these terms we refer to a great variety of different peoples. The description of the Arctic population as "Eskimo" is a mere accident in the history of northern exploration; they are as much part of the North American aboriginal population as the Indians are.

Ethnic labels have become a sensitive issue since the 1960s. The term "Native Americans" has become popular in the United States, and Canadian Indian leaders have promoted the term "First Nations."

However, official terminology tends to separate itself from the language of ordinary people. In my contacts with Indians, I have found that few of them are interested in such artificial problems. Tony Hillerman once attended an intertribal conference where this tortured subject came up. The verdict of the Indians was unanimous: Indians call each other Indians, unless the name of a specific tribe is in order. One native participant was greatly relieved that Columbus had not thought he had landed on the Virgin Islands! Following the consensus among the people in question, I use the terms "Indian" and

"native" interchangeably. In order to avoid confusion for the reader I will also retain the tribal names conventionally used in the literature, though most of these names are the final products of baffling corruptions of native terms.

In the early European-contact period of the 1500s, the total population of North America was an estimated 12 million people; these people spoke a greater variety of languages than anywhere else in the world. The more than 500 languages were derived from 12 major language families, as different from each other as German and Chinese. Any possible relationship with languages in Asia has been lost in the many thousand years of separation.

The European discovery of North America was a major event in the history of mankind. Never again will we experience such an unexpected meeting with long-lost relatives, not that our common humanity was immediately recognized. In 1512, the Pope proclaimed that the Indians were children of Adam and Eve, and should be respected as human beings. But the New World was far beyond the control of the Pope and other authorities. What appeared to the Micmac Indians to be bears on a floating island turned out to be bearded white strangers on a big ship. And invariably the European visitors mentioned in their early accounts of the native people that "they go naked except that at the private parts they wear some skins of little animals."

In large parts of North America, daily clothing was indeed minimal. Fully tailored or fitted garments were largely restricted to the arctic and sub-arctic regions. Yet it is in the other regions that we find the most spectacular development of festive or ceremonial dress, revealing the owner's social status, cult membership, military rank or simply his or her wealth. Pressured by the disapproval of white people, the Indians soon learned to keep their bodies covered.

Artistic expression was well developed among all these native peoples, though they lived in a social context that did not recognize art as something separate from the production of useful garments and utensils. Aesthetic norms were an inseparable component in the creation of functional objects; there was no art for art's sake. Local art styles proclaimed one's tribal identity. Crafts were part of the daily work assigned to men and women, divided according to the conventional domains of their economic activities. In most regions there were no professional artists, though elderly people tended to be more active in these respects, thereby making up for their withdrawal from more strenuous work. Obviously, some people of a strong creative inclination developed a recognized expertise, but that did not exclude them from other work. Accordingly, this book will not deal strictly with "art." The creativity evident in the beautiful garments related to the people's reflections upon the environment as they experienced it and their imagination in dealing with their changing world.

Population numbers and languages suffered a severe decline after the arrival of the Europeans. Unwittingly the latter introduced a host of infectious diseases for which the native people had no immunity. Generation after generation, epidemics ravaged the coastal regions and extinguished whole communities, while refugees carried the microbes even farther inland. These epidemics not only decimated the population, but also undermined their political and cultural structures. Most probably, even the earliest historical records present us with Indians who had become accustomed to contact with Europeans and who were by then a mere remnant of earlier populations. Their way of life had already changed due to earlier and unrecorded contacts.

Most of the native peoples had been living for centuries in the areas where they were found by the early European explorers. The tribal units in each of these so-called "culture areas" resembled each other to some extent in their economy, social organization, religious worldview and historical experiences. At least, they had culturally more in common with each other

than with people living beyond their culture area. This somewhat vaguely defined concept of culture area is as arbitrary as the drawing of boundaries for each of these areas, because in reality there has always been gradual culture change from one area to another. However, for our purposes, the concept enables us to recognize the typical configuration of worldview, economy, arts and crafts of each region.

As the European frontier moved across the continent, the native people responded to the impact with remarkable creativity in their experiments with the goods imported by the white traders. Cloth, beads and silver ornaments were adapted to native fashions, and elements of European folk art inspired developments in the native art traditions. Obviously, the Indian women played a major role in these innovations. Their creativity is documented and preserved in the rich collections of the historic era.

When the fur traders moved on to more profitable regions, the white settlers moved in. With the ensuing loss of their land, the Indians lost their traditional subsistence way of life and were exposed to the full impact of white civilization. Starting in the 18th century, much of native creativity was used to serve the growing tourist market. Traditional costumes functioned to maintain an Indian identity, in defiance of the many pressures emanating from the dominant society.

The circumstances that led to the collecting and preservation of native arts and crafts is a fascinating story in which Europeans and Euro-Americans have unwittingly left us a remarkable record of their own worldview. During the age of exploration and colonial expansion, the European elite considered the American Indian a symbol of everything noble and "natural," and Indian-made objects and apparel became objects of marvel and contemplation. Sailors, fur traders, missionaries, military people and nearly everyone else connected with the exploration and settlement of the New World gathered examples of native arts and crafts. Private collectors among the European elite

compared and exchanged these curios with each other as we used to do with coins and stamps. Some of their collections became the nucleus of the first public museums during the 19th century. This insatiable curiosity about human life in faraway places and other times is an ancient and distinct feature of Western society, a curiosity that made white people seem distinctly odd to most other peoples. In the 1880s, Edward W. Nelson was named "the buyer of good-for-nothing things" by the local Eskimos of western Alaska. He gathered an irreplaceable collection of their utensils and garments, now in the National Museum of Natural History in Washington, D.C.

Not all those collections ended up in museums. Occasionally they come up at auctions, to be dispersed among new generations of collectors and tribal art dealers. Efforts by American and Canadian museums to repatriate such artifacts to their country of origin made people aware of these objects as a source of investment, comparable to other forms of art. Without this market activity, much of this material would have remained in the attics of families who have often owned it for many generations. Many of these beautiful examples of Indian art are now circulating among dealers and private collectors and are seldom on public exhibition. In the planning of this book, we have made serious efforts to include some of these unique pieces.

The decision to use these private sources defined the period covered in this book: much of the Indian art in these collections was created before the end of the 19th century. Far from marking the demise of native creativity, more than ever before the later art developments are interrelated with the non-Indian art market. The complex context of contemporary Indian art, and the desire of modern Indian artists to contribute to global art developments, deserves its own publication.

T.J. Brasser

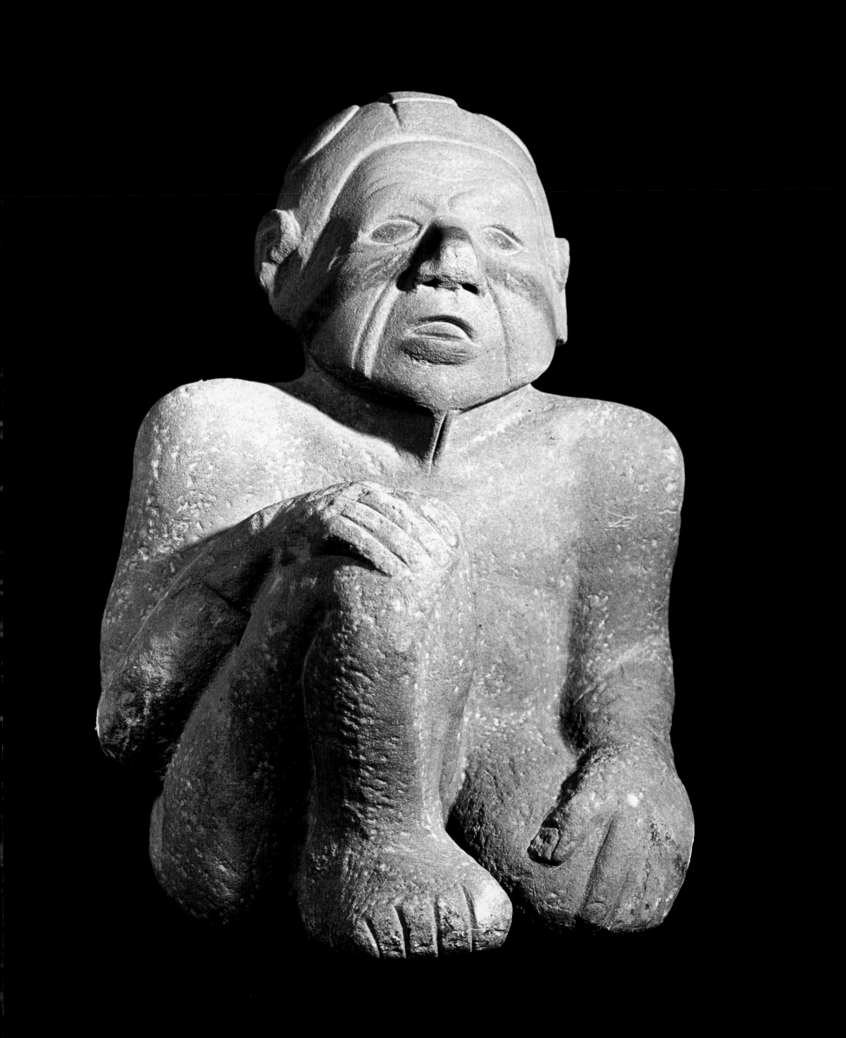

1 | In the Land of Corn Mother

Previous page: **Kneeling male figure, Wilson County, Tennessee, AD 1200–1450.**
This sandstone sculpture, 18 inches / 46 cm high, testifies to the
sophistication of the artists of the Mississippian Culture. This middle-aged
man probably represents a chief, buried at a local site. The simplified limbs
and torso suggest that the figure was clothed in a robe or mantle.
Courtesy Frank H. McClung Museum, University of Tennessee, Knoxville, Tennessee.

In the early 1500s, when the first Europeans explored the coasts of southeastern North America, forests still covered much of the land, but it was not a pristine wilderness. Systematic burning of the underbrush made travel fairly easy. The region was inhabited by a dense population that subsisted on a mixed economy of horticulture, hunting and fishing. The people lived along the rivers in large towns, each consisting of a ceremonial center surrounded by smaller settlements. These politically independent towns were ruled by hereditary chiefs. More complex than tribes, such stratified societies are called chiefdoms.

The traditions of these people recalled vague memories of elaborate ceremonials in a former golden age. Silenced and deserted, the ceremonial precincts of long ago consisted of huge, flat-topped pyramidal mounds, once occupied by temples or the residences of deified hereditary rulers. Other mounds contained the deceased members of these high-ranking families, wrapped in shell-bead-embroidered robes. The organized labor necessary to construct these earthworks with countless basketloads of soil was another aspect of these stratified societies, one that extended far beyond the historic Southeast.

The first cultivation of wild plants some 3,000 years ago had marked the beginnings of a rudimentary horticulture, and as a result, the people settled in semi-permanent villages. Over time, native trade contacts expanded throughout a vast part of North America. Much of this trade was stimulated by the belief that shining metal, white marine shell and crystals had the power to promote the health and well-being of both the living and the dead. Shell from the Gulf Coast, copper from Lake Superior, silver from northern Ontario, obsidian from the Rocky Mountains, and other highly prized materials were employed in the production of sculpture, costumes and other artwork. Stone tablets engraved with the designs of highly stylized birds were used as stamps, probably for decorating tanned skin robes. Much of this production was used as grave gifts in the burials of chiefs and their relatives.

Throughout the eastern parts of the continent, there spread a basically similar spiritual view of the universe. The forms and decorations of some burial goods reveal a cosmology in which winged beings competed with horned or antlered reptiles. This cosmic warfare between "Sky" and "Underworld" was prevalent in the native worldview for many centuries and is still a part of traditional Indian religion today. Feathered, horned or antlered headdresses continue to be considered imbued with such spiritual powers in recent times.

These are but some of the characteristic features that developed in a succession of prehistoric cultures throughout the eastern parts of the continent. In

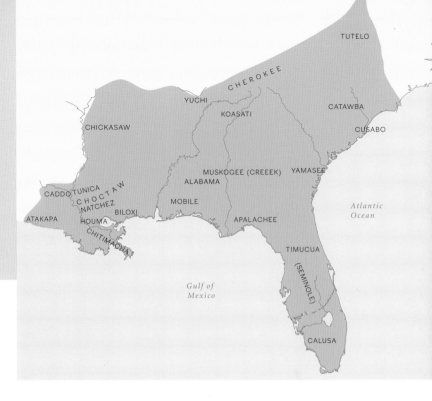

these developments, the Southeast was only barely visible as different in culture from a much larger region. By AD 800, the increased cultivation of corn, beans, squash and sunflowers had boosted the spread of the Mississippian Culture, with prominent centers in the Southeast, western Illinois and eastern Oklahoma after AD 1000. The intensive riverine horticulture of the Southeast resulted in a regional population density that was the highest in North America. Priestly chiefs directed the planting and harvesting of crops, controlled communal granaries and officiated in ceremonies believed to maintain harmony in the universe. The complexity and artistic brilliance of the Mississippian Culture was reminiscent of that of the great civilizations of Mexico and Peru. Some of the most striking pottery in prehistoric North America was produced during this period. Through trade and warfare, Mississippian reverberations were felt throughout a large part of North America, but for reasons still poorly understood, the great centers of this culture were losing their vigor by around AD 1400. By that time, the Southeast had acquired the character of a distinct culture area.

Narrowly defined, the Southeastern Culture area consisted of the Muskogee, or Creek, towns and their immediate neighbors, but its cultural influence reached north into Virginia and west across the lower Mississippi Valley. Most of the languages spoken in the region belonged either to the Muskogee, Siouan and Iroquoian language families. The population size of the Southeast circa 1500 was probably about 500,000, though this is only the average of fluctuating estimates.

In their traditional economic activities, the men were most active in the winter when they hunted, while the women made their major contribution as farmers in the summer. These differences between the seasonal taking of life by the men and the seasonal cultivating of life by the women were reflected in their different behaviors, and were related to roles of warfare and fertility in the annual cycle of ceremonies. Corn was believed to be of supernatural origin and was spiritually associated with women as the source of life. Tobacco was cultivated in separate fields by the men, and its smoke was believed to carry the people's thoughts and prayers. The differences between the roles of men and women were most obvious in their clothing and decoration.

Clothing consisted mainly of wrapped or draped garments, any tailoring being restricted to moccasins and leggings, which were sewn with thread made of

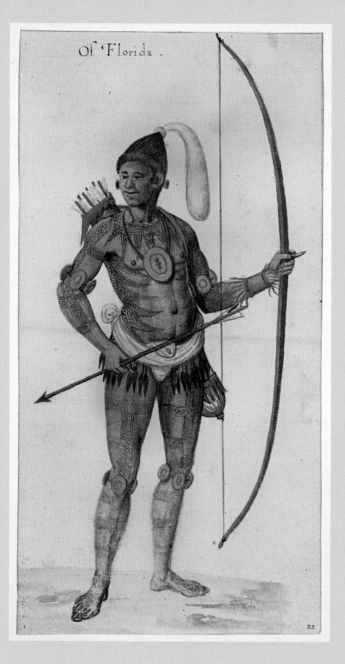

Of 'Florida.

Indian of Florida, 16th century.
Watercolor by John White in the 1580s, after a lost drawing by Jacques Le Moyne in the 1560s. The gorget on the man's chest and the oval plates at his elbows and knees were probably made of silver, salvaged from Spanish shipwrecks. Elaborate tattooing was restricted to chiefly individuals.

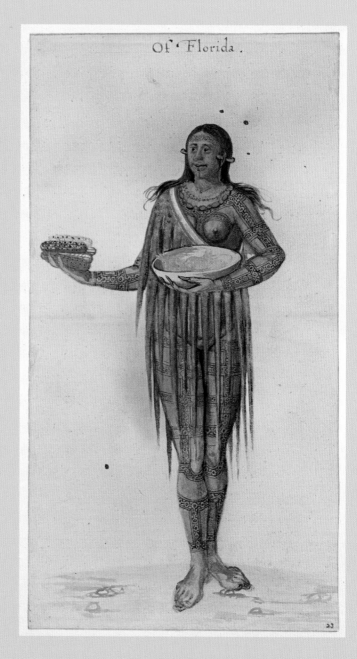

Of 'Florida.

Indian Woman of Florida, 16th century.
Watercolor by John White in the 1580s, after a lost drawing by Jacques Le Moyne in the 1560s. The woman's single garment of Spanish moss was probably less scanty than pictured here by the wide-eyed European artist. Extensive tattooing and long fingernails indicate her high social status.

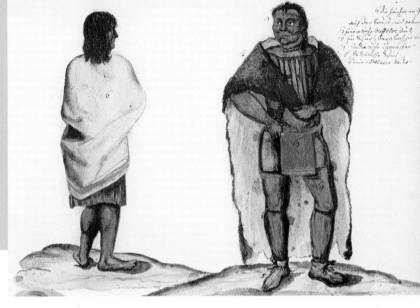

Chief Senkaitchi, **Yuchi tribe, 1736.**
Watercolor by Philip G.F. Von Reck, while visiting the English colony on the Savannah River. The man's breechclout and leggings were made of red and blue trade cloth. The buffalo robe partially covers his tattooed torso. Part of the Yuchi, attracted by the white traders, had moved from the western interior to the Savannah River in 1707. Courtesy collection of the author.

deer sinew. Surviving fragments of woven cloaks and early historical observations document the use of plant and animal hair fibers in twined and otherwise woven fabrics.

Men wore at all times a breechclout, a rectangular piece of soft leather or native textile, worn between the legs with the ends hanging down over a belt in front and behind. The earliest pictures suggest that in Florida this garment was hardly more than a G-string. Finger-woven sashes similar to those pictured in ancient shell engravings from the region were often worn tied around the waist.

Moccasins and leggings were worn for travel and in cold weather. Moccasins were made of a single piece of deer or elk skin, the edges gathered over the instep in a puckered seam running from the toe almost to the ankle, and another seam vertically up the heel. The integral ankle flaps could be wrapped around the legs, though they were usually folded down. The deerskin leggings were suspended from the belt and gathered below the knees with garters. Garters were also worn without the leggings.

Women wore a wraparound skirt that fell from the waist down to the knees. The skirt might be of deerskin, woven of buffalo hair and plant fiber, or twined of "silk grass." The inner bark of the mulberry tree and slippery elm provided fiber that was woven into white fabric and used to make skirts and short mantles for women. Such mantles passed over the left shoulder, leaving the right arm free. Garments made of Spanish moss were used by women in the southern parts of the region. Robes made of deer or buffalo hides, bear and beaver pelts were in general use during cold weather.

Men and women of prestigious families used feathered robes made of rows of turkey or swan feathers attached like shingles to a netting of hemp strings. The color-dyeing of their skin garments was mentioned in several early historic accounts: "The skins are well dressed … the color being given to them that is wished … and in such perfection that when of vermillion they look like very fine red broadcloth; and when black – the sort in use for shoes – they are of the purest. The same hues are given to blankets." Robes might also be decorated with paintings, freshwater pearls or shell beads. Beautiful garments of this type distinguished the families of chiefs from the common people.

✳

The first Europeans to contact the Southeast Indians were Spanish sailors searching for slaves to replace the rapidly diminishing native population in the West

Indies. They explored Florida as early as 1513 and established St. Augustine in 1565. The earliest portraits of North American Indians were some interesting drawings made in those years by Jacques Le Moyne. Some of them survive only as copies made by John White in the 1580s, or as engravings by Theodor de Bry in 1591.

Roman Catholic missions were established in Florida, along the Georgia coast and, for a few years, in Virginia. Though not of economic importance to the Spanish, the missions functioned to maintain the Spanish claims against the English and the French. These Spanish settlements endured for more than a century, creating large communities of more or less converted Indians, despite occasional rebellions and the first effects of new diseases. The Indians were attracted to these missions by the distribution of European imports, including woolen blankets and cloth garments, modesty in dress being a Christian virtue they were encouraged to embrace.

In the interior, powerful chiefdoms were still functioning until the invasion, in 1539, by a Spanish army in search of gold. Led by Hernando De Soto, the army wandered through the region for a few years, leaving a trail of brutal destruction and cruel death. Infectious diseases spread like wildfire, causing an unprecedented decline in the population and initiating the collapse of the old chiefdoms.

This situation changed somewhat in 1670, when the English established a colony on the coast of South Carolina. Within a few years their trade with the Indians was expanding. Southern furs were found to be inferior in quality to those from more northern regions, yet deer were there in large numbers. By 1699, the English colonists were exporting 54,000 deerskins annually from Charlestown, and those numbers increased in the following decades. In their contacts with the Catawba and Cherokee, the men from Charlestown met unexpected competition. They found these Indians already equipped with metal tools and guns, imported by traders from Virginia. Unknown to most other people, these Virginians were already traveling with trains of packhorses along Indian trails through the interior mountain ranges, returning with deerskins and slaves.

Many of the colonists in Charlestown originated from the West Indies, where slave labor was used on the plantations, and it was with this economy in mind that they came to the Southeast. Pitting one tribe against another, the colonial authorities offered trade goods in return for the captives and made it into a profitable business. Unable to protect their converts against the slave raiders, the Spanish abandoned their coastal outposts and withdrew to St. Augustine. When Florida became British territory in 1763, the few survivors of the local tribes joined the Spanish in their removal to Cuba.

Indian slaves were used on the local plantations as well as exported by the shiploads. As the supply of Indian slaves diminished in the 18th century, the colonists relied more and more on imported Africans. It is estimated that by 1700 the native population of the Southeast had decreased by nearly 80 percent. The old chiefdoms had shriveled to small villages, which joined together into loose confederations or "tribes" such as the Creek, Catawba and Cherokee. After an uprising against the colonists in 1715, a gradual emigration started of Creek and other Indians into Florida, which had also become a refuge for runaway black slaves. The Indians did not consider skin color of great importance, and from these Indian and black refugees the Seminole tribe emerged by the 1750s. By the mid-18th century and throughout the Southeast, many Indian villages had a resident white trader who usually married into a chiefly family. Many of their mixed-blood descendants claimed their mothers' prestigious status in this matrilineal society and became active as tribal leaders.

Shortly after 1700, the French established their Louisiana colony along the lower Mississippi. In the

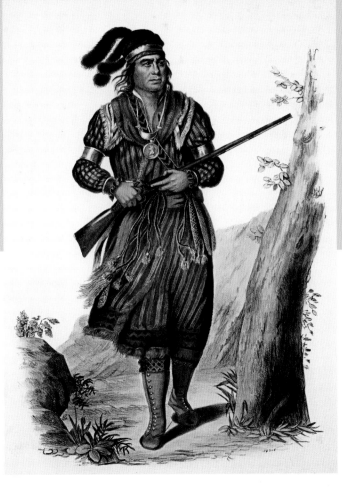

Tuko-See-Matha, Seminole Chief.
Illustration by Charles Bird King, circa 1865–75.
Courtesy Smithsonian American Art Museum,
Washington, DC / Art Resource, New York, NY.

competition between the French and the English, their Indian trading partners were encouraged to do the dirty work. Warfare raged for many years between the Choctaw allies of the French and their close relatives, the English-supported Chickasaw. In the final struggle between France and England, British troops invaded Cherokee territory and destroyed their villages and cornfields. Almost half the Cherokee population perished in this war and the ensuing starvation.

In the 1770s, the Indians were forced to take sides in the conflict between the American colonies and British rule. Most of the tribes supported the British, fearing that an American victory would allow hordes of white settlers to invade the Indian country.

By that time the world of the Indians had changed considerably, though it is remarkable how long certain glimpses of the past were still appearing in the colonial records. With the disintegration of the old chiefdoms, a more egalitarian society emerged in which the chiefs had lost their divine status, but burial mounds for such individuals were still built in the 17th century. Many of the European-imported goods initially served only as prestigious burial gifts. Despite the import of cloth garments, full dress remained restricted for visits to the white settlements; tattooing and body painting was still common in the 1740s.

Stimulated by the white traders, the Indians had become commercial deer hunters. In addition to hunting, rearing and trading horses and cattle became important. This new economy and intertribal warfare led to the disappearance of wood- and stone-carving, shell engraving, murals painted on plastered house walls, and other art expressions in which the men specialized. The women remained farmers and added several European crops to their production. Surviving were also the female arts of basketry and ceramics. The scrolls and spirals decorating their pottery have been interpreted as water symbols and related to concepts of fertility. Using European pots and pitchers as models, the women produced large quantities of "colono-Indian" pottery for trade to the white settlers.

In their manufacture and decoration of clothing, feather robes and painted-skin garments gradually

Coat, Creek or Cherokee, 1840s.
Beadwork on black-dyed deerskin.
Coats of this type were the Indian
version of the white man's fashion of
the period. This picture was made
before this irreplaceable garment
disintegrated in the 1980s.
Courtesy Onondaga Historical Association,
Syracuse, New York. Cat. no. 1988.1-6.

Facing page: *Portrait of William McIntosh, Chief of the Lower Creek Indians
in Georgia.* **Oil painting attributed to Nathan and Joseph Negus, 1821.**
Of mixed ancestry, McIntosh was executed by order of the Creek National
Council for signing an American treaty by which the Creeks lost their land.
In this picture, the chief wears a finger-woven sash and garters, front-seam
leggings of blue cloth, moccasins and an early type of shoulder bag. In all other
details his costume is that of a wealthy plantation owner, which he was.
Courtesy Alabama Department of Archives and History, Montgomery, Alabama.

disappeared as blankets, cloth, steel needles, scissors and glass beads became widely available. Commercial yarn replaced native fibers in finger-woven sashes. The women adopted cotton shirts and made their wraparound skirts of cloth. Calico and laced or ruffled white shirts were popular among the men, combined with their deerskin or stroud-cloth leggings. They also adopted cloth turbans, often decorated with silver bands and imported ostrich feathers. Most of these details are known only from eyewitness accounts and a few early pictures. Very few of the surviving ethnographic specimens predate the American Revolution.

After the American Revolution, the Southeast was flooded with white settlers. Neither here nor in other parts of the country was the federal government ever able to control its citizens or protect the Indians in this "manifest destiny." Large numbers of the Creeks joined the Seminoles in Florida, who started a guerilla warfare that flared up time and again until 1858. The desperate resistance of the Indians did not prevent the inevitable loss of their land. Dreaming of assimilation into American society, the largely mixed-blood native leaders were given to cooperation with the American authorities, but it was to no avail. The growth of plantations, which were producing great wealth in cotton and tobacco, was not to be hindered by anyone.

Responding to the demands of the white settlers, the American Congress passed the Indian Removal Act in 1830, and in the following decade the Indian people were forcibly removed from their ancestral lands. Along the "Trail of Tears" to present-day Oklahoma were buried about 5,000 Cherokee, 7,000 Creek and comparable numbers of Choctaw, Chickasaw, Seminole and other tribes.

The literature describing the "removal" of the Indians deals largely with the politics involved; the native people themselves are seldom heard in these records. Yet it was precisely in this dark period that Indian women of the Southeast created the most beautiful costumes and apparel, much of which has survived in public and private collections. Inspired by the patterns on printed cloth and calico, they executed abstract and highly stylized floral designs in overlay or spot-stitch beadwork on garments, moccasins and brilliant shoulder bags. Much of this work shows contour beading, that is, the layout of the bead lanes follows the white border lines of the design elements. Interlocking diamonds and zigzags were popular in the woven beadwork of garters and belts; scrolls and spirals in spot-stitched white beads decorated the red cloth bandoliers of the Choctaw. Some of these designs relate to the patterns stamped on traditional ceramics. Also of ancient design were finger-woven sashes with geometric patterns outlined by white beads and with long, heddle-woven drops at both ends. Practically all this colorful apparel, however, was

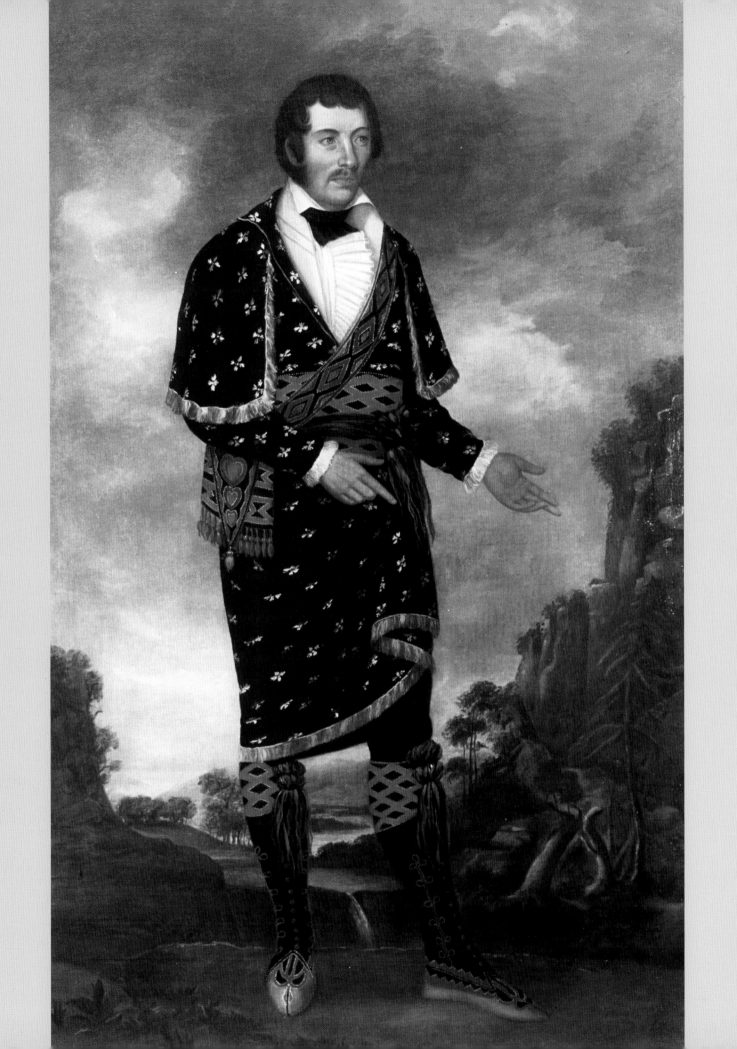

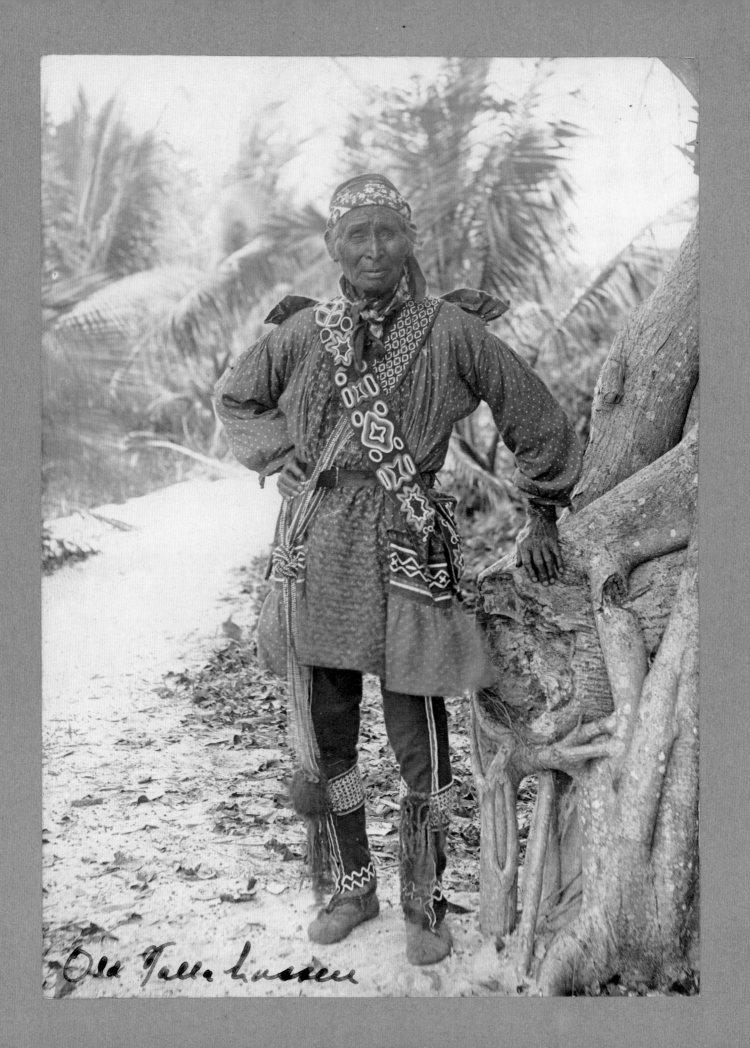

Old Tulla Lussen

Facing page: **"Old Tallahassee," Seminole Indian, circa 1884.**
Tallahassee wears a finger-woven sash across one of his
shoulders, and finger-woven garters, both interwoven with
beads. He carries a beadworked bandolier bag over the other
shoulder. His cloth leggings have a front seam and beadwork at
the bottom. This picture shows that elderly Indians at the end
of the 19th century still held on to a fully traditional costume.
Courtesy National Anthropological Archives, Smithsonian
Institution, neg. 44352. Photo by F.A. Rinehart.

Basket, Eastern Cherokee, circa 1970.
Traditional plaited cane basketry is still produced by the Cherokee
near Waynesville, North Carolina. These people escaped the
forced removal of the 1830s by hiding in the mountains.
Courtesy collection of the author.

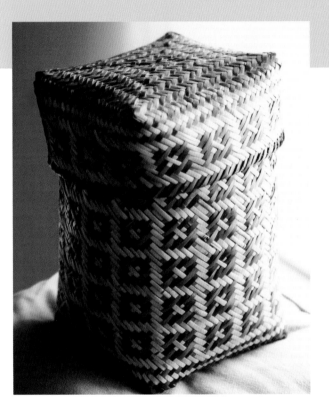

made by the women for their menfolk. For them-
selves they adopted dresses very much like those worn
by their white neighbors. The Cherokee women made
such dresses of cotton, which they had been weaving
in large quantities since the 1790s.

About 500 Seminole and comparable groups of
Cherokee and Choctaw eluded deportation by hiding
in swamps, forests and mountains; their descen-
dants still inhabit their homelands in Florida, North
Carolina and Mississippi. Also ignored were a number
of small communities such as the Chitimacha in
Louisiana. For these tenacious survivors, the con-
tinuation of their arts and crafts became a means to
maintain their Indian identity.

In the late 19th century, the Choctaw developed
a distinct type of appliqué decoration on the men's
shirts and women's dresses. The introduction of hand-
operated sewing machines brought about a surprising
change in the decoration of Seminole garments by
around 1920. Before that time such decoration con-
sisted of geometric patterns of appliqué work, similar
to those on Choctaw dresses. Following a period of
experimentation, the Seminole decorated their skirts,
shirts and jackets with multicolored bands of intricate
patchwork created with their sewing machines. Over
the years the designs have become more complicated.
Today, many Seminole people wear this colorful cloth-
ing at festive events.

In the Land of Corn Mother

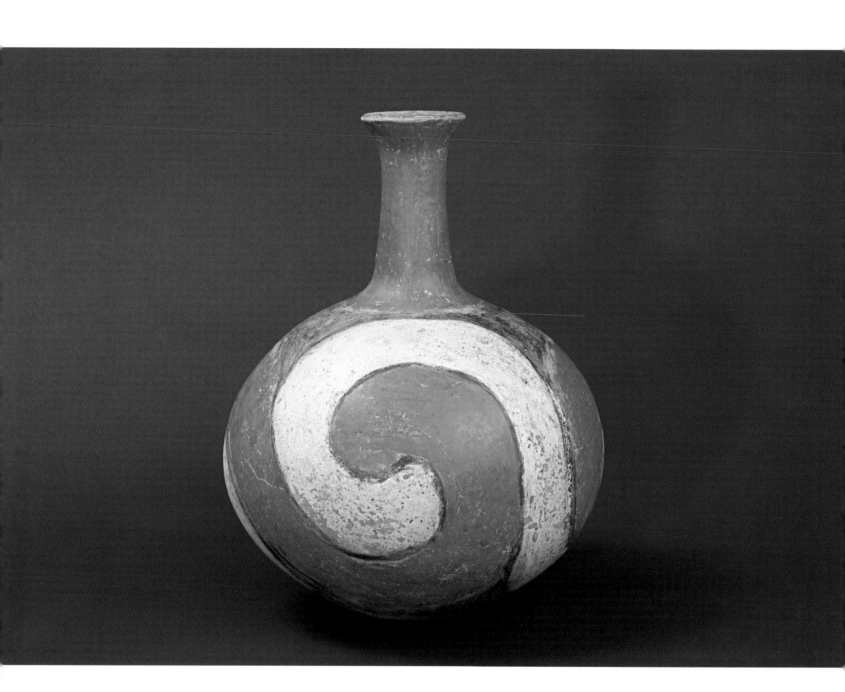

Long-necked globular bottle, Arkansas,
AD 1300–1500.
The polychrome interlocking scrolls on this bottle are thought
to allude to water and fertility. This pattern was popular
on Southeastern ceramics in the Mississippian period.
Courtesy James and Elaine Kinker Collection.

Facing page: **Shoulder bag, Creek, circa 1830.**
Length, 28 inches / 71 cm. Shoulder bags of this type replaced an
earlier twined-woven bag in the 1820s. Without information on their
provenance, it is assumed that many Southeastern bags are of Seminole
origin, but the whimsical style of beadwork on this example is reliably
documented as typical of the Muskogee, or Creek, Indians in the
1830s. Halfway along the shoulder strap, the decoration changes. This
feature was common from the Great Lakes down into the Southeast.
© Christie's Images Ltd., 2009.

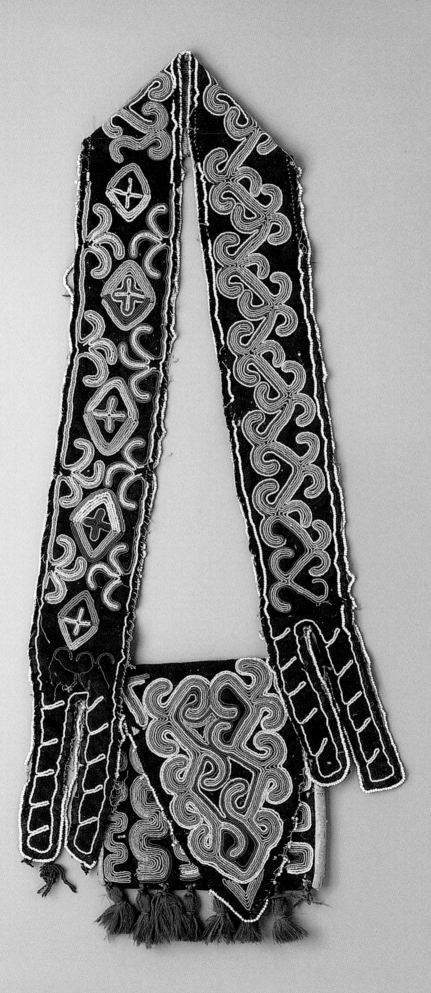

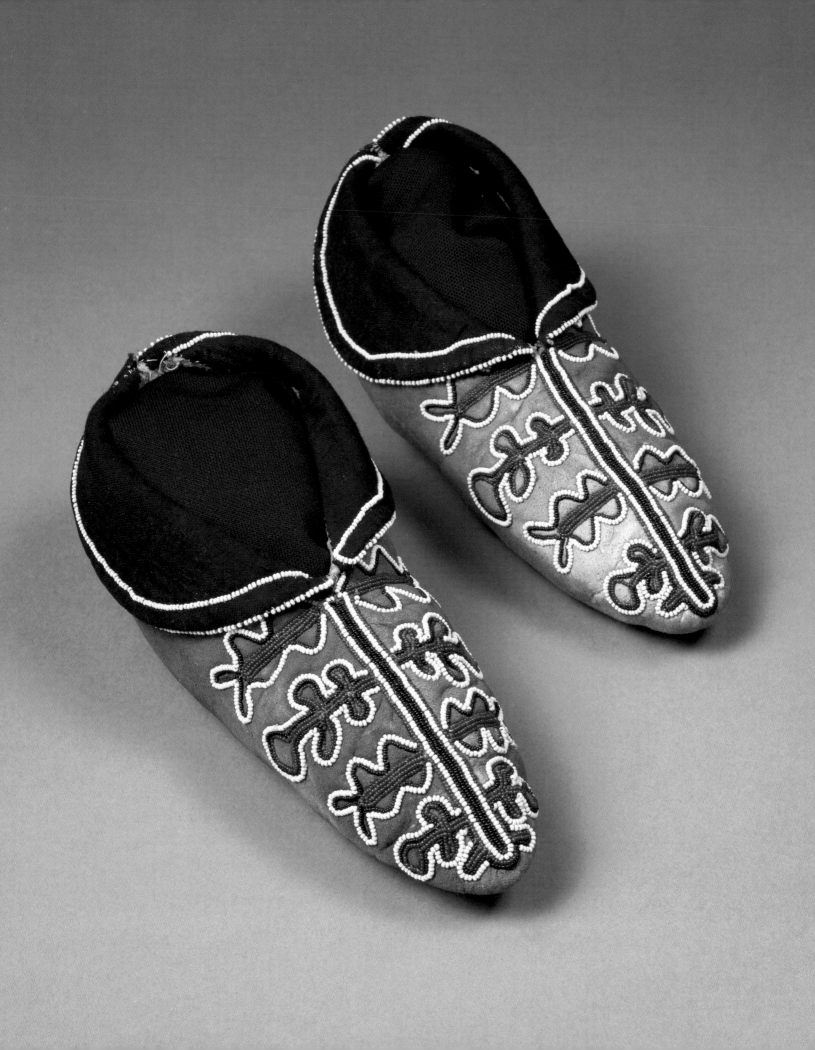

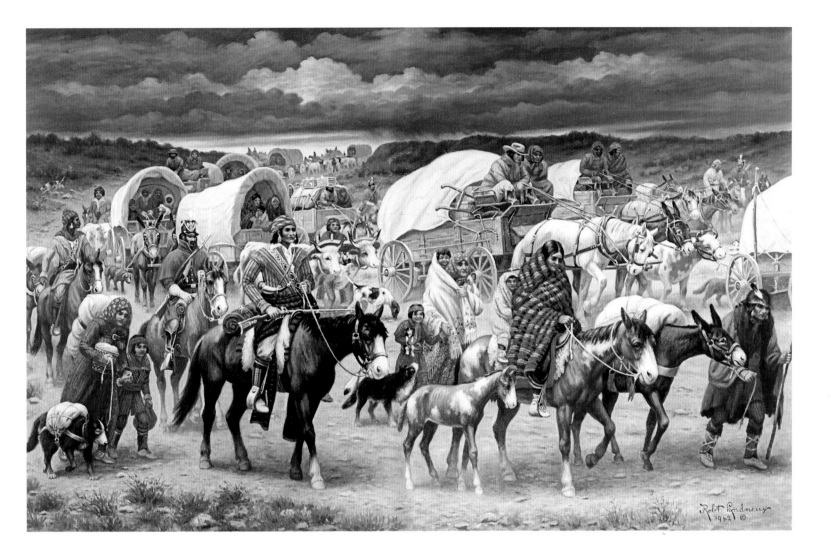

Facing page: **Moccasins, Creek, 1830s.**
Beadwork on deerskin, lined with indigo-blue cotton cloth.
The use of rounded cuffs is typical for Southeastern
Indians, perhaps for women's moccasins in particular.
Courtesy Ned Jalbert, Westborough, Massachusetts.

The Trail of Tears.

Oil painting by Robert Lindneux, 1942. Serious research by the
artist enabled him to create a believable picture of a moment in this
incredible tragedy. Escorted by federal soldiers, many thousands
of Indian people were forcibly removed from their Southeastern
homeland and marched to present-day Oklahoma in the 1830s.
Courtesy Woolaroc Museum, Bartlesville, Oklahoma.

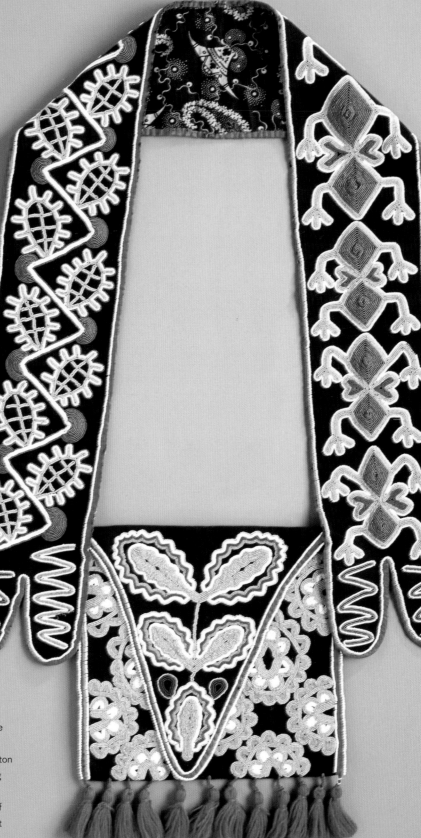

Bandolier bag, Cherokee?, circa 1840.
Beadwork on black cloth. This semi-floral style
of beadwork may have been inspired by the
patterns observed on commercial printed cotton
cloth (calico), which was often used as a lining
in these shoulder bags. The remarkably large
production of colorful apparel in this period of
poverty and social disintegration was a defiant
expression of the people's cultural pride.
Courtesy John and Marva Warnock Collection /
www.splendidheritage.com

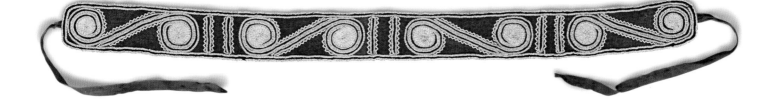

Above: **Bandolier, Choctaw, circa 1840.**
White pony beads and narrow strips of black wool
appliqué on red trade cloth. Length, 47 inches / 119 cm.
Bandoliers or baldrics of this type were worn crosswise
across the man's chest. They were most popular among
the Choctaw as early as the 1780s, but examples were also
acquired from the Koasati and Alabama around 1900.
Courtesy John and Marva Warnock Collection /
www.splendidheritage.com

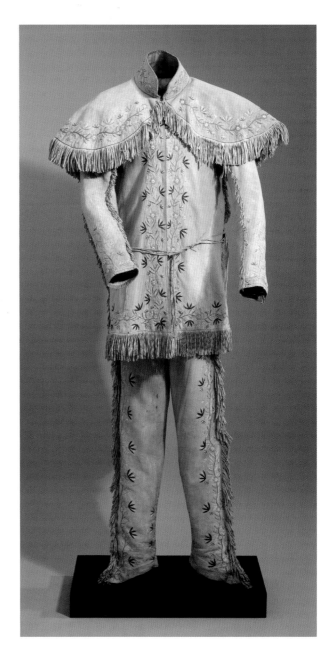

Right: **Costume, Western Cherokee, 1860s.**
Floral silk embroidery on deerskin. Reportedly once
belonged to Kit Carson. A similar coat decorated with
floral silk embroidery was made in 1865 by Western
Cherokee women in present-day Oklahoma; now
in the Milwaukee Public Museum (MPM 315).
Courtesy Trotta-Bono.

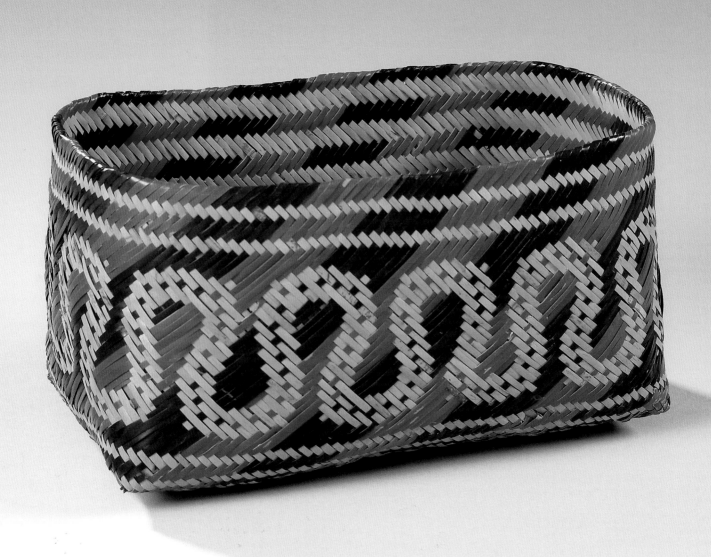

Basket, Chitimacha, circa 1900.

The Chitimacha, who live near Clarendon in coastal Louisiana, are well known for their fine split-
cane basketry. This basket, 9 inches / 22 cm long, was double woven in a twill-plaiting technique.
Courtesy Cowan's Auctions, Inc., Cincinnati, Ohio.

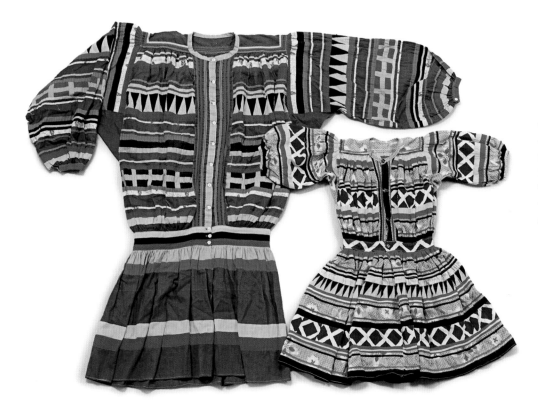

Patchwork shirts, Seminole, 1920s.
"Long shirts" of a man and a boy. The patchwork designs are made from strips of material cut apart, repositioned and reassembled on the sewing machine. In the 1930s, "long shirts" became shorter when the wearing of trousers became more common. Courtesy Skinner, Inc. Boston and Bolton, Massachusetts.

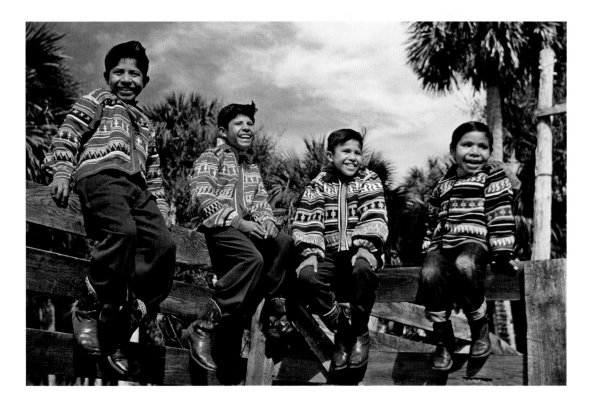

Seminole boys in their festive jackets, 1950s.
Courtesy Willard Culver / National Geographic Image Collection.

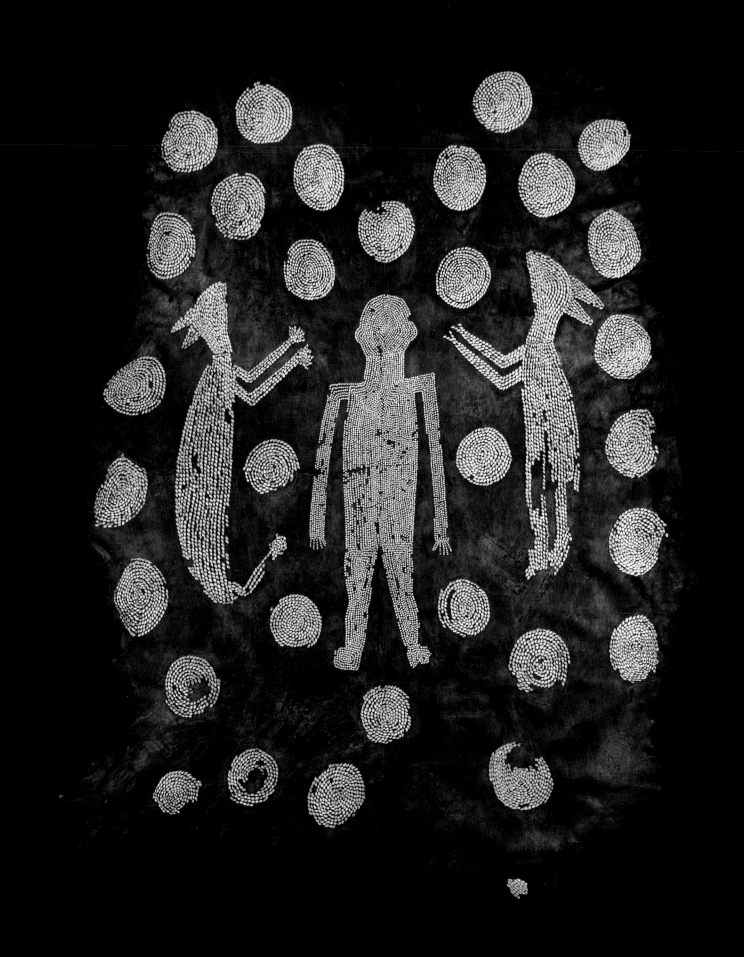

2 | The People of Dawnland

Previous page: **"Powhatan's Mantle." Virginia, before 1638.**
A fragment of an Indian garment, consisting of four pieces of deerskin, sewn together with sinew and decorated with native shell beads. Length, 92 inches / 233 cm. In his 1656 catalogue, the English collector John Tradescant described it as "Pohatan, King of Virginia's habit all embroidered with shells." It is assumed that this is a fragment of the mantle, given by Powhatan to Captain Newport in 1608. Holes in the skin outline the lost parts of the animal figures. Most probably, the knowledge of shell-bead stitching eased the later adoption of imported glass beads in the native arts.
Courtesy Ashmolean Museum, University of Oxford, England.

In the early 17th century, a variety of tribes inhabited the Atlantic seaboard from the northern shores of the Canadian Maritimes south to the coastal marshes of North Carolina. Forests covered most of the land, the northern pine trees giving way to deciduous hardwoods in northern New England. The lowlands and wider river valleys of New England and Virginia were the most densely populated parts of the region, inhabited by probably half of all the coastal people. The total population of the whole region in the century is estimated at about 133,000.

Contact between groups throughout the region was made easier by the Algonkian language shared by all these people. They also had in common a strong maritime orientation in their subsistence economy, most of them spending the summer along the coast and rivers, fishing and gathering huge quantities of shellfish. Their similar lifestyles were alluded to when they referred to themselves as Woapanachke or Wabanaki, "the people of dawnland."

Beyond these similarities, there was a major division in the region that had been created by the spread of agriculture. Originating in the Southeastern and Ohio regions, horticulture had been gradually adopted as far north as Maine, where the short growing season prevented horticulture from spreading farther north. In the northern reaches the people remained primarily hunters, and their customs and worldview related to those of the natives of the boreal forests of Canada. Dispersed in small bands, they spent the winter hunting moose and caribou in the interior. Such bands were led by elderly men recognized for their intimate acquaintance with the spirits of the game. In the spring these family groups came down the rivers in their birch-bark canoes, gathering in large camps along the coast, where they spent the better part of the summer with fishing and gathering of shellfish. Beyond their large summer camps these northern people did not recognize a political organization.

In more southern regions, horticulture had enabled the people to settle in semi-permanent villages, located near their cornfields in the river valleys. Dugout canoes of lengths up to 20 feet were used for travel on the rivers and out along the coast. In contrast to the conical wigwams used by the northern hunters, the dwellings of the villagers were of a Quonset type, some of them from 60 to 100 feet long and inhabited by several related families. By the end of the summer the people returned from the beaches to these villages for the harvest of corn, beans, squash and pumpkins. They stored the crops in large baskets and placed them in pits dug in the ground. Autumn was a period of collective deer-hunting drives, and the gathering of nuts in the forest, where the undergrowth was cleared by brush burning. In an annual cycle of festive ceremonials, the people thanked the spirits of nature for their well-being.

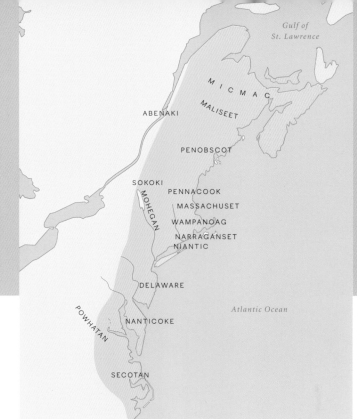

A rare series of colored drawings made by John White in 1585 documents Indian life on the coast of North Carolina. White showed men and women dancing around a circle of wooden posts, on which carved human heads are visible. This dance in July may have been part of the Green Corn Festival, celebrated throughout the region. Similar carved posts in Virginia were later reported, as were carved posts in the ceremonial lodges of the Delaware Indians in the 18th century. Stone-carved human faces found in the general region may have had a similar function when tied onto posts. Presumably the carved faces represented spiritual beings associated with the well-being of the people. Among the Delaware, carved wooden masks were worn by dancers in bearskin costumes to represent the guardian spirits of the game. These masked dancers appeared at the start of the winter hunting season.

Influence from the far south manifested itself not only in farming. Other aspects included the making of pottery, fabrics twined of vegetable fiber, feathered robes, and a complex social organization. Hereditary political and religious leadership was centered in a small but rigidly marked upper class. Indians in Rhode Island remembered a chief, who "had only a Son and a Daughter; and he, esteeming none of Degree for them to marry with, married them together." Normally, chiefs found their marriage partners among the elite of neighboring groups.

Alliances brought about by the intermarriage of chiefly lineages created federations of tribes in the most densely populated areas already before European contact. Tribal territories coincided with the major river drainages, of which the rugged hinterlands were used for hunting. Ownership of the cleared land was vested in the families of the hereditary chiefs, who distributed the usufruct (the rights of use of and the fruits of the property) among the common people.

Restricted to the use of the chiefly class were feathered robes, beads made of native copper, and white and blue shell beads for decorating garments or woven into headbands and bandoliers. Gleaming copper and white shell ornaments were sacred because of their connotation of physical and spiritual well-being. Facial and body tattooing seem also to have been a prerogative of chiefly individuals.

Clothing was largely made by women, though one early account noted feathered robes, "curiously made

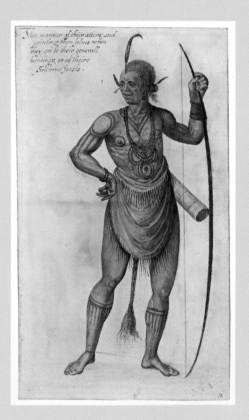

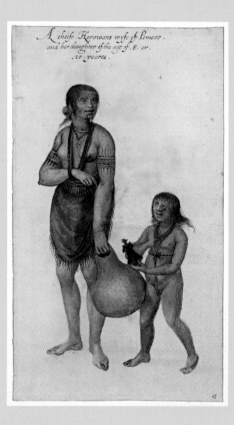

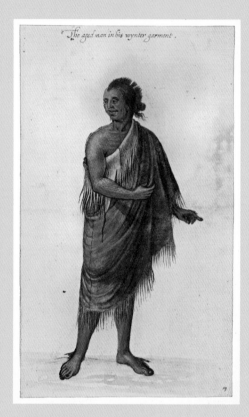

The manner of their attire and painting them selves. Coastal North Carolina, 1585.
Watercolor by John White. Few of the Indians observed by John White wore the breechclout known from later times; apparently an apron of fringed deerskin was more common. The animal tail that hangs down from this man's back may have been attached to the quiver made of twined rushes. On his left wrist is a bracer, or guard, to protect the wrist in bow hunting. Contemporary sources mention that body painting and tattooing distinguished chiefly people "in token of authoritye, and honor."

An Indian woman and child of Pomeiooc. Coastal North Carolina, 1585.
Watercolor by John White. The mother carries a large gourd water container, while the child holds a doll of the kind handed out by English settlers. The clothing of girls younger than 10 years was restricted to a leather string holding a pad of moss.

An old Indian man of Pomeiooc. Coastal North Carolina, 1585.
Watercolor by John White. The winter garment appears to be a fringed deerskin robe, fur inside, thrown over the left shoulder. A seam is visible down the left side. The native term for such a robe was "match core," from which came the English term "match coat," widely used in colonial times as a term for a short Indian coat.

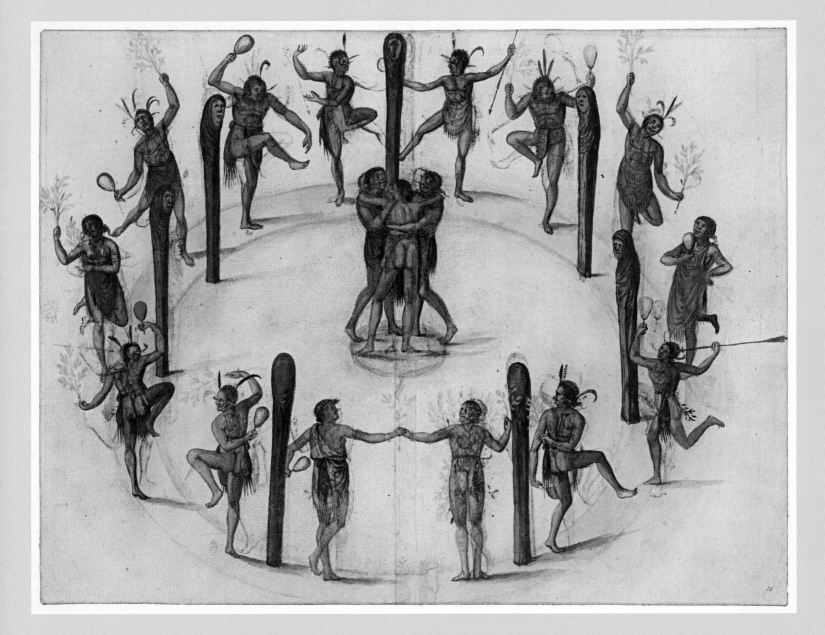

***A Festive Dance.* Coastal North Carolina, 1585.**

Watercolor by John White. Men and women dancing around seven posts
topped with carvings of human heads. The dancers hold leafy branches
and gourd rattles; some have leafy twigs also stuck in their belts.

of the fairiest feathers of Turkies, which commonly their old men make." The basic woman's dress was the knee-length wraparound skirt, made of deerskin or woven of hemp fiber. Men wore an apron or the usual breechclout of soft skin, worn between the legs with the ends hanging down over a belt in front and behind. A knife was customarily worn in a sheath hanging on the breast, suspended from a neck string. Upper garments were uncommon, though an untailored robe of tanned skin or beaver fur might be worn over one shoulder by both sexes. In cold weather, a muff-like sleeve covered the one arm left free by the robe. Short capes of twined strips of rabbit skin were worn by ritual leaders on the Carolina coast. Leggings and moccasins were worn in winter travel. Moccasins braided of cornhusks were noticed on the Hudson River. Boys went naked until about 12 years old, but girls were given a small cover as soon as they started to walk.

Garments were decorated with painted designs or embroidered with shell beads; with pearls in Virginia. In 1524, a chief in Rhode Island "had on his nude body a skin of a stag, artificially adorned like a damask with various embroideries." The bone tools used by the women in painting on skin garments were apparently of personal importance, for they were often buried with them. The idea that the animal's spiritual power survived in the skin used for clothing was common in more northern regions; it certainly was shared by the people in the Maritimes. From that region came the earliest observations of the use of color-dyed moose hair and porcupine quills in the decoration of skin garments. Throughout the range of the porcupine, quillwork was executed in wrapping, sewing, plaiting and weaving.

✻

The first contacts of the coastal Indians with Europeans were made around AD 1500, when Norman, Basque and English fishermen annually traveled to the fishing grounds off the American coast. With these fishermen operating in the north, and Spanish slave hunters mainly in the south, the 16th century was one of increasing knowledge of the whole Atlantic coastline.

The French fur trade started in the Gulf of St. Lawrence in the 1520s, and by that time the Indians as far south as Maine were also acquainted with the white man's desire for furs. By the end of the century, the coastal fur trade had changed from a sideline of fishermen to the major occupation of English and Dutch sailors. In the northern Maritimes, where specific bays were chosen as annual trade centers, the Indians chose to use the same places for their summer camps; this led to the formation of a smaller number of larger bands than before. These larger bands developed into the historic tribes.

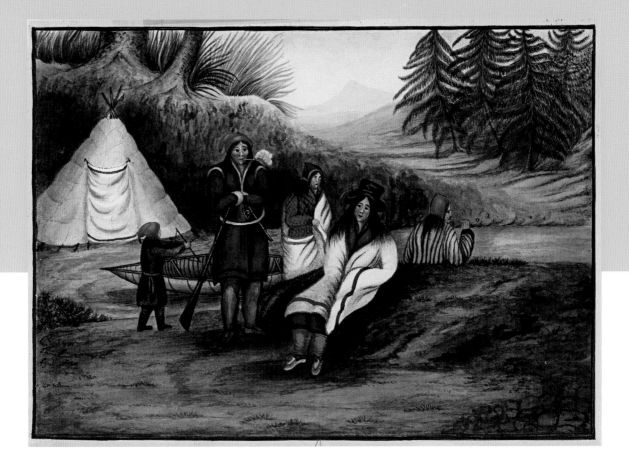

The coastal Indians bartered skins, furs and venison to the mariners in exchange for knives, fish hooks, metal pots, blankets and shirts. Blue and white glass beads were highly prized due to their resemblance to their own shell beads. Early names for the whites, such as "Knife Men" and "Coat Men," indicate the natives' appreciation for the imported wares.

Many of these imports acquired a different function in the native society: copper cooking pots were often placed over the heads of the deceased in burial; woolen socks might be used as tobacco pouches, decorated with metal thimbles serving as tinkling pendants. New materials, such as woven fabrics, were not always better than native materials, but they were considered superior. The trade goods were believed to be imbued with the supernatural powers attributed to the white strangers and their distant origins.

In those early years of European contact, the coastal Indians became crafty in their trade with the sailors, serving as middlemen in this trade with the more isolated groups of the interior. Rivalry over direct access to the white traders became a source of intertribal warfare. The fur trade required the Indians to spend more of their time trapping beavers and other small fur-bearing animals. Particularly in the horticultural region, the Indians were slow in adopting this change in their economy, as indicated by the directives given by the companies' governors to new traders: "They are plentifull in Corne and Tobacco but have not many Scins if you cannot other ways Deale with them, first making Tryall of all Fayr Courses, then do yor best to Seize their Corne and Provision for that will inforce them to Commerce and supply [your] wants …"

Starting in 1580, early reports tell of the incredible effects of epidemic diseases unwittingly introduced by the Europeans. Lacking immunity to these diseases, the coastal Indian population was decimated by them,

Facing page: *Eiakintomino in St. James's Park* [La.III.283. f254]. **From "Album Amicorum."**
Watercolor by Michael Van Meer, of an Indian visiting London in 1615. This picture includes the earliest evidence of a shoulder bag used by an Indian, correcting the assumption that the later Indian shoulder bags were inspired by European military apparel.
Image used with permission of Edinburgh University Library.

and refugees carried the diseases even farther inland. During the 16th century, all attempts at colonization were dramatic failures. Desperate for food, colonists often plundered the native villages and resorted to violence. Indians were often captured, either to be sold as slaves or used as guides on later expeditions. By 1600, all along the coast, there could be found native individuals who had spent some time in Europe.

In 1607, a group of English colonists arrived in the Chesapeake Bay of Virginia, heralding the start of a new experience for the Indians. The white man's desire for furs was to be replaced by his demand for land. Friction with the settlers had started when Chief Powhatan asked John Smith, "Why will you take by force what you may have quietly by love?" The love affair of his daughter, Pocahontas, was another story – or was it? Did Powhatan suggest wholesale intermarriage?

In 1609, Henry Hudson sailed up the river eventually named after him, and there he met an Indian chief "who carried him to his house and made him good cheere." Following subsequent visits, Dutch traders established a settlement in 1614 near present-day Albany, New York. Ten years later the town of New Amsterdam was founded on Manhattan Island, and Dutch trading posts were established on the Connecticut and Delaware Rivers.

In 1620, the Pilgrims arrived in Massachusetts, at a location where a severe epidemic had exterminated the native population. Chief Massasoit welcomed the settlers, saying "Englishmen, take the land, for none is left to occupy it."

Despite increasing hostilities, the principal chiefs tried to keep the peace, wishing and occasionally obtaining the alliance of the colonists in extending political control over the regional tribes. Friction started with mutual misunderstanding. In a dispute with the governor of Maryland, an Indian chief told him: "Since you are heere Strangers, and come into our Countrey, You should rather conforme Yourselves to the Customs of our Countrey, then impose Yours upon us." However, the imposition of European customs was considered a necessary precondition for the introduction of Christianity that was stipulated in all colonial charters. Moreover, the settlement of "civilized" Indians around the European colonies might serve as protection against hostile "savages." In hindsight, it is obvious that this program was doomed to fail, particularly in view of the somber cast of Puritan Christianity.

Woolen blankets had soon replaced skin and fur robes, but there was not much demand for European garments. "They love not to be imprisoned in our English fashion ... because their Women cannot wash them when they be soyled ... they rather goe naked than be lousie." European dress was primarily

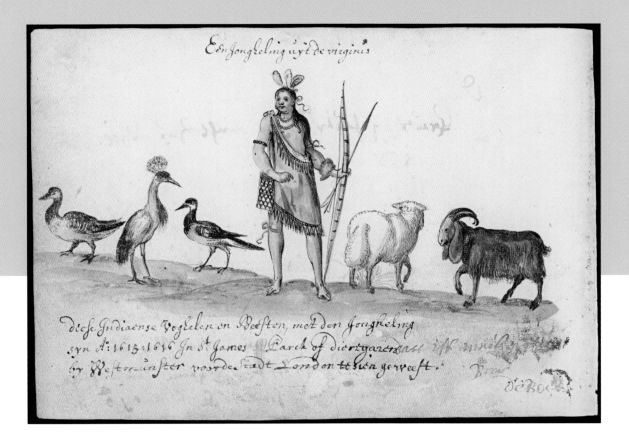

Een Jongeling uyt de virginis

diese Indiaense Vogelen en Beesten, met den Jongeling
syn A: 1615 1616 In St James Parck of diertgaerden
by Westmijnster voorde Stadt London te sien gerwcest.

adopted by the Indian chiefs, and even they used such garments only while visiting the colonial settlements. Imported cloth replaced buckskin, but the garments remained traditional in style. The Indians preferred cloth of subdued colors, blue or gray, in order not to attract the attention of game while hunting. However, by around 1630 the beaver population in the coastal areas was depleted, and the traders moved their trading posts up the rivers into the interior.

When white settlements began to spread, friction with the Indians grew more serious, and violence flared up time and again. Long-smoldering feelings of injustice exploded into open warfare, starting in Virginia in 1622. War in Connecticut in the 1630s spread into New Netherland, where hostilities lasted until the English took over the Dutch colony in 1664. In 1669, the Indians of northern Maryland were exterminated, and there was a desperate but final struggle of the Indians in Virginia and New England in the 1670s. When the smoke cleared, several tribes were virtually extinct, most of the "Praying Indian" villages of New England had disappeared, and many hundreds of Indians had been deported as slaves to the West Indies. Practically all the surviving Indians of the interior parts of New England had fled across the mountains to French protection along the St. Lawrence River. The native people of coastal New York, New Jersey and Maryland were retreating into Pennsylvania. It is estimated that by the end of the century, more than 70 percent of the coastal Indian population had died in warfare and epidemic diseases.

The colonial developments described so far relate primarily to the areas south of the Canadian Maritimes. European settlement in the more northern parts of the Atlantic coastal region came later because of the colonial focus on the better farmlands down the coast and also in the face of the territorial claims of the French. The French claims were centered in but not restricted to the St. Lawrence Valley. Since 1605 there had been a sprinkling of French settlers in the Maritimes, and they

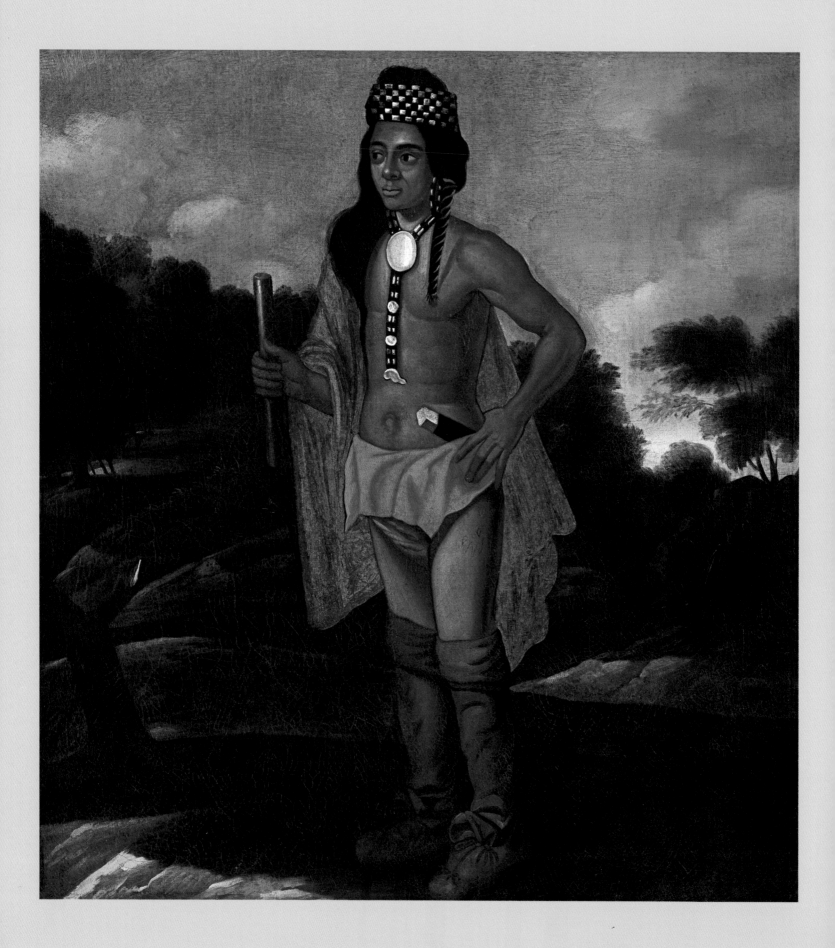

The People of Dawnland

Facing page: *Native American Sachem,* circa 1700. **American, 48.246.**
Anonymous oil painting on canvas. The youthful appearance of this man raises the question whether this represents Ninigret, who was described as an elderly man in 1675, or his son Ninigret II, who died in 1723. Ninigret wears a robe, a breechclout, leggings held up by garters, and moccasins. His headband and necklace of wampum beads indicate his chiefly status. Courtesy Museum of Art, Rhode Island School of Design. Gift of Mr. Robert Winthrop. Photo by Erik Gould.

Micmac Indian Woman, circa 1850–60.
Anonymous pastel.
Courtesy the New Brunswick Museum, Saint John, New Brunswick. Acc. no. W3957.

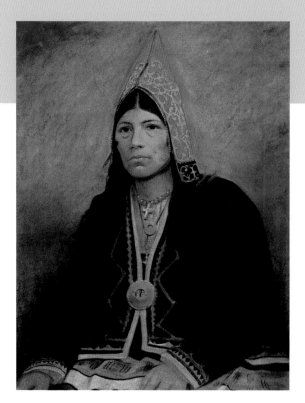

maintained a friendly relationship with the native people. Thus these Indians were allowed almost a century longer to adjust their society to gradual change. The fur trade remained important because trapping of fur-bearing game did not force the Indians to change their annual cycle of hunting and fishing as much as it had the agricultural societies farther down the coast. Yet the time they would formerly have spent making their own utensils was now needed for activities related to the fur trade. Metal tools, firearms and cloth gradually replaced all native crafts, and the price of all these novelties was the economic independence of the Indians.

Roman Catholic mission work in the Maritimes started in 1619, but for many years the efforts of these French missionaries had no apparent results. Here as well as elsewhere, the native people remained confident of their own beliefs as long as their world and well-being were not undermined by the more brutal effects of European contact. The missionaries protested against the liberal use of rum and brandy in the fur trade, which caused violent disorders in the Indian camps. In 1660, the bishop of Quebec threatened to excommunicate all those who were selling liquor to the Indians, but the colonial authorities argued that the Indian trade would go to the English and Dutch if the French traders were forbidden to sell liquor.

In the French reports the Indians were praised for their wood carvings, their woven mats and the decoration of their garments with porcupine quill-work. Birch-bark canoes, snowshoes and moccasins were readily adopted by the French. The apparent popularity of quillwork-decorated moccasins in the 17th century suggests the early beginnings of a souvenir production that was to become an important source of income in later times.

Although the materials were changing, the style of both male and female clothing remained relatively unchanged. In 1675, it was mentioned that "some of our Indians … make use of a white or red blanket, which falls from the shoulders to the mid-leg in the form of a tunic; which this they enwrap all the body,

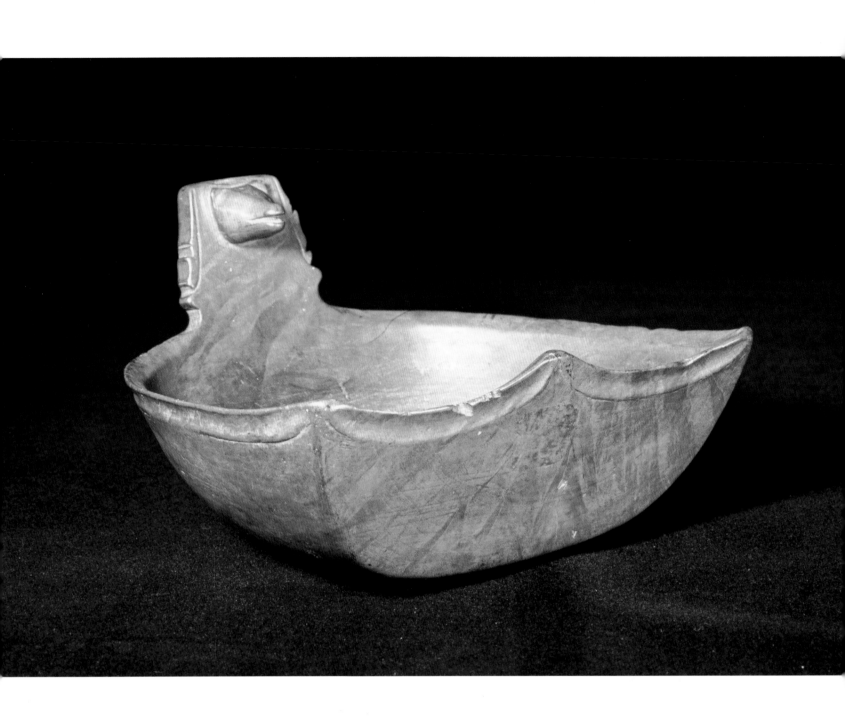

Wooden bowl, Mohegan, circa 1680.
Several of these rare wooden bowls from southern
New England show inward-looking animal heads.
Remarkably similar effigy bowls were made by the
Eastern Sioux in Minnesota in much later times.
Courtesy Donald Ellis Gallery, Dundas, ON, New York, NY.

and they belt it by a girdle ornamented with bead-work." Yet in the same period the Abenaki still made similar sleeveless tunics of moose hide, to which separate sleeves might be added. These garments were worn by both men and women in cold weather. A cotton blouse was added to the woman's skirt in the 18th century. Peaked hood-like caps may have been introduced during the fur trade era. Initially worn by both sexes, these caps survived as part of the women's costume in the Maritimes until the end of the 19th century.

Both glass beads and ribbons were highly prized by the Indians. Cloth did not lend itself to painted decoration, but it made the perfect background for beadwork and ribbon appliqué. In both media, the Maritime Indian women developed regionally distinct art styles. The curvilinear designs of their beadwork may well have been a continuation of the "lace-like patterns" noticed on skin garments in the accounts of early contacts. The fine ribbon appliqué patterns may also represent a transfer of earlier patterns in the new medium. Early accounts mention that the Indians painted pictures of birds and animals on their robes and on themselves, but this depiction of life forms was probably abandoned in the adoption of the new religion.

Christianity was spreading in the 1670s, signifi-cantly coinciding with evidence that the native society was in crisis. The Indians were staunch allies of the French in their colonial wars, the declining fur trade caused poverty, and alcoholism was rampant. After the British conquest of French Canada in 1760, white settlers from New England were expanding into the Maritimes, forcing the Indians to retreat from their coastal fishing grounds. The annual salmon run up the rivers remained an important source of food and trade, augmented by employment in the lumber industry and increasing production of crafts for sale to the white population. The Indians survived as small communities reintegrated around Roman Catholic

missions. A distinct style of dress emerged in the 18th century, with rich beadwork decorating the prevailing blue cloth. Beadwork ornaments also decorated the interior of some Indian churches.

When it came to producing crafts for commercial sale, the Maritime Indians adopted the manufacture of basketry woven of thin strips of wood. Introduced by Indians from New England, splint basketry was produced in large quantities for practical use by the white farmers as well as for the tourist trade. The Penobscot and Maliseet specialized in the produc-tion of canoes and snowshoes. They decorated their bark baskets with incised curvilinear patterns. In contrast to these traditional crafts, the Micmac women made a variety of bark ware decorated with colored porcupine quills. Apparently inspired by similar souvenirs made in Quebec convents, the Micmac adopted this art form in the 1750s. Moccasins continued to be in demand, but the old front-seam type was replaced by moccasins with a vamp inserted at the instep. During the fur trade era, this stronger construction became popular all over the northeastern parts of North America.

South of the Maritimes, the final defeat of the Indians in the 1670s had left the survivors at the mercy of the colonial authorities. Their last remain-ing lands were whittled away by greedy settlers and corrupt government officials who were appointed to protect the Indians. The natives of Virginia were confined to isolated hamlets and had to pay an annual tribute of fish and venison to the Governor, which they still do today. Those of the coastal Indians in North Carolina who remained disappeared into the regional black population.

Starting in the 1730s, the Indians along the Hudson River began leaving, most of them to join refugee groups in Pennsylvania, others heading for Massachusetts. Following the "Great Awakening" of religious fervor among the New Englanders, a Protestant mission was established for the Indians

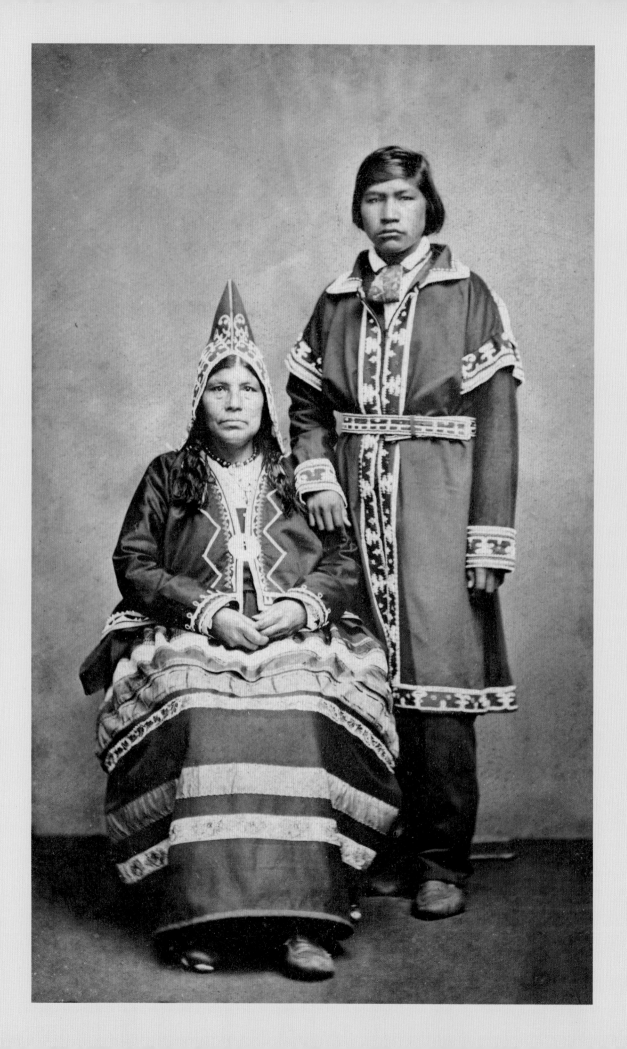

Facing page: **Micmac Indians in festive costume, Nova Scotia, 1865.**
Christine Ann Morris, also known as Mary Christianne Mollise, and her adopted son, Joe. This woman made the decoration on the Micmac cradle that appears on page 59.
Courtesy National Anthropological Archives, Smithsonian Institution, neg. 56.827.

at Stockbridge in western Massachusetts. There were other native communities on Cape Cod and the nearby islands, in Rhode Island and in Connecticut. The churches in these settlements became focal points for community solidarity.

The tenacity of the coastal Indians south of the Maritimes in maintaining traditional customs was evident in the survival of hereditary chiefs until the late 18th century; the people paid them respect by personal services. The men were still fishing and did some hunting, while the women tended their corn-fields and some cattle. In their contacts with white neighbors, the Indians of Rhode Island mastered the art of casting pewter reproductions of their own carv-ings. Along the lower Delaware River, Swedish settlers introduced the local Indians to the weaving of wood strips into baskets. After 1700, this craft of splint bas-ketry spread among the Indians of New York and New England to become a major source of their income. The checker-woven wood strips were often decorated with potato-stamped or hand-painted designs.

In contrast to the Indians of the Maritimes, the more southern coastal native people accepted the white man's garments without any innovations, occu-pied as they were with the sheer challenges of physical survival. Other than the use of moccasins and of blankets as robes, there is not much evidence of the survival of Indian dress after the 1750s.

After the American Revolution, the Stockbridge Indians were crowded out of their mission town by white settlers. In the 1820s they moved to Wisconsin. Whatever land the coastal Indians still owned was rented out to white farmers. The native women were either employed in white households or adopted a more nomadic life producing and selling baskets. In southern New England, many Indians were employed on the whaling ships, like the harpooner "Tashtego" in Melville's *Moby-Dick*; as a result, scrimshaw began to influence native wood carvings.

During the 19th century, the remaining coastal Indians south of Maritimes were socially and cultur-ally at rock bottom. Intermarriage with black refugees raised questions about their ethnic identity among race-conscious Americans. Several of these communi-ties disintegrated, the people disappearing into the general population. In the surviving communities, however, the people retained a strong sense of their Indian identity, inspiring the emergence of a neo-Indian culture by the end of the century. Borrowing the details from western Indians, natives replaced the Christian June Meetings with powwows. The Indian Reorganization Act of 1934 fostered the tribal incor-poration of the remnant groups. All along the East Coast, native communities have become visible again, tapping into the tourist industry.

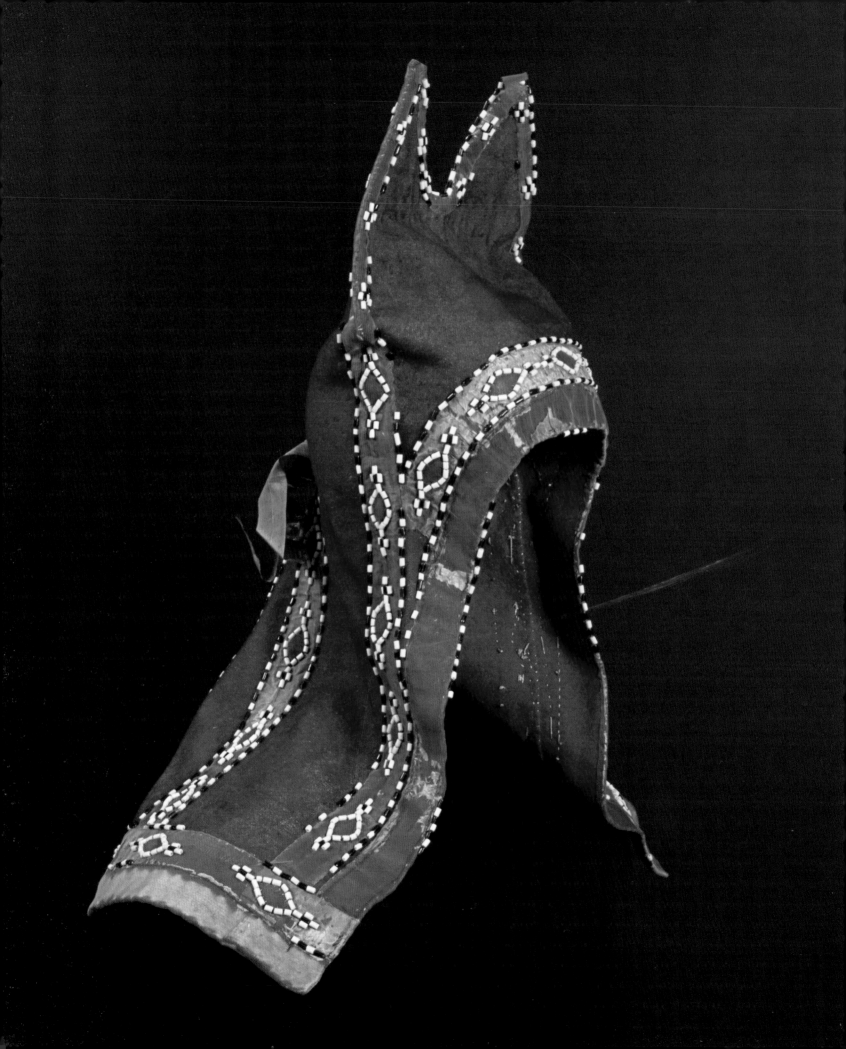

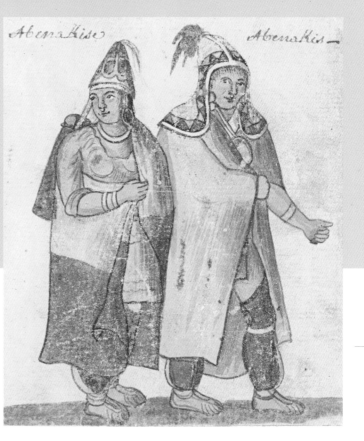

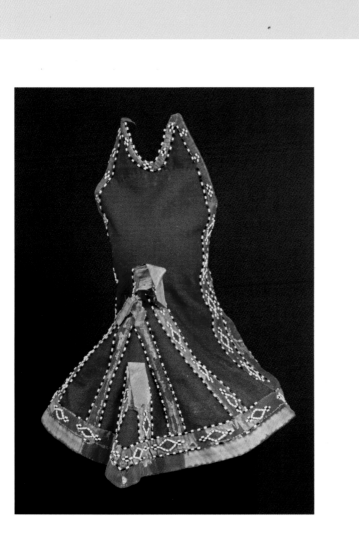

Abenaki Indian Couple, circa 1750.
Anonymous watercolor in the Gagnon Collection. As refugees
of the Indian wars in New England, the Abenaki people lived at
Becancour in the St. Lawrence Valley. Peaked hoods such as
the one worn by this man may have been popularized by the fur
trade; examples are known from the Canadian Maritimes, James
Bay and the western Great Lakes. All garments worn by this
couple were made of trade cloth, except for their moccasins.
Courtesy Archives of the City of Montreal, Quebec.

Facing page and above: **Man's hood, Maliseet, 18th century.**
Eared headdresses have a long history in the northeast, going
back to the hunters' use of caps made from an animal's head
fur with the ears attached.
Courtesy the New Brunswick Museum, Saint John,
New Brunswick. Acc. no. 1983.47.2.3.

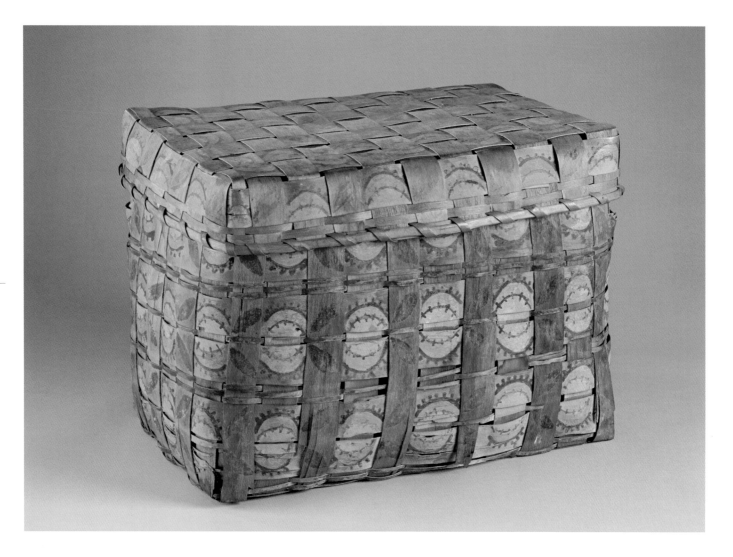

Splint basket, southern New England, circa 1840.
The production of splint basketry was a craft introduced by Swedish settlers on the lower Delaware River. By 1700, the local Indians had lost their land and the means of their traditional way of life. In need of a source of income, they adopted this style of basket-making from the Swedish, including the decoration with hand-painted or potato-stamped patterns. After 1750 the craft spread among the Indians of coastal New York, reaching southern New England by 1780. Courtesy The Joseph A. Skinner Museum, Mount Holyoke College, South Hadley, Massachusetts.

Facing page: **Birch-bark containers, Penobscot, 19th century.**
The Penobscot in Maine turned their traditional bark craft into a market-oriented production when hunting and trapping became less profitable. When the birch bark is turned inside out, the dark layer of cambium is exposed, allowing the creation of scraped designs in this Maritime art style. The rims of these containers were reinforced with wrappings of split spruce root. Courtesy Trotta-Bono.

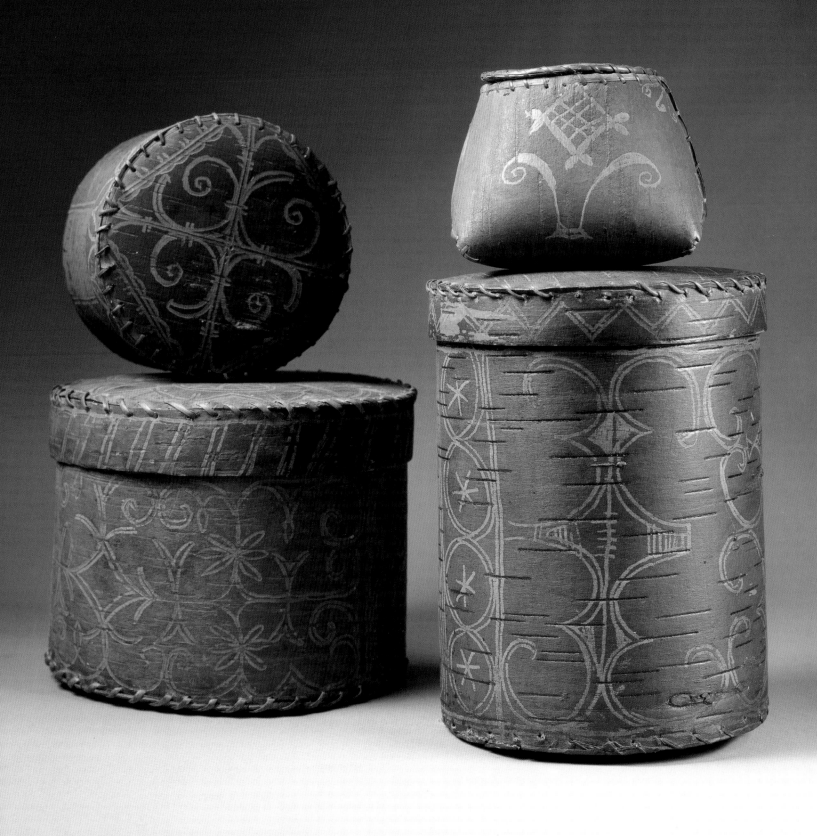

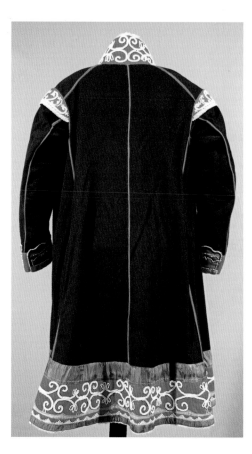

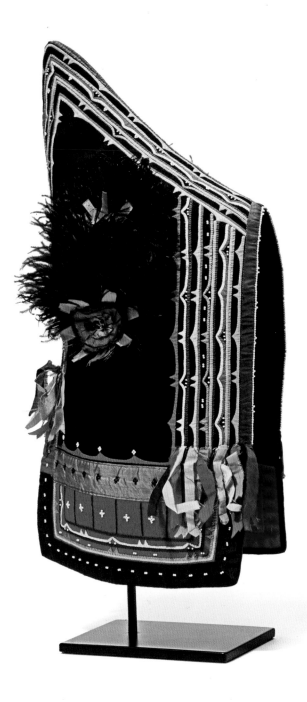

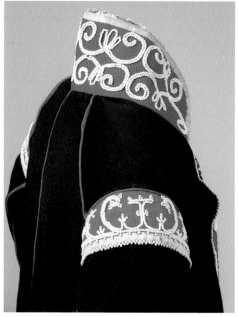

Peaked cap, Micmac, circa 1847–53.
Silk ribbon work on trade cloth. Height, 14.75 inches / 37
cm. A superb example of the fine ribbon appliqué style that
developed among the Micmac in the early 19th century.
Hoods of this type became fashionable among the Maritime
Indian women by the end of the 18th century. Dyed ostrich
feathers, as on this hood, were imported by the fur traders.
Courtesy Thaw Collection, Fenimore Art Museum,
Cooperstown, New York. Photo by John Bigelow Taylor, NYC.

Above and facing page: **Coat, Micmac, early
19th century.**
Beadwork and ribbon work on trade cloth. Length,
45 inches / 115 cm. It is assumed that military coats
were the prototypes of this regional Indian fashion.
Courtesy the New Brunswick Museum,
Saint John, New Brunswick. Acc. no. 30116.

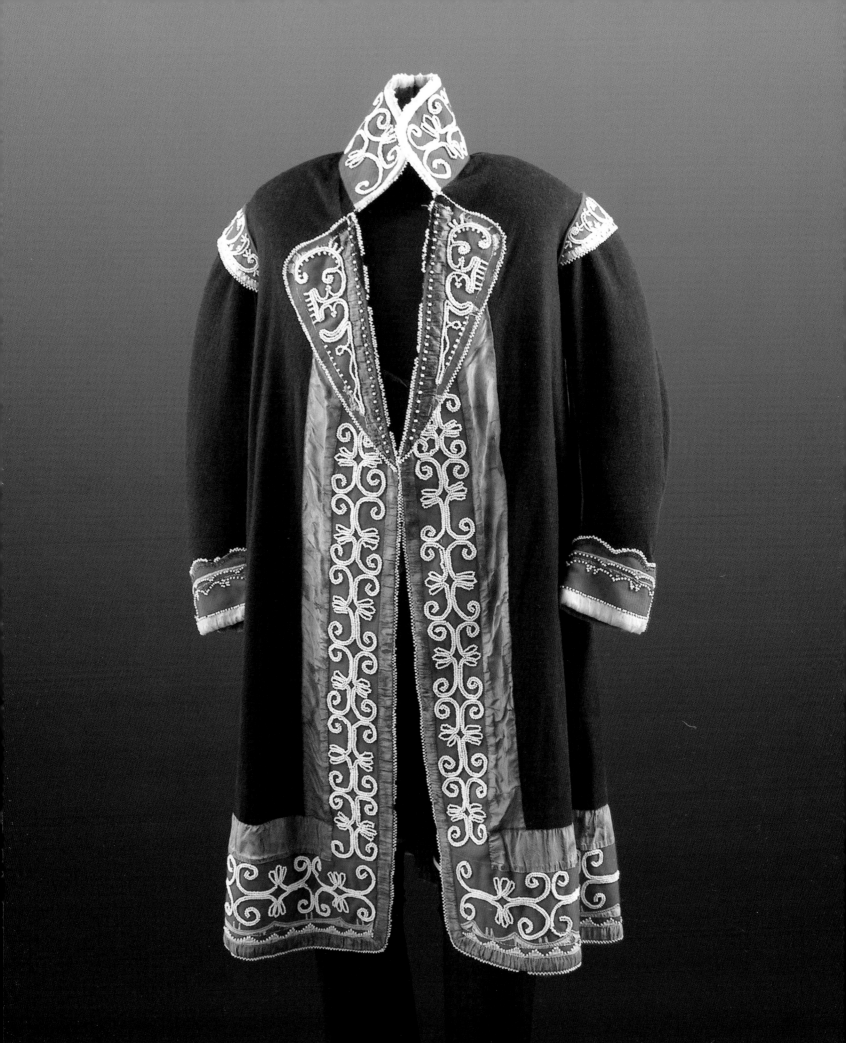

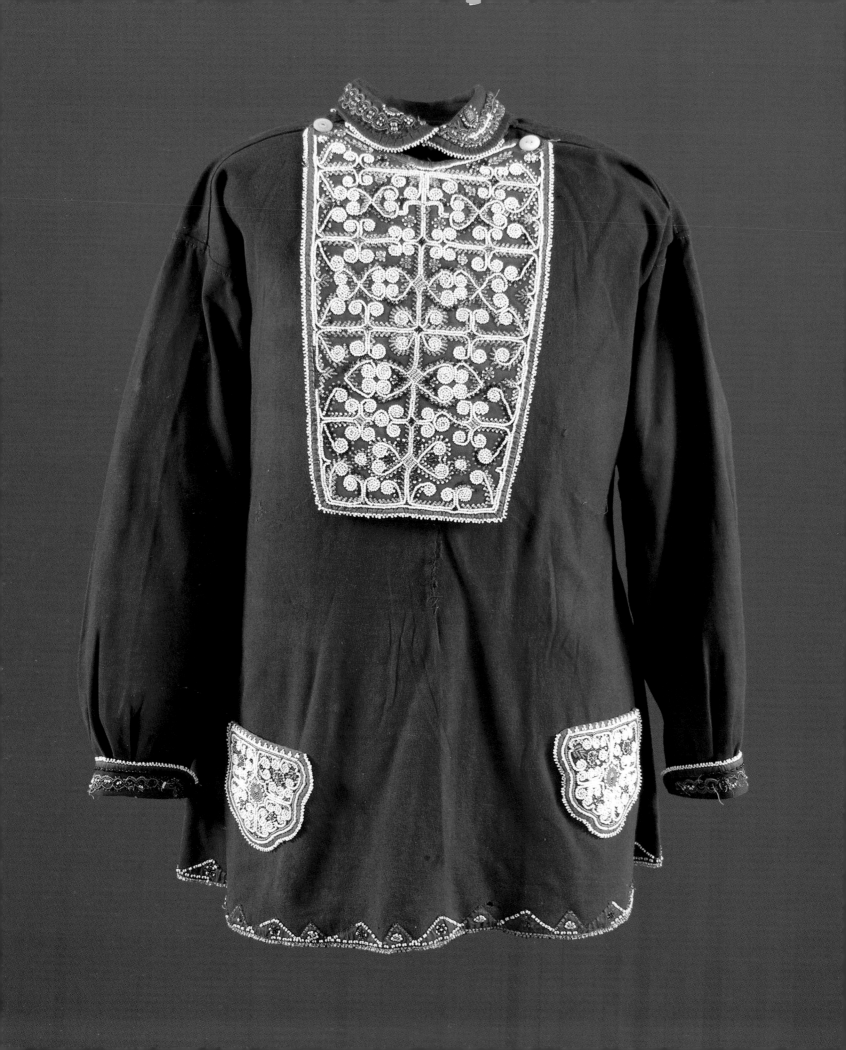

Left and facing page: **Ceremonial shirt. Maliseet, circa 1850.**
Blue cloth shirt with detachable plastron. Length,
29 inches / 74 cm. This beadwork is an excellent example
of the Maritime style of double curves within square
frames. These designs may well continue the painted
"lace-like patterns" mentioned in the 17th century.
Courtesy the New Brunswick Museum, Saint John, New Brunswick.
Acc. no. 1959.88.2A.

Below: **Micmac-decorated cradle, circa 1870.**
A Canadian wooden cradle, covered with quillworked birch-bark
panels, made by Christine Ann Morris, Micmac. A unique example
of the quillwork on bark, invented by Micmac women and used to
make chair seats, boxes and other objects for sale to white people.
Realistic designs such as this moose were uncommon in this art.
Courtesy DesBrisay Museum, Bridgewater, Nova Scotia
(acc. no. 184). Photo by Peter Barss.

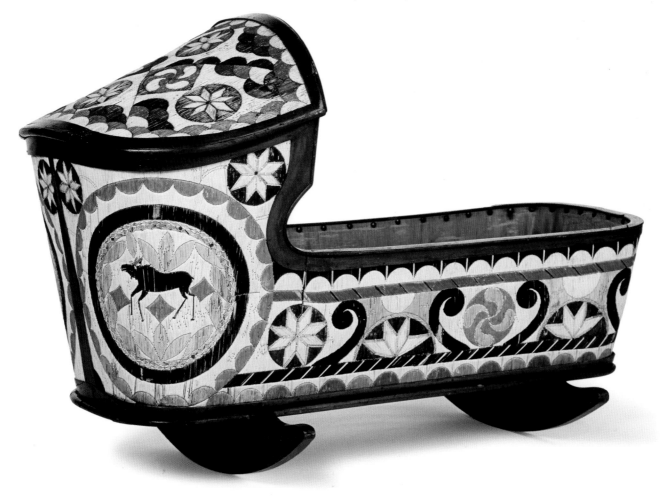

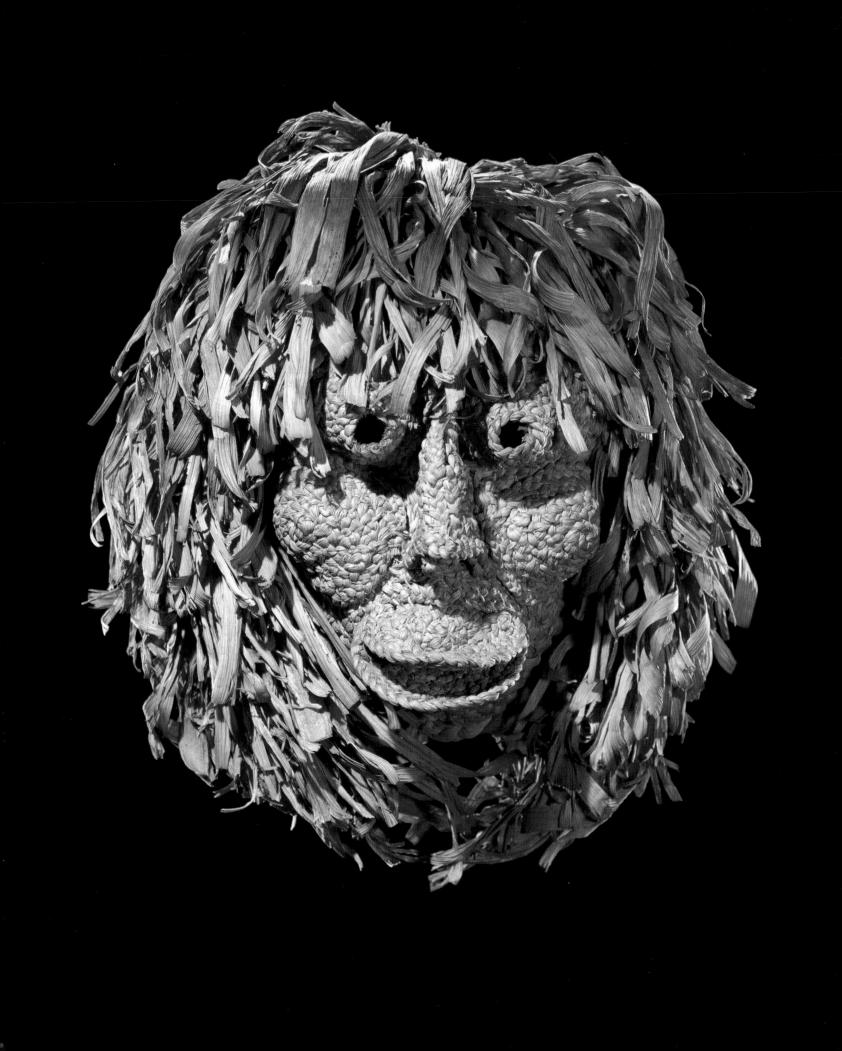

3 | Living on the Turtle's Back

The native peoples living around the lower Great
Lakes and the St. Lawrence River spoke the languages
of the Iroquoian language family. The term Iroquoian
is not to be confused with Iroquois, which is the name
of one of their nations. In their way of life, religion,
arts and crafts, these groups had much in common.
They conceived of their world as an island, created on
the back of a turtle that is floating in a primeval ocean.

In territory and language the Iroquoians formed a
wedge between the Algonkian-speaking tribes of the
Great Lakes and those of the East Coast. The consen-
sus among archaeologists has been that the Iroquoians
had already lived there for several thousands of years
before the arrival of Europeans. This general opinion
will probably be somewhat revised by recent stud-
ies that suggest the Iroquoians spread northward
from Pennsylvania, while adopting a more intensive
horticulture about AD 1000. The Northern Flint maize
used in their farming was indeed of Ohio origin, and
the date of its northward spread coincides with its
introduction among the coastal Algonkian tribes.

Much of the land was forest, inhabited by deer,
bears and other game; the rivers and lakes teemed
with fish, waterfowl and beaver. The people lived in
small settlements, consisting of a few longhouses at
clearings in the forest. The wooden frames of these
houses were covered with sheets of elm bark that
overlapped like large shingles. Light came in through

an entrance at each end and from the smoke holes
in the roof. The length of such a house was based on
the number of families who lived in it; each family
had its own fireplace. The longhouse was owned by a
group of women, related through their mother. Upon
marriage a man ideally moved in with his wife's family,
and his children traced their family along the mother's
line. Some of these maternal lineages had the right to
elect the civil chiefs. There were also war chiefs, who
achieved their status in warfare.

The people operated an annual cycle of hunt-
ing, fishing, farming and wild fruit gathering. In the
spring, "when the white oak leaves are the size of a
squirrel's foot," as they used to say, the women planted
the seeds of the Three Sisters: corn, beans and squash.
Sunflowers were grown for the oil extracted from their
seeds; tobacco was cultivated by the men.

By AD 1400, horticulture was becoming an increas-
ingly more important source of food than hunting.
Once farming by women began to provide about
three-quarters of the available food, the men may have
started to feel uneasy about the declining importance
of hunting. Men cleared the forest for new farmland,
built the houses, and made useful craft products, but
it was as hunters that they acquired prestige and
respect. It is this social change that may explain the
increasing evidence of warfare: the men remained
hunters, but the game changed from animals to

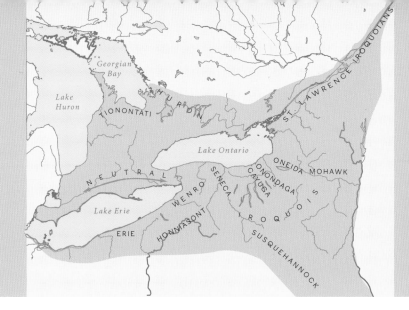

humans. The condition of human bones found in the prehistoric villages tells part of this story.

The many small settlements here consolidated into a smaller number of large villages, surrounded by palisades and usually located on hilltops or at other defensible locations. Many of these villages consisted of a large number of longhouses and were inhabited by up to 2,000 people. Because of the declining fertility of the farmland, the need to have firewood within easy reach, and the increasing filth in and around the houses, villages were moved several miles every 10 to 15 years. The Iroquoian tribes in Ontario celebrated a Feast of the Dead at each village removal, in which the bones of the deceased were cleaned and reburied in one common burial pit, together with pots filled with food, tobacco, smoking pipes and other gifts. Around each cluster of such villages, much of the land was abandoned, apparently no longer safe for farm work.

Warfare had become the avenue to prestige for the men. It was not motivated by territorial gain or economic advantage, but provoked by prolonged vendettas of long-forgotten origins. Dressed in protective suits of wooden slats, invading warriors were driven by fear of revenge when they killed as many people as possible. Women mourning and crying for vengeance stimulated the war parties. When they returned with captives ritually bound like captured game animals,

the women claimed these captives as they used to claim meat brought home from the hunt. Prolonged torture developed into a gruesome art, in which the victims were kept alive until sunrise, for the sun had to witness this sacrifice to the god of war. The body was cut up to be cooked and eaten, while the people created pandemonium in order to drive the victim's spirit from the village. Possibly it was in this period that "Men-Eaters" became the name used by the coastal Algonkian tribes for these Iroquoian peoples.

By AD 1500 this warfare was endemic throughout the region, causing the death of large numbers of people. The need to replace the dead started to save the lives of many young captives, as they were adopted in families to replace fallen relatives. Cannibalism declined in the 16th century, and white dogs increasingly served as substitute sacrifices in war rituals.

Efforts to suppress hostilities by means of a number of alliances began with the concentration of tribal villages surrounded by large buffer zones. The native traditions concerning the founding of these alliances or confederacies are highly compressed narratives, cast in more symbolic than historical terms. Iroquois traditions mention Deganawidah and Hiawatha, and undoubtedly such enlightened and influential politicians were involved. It was no coincidence that all these confederacies seem to have emerged about the mid-16th century.

This process may have started when the eight Neutral tribes concentrated their villages in the Niagara Peninsula. They were called Neutral because visitors had to suppress their feuds if they wished to quarry the large deposits of flint in Neutral territory. They were said to be the parent body of the Iroquoian peoples, for it was a Neutral maternal lineage that was named "Mother of Nations" and believed to be the lineal descendants of the first woman on earth.

The Iroquois League united five tribes: Mohawk, Oneida, Onondaga, Cayuga and Seneca. They referred metaphorically to their confederacy as a longhouse, stretched across upstate New York. The Mohawk were the guardians of the eastern door, the Seneca guarded the western door, and the Onondaga were the caretakers of the central council fire. The tribal chiefs who came together there for the first time are remembered as the founders of the League, and their names became titles for their successors in the great council. Their stated long-term goal was to spread the Great Peace by uniting all tribes as "one people in one land." This theme was repeatedly stated by the Iroquois in early historic times, and it may well have originated in the earliest days of the League. Unfortunately for all their neighbors, the peace propagated by the Iroquois was in effect the peace of death.

In order to escape from the Iroquois conquest, and attracted by opportunities of trade, the tribes of the upper Susquehanna River moved downstream and settled near Chesapeake Bay. There they became known as the Susquehannock. The Erie in western Pennsylvania also made a confederacy of several tribes.

Prolonged warfare between the Iroquois and the Iroquoian tribes along the Canadian shores of Lake Ontario culminated around 1550 in the latter's retreat toward Georgian Bay. Four tribes united there in the Huron Confederacy. Their pottery trade reached north from Georgian Bay toward James Bay, and they imported native copper and buffalo robes from the Wisconsin region. Nomadic Indians from the northwest used to set up their winter camps near the Huron villages, trading their furs, moose skins and fish for corn from the Huron women.

Before the epidemics of European diseases, the total population of all these Iroquoian peoples may have been around 55,000. They were remarkable for their political organizations and their ferocious warfare, but in their arts and crafts they were not significantly different from the Algonkian-speaking tribes around their territory. The people rubbed their hair with sunflower oil and greased their bodies with animal fat. Total nudity was common among the Neutral men, who tattooed pictures of animals and geometric patterns all over their bodies. A deerskin breechclout was the standard dress of men from the other tribes; women wore a knee-length wraparound skirt. In wintertime, leggings, moccasins and fur sleeves were worn. The Neutral were known for their robes made of black squirrel pelts. Tailored moose-skin shirts might be acquired in trade with the northern Cree. In addition to deerskin moccasins of the common front-seam type, there were moccasins braided of cornhusks, probably worn by women in their farming work.

Skin garments might be dyed black, painted with geometric patterns or decorated with porcupine quillwork. Fur robes were often decorated with rows of raccoon tails. At feasts and other celebrations, chiefly individuals wore belts, bracelets and necklaces of woven shell beads. The sacred qualities of these shell beads and their restricted use by the elite has been mentioned in former chapters.

The fibers of milkweed and Indian hemp were twined-woven into burden straps (tumplines), used to carry heavy loads on the back. These straps were often embroidered with dyed moose hair. In this so-called "false embroidery," the weft of the strap was wrapped with the colored hair during the process of twining. Many of these antique straps have survived, each of them decorated with a different geometric design. Bags and baskets were also created the same

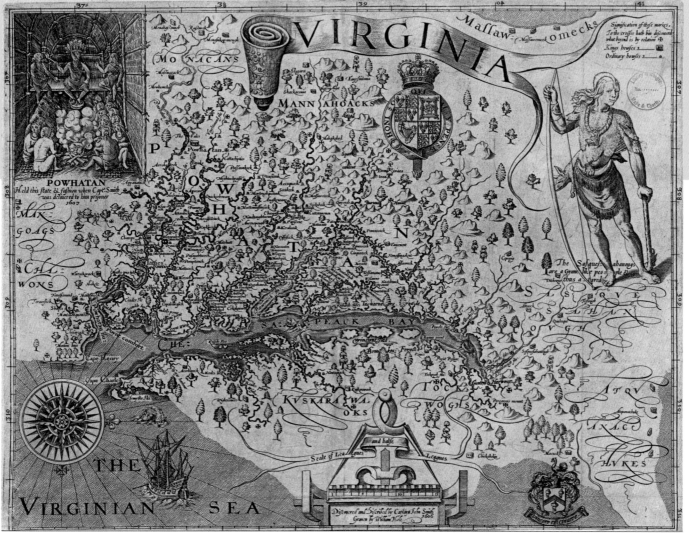

Susquehanna Indian of the Upper Chesapeake Bay.
Engraving by William Hole, on Captain John Smith's Map of Virginia,
1612. Working in England, the artist used earlier pictures of North
Carolina Indians and added some details based on Captain Smith's
descriptions of Susquehanna Indians: a short fur cape and a
necklace, a quiver made of a whole animal skin, and the war club.
Courtesy The Virtual Jamestown Archive / www.virtualjamestown.org

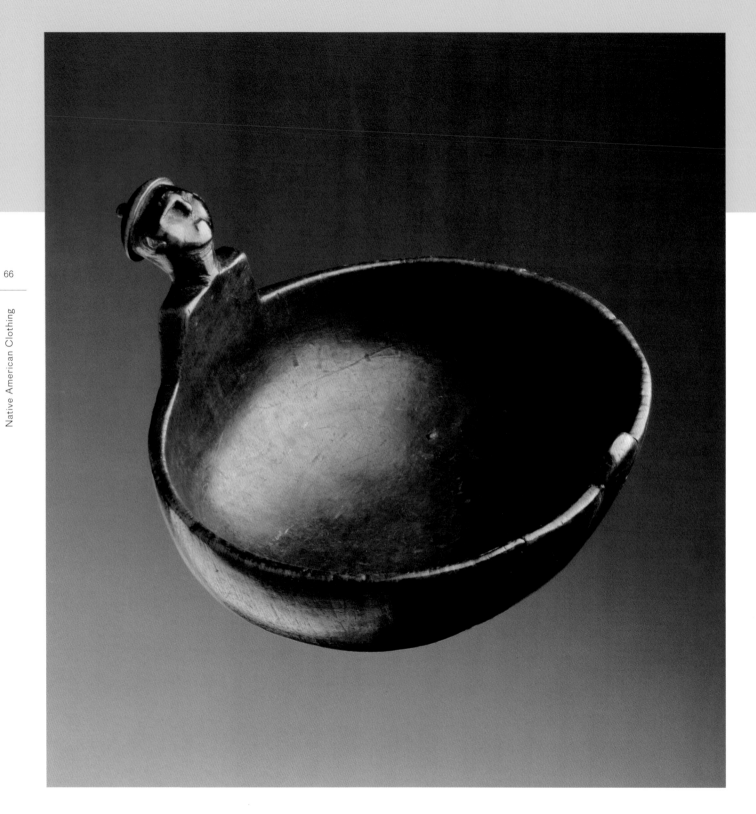

Facing page: **Effigy bowl, probably Iroquois, 1770s.**

Carved of maple burl, diameter 6.125 inches / 16 cm.

Most Indian bowls were carved from a burl, whose dense and twisted grain made the bowl more resistant to splitting. Depictions of a human head carved on the rim usually faced the interior, and the contents, of the bowl. According to the Iroquois, such figurines served "to satisfy the desires of the soul," because their carving was motivated by dreams. The origin of this bowl is unknown, but a very similar example was acquired in either upstate New York or Pennsylvania, circa 1770.

Courtesy Donald Ellis Gallery, Dundas, ON, New York, NY.

way, some of them completely covered with this false embroidery.

Geometric patterns were incised around the upper rims of pottery made by the women. The rise of confederacies was reflected in the disappearance of many local pottery styles and in their increasing similarity. In contrast to the great variety of ceramic forms in the Southeast, the pottery of the Iroquoians showed only a limited range of regional types.

The men made utilitarian containers and canoes of elm bark, as well as snowshoes, stone axe heads, flint knives and arrowheads. There were reports of fairly large wooden sculptures noticed at the entrance of villages and cemeteries in early colonial times. However, none of these large carvings has survived, creating the impression that Iroquoian sculpture was restricted to small, portable carvings. Some of the men were indeed experts in the carving of wooden bowls, wooden spoons, ornamental combs made of antler, ceramic and stone-carved pipes, and wooden masks. Much of this work was decorated with intriguing small sculpture inlaid with copper or white shell. The small carvings on bowls and spoons show highly stylized human figures, in contrast to the naturalistic forms of birds and mammals. The bird figures are most frequently migratory waterfowl, and the mammal figures are those of hibernators. It has been suggested that these images were symbolically related to the changing seasons, to change and renewal, and to the continuation of life.

The effigies carved or modeled on pipes were said "to satisfy the desires of the soul." Nearly always facing the smoker, these figurines most probably represented the personal guardian spirits of the pipe owners. Tobacco smoke served as an incense in man's communication with the spirits. In 1669, it was noticed that "chiefs ... light their pipes, which they scarcely remove from their mouths during the entire council, on the supposition that good thoughts come while smoking."

The function and symbolism of masks among the Iroquois had much in common with their use among the neighboring Delaware Indians. The False Faces represented, if not embodied, the descendants of primeval stone giants living in the wilderness. They were believed to have control of game animals, and have great knowledge of medicinal herbs. Craving the gifts of corn and tobacco, their masked representatives appeared during the fall and spring, when they drove the evil spirits of disease from the villages. Besides these wooden masks, there were masks made by the women, braided or twined of cornhusks. Representing the spirits of cultivated plants, they appeared at celebrations during the summer and were believed to promote the abundance of crops.

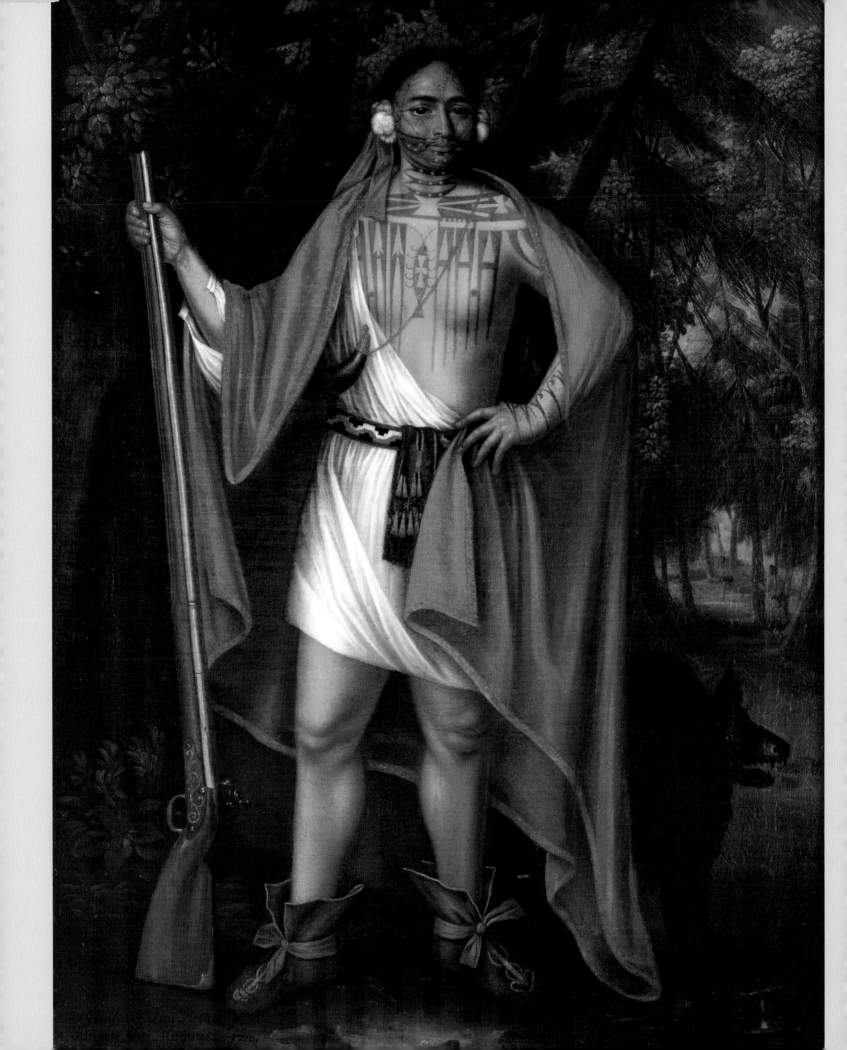

European contact first occurred in 1535, when Jacques Cartier sailed into the St. Lawrence River. He found the valley occupied by several Iroquoian tribes who were at war with all their neighbors. Their major villages were Hochelaga at present-day Montreal and Stadacona at present-day Quebec City. Cartier called the valley "Canada" after the native word for "village." As Cartier had come in search of a route to China, he did not have much to trade with the Indians. He returned to France with 10 kidnapped natives, including the local chief. Not one of them ever returned to Canada; they were the first victims of the European diseases that were to ravage the native population.

Following Cartier there were some sporadic French visits, but the hostile behavior of the Indians discouraged trade. Before 1580, only small amounts of European imports reached the Neutral as part of their shell trade with the Susquehannock on Chesapeake Bay. Efforts to develop the fur trade were begun only after the export of Russian furs to western Europe dried up in the 1580s.

When Samuel de Champlain arrived on the St. Lawrence in 1603, the local Iroquoian population had disappeared, and Algonkian-speaking people were spreading in the valley. Information from their fishing camps and later from the Huron indicated that warfare had dispersed the St. Lawrence Iroquoians. Their pottery found at Huron village sites suggests that many of the women were absorbed by the Huron, but the men may have been massacred: their smoking pipes were not found in Huron country. Other survivors joined the Iroquois.

Champlain found the St. Lawrence Valley infested by Iroquois raiders, and he joined the local Algonkin Indians in defeating the invaders. Iroquois resentment was bitter, and they never forgot it. With the founding of Quebec in 1609 and the arrival of Dutch traders on the upper Hudson River in 1614, the basic outlines emerged of the regional fur trade and of colonial relations with the native peoples. Extending their colony upriver to Montreal, the French identified with the Huron and Algonkin tribes as allies. Establishing Fort Orange at present-day Albany, the Dutch allied with the Iroquois for similar reasons. It did not take long before the Huron, Iroquois and Susquehannock were locked in combat for the exclusive domination of the fur trade.

The role played by the Huron in the French fur trade was an extension of their traditional trading activities. In order to maintain a monopoly in this trade, they provided the Tionontati and Neutral with French goods in return for corn and tobacco. Imports were also carried far north, where they were exchanged for furs. The Huron returned with those furs to trade with the French. To protect this profitable circuit, the Huron tried to prevent the French

traders from traveling beyond the Huron villages. Trading was understood by the Indians as an exchange of gifts, requiring the creation of a fictive kinship between trading partners. The whites were expected to conform to native conventions of generosity, and the Indians were annoyed by the haggling of the traders over prices. The Iroquois complained of the Dutch lack of hospitality, saying that friendship apparently "lasts only so long as we have beavers."

The Iroquois made themselves intermediaries for all other tribes who tried to deal with the Dutch, and later with the English at Albany. They were unable, however, to prevent the Susquehannock from siphoning off large numbers of furs to traders on Chesapeake Bay. In this period, the Iroquois subjected the coastal tribes and forced them to pay an annual tribute in shell beads. Traditionally valued as a token of homage to chiefs, wampum was now woven into long strips or "belts" that served as records in intertribal transactions.

The supply of furs from the coastal regions had already been exhausted when, in the 1640s, beaver was also becoming scarce in Iroquois territory. The Iroquois tried to make up by plundering the travelers along the French trade routes, but it was evident that it was impossible for the Iroquois to enjoy sustained access to trade as long as the Huron controlled all trade from the Canadian interior.

Depending upon the Iroquois for furs, the Dutch provided them with firearms; this was a merchandise denied by the French to their own allies. Iroquois warfare escalated; in 1649 they attacked and destroyed Huronia, and then the Tionontati and the Neutral. By 1651, there were no longer any people living in southern Ontario. Several thousands died; some of the survivors fled west; others escaped into Quebec, where their descendants still live today near Quebec City. But most of the survivors were absorbed into the five Iroquois tribes.

The defeat of the Huron Confederacy finds part of its explanation in the politics of trade, but that does not explain the wars against the Neutral and others. Smallpox epidemics had decimated all regional tribes, and they fought their wars ravaged by disease. Apparently, the wholesale destruction of the Ontario Iroquoians was primarily motivated by the Iroquois' need to replace and increase their dwindling population with new people. This may also explain why the Iroquois crushed the Erie in 1656, followed by the total depopulation of the Ohio country. The Iroquois were determined to spread their Great Peace, and create "one people and one land," whatever the price in human lives. Between the destruction of the Huron in 1649 and the defeat of the Susquehannock some 30 years later, several thousands of captives were assimilated by the Iroquois. By the end of the 17th century these adoptees and their offspring outnumbered the original Iroquois, but all evidence suggests that they had become loyal members of the Iroquois League.

If the Iroquois expected to replace the Huron as middlemen in the French fur trade, they were in for a disappointment. While harboring Huron refugees in the western Great Lakes region, the Ottawa took control of the old trade routes to Montreal. After the dispersal of the Susquehannock, the Iroquois expanded into the Ohio country, but the "Beaver wars" and frequent epidemics had exhausted the League's military potential. Though forced to make peace with the French in 1701, through the acumen of their chiefs the Iroquois were maintained as a buffer between the English colonies and the French. In their continued assimilation of tribal remnants, the Iroquois became the "Six Nations" in 1720, when they adopted the Tuscarora refugees from North Carolina. During the American Revolution most of the Iroquois remained loyal to the English, and led by the war chief Joseph Brant they raided the American settlements. In reprisal, General Sullivan's army invaded Iroquois territory, burned their villages and cut down their cornfields. The powerful Iroquois League was no more, and a great number of its people retreated into Ontario.

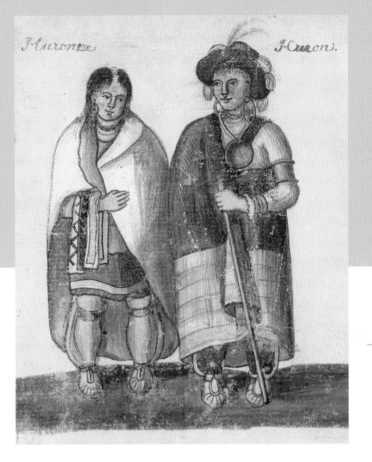

***A Huron Indian Couple,* circa 1750.**
Anonymous watercolor, Coll. Gagnon. Most probably they were Huron Indians from Lorette, near Quebec City. The robe of the man shows ribbon appliqué in its earliest form: ribbons simply sewn on side by side. The couple is wearing moccasins in transition from front-seam to vamp type. Courtesy Archives of the City of Montreal, Quebec.

The Iroquois and their world had changed considerably since 1600. Most visible were the imports of the fur traders: metal axes, knives, scissors, hoes, kettles, glazed ceramics, guns, steel tomahawks, striped blankets, ribbons, beads, etc. Women adopted a short cotton dress and wore it over their skirts. Fashionable leggings made of red or blue trade cloth had a front seam, decorated with ribbons and beads. The large ostrich plumes decorating the hats of colonial authorities were imported by the traders to satisfy the demand of their native customers. Commercially dyed wool replaced the native fibers in finger-woven sashes and garters, many of them interwoven with white beads. White linen shirts and coats of blue cloth with brass buttons and decorated with lace were popular among the men. Metal sheet cut from old kettles was rolled into small cones used to hold tassels of red-dyed deer hair in the decoration of moccasins and shoulder bags. Aboriginal ornaments made of shell were gradually replaced by silver gorgets, armbands, ear rings and nose rings. By the end of the fur trade period, many Iroquois became prolific silversmiths themselves.

Pottery excepted, the native arts and crafts did not rapidly disappear. Black-dyed deerskin continued to be used for leggings and moccasins. Beadwork became popular, but porcupine quillwork survived up to the 1820s. Ornamental combs made of antler became elaborate carvings in the 17th century and were worn by both men and women. In their account books, the Albany traders sketched the facial tattoos of their customers in order to recognize the individuals. Tattooing of these warriors continued well into the 18th century.

Contact with colonial white society was not at all restricted to material goods. Aboriginal decorative designs were originally abstract and geometrical, but a curvilinear art style became popular in the 1750s. This new art style was adopted by all native peoples around French Quebec, suggesting that it was inspired by some form of French art. Later inspiration may have come from exposure to American folk art, emerging after the American Revolution. In 1780, the Iroquois living in Ontario were noted for the beautiful decoration of moccasins, which they made for sale; by the 1820s, the Seneca Iroquois in New York State had made this a source of their income as well.

War club, Iroquois.
Wood.
With permission of the Royal Ontario Museum © ROM.
Acc. no. 911.3.167; image no. ROM2009_10546_11.

A distinctly new art style developed among the remaining Huron living near Quebec City in the 1770s. Instructed by the nuns at nearby convents, the local Indian women became known for their use of dyed moose hair in the embroidery of garments, moccasins and pouches made of black-dyed deerskin. Initially the curvilinear designs were combined with earlier patterns in quillwork, but by 1820 a complex floral art style emerged among these Huron women. From the very beginning this production was stimulated by the demand from European visitors, particularly when Niagara Falls became a major attraction for tourists.

Because they lived near the Falls, the Tuscarora produced much souvenir art, but they were also active as middlemen in this new trade. They provided the honeymooners with fine embroidery of the Huron, beadwork and splint baskets from the Abenaki and Iroquois, and bark ware from the Great Lakes Indians. The study of these arts and crafts in the early 19th century does not so much reveal a continuation of old tribal styles as it does the development of different art styles in each of the reservation communities.

After 1700, the large Indian villages had disappeared, to be replaced by smaller and more numerous settlements, in which log cabins were replacing the multi-family longhouses. European crops were adopted, soon to be followed by the rearing of pigs, chickens, horses and cattle. Orchards were noted near the Indian villages in the 1770s.

The American Revolution marked the end of political independence for the Iroquois. The native culture retreated into and around the native religion. These were the circumstances in which a Seneca prophet started a religious revival based on his vision in 1799. The "Good Message" of Handsome Lake combined traditional native and Christian elements in teaching the people how to maintain their ethnic identity. Over time, this reformation became the center of the conservative faction in the Iroquois population.

As farming has declined, the reservations have become suburbs from which the people commute to their work in nearby cities. Traditional wooden masks are still being produced, but a number of Iroquois artists are also carving complex images relating to their mythology. It is interesting that in the efforts to maintain an Iroquois identity, the "progressive" faction is more active than the conservative minority.

Traditional Iroquois woman's dress.
Mrs. Ethel Brant Monture, in the type of dress
worn by her people on festive occasions. The long
shirt was adopted in early colonial times, but all
the other details are of ancient native origin.
Courtesy B. Anthony Stewart / National Geographic
Image Collection.

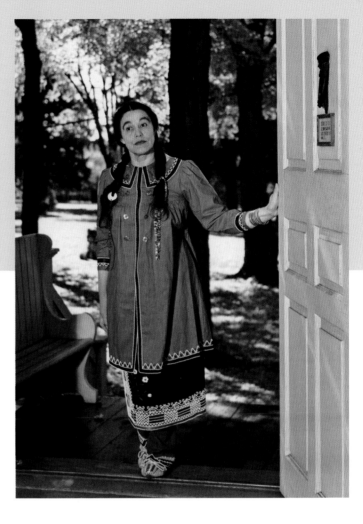

Below: **Woman's skirt, Iroquois, circa 1900.**
Beadwork on cloth.
Courtesy Skinner, Inc. Boston and Bolton, Massachusetts.

Native American Clothing

Ornamental combs, Seneca-Iroquois, 17th century.

The introduction of steel knives promoted the development of the elaborate carving and fine teeth on these combs, which were fashionable from about 1650 to 1740, particularly among the Seneca. These combs were mostly, but not exclusively, used by women as hair ornaments.

Above: **Seneca comb, carved of antler, circa 1687.**

Height, 4.5 inches / 11 cm. The arbor-like motif, used on many of these combs, may represent the Iroquois Confederacy, viewed as a longhouse stretching across upstate New York. Though inhabited by five tribes, only the three "elder brothers" are pictured here: Mohawk, Onondaga and Seneca. The animal figures refer to the Seneca Wolf clan, the guardians of the western door of this metaphorical longhouse.

Courtesy Rochester Museum & Science Center, Rochester, New York. RFC 734/29.

Facing page: **Effigy comb; carved of antler, 1670–87.**

Height, 3.25 inches / 8 cm. The long tails of the two pictured animals identify them as panthers. Panther figures are uncommon in Iroquois art; they suggest that this comb was made by an Algonkian captive, many of whom were adopted by the Iroquois.

Courtesy Thaw Collection, Fenimore Art Museum, Cooperstown, New York.

Photo by John Bigelow Taylor, NYC.

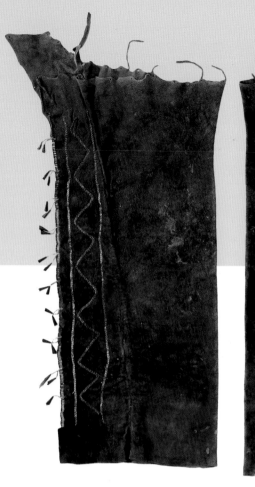

Pair of man's leggings, 18th century.
Quillwork on black-dyed deerskin.
Though nothing is known of their origin,
the cut and decoration of these leggings
indicate they came from the northeastern
part of the country, perhaps from the
St. Lawrence Valley. The decoration is
restricted to the wide, double side flaps.
© Livrustkammaren / The Royal Armoury.
Photographer: Göran Schmidt.
(LRK inv. no. 20643 & 20644.)

Man's leggings, Seneca, New York,
circa 1850.
Beadwork and silk appliqué on blue cloth.
Length, 26 inches / 66 cm.
The beadwork design closely resembles
the earlier quillwork by these people.
Courtesy National Museum of the American
Indian, Smithsonian Institution (029654).
Photo by NMAI photo services staff.

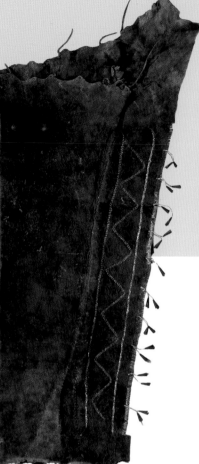

Flat pouch, Huron, circa 1720s.
Seamless, twined-woven vegetable fiber,
fully covered with false-embroidered
dyed moose hair. Dimensions, 7.5
inches by 8.5 inches / 19 x 21 cm. False
embroidery consists of the wrapping
of the weft with the colored hair during
the weaving. This technique and the
geometric designs are representative
of the regional native art before the
adoption of curvilinear and floral art
designs. The visual interplay of color
reversals on this example resembles
patterns in Midwestern ribbon work of
much later times. Altogether only six
pouches of this type have survived.
© Museum Volkenkunde.

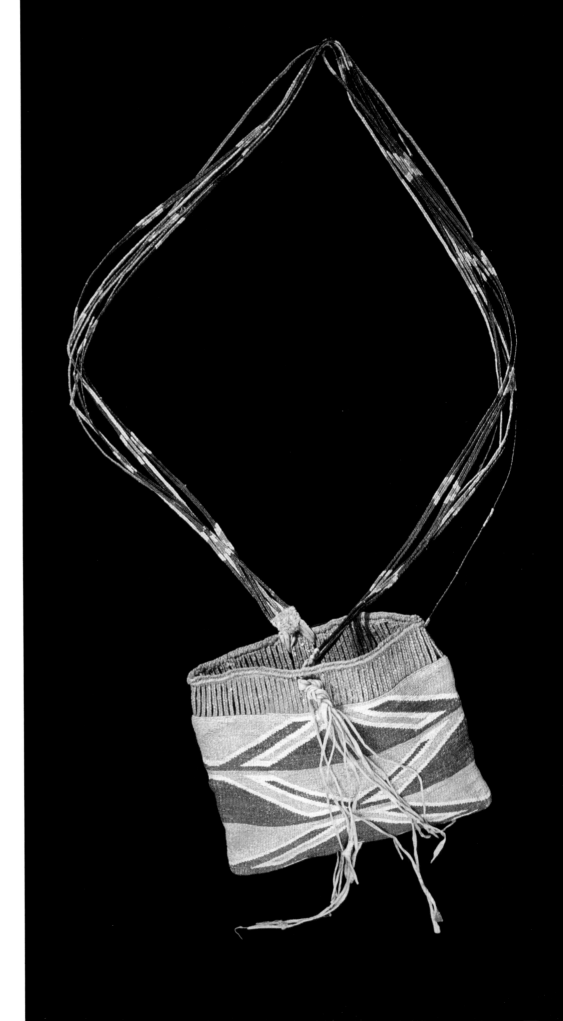

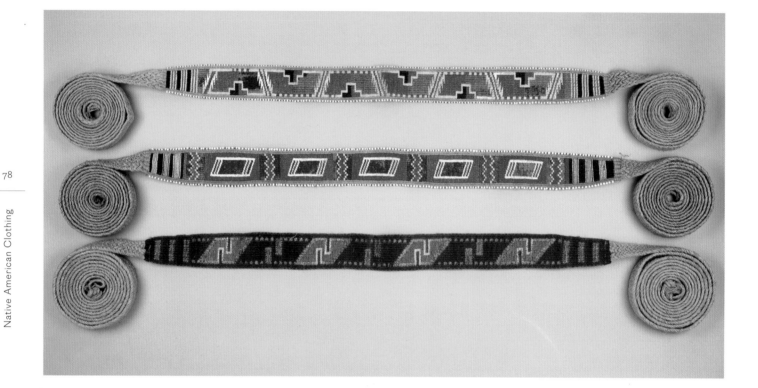

Burden straps, or tumplines, Iroquois, circa 1780.
Twined woven Indian hemp, decorated with dyed moose
hair in false embroidery; the long tie straps at both ends
are braided. Length of decorated sections 21.75 to 23
inches / 55–58 cm. Most surviving burden straps are of
Iroquois origin, though the art of false embroidery was also
practiced by the Huron and neighboring Algonkian tribes.
Courtesy John and Marva Warnock Collection /
www.splendidheritage.com

Facing page: **Carved wooden ladle, Wyandot type, circa 1750.**
Length, 9.5 inches / 24 cm. The effigy carved on top of the short
handle represents a human figure holding up, or drinking from,
a rum keg. This theme is familiar from several other Wyandot
carvings and probably refers to the role of rum drinking in the
annual rites of the White Panther cult among the Wyandot
Indians. This shamanistic cult worshipped Ontarraoura, the
giant panther-like ruler of the underworld. The ceremonial
use of rum provided a shortcut to "visionary" experiences.
Courtesy Thaw Collection, Fenimore Art Museum,
Cooperstown, New York. Photo by John Bigelow Taylor, NYC.

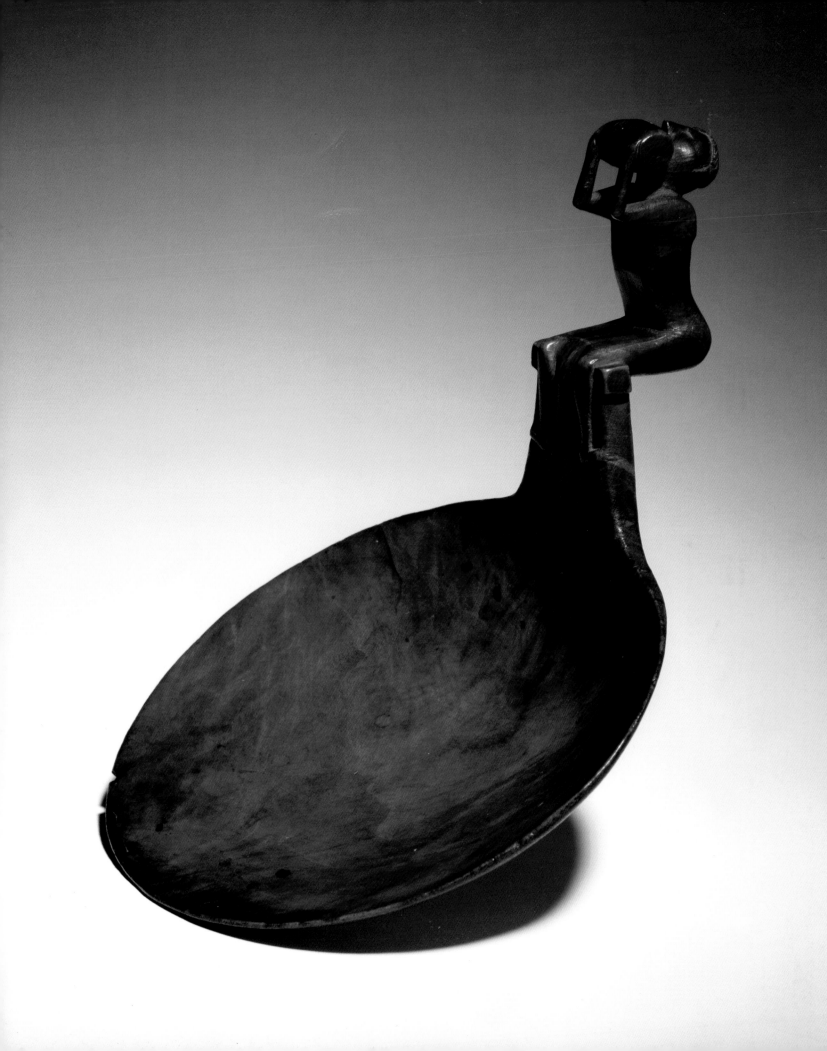

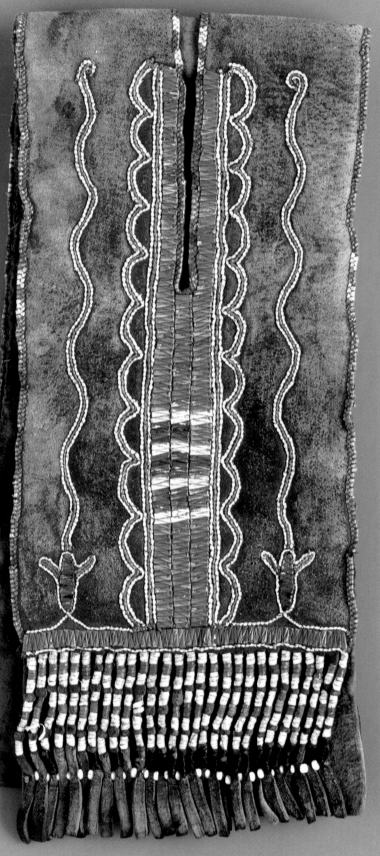

Right: **Belt pouch, Iroquois type, late 18th century.**
Quillwork on dark-dyed deerskin; quill-wrapped fringes. Length, 25.25 inches / 64 cm. The man pictured on page 68 shows how this pouch was carried: folded over the belt. The opening is a vertical slit on the halfway fold of the pouch.
Courtesy John and Marva Warnock Collection / www. splendidheritage.com

Facing page: **Finger-woven sash, Iroquois, circa 1800.**
Wool interwoven with white beads. Length, 115 inches / 290 cm. In 1806, this sash was given by Chief Joseph Brant to friends in Albany, New York. In its braiding technique, it is related to the sashes woven for the Indian trade by French Canadians in rural Quebec, but the design of this sash and the interwoven beads suggest the work of an Indian artisan.
Courtesy Fenimore Art Museum, Cooperstown, New York.

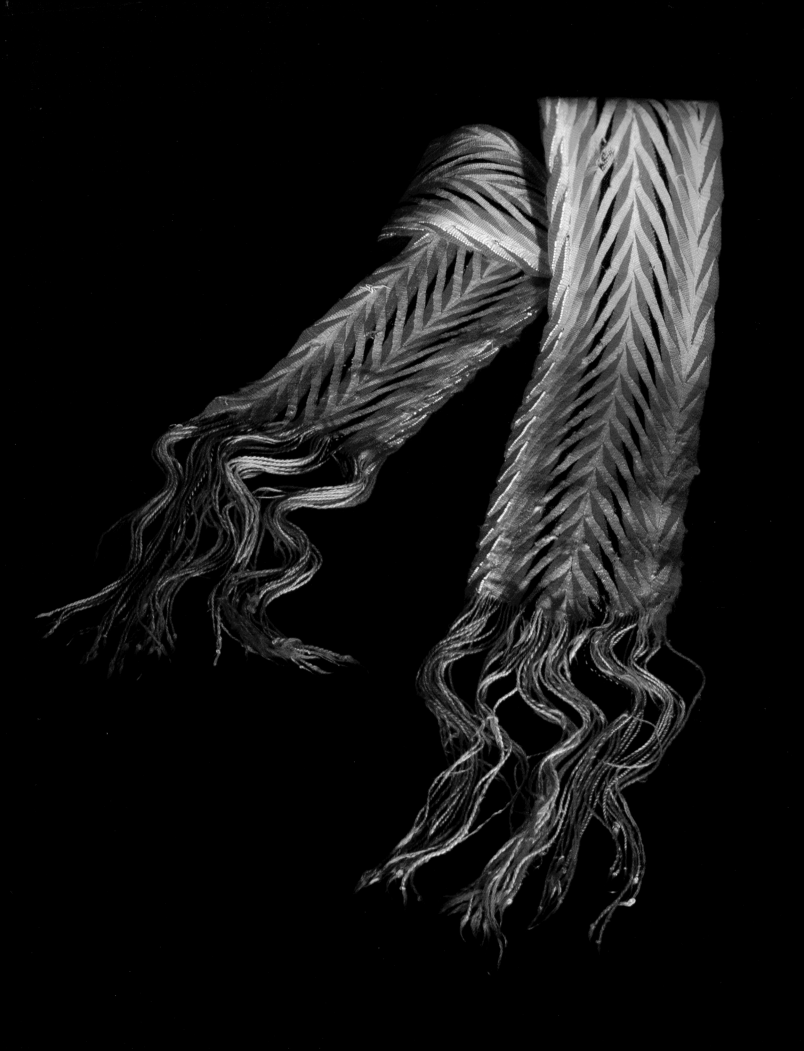

Right: **Moccasins, probably Iroquois, circa 1780.**
Quillwork-decorated, front-seam type moccasins, with red-dyed hair tassels in metal cones as pendants. On both sides of the front seam is fine double-curved quillwork, curving in opposite directions, which is often oberved in Iroquois art. Courtesy John and Marva Warnock Collection / www. splendidheritage.com

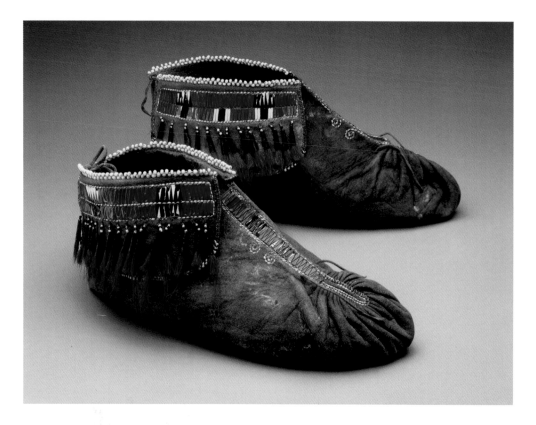

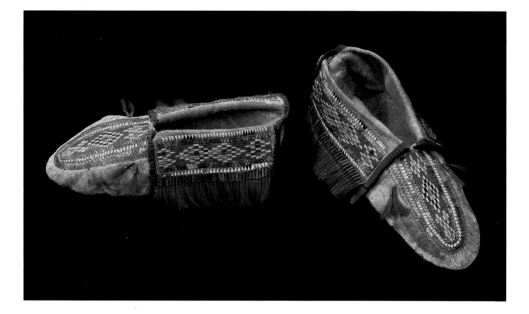

Left: **Moccasins, Huron, 1780–1800.**
Woven quillwork bordered by sewn quills; the cuffs trimmed with red-dyed hair tassels in metal cones. By circa 1780, the Hurons covered the front seam of their moccasins with a long strip, creating the impression of an inserted vamp. Presumably this novelty was a result of the growing popularity of vamp-type moccasins among their northern Indian neighbors. After 1810 this pseudo vamp was replaced by a real inserted vamp, and the fine woven quillwork gave way to floral hair embroidery. Present location unknown. Courtesy collection of the author.

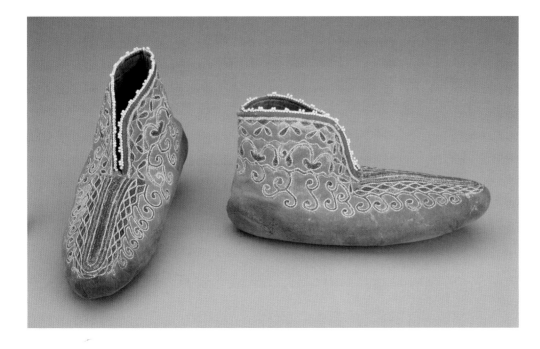

Left: **Moccasins, Seneca-Iroquois, circa 1820.**
Fine quillwork on front-seam type moccasins, the designs typical for the Seneca in the early 19th century. Much of this work became a source of income after the demise of the fur trade. Photo © Canadian Museum of Civilization, artifact III-I-1419 a-b, image s96-4902.

Right: **Moccasins, Huron, 1830s.**
Dyed moose hair embroidery on black-dyed deerskin. Catering to the Victorian taste of the early tourists, the Huron women of Lorette, Quebec, displayed great skill in their floral embroidery. Nuns from local convents taught them the European embroidery technique and floral patterns. The production of this art on moccasins and other items became an important source of income for the Huron Indians. Courtesy John and Marva Warnock Collection / www.splendidheritage.com

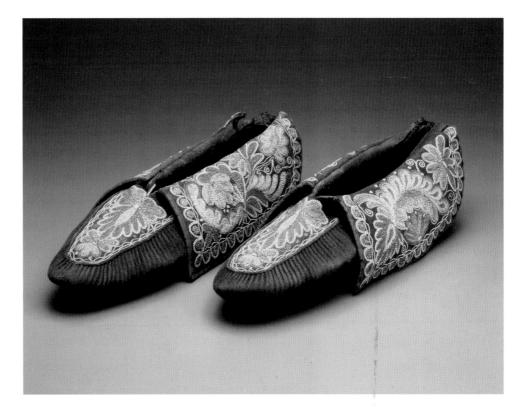

Living on the Turtle's Back

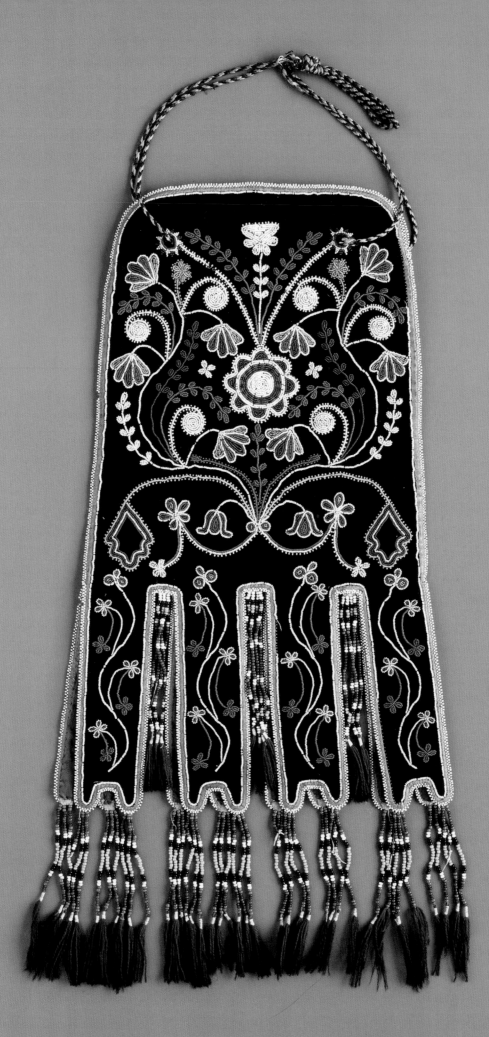

4 | Pleasing the Spirits

The eastern part of the Canadian Shield extends from the Great Lakes north into Labrador, and from Saskatchewan east to Newfoundland. The glaciated country is covered with coniferous forests, thinning out toward the open tundra in the north. Caribou herds, moose, deer, bears and hares live along innumerable lakes and rivers rich in fish and inhabited by beaver, otter and muskrat. Large flocks of migratory waterfowl pass through the region in spring and fall. The winters are bitterly cold, and clouds of mosquitoes appear during the short but hot summers.

The network of rivers and lakes, traveled by birch-bark canoe in summer and on snowshoes in wintertime, provided effective routes of communication for the inhabitants of the Eastern Boreal Forest. Bands of nomadic hunters followed the caribou herds from fall to spring, the toboggans pulled by the women, mothers carrying their babies in cradleboards on their back. Each band set up its camp of conical wigwams in the summer at its own lake or other good fishing location. By the end of the summer, the women filled large bark containers with blueberries; geese and ducks were a welcome addition to the diet in the fall and spring.

Widespread forest fires and sudden changes in the migration routes of the caribou herds often caused severe hardship for the native people. The land was beautiful and harsh, generous and cruel, and always inscrutable. There ruled powerful forces of nature,

with whom the people tried to cultivate a friendly relationship. The saying "from great-grandparents to great-grandchildren we are only knots in a string" may refer to this dependency on the goodwill of these spirits. In the native worldview, man survived by living in harmony with all other beings, visible and invisible, of the natural environment.

This basic economy of hunting and fishing remained unchanged for more than 7,000 years before contact with Europeans. Pottery making of a distinctive type had spread by 300 BC, gradually developing into two regional styles. The pottery marked the slight cultural differences between the Selkirk style of the northern Cree and the Blackduck pottery of the Ojibwa along the northern shores of the Upper Great Lakes. Huron and other Iroquoian influence is noticeable in pottery of the eastern parts of the region. On the cliffs rising up from the waters, many red ocher paintings date back to this early period. They show moose, geese and thunderbirds, people in canoes, and human beings with their hands raised as in prayerful supplication.

All the peoples of this region speak Algonkian languages. This widespread language family was named after the Algonkin Indians living on the southeastern margins of this region. The names used to refer to regional groups, such as "Cree" and "Ojibwa," refer to the languages of the many local bands. The terms "Montagnais" and "Naskapi" merely refer to

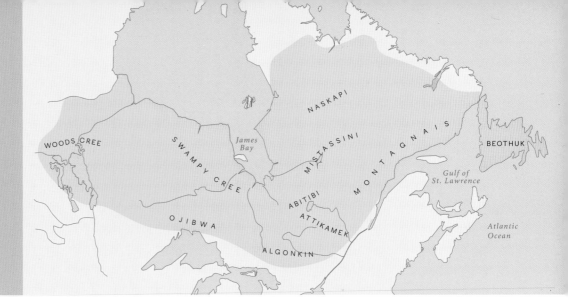

the southern versus the northern bands of the same language group. Beyond the local bands there were no "tribal" organizations.

The most important materials in their arts and crafts were animal skins and birch bark. The cleaned and cured animal skin was left in its white, dry-frozen condition if intended for use as decoration with painted designs. Most other skins were smoked, in order to prevent them from drying hard and stiff after use in wet weather. The smell of the smoked skin provided some protection against the mosquitoes. The soft skin of antique garments in museum collections testifies to the unsurpassed quality of the Indian tanning methods.

While bark was invariably sewn with split roots, animal skin was sewn with thread made of shredded sinew stitched with bone needles. Most probably it was considered offensive to the forest spirits to sew bark with a material given by animals, and vice versa. Women prepared the skins, made them into clothing and decorated them. Men carved the frames of snowshoes, canoes and drums, and they carved canoe paddles, cradleboards and other utensils. While building the canoe they sang magic songs, in which maritime animals and waterfowl were implored to imbue the canoe with their specific abilities. Most probably, similar songs accompanied the construction of snowshoes and toboggans.

Garments made of the soft tanned skins included knee-length shirts for the men, worn over the breechclout. Their leggings were attached to the belt, and worn with garters below the knees. The woman's dress was supported by shoulder straps and included detachable sleeves. The dress covered the garters that held up short leggings. Skin and fur caps were used, and hoods were attached to the winter parkas. Moccasins consisted of a soft sole turned up over the foot and gathered along a front seam. Robes were made of large moose or caribou skins, beaver fur, or braided strips of hare fur. Mittens were attached on a string that hung around the neck, so they would not get lost when fingers were needed to set traps or do other tasks.

On the open tundra, the wigwams were covered with a tarpaulin sewn of caribou skin, but large sheets of birch bark covered the wigwam frames in the forested regions. Seams in the birch-bark cover of the canoe were waterproofed with resin, and the bark was often colored red with a dye made of willow roots. Birch bark was also used to make a variety of boxes and baskets. The brown inside of the bark, used as the outside of these containers, lent itself to decoration by means of scraped designs.

Garments, pouches and bags made of skin were decorated either by means of quillwork or with paintings. The quills of porcupines and bird feathers were color-dyed and loom-woven into strips, and applied

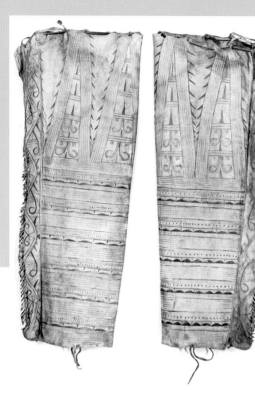

Pair of Leggings. Naskapi, circa 1770–1800.
Painted caribou skin. Length, 28 inches /
71 cm. Red-dyed porcupine quills wrapped
around the short fringes of the double side
flaps. A strap attached at the bottom served
to keep the legging tight to the foot.
© DLM-Ledermuseum Offenbach.

to the skin in sewing and plaiting techniques or wrapped around the fringes. Red and black pigments mixed with a grease made of fish roe were used in painting with a bone or wooden tool called a stylus. A fork-like stylus was used to draw parallel lines. The traditional art style of this region was based on the use of such parallel and zigzag lines, and triangles and rows of dots combined into rigidly geometric patterns. The prevailing two-sided symmetry of these designs may have originated from the patterns bitten on thin, folded sheets of birch bark, which was a popular pastime among the women. When the birch bark was opened and held up to the light, bilateral symmetry revealed itself in the dotted patterns.

In trying to understand the rich decoration of garments, tools and other utensils, we have to enter the spiritual domain of these people. Decorative art undoubtedly satisfied their aesthetic creativity, but its first and foremost function was to please the spirits. Fundamental to the native worldview was the belief that spirits, or spiritual power, resided not only in human beings, but also in animals, plants, rocks and

other natural phenomena. To the Indians there was nothing "supernatural" about such powers; they were part of the natural reality. Their livelihoods, clothing, food and shelter were all acquired from these sources. Life, and certainly hunting, was a sacred enterprise. They expressed this in numerous ritual practices, none of them spectacular, but performed every day. It was believed that this consecration of everyday work was what produced the desired results and the well-being of the people.

In nature, as conceived by the Indians, every type of animal and plant had its own society, each with its master or chief – in all respects similar to human society. As the owners of the land these spirit chiefs were manitous, solitary characters who had the power to give to or withhold game from the hunters. Success in hunting dominated the thoughts and dreams of these people, and it was in dreams that spirits blessed them with magical songs, ritual instructions, the art of curing disease, or some other specialty. Every successful hunter was believed to have acquired such blessings in his dreams. A shaman or "medicine man" might have acquired more blessings than ordinary people, but they came from the same sources and were of the same kind. Each local band recognized such a specially blessed man as its leader. While luring a caribou herd, the Naskapi band leader wore a painted robe, believed to turn him into a caribou. Once the

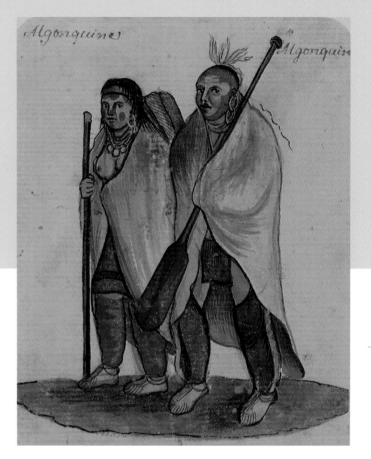

Algonkin Indians, Ottawa Valley, **circa 1750.**
Living close to major trade centers, the Algonkin women replaced deerskin with trade cloth as the material of their garments, but had apparently not yet adopted the French blouses. Anonymous watercolor in the Coll. Gagnon. Courtesy Archives of the City of Montreal, Quebec.

herd entered the trap, the leader revealed himself as a human being while his men moved in for the kill.

The game spirits were thought to be pleased to see that the symbolic designs given by them in dreams were used to decorate the hunter's clothing. Moreover, such decorations were believed to repel vicious demons manipulated by witchcraft. While painting her husband's garments, the hunter's wife adjusted the revelations to conform to the regional art style. The specific meaning remained the couple's secret, but certain design elements were well known. The white skin itself related to the snow and the caribou of the winter hunt. Parallel lines and rows of dots represented the trails and tracks of animals, or the tracks of a game-laden toboggan. Arranged crosswise, red dots referred to the hunter's "soul spirit"; a U-shaped pattern represented antlers and referred to, of course, the caribou. Such painted garments were believed to retain their magical quality for one hunting season only. The intricate and time-consuming painting of a new outfit every year required the successful hunter to have the help of an extra wife, unless there were daughters to do the daily chores.

This urge to please the spirits by means of decoration extended to all other parts of the hunter's outfit, as well as to the remains of the killed game. Paintings, tassels or fringes decorated snowshoes, toboggans, canoes, the skin covers of wigwams, the special strings used to carry or drag game, and various charms. A little willow ring filled with netting was hung above the cradle; it was believed to protect the child from evil witchcraft, just as flies are caught in a spider's web. Decorated animal skulls and antlers were tied to trees for display. The bones of animals and fish were carefully deposited beyond the reach of the dogs because it was believed that the animal chiefs used such bones in the reincarnation of wildlife.

✳

Exploring the coasts south of their Greenland colony, Norsemen discovered Labrador and Newfoundland about AD 1000. For a short while they even established a small colony in northern Newfoundland, but their behavior aroused the hostility of the local natives, who forced the colonists to give up and return to Greenland.

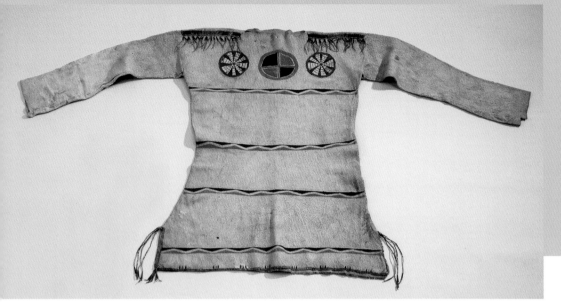

Portuguese, Breton and Basque fishermen had explored the coast of Newfoundland by 1500, and they entered the Gulf of St. Lawrence a few years later. Trade with the friendly Montagnais soon developed, but from the outset misunderstandings and violence discouraged the Beothuk of Newfoundland from contacts with the Europeans. The term Red Indians originated from the Beothuk's liberal use of red ocher all over their bodies and clothing.

After 1600 and the establishment of the French colony on the St. Lawrence, the Huron Indians expanded their traditional role as traders to become middlemen in the French fur trade with the northern Indians. In this context the Feast of the Dead of the Huron was adopted by the Ojibwa bands along and west of Georgian Bay, foreshadowing their tribal union.

After the defeat of the Huron in 1649, and threatened by inroads made by Iroquois war parties, the French relocated their trading posts to the interior. Determined to increase their role in the fur trade, the Iroquois now raided even further inland, forcing several Ojibwa and Algonkin bands to retreat westward. Peace was finally restored by a French treaty with the Iroquois in 1701, but in the meantime the prospects of northern expansion of the French trade had been diminished by events on James Bay.

In 1668, the British Hudson's Bay Company established its first trading post at Rupert House (present Waskaganish, Quebec), followed by posts at Moose Factory, Fort Albany, York Factory and Churchill. Competition with the French traders on the Great Lakes soon assured the Indians of an abundant supply of axes, knives, fire arms, kettles, cloth and other European imports. Most strongly affected were some of the Cree bands near James Bay, as they became middlemen for the traders and were later employed in the transport of supplies by canoe to posts on Lake Winnipeg. In contrast, native people located far from the trading posts scarcely saw white traders before the 19th century.

In the dawn of the new era, the spread of epidemic diseases had a greater impact than the introduction of trade goods. Starting in 1633 along the Gulf of St. Lawrence, a lethal smallpox epidemic spread throughout the whole northeast, followed by slowly diminishing outbreaks in practically every generation.

Change as a result of the fur trade came very slowly. The Indians viewed the trade as a form of gift exchange, and they never supplied more furs than were required to satisfy their limited needs. The trapping of beaver, otter, mink and other small fur-bearing animals for the traders infringed on the hunting of big

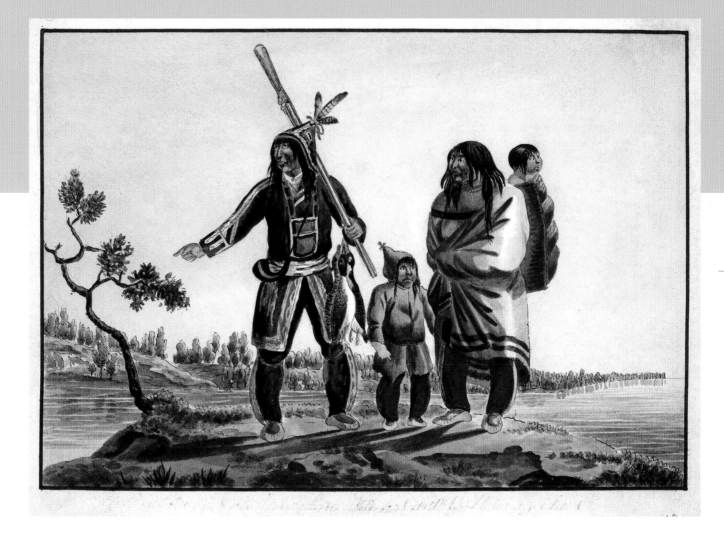

A Hunter Family of Cree Indians at York Fort, **drawn from nature, 1821.**
Watercolor by Peter Rindisbacher. York Factory was located at the mouth of the
Nelson River, Hudson Bay. Trade cloth has replaced skin as the material of their
clothing, but the woman has not yet adopted upper garments other than a blanket.
She is carrying a child in a cradleboard on a chest strap. The man has a shot-pouch
hanging on his chest; shoulder bags never became popular in these northern regions.
Courtesy Library and Archives Canada / acc. no. 1988-250-16 / C-001917.

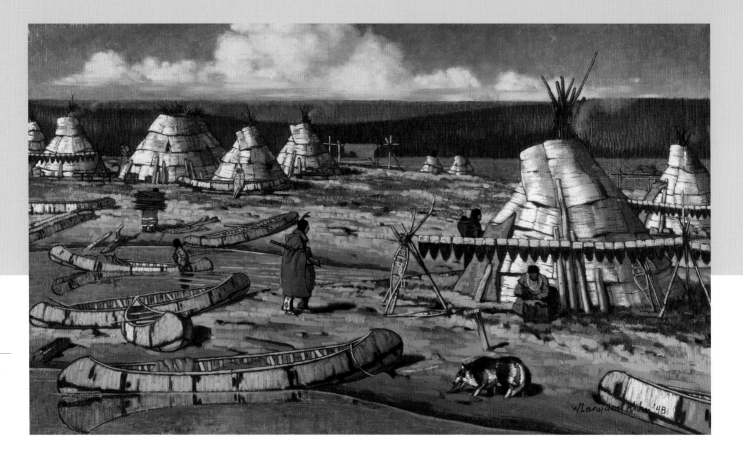

game for the Indians' subsistence. The traders reward-
ed successful trappers with lace-decorated coats and
plumed hats, and appointed them as "chiefs." Rum
and tobacco were generously distributed as goodwill
presents. Gradually the number of families who spent
more time in trapping increased. The bands broke up
into family units, each with its own trapping territory.
The new "trading post band" consisted of the fami-
lies who spent the summer together near a trading
post. This new system aimed at trapping fur-bearing
animals did not spread north of the range of these ani-
mals. In the more northern region, the hunting of the
migratory caribou prevented the dissolution of the
old nomadic bands. Obviously, the hunting of moose
and deer, with all its religious implications, continued
to be a necessity for the trappers as well. Nevertheless,
trapping locked these people into an economic
system in which they became dependent upon the
commodities supplied by the fur traders.

Colonial warfare around the Great Lakes led to
the merging of the Ojibwa-speaking bands and their
emergence as a distinct tribe with recognized chiefs.
By 1760, many of these Ojibwa were spreading into
northwestern Ontario and Manitoba, where they
mixed with the Cree people. In their competition
with the Hudson's Bay Company, the French and
Scottish traders in Ojibwa country did not wait for
their native customers to come to the trading posts.
They penetrated deep into the interior and created
intimate relations by marrying into the Indian bands.
Initially their children joined their mothers' people,
but by around 1800 many of these Métis settled in
southern Manitoba as a separate ethnic group, the
children of the fur trade.

The native society had adjusted itself to the fur
trade as a fairly stable economy until the 1820s, when
both fur-bearing game and large game were becom-
ing scarce, causing periods of famine. Unprofitable

Facing page: **A Spring Camp of the Northern Cree,
19th century.**
Painting by W. Langdon Kihn, 1948, based on a study of
early pictures. This picture illustrates the importance of
birch bark in the construction of wigwams and canoes.
Rows of muskrat pelts on wooden stretchers are hanging
to dry before being taken to a trading post.
Courtesy W. Langdon Kihn / National Geographic Image Collection.

trading posts were closed, and hares, fish and the annual return of the geese and ducks became the means of survival. Among the western Ojibwa, a new cult had emerged as a nativistic response to increasing social and economic problems. Called the Midaywiwin or Medicine Dance Society, this cult initially combined and elaborated ancient rituals in honor of the game spirits. Gradually the focus changed to the curing of disease and the promotion of good health. The members carried their charms in bags made of the whole pelt of otters and other animals, and they recorded the texts of chants and magical recitations in symbols, incised on birch-bark scrolls and wooden boards. As a regional reformation in the native religion, the Midaywiwin spread around Lake Superior, and its influence reached north among the Cree. However, it did not move the spirits to bring back the game. While the center of the fur trade was moving west, in Newfoundland the last Beothuk died, closing the long and bleak history of their extermination by murder, starvation and disease.

Three centuries had passed, in which the impact of European enterprise had broken down the isolation of the northeastern Indian world. Change was most noticeable in the replacement of stone-age crafts by commercial goods, in social and economic change, and in the ravages of alcohol use and disease. The making of pottery and stone tools, unnoticed by the early explorers, seems to have been abandoned in the earliest years of European contact. And indeed, metal kettles, axes and other hardware first interested the Indians. For a long time, cloth was mainly used for blankets worn over the skin garments. The long-continued use of the painted skin clothing may be explained by the religious attitude of the Indians toward the game animals, an attitude that endured practically undiminished until recent times.

However, the cut of the white man's coats did not go unnoticed by the Indians; they changed their long shirt into a coat simply by cutting the front open. Reported as traditional among the James Bay Cree in 1743, this new fashion may have already been adopted long before among the more eastern Montagnais. The use of these long skin coats painted with traditional designs spread as far west as Saskatchewan. The price of this fashion was a loss in efficiency, however, as the Indians never adopted the use of buttons but used a belt or French Canadian sash instead to keep the coat closed.

Living in eastern Quebec, the Montagnais were early and continually exposed to French Canadian fashions and art. As early as 1646, it was noticed that the Montagnais women were experimenting with French ornamental patterns in the decoration of their skin garments, and in the same period French nuns in Quebec started their instruction of native girls in embroidery work. The curvilinear style of skin

Facing page: **Long shirt, Eastern Sub-Arctic, early 17th century.**
John Tradescant, an English collector, listed this garment as "match coat from Canada" in his catalogue of 1656.
The garment is 50 inches / 126 cm long, made of caribou skin, sewn with sinew and decorated with porcupine
quillwork in several different techniques. Beaver claws hang as pendants on many quill-wrapped strings. No
information survives on where Tradescant acquired this garment, though in the early 17th century, "Canada" referred to
the French colony on the St. Lawrence River. Rough handling has left it with much damage, but this is the oldest North
American Indian garment in existence. Several details of the decoration suggest an origin from the northern Cree
Indians. It was this type of long shirt that the Indians later cut in the front, in order to imitate the white man's coat.
Courtesy Ashmolean Museum, University of Oxford, England.

painting developed by the Montagnais spread north-ward among their Naskapi relatives and replaced the old geometric art style among these people. The fitted waist and flared lower skirt of French coats was also adopted by them in the 18th century. Long, straight skin coats decorated in the old style continued in use among the more remote Cree and northern Ojibwa until the disappearance of large game in the 1820s.

The use of painted skin garments continued only among the most remote Naskapi, thanks to the survival of the caribou herds in Labrador. Rabbit skin garments, once restricted to poor elderly people, were widely used after 1820. The traders' cloth was soon adopted as the dominant material for clothing. As this woolen cloth did not lend itself to painting, beadwork became most important in decorative art. Loom-woven beadwork had been competing with quillwork already for a long time; the earliest examples came from the James Bay Cree in the 1740s. Beadwork reached its most colorful perfection in the early 19th century, when a sewing technique called overlay, or spot-stitch, became popular in the region. This technique allowed the creation of floral designs by the Métis of southern Manitoba. Employed in the fur trade, these Métis made this floral style popular throughout the Canadian north in the mid-19th century. There is some evidence that the magico-religious symbolism of the old painted designs was transferred into this floral art style. Silk embroidery became popular among the Swampy Cree in the late 19th century.

Although French Catholic missionaries had been active in the 17th century, Christianity started to spread only in the mid-19th century, that is, when the native rituals failed to bring back better times. While the Christian religion was honored during the summer residence in the villages, hunting and trapping remained inextricably associated with traditional religious observances.

Economic conditions improved after about 1900 when the moose, caribou and beavers increased again in numbers. However, when the fur market collapsed in the 1920s, the Canadian government was forced to introduce welfare income to prevent starvation. Subsequently, modern housing and schools made their entry, followed by skidoos, pickup trucks, and television. A controversial hydro-electric project permanently flooded many thousand square miles of land in northwestern Quebec, with devastating effects on the native people, and the drowning of thousands of caribou. Many native people still lead an essentially mobile way of life. In the fall they still disperse for hunting and trapping, but hunting is no longer a viable future for the growing population. Other occupations and more employment will have to be created.

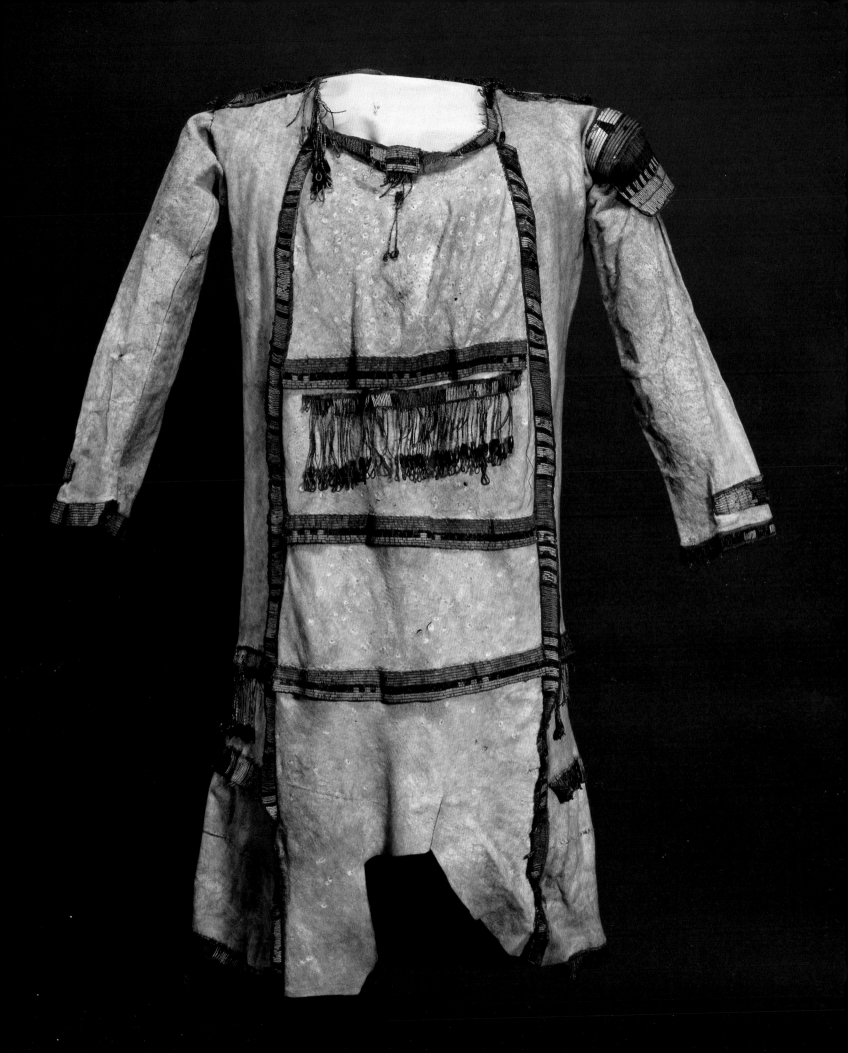

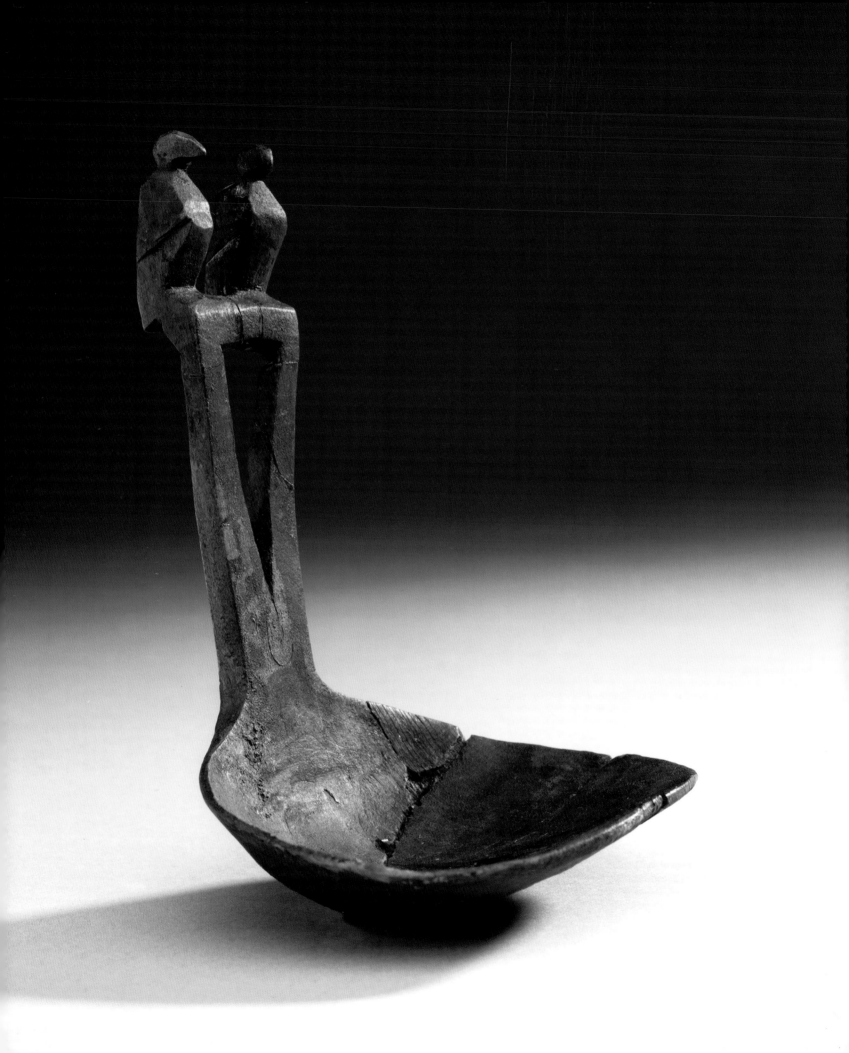

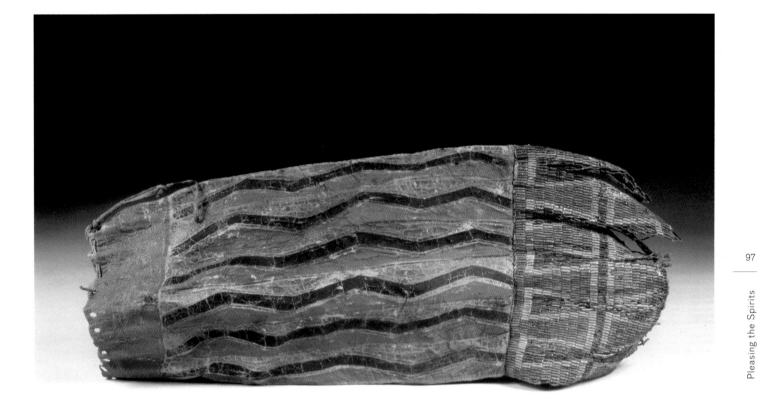

Facing page: **Wooden Effigy Spoon, Rainy River, Ontario, circa 1700.**
Found in a copper kettle that was placed in a grave on an island in Rainy River. Other details of the excavation associate the grave with the Black Duck Culture of the early Ojibwa people. The couple of thunderbirds carved on this spoon may represent the guardian spirits of the spoon owner. With permission of the Royal Ontario Museum © ROM. Acc. no. 964.283.6; image no. ROM2005_10360_1.

Tobacco bag, Western Great Lakes, 1720s.
A painted skin bag, with a panel of netted quillwork at the bottom. Length, 15.25 inches / 38.7 cm. With several other examples in European collections, this bag forms a small group of early and rare Indian pouches. What they have in common is that the paintings on one side of the bag are different from those on the other side. Courtesy Pocumtuck Valley Memorial Association, Memorial Hall Museum, Deerfield, Massachusetts.

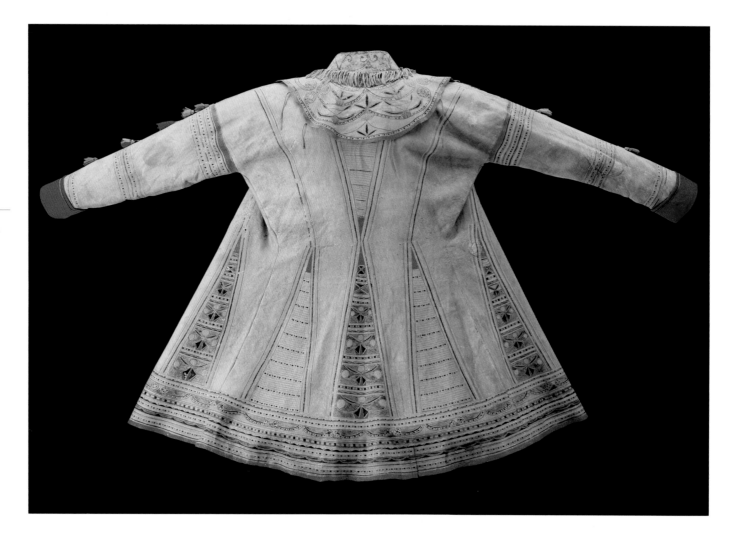

Coat, Naskapi, circa 1840.

Made of caribou skin. Length, 40 inches / 102 cm. Owing to French
colonial influence in the 18th century, the Montagnais and Naskapi
adopted a more tailored type of skin coat with a flaring lower part.
In their painted decoration they combine aboriginal design elements
with curvilinear patterns inspired by French decorative art.
Courtesy Donald Ellis Gallery, Dundas, ON, New York, NY.

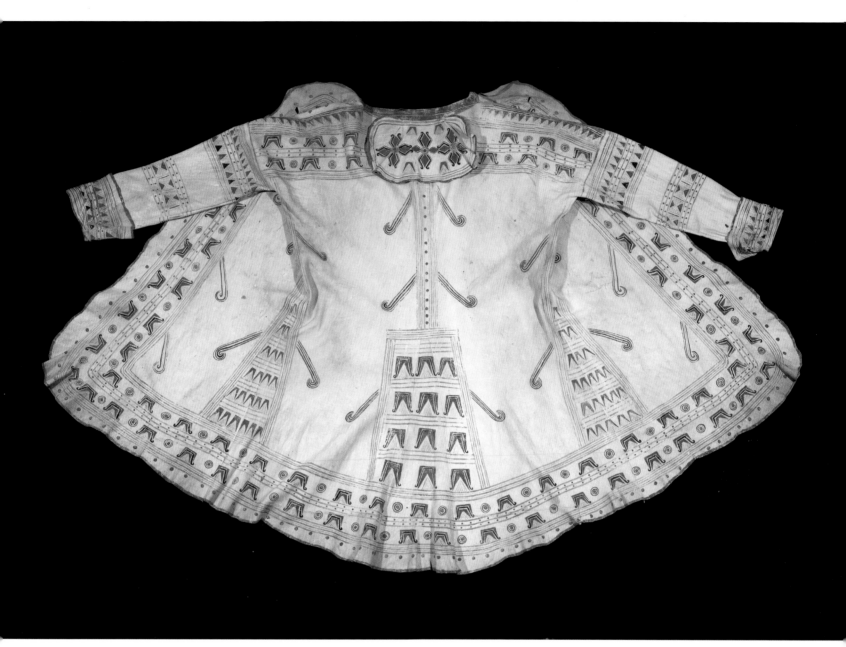

Coat. East Main Cree?, circa 1830.

Painted caribou skin, sinew-sewn. Length, 52 inches / 133 cm. The cut of
this coat is similar to that of Naskapi coats, whereas the style of painting is
reminiscent of the painted coats of the Swampy Cree. As such, this coat appears
to be a unique example from the intermediate region, that is, the Cree east of
James Bay. Painted skin clothing was still remembered by these people in 1908.
Courtesy Donald Ellis Gallery, Dundas, ON, New York, NY.

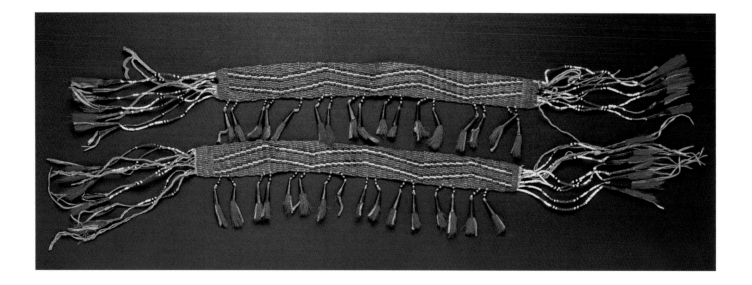

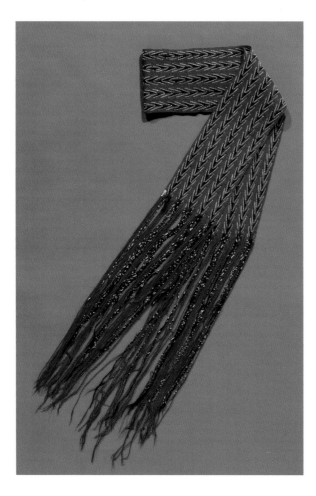

Above: **A pair of garters, Ojibwa type, circa 1770–1800.**
Made of netted quillwork. In this technique, a series of fine leather strings were wrapped in pairs with porcupine quills, alternating the pairs at each row of wrappings, thereby creating a net-like effect. Netted quillwork appears to have been largely restricted to the region around the Upper Great Lakes in the 18th century. Wider garters of woven beadwork became fashionable after around 1800. Present location unknown. Photo courtesy Messiter Collection.

Left: **A belt, Northern Ojibwa, circa 1820s.**
Porcupine quillwork, woven on a bow loom and backed with blue trade cloth. Short wooden sticks were sewn on to both ends of such belts, presumably to prevent wrinkles in the quillwork. Leather loops fit around the two antique British buttons.
Courtesy Walter Banko, Montreal, Quebec.

Above: **Beaded, plaited sash 1825–75 from Quebec.**
With permission of the Royal Ontario Museum © ROM.
Acc. No 967.148; image no. ROM2009_10546_2.

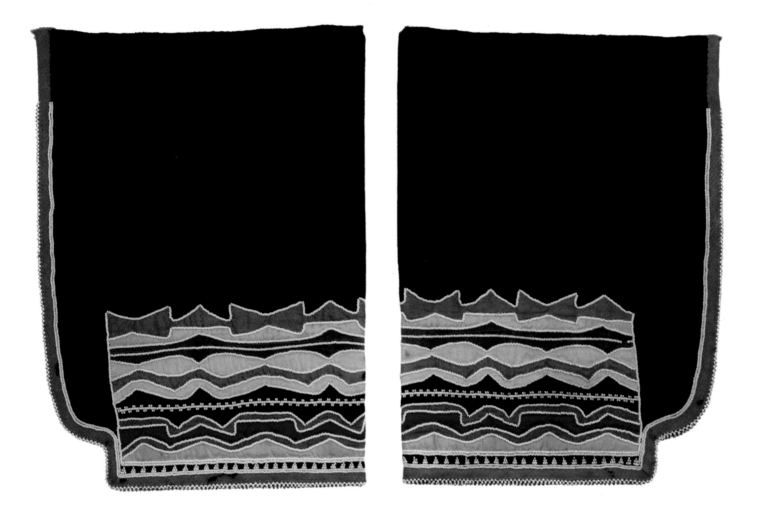

Pair of woman's leggings, Swampy Cree, circa 1840s.
Ribbon appliqué designs outlined by white beads, on blue trade cloth. Silk ribbon became available at the James Bay trading posts in the early 1800s, but the earliest evidence of ribbon work by the local Cree women is from around 1840. Contacts with Cree-Métis from Manitoba may have introduced the required technique, but the designs in James Bay ribbon work are direct transfers from earlier regional quillwork and painting. Ribbon work did not remain popular for long here; by 1860, spot-stitch beadwork was adopted and became the major art expression of the Swampy Cree. Courtesy Walter Banko, Montreal, Quebec.

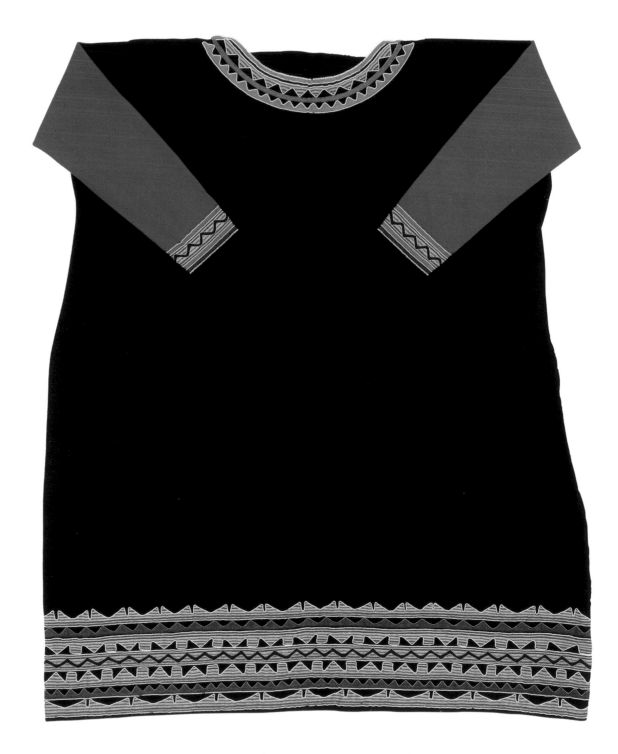

Woman's dress, Swampy Cree, circa 1850.

Made of trade cloth, decorated with silk appliqué and white beads. Length, 48 inches /
122 cm. The detachable sleeves continue the earlier fashion. Also on this dress, traditional
design elements form the decoration, comparable to those seen on the leggings shown
on the previous page. This dress was acquired around 1856 together with the leggings
and hood, facing page, suggesting that the local art style changed in this period.
Courtesy Donald Ellis Gallery, Dundas, ON, New York, NY.

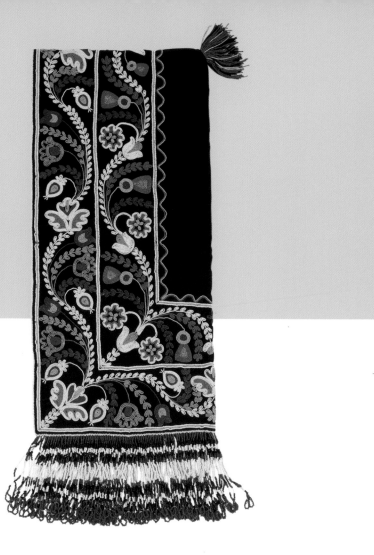

Woman's hood, Swampy Cree, 1850s.
Beadwork on trade cloth. Length, 25 inches / 63 cm.
Peaked hoods were formerly worn by men as well; see
illustration on page 91. After about 1850, this floral art style
became a hallmark of northern Cree art. Typically Cree
is the fringe of beads arranged in bars of different colors.
Cree women abandoned these hoods by around 1890.
Courtesy Donald Ellis Gallery, Dundas, ON, New York, NY.

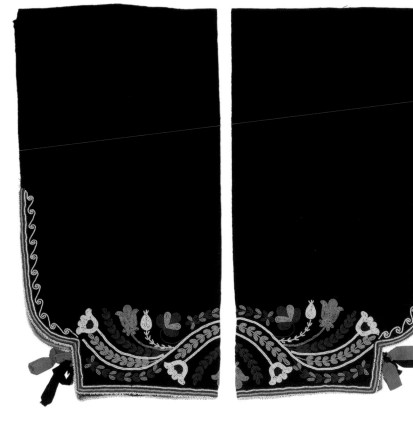

Woman's leggings, Swampy Cree, 1850s.
Beadwork on trade cloth.
Length, 19 inches / 48 cm. This multi-
colored floral art style emerged among the
Red River Métis of southern Manitoba in
the 1840s. As canoe paddlers employed
in the fur trade, the Métis transported this
art style all over northern Canada, and it
reached the James Bay Cree by around
1850. The new style appears to have strongly
appealed to the Cree women and led them to
abandon their older geometric art designs.
Courtesy Donald Ellis Gallery,
Dundas, ON, New York, NY.

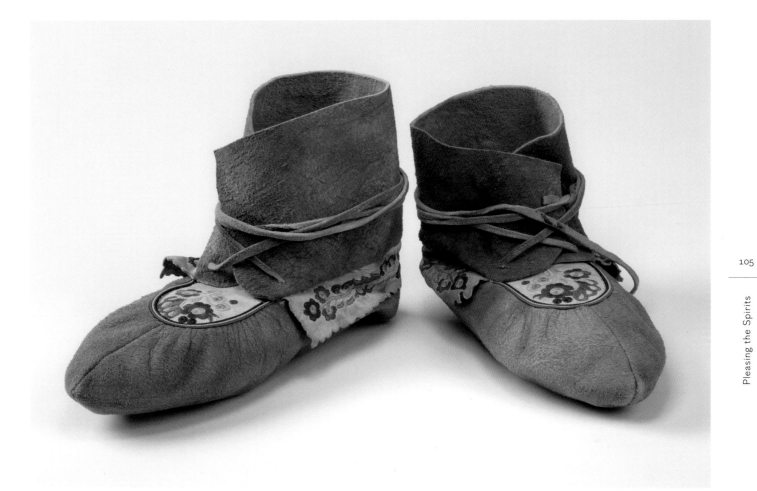

Facing page: **Dress, Naskapi.**
Caribou skin, decorated with traditional paintings. The dress consists
of a tubular body. This is one of the last dresses made by these people;
traditional dress and its painted decoration was abandoned in around
1930, when many people died in an epidemic of influenza and smallpox.
With permission of the Royal Ontario Museum © ROM.
Acc. no. HC2255; image no. ROM2009_10546_6.

Moccasins, Manitoba Cree, circa 1920.
A flamboyant floral art style of silk-floss embroidery developed
among the Cree northeast of Lake Winnipeg. Apparently it started at
Norway House in the 1890s and remained popular until the 1920s.
© Bata Shoe Museum, Toronto, Ontario. Photo by Pete Paterson.

5 | Between Sky and Underwater

Previous page: **Wooden spoon, Midwest, early 19th century.**
Carved spoons of this type were common south of the Great Lakes. The effigies carved on the curved handles fitted over the rim of the food bowl and prevented the spoon from sliding into the food. Spoons and food bowls were individually owned; visitors used to bring their own tableware.
Courtesy Donald Ellis Gallery, Dundas, ON, New York, NY.

Below: **Cahokia, in AD 1300.**
View looking east across the ceremonial center of the largest Mississippian town. Painted re-creation by Richard Schlecht. Courtesy Richard Schlecht / National Geographic Image Collection.

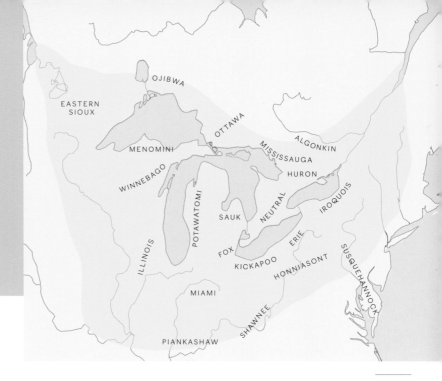

Near present-day Alton, Illinois, on a high rock wall overlooking the Mississippi River, there used to be a remarkable painting. When Father Marquette's canoe passed by it in 1673, he described it as a picture of large horned animals with human faces, winged, with their long tails passing around their bodies and ending like fishtails. The Indians did not like to look at it, but they threw tobacco in the water as a sacrifice. The same creature, but with the tail of a rattlesnake, was carved some 2,000 years ago by a Hopewell Indian artist in Ohio, and we recognize it as the horned Underwater Panther, pictured in the historic art of the Great Lakes Indians. It represented the ruler of the underworld, in dualistic opposition to the Thunderbird, who was a major power of the world in the sky. As a patron of warriors, the Thunderbird also has a long history in the regional native art. Control of the earth and its inhabitants motivated the cosmic, never-ending warfare between these rulers of the universe. All animals on the earth were associated with either Sky or Underwater as descendants of mythical prototypes inhabiting those realms.

Shortly before Father Marquette noticed the rock paintings he passed along the location of present-day St. Louis, and in the distance, behind the opposite river shore, he may have seen some high hills. More than a century later these hills were recognized as manmade mounds and the former location of an ancient city. In its golden age, AD 1050 to AD 1250, Cahokia covered more than five square miles, and its approximately 30,000 inhabitants formed the highest concentration of people in prehistoric North America.

Like suburbs, these settlements surrounded a center of more than a hundred mounds, some of them surmounted by temples or chiefly residences. In one of the burial mounds, the body of an important individual was laid out on a bed of 20,000 shell beads arranged in the form of a bird. Nearby were the bodies of four beheaded men and more than 50 young women, presumably elected to accompany their chief in the hereafter. Overlooking a large plaza in the center of Cahokia was a temple mound 100 feet high, with a commanding view of extensive cornfields in the river valley.

The spread of corn agriculture from the Mississippi Valley by AD 800 is what initiated the emergence of this Mississippian Culture as far north as Ohio. Along old trails and river routes, trade from distant regions provided exotic raw materials to be converted into ornaments and prestigious artifacts for ceremonial display and grave gifts for the elite. Within a variety of regional art styles, we can perceive a commonly

Facing page: **Memory Board, Menomini or Ojibwa, mid-19th century.** A wooden board, 4.75 inches by 15 inches / 12 x 38 cm, engraved with the pictures of the horned Underwater Panthers, male and female, surrounded by beavers and bears, their spiritual identity indicated by heart lines. They represent the major rulers of the underworld with some of their associates. Boards of this type and birch-bark scrolls were used by the members of the Medicine Dance Society, the incised images serving as a memory aid in the recitation of sacred chants and formulas. Courtesy Richard Pohrt, Jr., Ann Arbor, Michigan.

shared symbolism that reflects a widespread similarity in religious worldview and mythology. Carvings and engravings depicted reptiles, panthers and predatory birds related to cults of agricultural fertility, to warrior societies and to chiefly ancestors. Many of these images originated in earlier regional cultures, so any direct Mexican influence in the Mississippian Culture cannot be assumed. Yet the artistic imagery of this culture and its symbolic associations are remarkably like the religious art of pre-Columbian Middle America.

Cahokia was a major center, but there were a large number of similar though smaller mound centers in the region. Aztalan in Wisconsin was probably a northern colony of Cahokia. The hereditary chiefs of these communities were believed to be the descendants of the mythical rulers of Sky and Underwater. Their burial mounds and the abundance of costly grave gifts testify to the importance of funerary ceremonials, to the cooperative labor of the common people and to the power of prestigious nobility.

About AD 1100, ceremonials related to the honoring of ancestors motivated the Indians of southern Wisconsin, southern Ohio and nearby Kentucky to construct large numbers of mounds, shaped to represent long-tailed panthers, bears, snakes and birds. Most of them were about four to five feet high and several hundred feet in length. Burials were interred at focal points of these effigies, such as the head or heart,

indicating a close association of the deceased with the totemic animal or bird.

By circa 1500, the large Mississippian centers had been deserted. Most of their former inhabitants may have moved west across the Mississippi, leaving only the Winnebago as a Siouan-speaking enclave in the Algonkian-speaking population south of the Great Lakes.

That these Algonkin tribes were not recent immigrants was evident in the strong Mississippian influence in their culture, particularly among the Shawnee and other southern tribes. Most of these tribes were divided into two groups of clans: those associated with the Sky powers, versus those originating from Earth or Underwater. Government and religion were interlocking in the role of hereditary clan chiefs, who were the custodians of the sacred bundles. These bundles wrapped in painted skins contained pipes, bird skins and other objects relating to the mythical origin of the clan. The chiefs functioned as ritual leaders in annual ceremonies in honor of these bundles. One of the clan chiefs was recognized as the principal tribal chief, and his exalted status was reminiscent of that of the ancient rulers buried in the mounds.

The people occupied dome-shaped wigwams in permanent villages along the rivers and derived their livelihood from extensive gardens, hunting and fishing. Particularly those living near the Great Lakes

depended heavily upon fishing and the harvesting of wild rice. Annual cooperative buffalo hunting provided meat, hides, and a wool that the women wove into bags and other fabrics. The earliest records mention that complete nudity of the men was common in daily life among some tribes, where profuse tattooing was fashionable. Specific face paintings distinguished the members of each clan. Fragments of clothing found in the graves confirm that fabrics and deerskin used in garments were often dyed dark brown or black and decorated with porcupine quillwork, bands of shell beads decorated the wraparound skirts of women, and robes were made of turkey feathers. Curvilinear patterns were painted on skin robes and incised on pottery. The frequent images of thunderbirds, long-tailed panthers, and horned snakes testify to the continuation of ancient mythical themes.

The region east of the upper Great Lakes was inhabited by people speaking Iroquoian languages. In late prehistoric times, these tribes were in chronic warfare among themselves as well as with most of their Algonkin neighbors. In 1600, French explorers on the St. Lawrence River heard about a war going on between the Neutral of southern Ontario and a "Fire Nation" in northern Ohio. In 1642, the Neutral captured more than a thousand of these distant people and forced the remainder to flee to Wisconsin. Their descendants were the present-day Sauk, Fox

and Kickapoo tribes. By around 1640 the Iroquois of upstate New York had started their conquests, destroying the Neutral in 1651 and the Erie three years later, thereby clearing the way for their invasion of Ohio. In the 1660s, Iroquois war parties were devastating the country from the Appalachian Mountains west as far as Illinois. Most of the regional tribes fled west; some of the Shawnee retreated into the Southeast.

For the Indians south of the Great Lakes, this total destruction of their world had begun in the 16th century with ominous rumors from far beyond the eastern horizons. White strangers, supernaturals perhaps, had come up from the eastern ocean, and new and lethal diseases had spread inland. Along the native trade routes, metal objects and glass beads were arriving from the St. Lawrence River, Chesapeake Bay and Florida. By 1680, the Iroquois conquests changed all of Ohio, Kentucky, Indiana and Michigan into a dangerous and empty no-man's land. The first French traders and missionaries reaching the upper Great Lakes found an estimated 10,000 refugees settled as unwelcome guests among the local tribes of Wisconsin, Iowa and northern Illinois.

Inhabited by a mixed population of what was left of various tribes, the refugee villages were a far cry from the former tribal villages. Intermarriage and the breakdown of tribal isolation led to the emergence of a generalized regional culture in which tribal

Facing page: **Moccasins, eastern Great Lakes, circa 1770–1800.** Named after its most obvious detail, the front-seam moccasin was the most common type in the eastern parts of the country. It is made of a single piece of soft tanned hide, with a seam up the instep and another vertical seam up the heel. The porcupine quillwork on these moccasins suggests an Eastern Ojibwa or Ottawa origin. Courtesy John and Marva Warnock Collection / www.splendidheritage.com

differences were fading. Now living closely and uneasily together, with their traditional societies disrupted, the refugee villagers adopted a ceremonial procedure for reconciliation with former enemies and the creation of friendly relations between individuals or tribes. This "calumet ceremony" elaborated upon the shared smoking of ceremonial "peace pipes," deriving its name from a dance with two long-stemmed and feather-decorated pipes that symbolized cornstalks. These calumets represented major spirits of Sky and Earth, who were called upon as witnesses in this symbolic transformation of strangers into kin relations. By means of the calumet ceremony a widespread network of intertribal alliances emerged, which remained effective well into the 19th century.

In response to the Iroquois wars the French had moved their fur trade west, where they established military garrisons at Michilimackinac, Green Bay and other locations. Mobilized and led by the French, Great Lakes Indian warriors drove the Iroquois back beyond the lower Great Lakes. Peace was finally restored by a French treaty with the Iroquois in 1701. A French fort established at present-day Detroit gradually allowed the many refugees to return eastward, where they pieced a new world together based upon the fur trade. However, hunting, fishing and agriculture remained essential to survival.

European imports had gradually become available in the Great Lakes region. By 1680, metal kettles, axes and knives had replaced native pottery and stone tools, and trade silver had replaced shell ornaments. Though cloth and beads were available, skin garments, porcupine quillwork, and the use of native fibers in twined and finger-woven fabrics did not disappear. The metal tools actually led to a blossoming of wood- and stone-carving. Wooden bowls were carved in the shapes of beaver and other animals, and were reminiscent of ceramic versions from earlier times. Several early references indicate that many of these bowls and spoons were carved by women. There was an increasing production of elaborately carved stone and wooden pipes. With the effigies on these pipes facing the smoker, they served as a personal devotion to the guardian spirits depicted by these effigies. In contrast, lizard-like effigies on war clubs faced the enemy. As part of the new regional culture, however, artistic expressions were losing their former tribal distinctiveness.

When the refugees returned to their former homelands by about 1700, they did not re-create their former tribal territories. Multi-ethnic villages became autonomous units, and they were established at sites around the French trade centers at Mackinac, Green Bay, Chicago, Detroit, Vincennes, Kaskaskia and other places. The typical French center was a combination of military fort, trading post and mission, offering a variety of fascinating impressions upon the daily

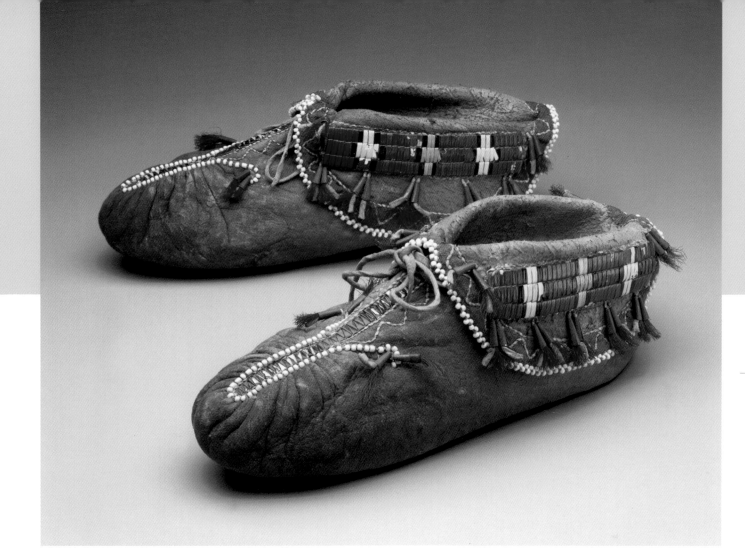

native visitors. The Indian chiefs were often invited to visit the French governor in Montreal, where they were generously entertained, returning with flags, medals and other gifts.

A veneer of Christianity colored the native religion among some tribes, particularly in the mission villages established among the Illinois and the Wyandot Indians. The Wyandot was a new tribe, composed of the remnants of Huron, Tionontati and Neutral tribes. The leaders of these three factions played the role of the Three Kings in annual Christmas pageants. Marriages of the French traders with native women were common, and created a growing population of Métis people.

The establishment of French centers in the Ohio country (roughly, modern Ohio, eastern Indiana, west Pennsylvania and northwest West Virginia) was intended to prevent the western expansion of the British fur trade and, most important, to assert a French colonial claim on the territory between Canada and French Louisiana. Thus the Ohio Valley was bound to become the focus of contention between France and the British colonies. French efforts to control regional developments became obvious when growing numbers of Indians uprooted from the British colonies crossed the Allegheny Mountains and moved into the French orbit. Delaware Indians, the remnants of several other coastal tribes, and also many Iroquois established their villages in Ohio after 1730.

Facing page: **Chief Moses Keokuk, Sauk tribe, 1868.**
Moses was the son of old chief Keokuk. His costume is that
of a prestigious person: a finger-woven sash as a turban,
a necklace of grizzly bear claws, a robe decorated with
colorful ribbon work and front-seam leggings beadworked
in the "prairie style." The decoration on the eagle feathers
of his fan may indicate an achievement in warfare.
Courtesy National Anthropological Archives,
Smithsonian Institution, neg. 622 a.

Although in these eastern parts of the region the fur trade served as the basis of a new Indian Culture, the Indians living around Lake Superior had not experienced the ordeal of the refugee tribes. The Minnesota and Wisconsin tribes had largely maintained their traditional culture, although the demands of the fur trade were disturbing the region. The establishment of French trading posts along the northern Minnesota border incited the Ojibwa to invade the Eastern Sioux country in the 1740s. This warfare raged on well into the 19th century, forcing these Sioux or Dakota to retreat into southern Minnesota.

From the Indian point of view, the traders' insatiable demand for beaver, otter and other water-dwelling animals threatened the benevolent attitude of the Underwater rulers of these animals, as indicated by the decreasing beaver numbers. It was in response to this situation that the Horned Panther and other Underwater powers became the spiritual patrons of a cult among the Ojibwa. In its early form south of the Great Lakes, it may have been called the Black Dance and was a celebration in honor of the game animal spirits. Later, reflecting changing problems, it became known as the Midaywiwin or Medicine Dance, when its focus shifted toward the curing of disease and the promotion of good health. As mentioned in Chapter 4, Pleasing the Spirits, the cult spread around Lake Superior and westward to the Missouri River.

In the Ohio country, the French-British competition led to full-scale warfare. During these conflicts, and those that followed between the British and Americans, the Indians were never allowed to stay neutral. But their alliances were motivated by their determination to resist the loss of their lands. The French and Indian War (1754–1760) involved large numbers of Indian allies, the capture of hundreds of white settlers, and the adoption of many children by Indian families, children who later refused to return to the colonial society. The French defeat ended the war in 1760, to the consternation and disbelief of the Indians. The British frontier crossed the Allegheny Mountains, and British troops occupied the former French posts in the Midwest.

The British military discontinued the liberal distribution of gifts in the fur trade, and the Indians feared that these military people were the vanguard of colonial settlement. The violent Indian protest that erupted is called Pontiac's War, named after the Ottawa war chief who played a major role in it. He almost succeeded in driving the British out of the region, but dissension among the Indians forced Pontiac to sign a peace treaty in 1766. The buffalo herds and other game were disappearing from the eastern regions, and some Indian bands were already removing west of the Mississippi.

By royal proclamation in 1768, white settlement

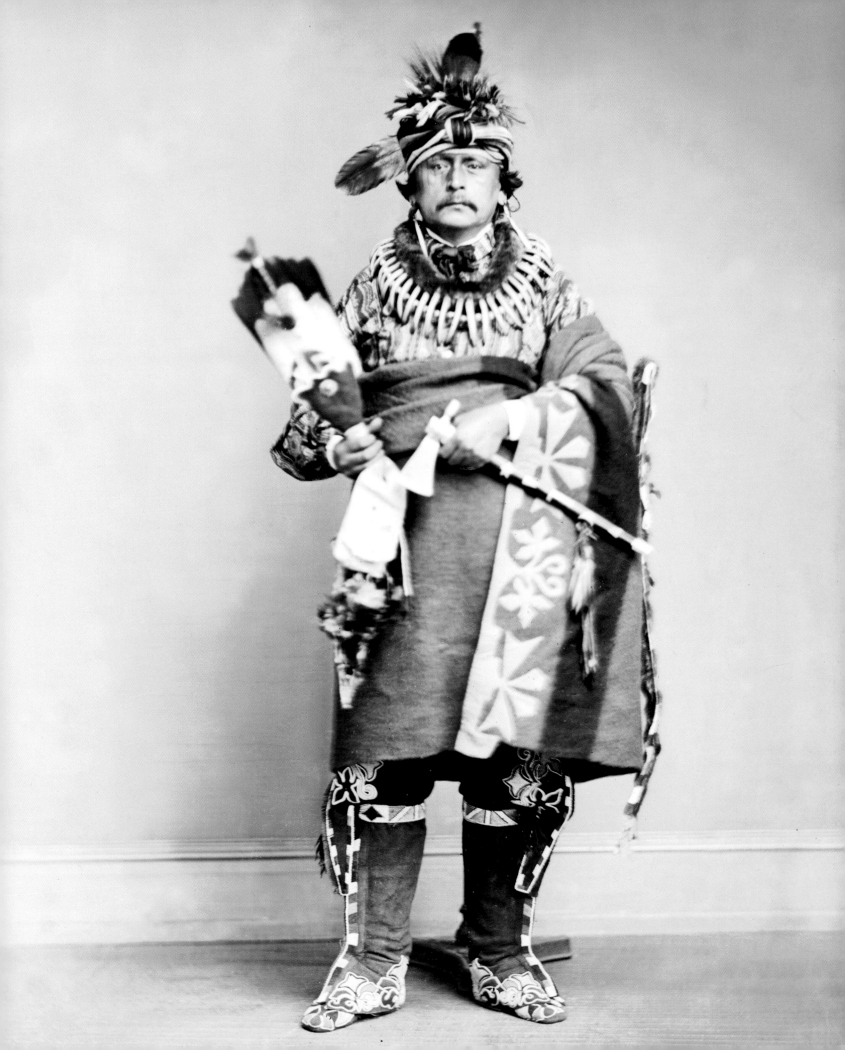

had been restricted to the area east of the Ohio River, but this ruling was ineffective in practice. By 1773, some 60,000 land-hungry settlers had reached the Ohio River, and the Indians were complaining of squatters pouring into their lands. The British traders supported the Indians because the fur trade required the undisturbed preservation of the hunting territories, but government authorities had neither the military manpower nor the political will to stem the invading hordes. Border warfare was brutal, with atrocities from both sides.

The American Revolution and the end of British rule did not bring peace to the Indians. American expeditions invaded the Ohio country, burned the Indian villages and destroyed their large cornfields; except for horses and cattle, they did not take prisoners. The traditional chiefs were losing their authority to the warriors who came of age during the long years of border warfare. Continuous violence fragmented the tribes, forcing increasing numbers of native people to move away across the Mississippi River. The fur traders were also moving west to more profitable regions. The attempts of the Shawnee chief Tecumseh to arrest the influx of white people and to restore the integrity of the native communities were accompanied by a religious revival led by his brother Tenskwatawa. The prophet's dreams evaporated in the Battle of Tippecanoe, and his famous brother died in the War of 1812.

The fur trade had begun a century in which native artisans experimented with new materials and new ideas. Retaining their own cultural values, they were selective in the assimilation of these novelties and created new and yet distinctly Indian forms of art. Complex and prestigious tattooing disappeared when full body covering became common, but the decoration of this clothing remained integrated with the social and ceremonial aspects of the native society. The use of native materials in these arts continued in diminishing ratios, making way for woolen and printed cotton fabrics. Blanket ravelings and woolen yarns replaced buffalo hair and native fibers in twined and finger-woven bags, sashes and garters, which became more colorful as a result. Sashes were worn around the waist; men often wore them wrapped around the heads as turbans or as straps for powder horns or shoulder bags. White beads had been rapidly adopted as a replacement for the native handmade white shell beads. The demand for colored beads increased only after imported fabrics replaced skin garments. The women used these beads in a spot-stitch embroidery of curvilinear patterns and in several weaving techniques. There is some evidence that the weaving of beadwork on a simple bow loom was first developed north of the Great Lakes, but it became a major type of decorative art in the Midwest after the introduction of the heddle in the 19th century. The heddle separates

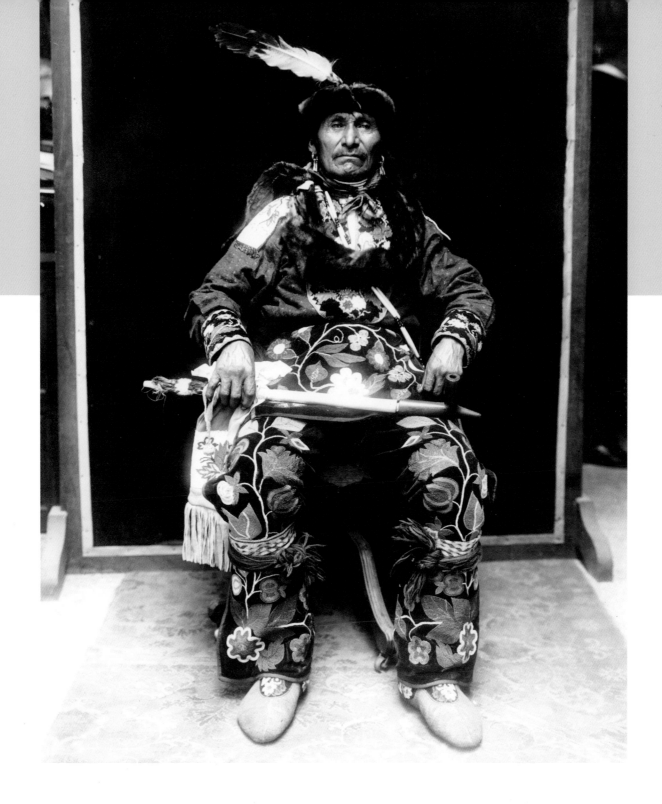

Facing page: **Pair of garters, Potawatomi, circa 1880.**
Woven beadwork became most popular after the
adoption of the European heddle, which consisted
of a rectangular wooden grid of alternate slots and
perforated slats. By moving the heddle up or down,
a space, or "shed," is opened up for the weft.
Courtesy Richard Pohrt, Jr., Ann Arbor, Michigan.

**Kaydug-egwonay-aush, also known as Julius Brown,
a Minnesota Ojibwa, 1911.**
Brown's ceremonial costume is a display of the realistic floral
beadwork style of his people.
Courtesy National Anthropological Archives,
Smithsonian Institution, neg. 594-b-2.

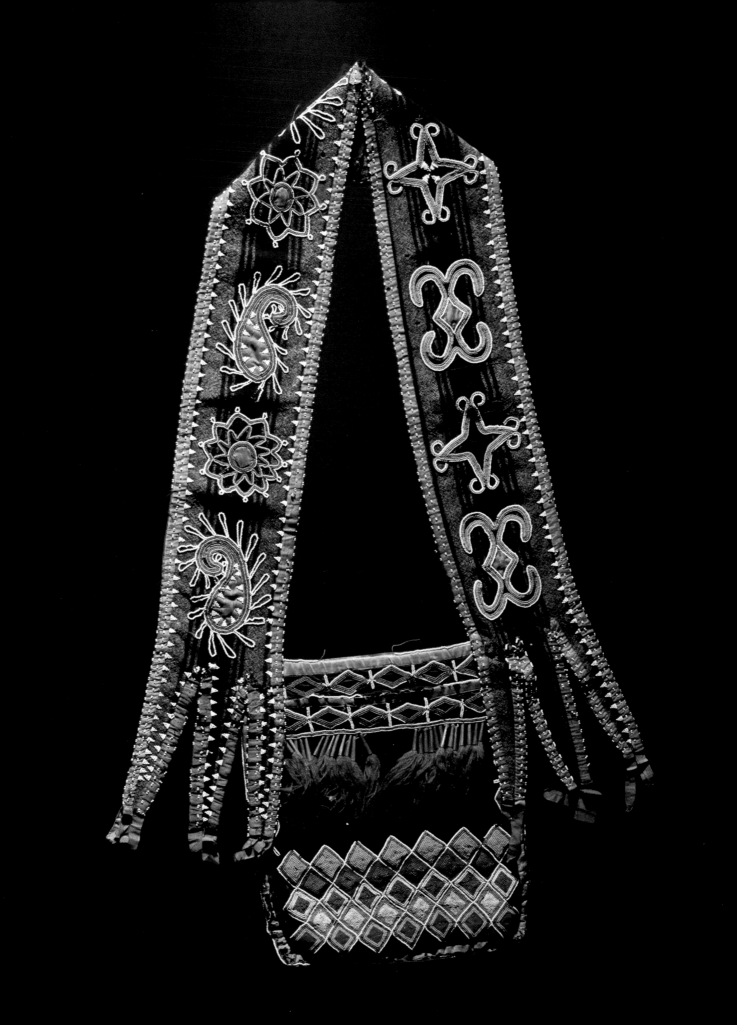

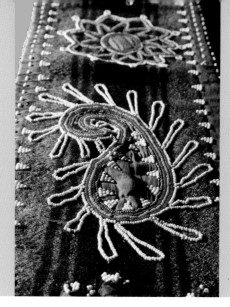

alternate warps for the insertion of the weft, resulting in a less time-consuming technique.

The decoration of cloth garments with ribbon appliqué had originated in the St. Lawrence Valley, where the Indians sewed simple strips of silk on their blanket robes in the early 1700s. The spread of the fur trade south of the Great Lakes made silk ribbons (and scissors) available in large quantities. Intricate and colorful appliqué patterns were created by the native women on their robes and skirts. Silver brooches literally covered the dress of wealthy individuals.

During the 18th century, there was a rapid increase in the number from offspring of the unions of French-Canadian trade employees and native women. Many of these children joined the native society, but growing numbers of them were employed in the fur trade. By the 1780s, the settlements around the trading posts were predominantly inhabited by Métis people. Métis women originated a floral style of beadwork that became popular among the Great Lakes Indians by about 1800. Most probably this new art style was inspired by the instruction in fine embroidery at mission schools, but it may be significant that studies of colonial folk art indicate that American folk art started to blossom in the same period. By the 1830s, demand from white traders stimulated an industry of effigy pipe carving among the Ojibwa.

Faced by unrelenting pressure from the white settlers, the American government started the removal of the Indians to more western regions in 1818, culminating in the federal Removal Act of 1830. Many of the Indians in the forests of northern Michigan, Wisconsin and Minnesota escaped this ethnic cleansing. While some managed to escape to Canada, starvation and disease took a terrible toll on those removed to Kansas and present-day Oklahoma.

In these western regions the refugee Indians found themselves in close contact with local tribes as well as with native people removed from the Southeast. Their common efforts to revitalize a native identity are reflected in the emergence of the so-called "prairie style" of beadwork, consisting of dense semi-floral patterns combined with abstract elements. In the 1850s, large and elaborately decorated shoulder bags became fashionable among the Ojibwa in Minnesota, and they were subsequently adopted throughout the Great Lakes region.

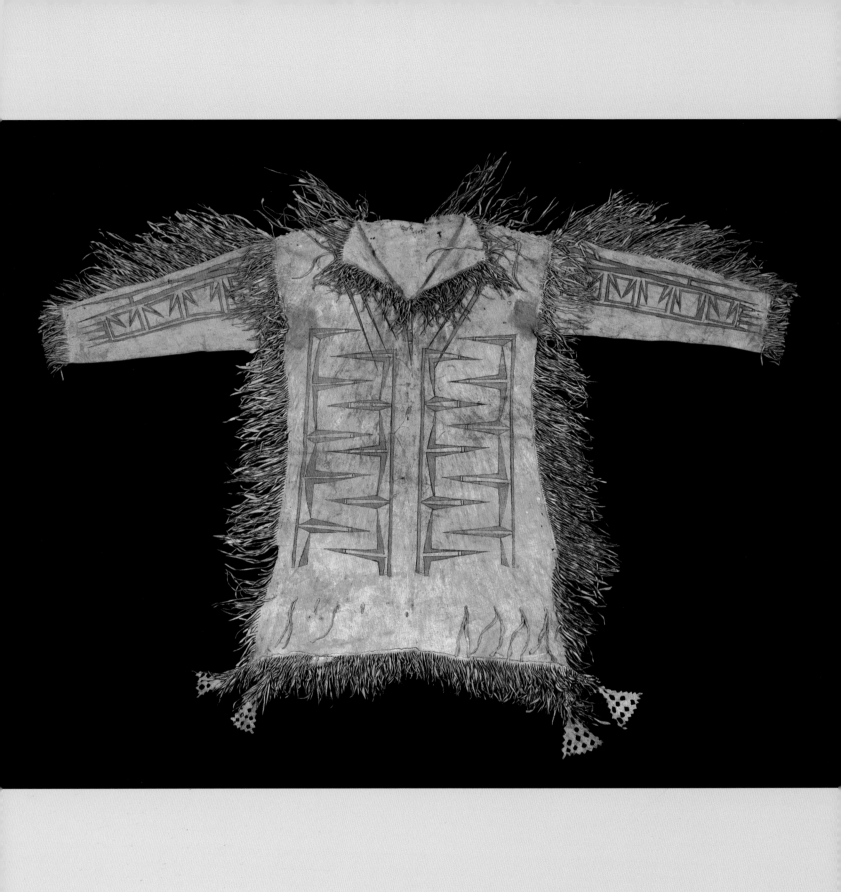

Painted skin shirt, Eastern Sioux?, 1720s.
A deerskin shirt. Length, 39 inches / 1 m, fringed along body and sleeves; with pierced skin pendants at the neck, shoulders and bottom corners. A larger tab extends from the back of the neck opening. Geometric red paintings in thin black outlines decorate the front, back and sleeves. Most probably, these paintings represent birds, and they may be a transfer of tattoo patterns from the human body. The paintings resemble those on some painted skin artifacts predating the 1750s, presently in several European museums collections. Pierced skin tabs are known from early skin garments of the Great Lakes region. This shirt likely originated from the upper Mississippi in present-day Minnesota. Courtesy Donald Ellis Gallery, Dundas, ON, New York, NY.

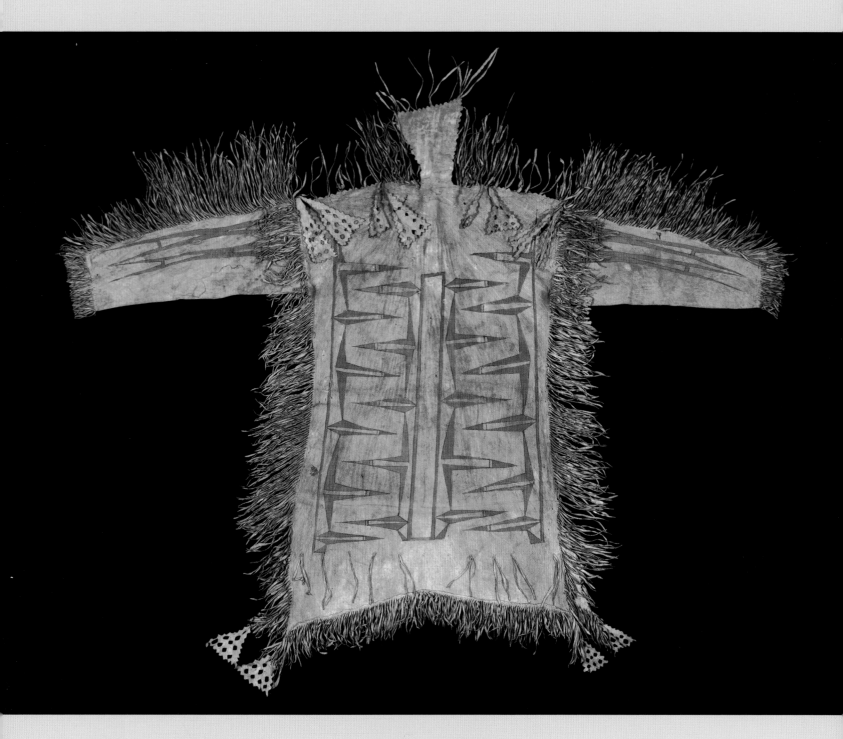

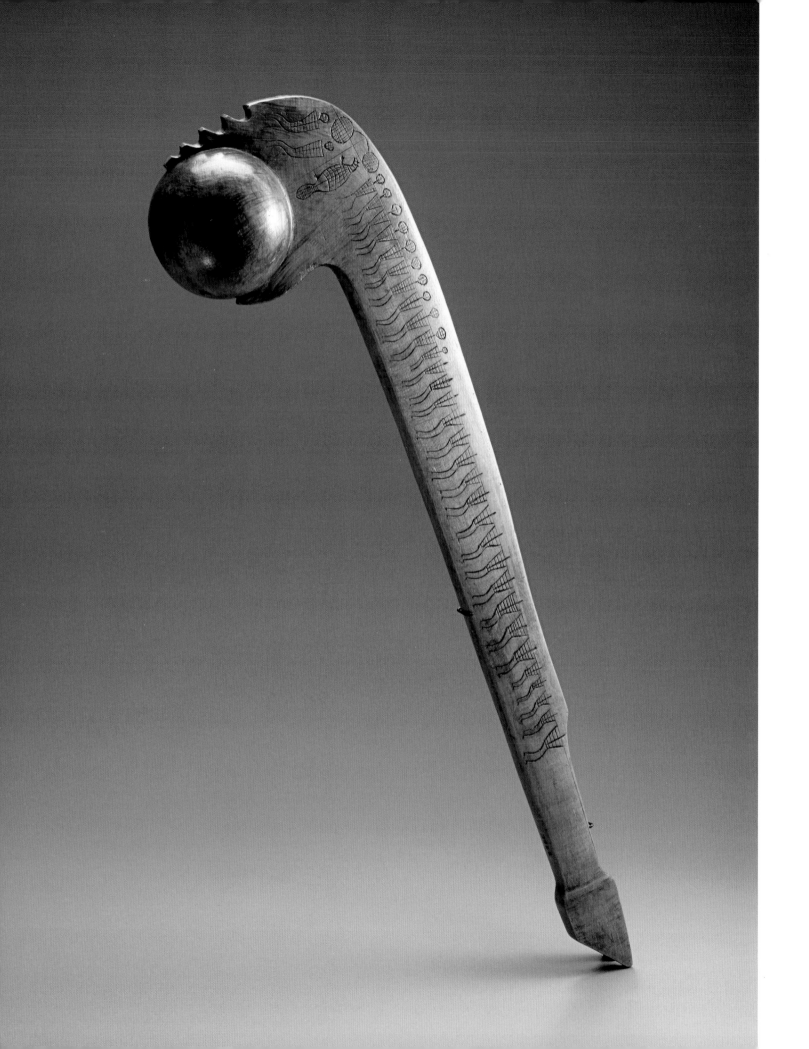

Facing page: **War club, southwestern Ojibwa, circa 1770–1800.**
Carved from a single piece of maple wood. Length, 24 inches / 62 cm. The incised images on the handle appear to record a war party of which many members perished, as indicated by the headless figures. The notched edge above the ball may represent the spikes on a dragon's back. As such, it is an abstract reference to an Underwater power. Courtesy John and Marva Warnock Collection / www.splendidheritage.com

Right: **War club, Potawatomi?, circa 1800.**
Ballhead clubs were common throughout the eastern parts of the continent; the discovery of this example in southern Michigan suggests a Potawatomi origin. Effigies of long-tailed animals facing the enemy from the club's ball relate to the owner's trust in magical support from Underwater powers. Courtesy Richard Pohrt, Jr., Ann Arbor, Michigan.

Garter pendants, Ojibwa, pre-1780.

A pair of finger-woven strips of black woolen yarn, interwoven with white pony beads, sewn on to small panels of netted quillwork. Length, 30 inches / 76 cm. Both panels show the image of a thunderbird. Tied on to the knee garters, such pendants were used at festive or ceremonial occasions. The manufacture of netted quillwork appears to have been largely restricted to the regions around the Upper Great Lakes until the end of the 18th century. Courtesy John and Marva Warnock Collection / www. splendidheritage.com

Facing page: **Horned headdress, Winnebago?, circa 1780.**
Browband of quill-wrapped bark strips, the skin cap covered with red-dyed horsehair. Very few headdresses of this type have survived; they seem to have originated from Winnebago, Osage and other Siouan tribes southwest of the Great Lakes. Photo © Canadian Museum of Civilization, artifact v-x-446, image s82-267.

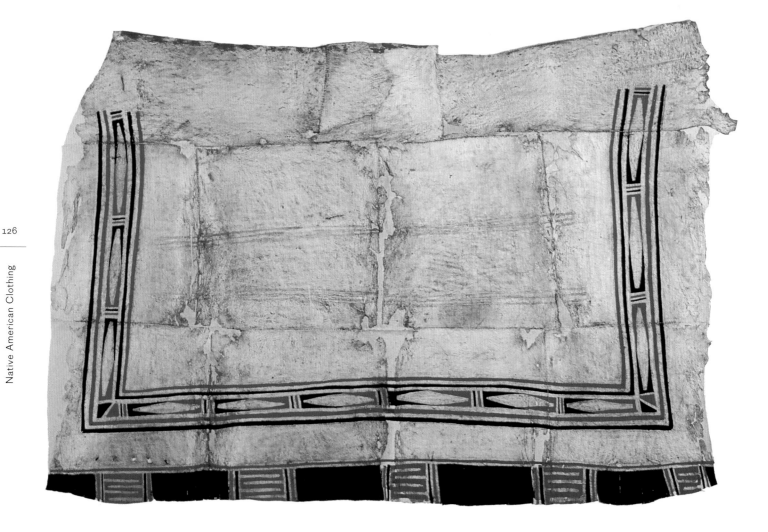

Woman's dress?, Midwest, circa 1780.

The folds in this painted skin, and the layout of the painting, suggest that this is a so-called side-fold dress, an early style of woman's dress of which very few examples have survived. Basically, it is a longer version of the wraparound skirt that was worn throughout the eastern parts of the country. The upper part was folded over and held up by shoulder straps. Most probably the surviving examples originated from the borderland between the western Great Lakes and the northeastern Plains. They had become old-fashioned and were disappearing by around 1800.
© Museo de América, Madrid, Spain. Cat. no. MAM 16370.

Facing page: **Hunter's bag, Ottawa, circa 1780.**

Dimensions, 9.25 inches by 11.25 inches / 23.5 x 28.6 cm.
Black skin bags of this type, remarkably uniform in size and shape, were popular among the Michigan Ottawa and Eastern Ojibwa from around 1760 until the 1820s. Their quillwork decoration shows primarily thunderbirds or horned panthers, suggesting that the owners were devoted to the spiritual powers of either Sky or Underwater. Most likely the thunderbirds pictured on this bag relate to the owner's guardian spirits. In dreams, such spirits appeared often as a couple, male and female, who adopted the dreamer as their "sacred child." The latter is pictured here in bird form between his spiritual parents.

Early examples, including this bag, were worn on the chest by means of a short neckstrap. By 1800, American influence made longer shoulder straps more popular. Charms related to hunting and warfare were carried in these bags, as were pipe and tobacco.
Courtesy John and Marva Warnock Collection / www.splendidheritage.com

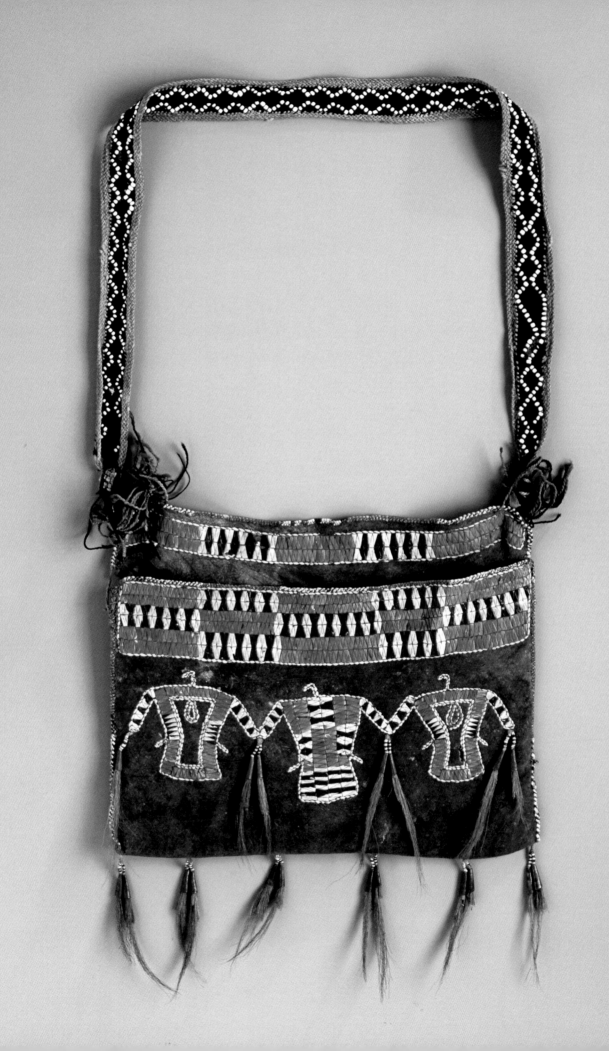

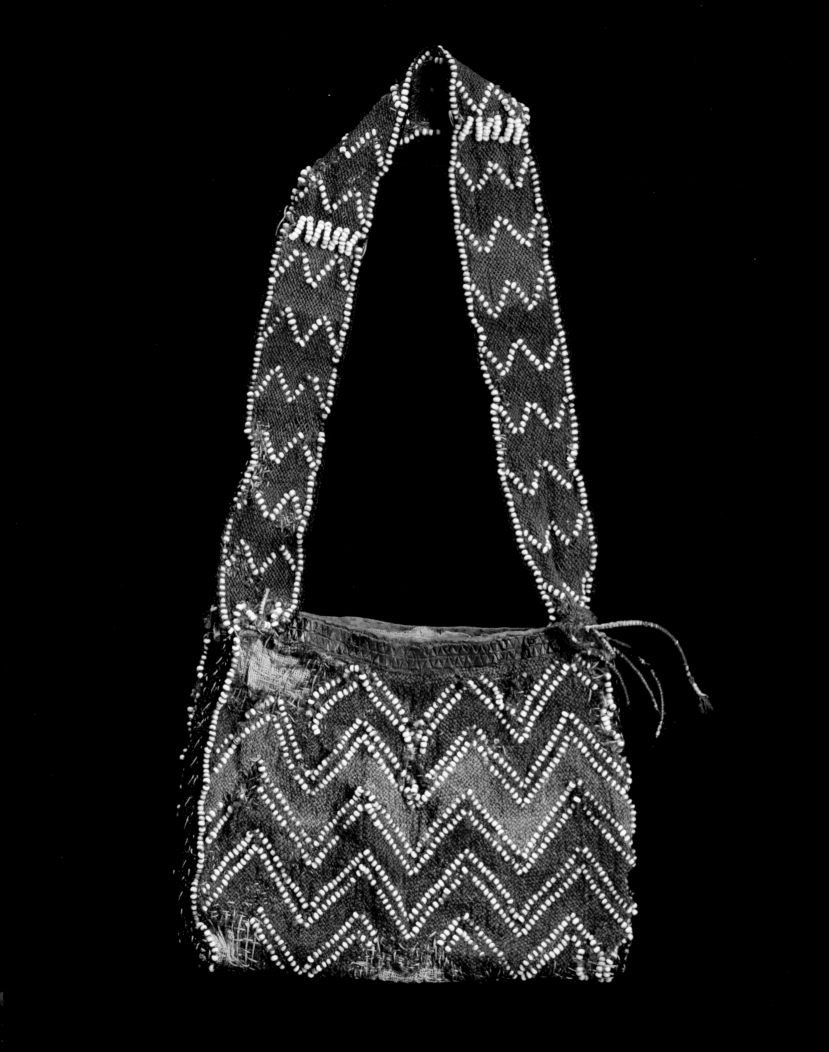

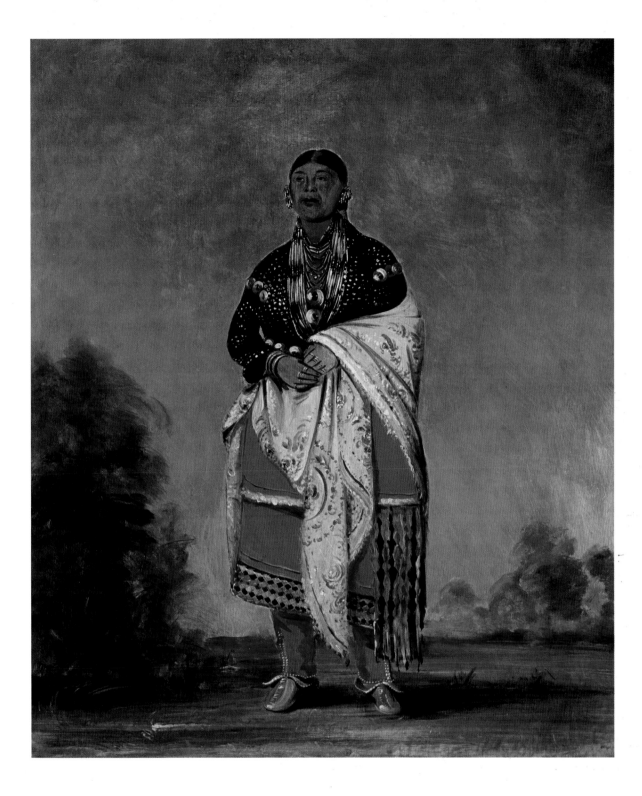

Facing page: **Shoulder bag, Illinois?, 1760s.**

A finger-woven bag of brownish red wool yarn, interwoven with white pony beads in different designs on front and back. Dimensions, 16.5 inches by 8.25 inches / 42 x 21 cm. Finger weaving is actually a braiding technique called "oblique interlace." At several places on the bag and strap, the color of the wool has been changed to yellow. Similar color changes are typical for the oldest surviving native fabrics from south of the Great Lakes. A resist- or discharge-dyeing technique was probably used to create such color changes. Courtesy John and Marva Warnock Collection / www.splendidheritage.com

Nah-wee-re-coo, the wife of Chief Keokuk, Sauk tribe, 1835.

Painting by George Catlin at Keokuk's camp in 1835. With red face paint, she wears a black cloth blouse decorated with silver brooches; her red cloth skirt shows rich ribbon appliqué; her red cloth leggings are edged with white beads. Courtesy Smithsonian American Art Museum, Washington, DC / New York, NY.

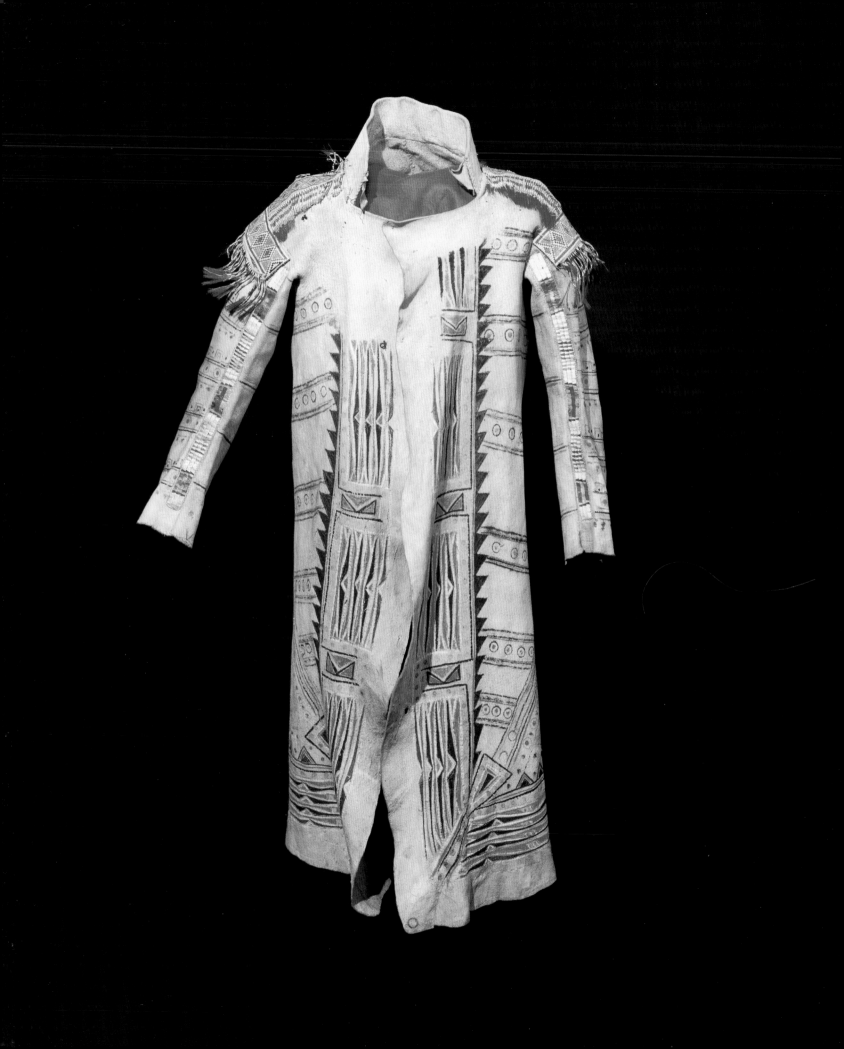

Facing page: **Painted skin coat, western Ojibwa, circa 1780.**
Made of moose skin, decorated with painted designs and porcupine quillwork. Length, 47 inches / 120 cm. The construction and decoration of this coat resembles that of the long coats of the northern Ojibwa and Cree Indians in the 18th century, but the style of painting indicates its origin among the Ojibwa of northern Minnesota or the adjoining parts of southern Manitoba. As such, this coat is intermediate in style between the northern straight coats and those created by the Red River Métis in the 1840s. Closed with a belt, such painted skin coats were worn in wintertime; their decoration was meant to please the game spirits and stimulate their generosity. Courtesy Ned Jalbert, Westborough, Massachusetts.

Medicine bag, Potawatomi type, circa 1870.
Made of a whole otter pelt, decorated with panels of beadwork on paws and tail. Length, 49 inches / 125 cm. Semi-floral beadwork replaced the geometric quillwork after the 1830s. In these bags members of the Medicine Dance Society carried some cowrie shells for use in "shooting" the new members during their initiation; a small bag of blue face paint, several packages of herbal medicine and any number of personal charms. Some of these otter-bags could be made to whistle by means of air pressed through a bone tube in the otter's throat. Courtesy Charles Derby, Northampton, Massachusetts.

SIR JOS JEBB.

**Two Ottawa Chiefs Who with others Lately Came Down
from Michillimackinac Lake Huron to Have a Talk with
Their Great Father The King or His Representative.**
Watercolor attributed to Sir Joshua Jebb, 1813–20. One
of the chiefs holds his top hat; his friend wears a painted
skin robe. Most conspicuous is their wealth in silver
ornaments, made in large amounts for the Indian trade by
silversmiths in Montreal, Philadelphia and other places.
Courtesy Library and Archives Canada /
acc. no. 1981-55-41 / C-114375.

Capt. S. Eastman U.S. Army Del.

INDIAN SUGAR CAMP

Indian Sugar Camp, **Minnesota Ojibwa, 1830s.**

Lithograph after watercolor by Seth Eastman,

illustrated in Schoolcraft, 1851–57.

Courtesy the W. Duncan MacMillan Foundation and Afton Press.

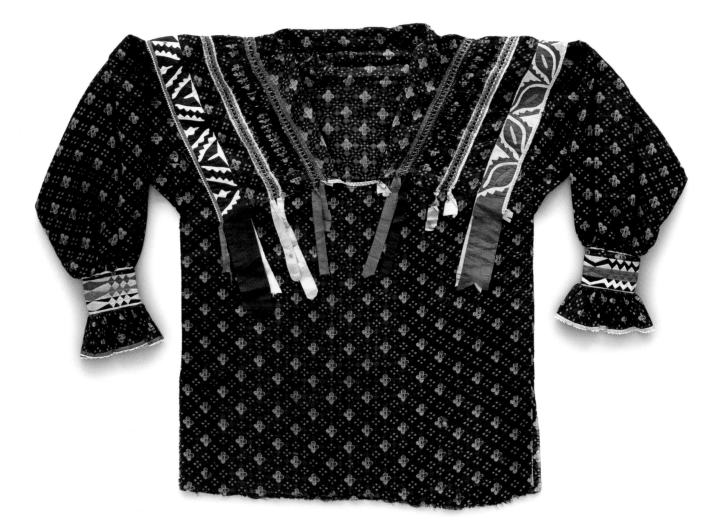

Wraparound skirt, Winnebago, 1860s.
Length, 37 inches / 94 cm. Proudly
proclaiming an Indian identity, beautiful
skirts such as these were worn
with cotton blouses, often covered
with rows of silver brooches.
Courtesy Richard Pohrt, Jr.,
Ann Arbor, Michigan.

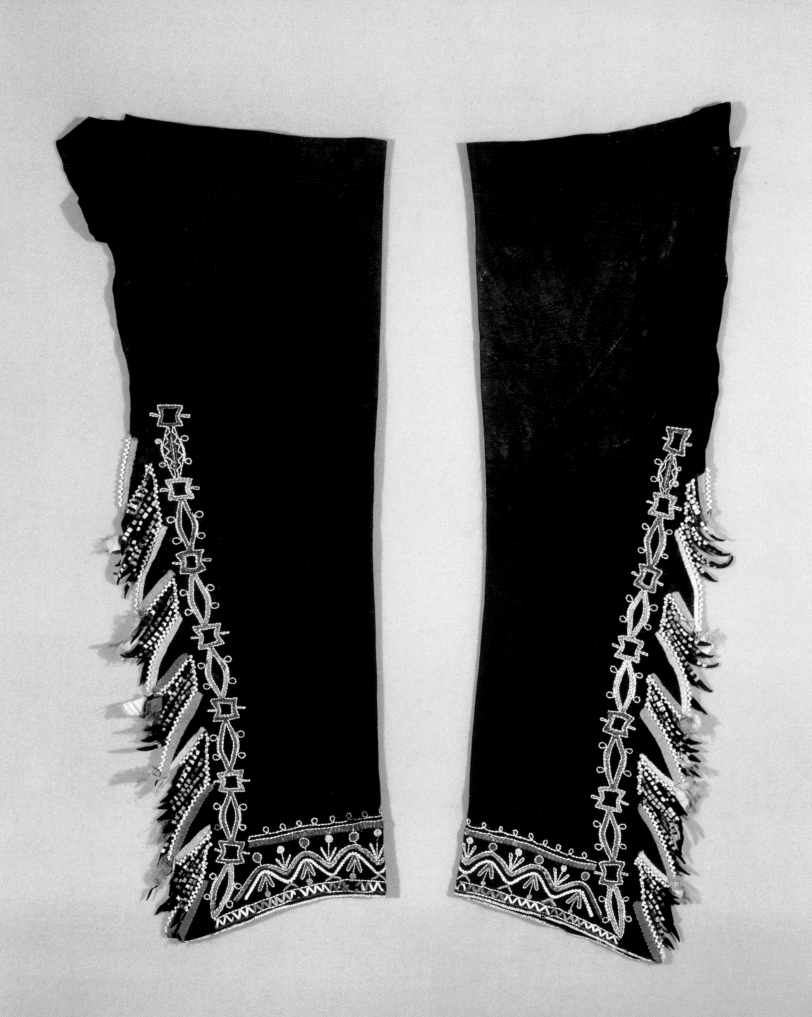

Right: **Woman's leggings, Winnebago, circa 1865.**

Red trade cloth, decorated with ribbon appliqué in different designs on both sides. Length, 23.25 inches / 59 cm. The leggings of women reached up to the knees; the extent of skirt overlap indicated by the upper end of the ribbon work. Starting in the 1790s, ribbon work became most elaborate by the 1830s. Basically, it involves the cutting out of designs in one color of silk and sewing it to a background of a differently colored silk. Several such strips, each of a different color, may be sewn side by side onto a garment. Courtesy John and Marva Warnock Collection / www.splendidheritage.com

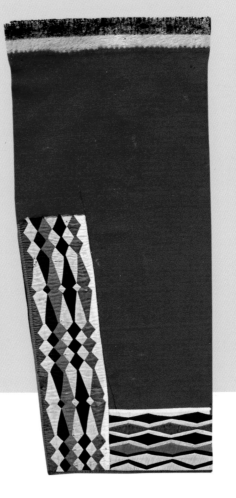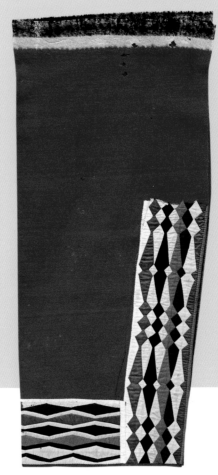

Right: **Woman's leggings, Minnesota Ojibwa, 1880s.**

Length, 15 inches / 38 cm. Realistic floral designs in spot-stitch beadwork became a hallmark of western Ojibwa art in the 19th century. Courtesy John and Marva Warnock Collection / www.splendidheritage.com

Facing page: **Man's leggings, Southwestern Ojibwa, circa 1800.**

An excellent example of the old style of quillwork on black-dyed skin. Courtesy National Museum of the American Indian, Smithsonian Institution (200897). Photo by NMAI photo services staff.

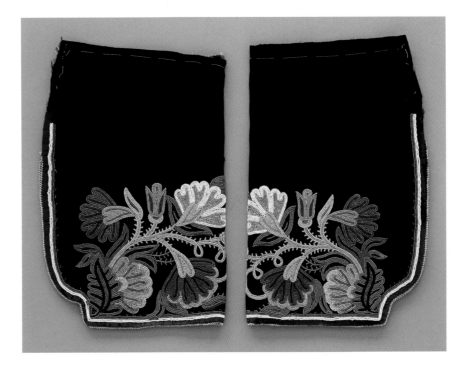

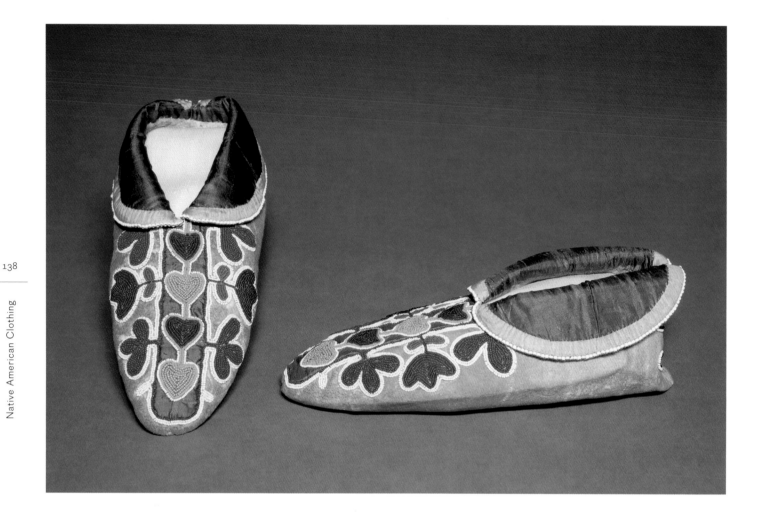

Moccasins, Delaware, 1860s.

These moccasins were acquired in eastern Kansas in 1867. At that time the local Delaware Indians were selling most of their property and preparing to move to the Cherokee Nation in present-day Oklahoma. The semi-circular cut of the moccasin flaps suggests Southeastern Indian influence. Courtesy Ned Jalbert, Westborough, Massachusetts.

Facing page: **Bandolier bag, Ojibwa type, circa 1870s.**

Loom-woven beadwork sewn on to a backing of black cloth; yarn tassels. By around 1850, the Ojibwa women in Minnesota started to produce this type of shoulder bag in large numbers, trading them far and wide to other Indians of the Great Lakes and Plains regions. Despite their large numbers, identical duplicates are hard to find. The aboriginal prototype of these bags is illustrated on page 127. Resembling the old black-dyed buckskin, black cloth became a popular background for this beadwork. The designs on pouch and shoulder strap are variations of an X-pattern that was typical of this Ojibwa style; the asymmetrical decoration of the strap is a common feature in many of these bags. Less common is the halfway split of the shoulder strap, which suggests influence from the Manitoba Cree. Courtesy Richard Pohrt, Jr., Ann Arbor, Michigan.

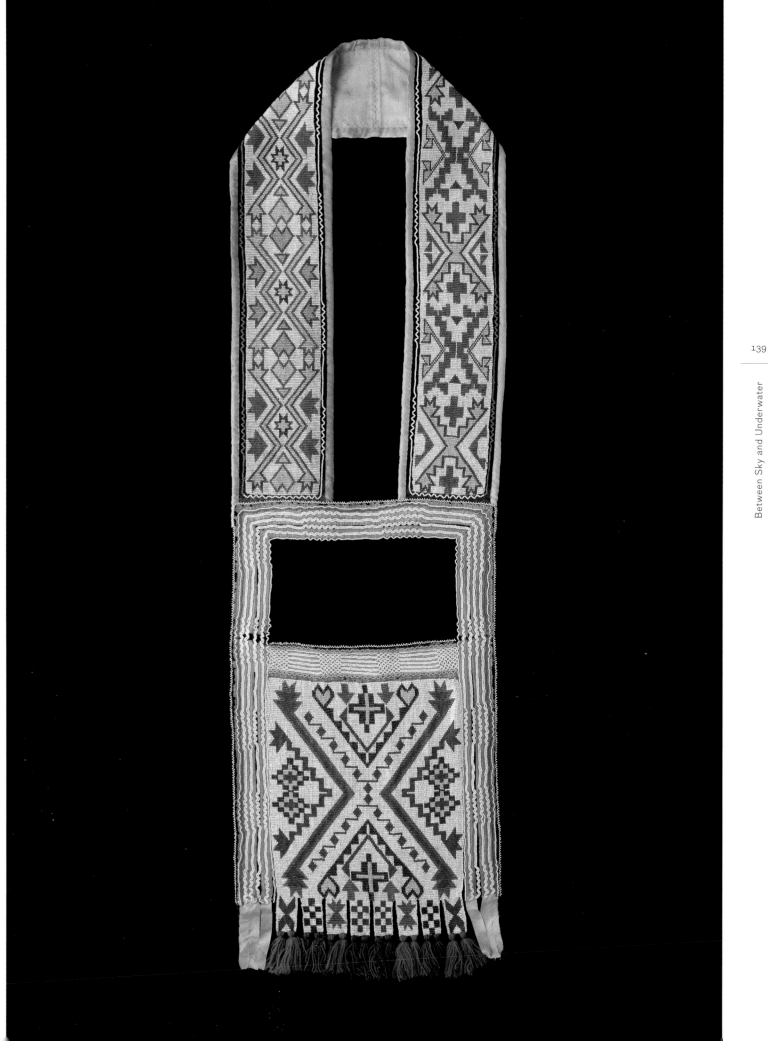

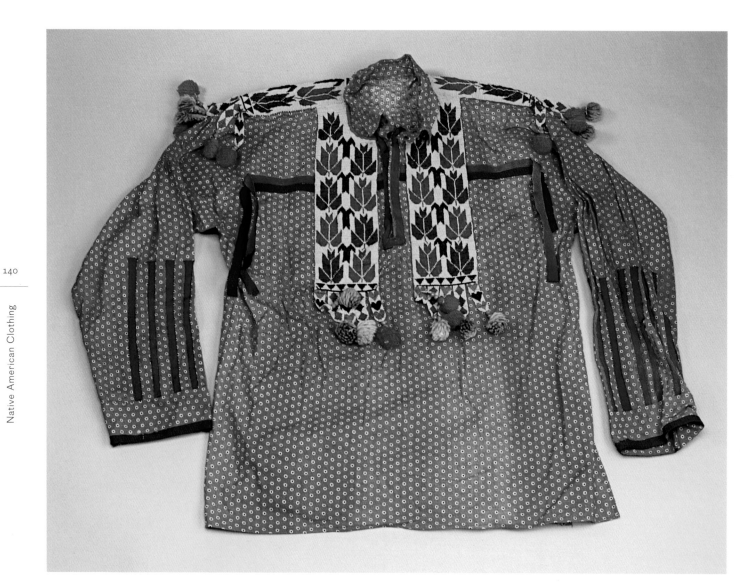

Man's shirt, Winnebago, 1880s.
Panels of loom-woven beadwork sewn on the chest and
shoulders, terminating in short tabs with yarn pompoms.
This placement of decoration on cotton shirts became popular
among the Wisconsin tribes in the late 19th century.
Courtesy Skinner, Inc. Boston and Bolton, Massachusetts.

Facing page: **Man's leggings, Sauk and Fox,
circa 1865.**
Length, 36 inches / 91.5 cm. Front-seam leggings became
fashionable among the Midwestern tribes in the 1830s,
particularly among the Sauk and Fox Indians. Many leggings
of this type have this pendant flap, made to hang over the
knee garters, with the bottom of the leggings covering the
feet. The beadwork patterns on this pair are representative
of the "prairie style" of abstract floral designs.
Courtesy John and Marva Warnock Collection
/ www.splendidheritage.com

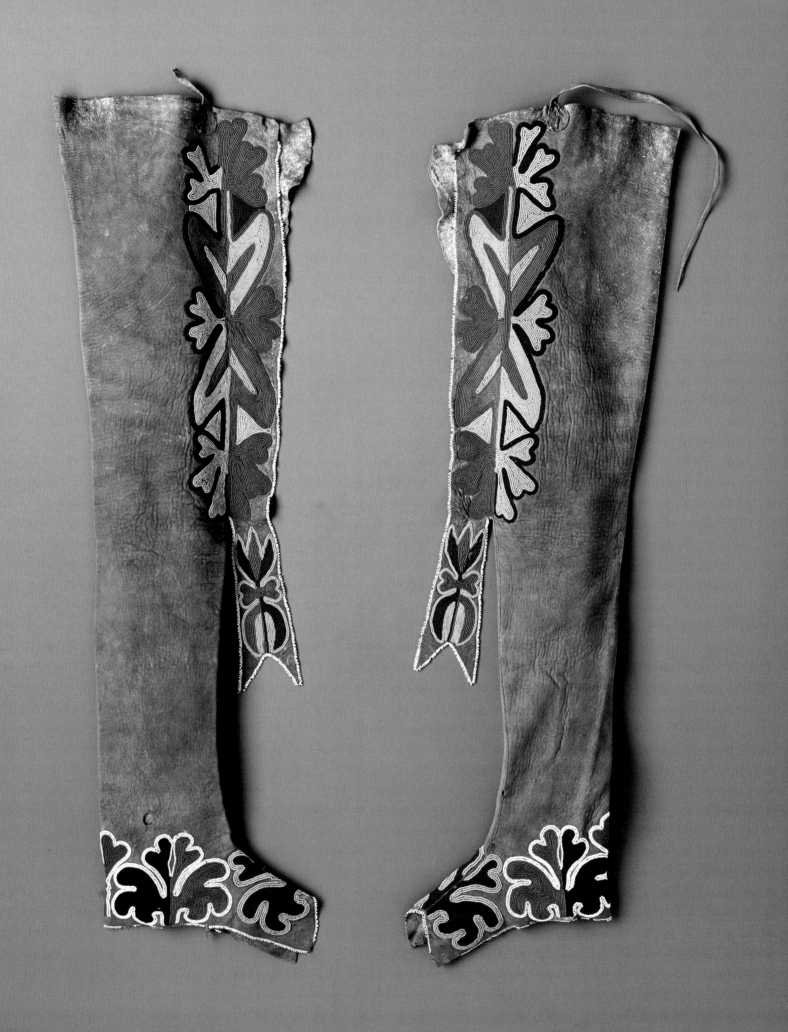

6 | By the Power of Their Dreams

Previous page: **Painted hide robe, Southern Arapaho, circa 1850.**
Native-tanned elk hide, 79 inches / 201 cm long, with painted decoration. This painted design
is well known from buffalo robes of the Comanche Indians, with the exception of the band of
parallel lines that runs from the central pattern to the border. This detail points to the Arapaho,
who employed a band of multiple lines to represent buffalo trails. The Arapaho name for the
total design is "Comanche painted robe," indicating their source of inspiration. Some Arapaho
resided with the Comanche after around 1810, and by the mid-19th century the Arapaho were
divided into a northern and a southern division, which led to differences in their art expressions.
Courtesy John and Marva Warnock Collection / www.splendidheritage.com

The North American Plains extend from the mountainous backbone of the continent eastward almost to the Mississippi River, and from the Saskatchewan River south into Texas. Within this region the western High Plains are arid, with trees growing mainly in the valleys of the few rivers. Surrounding the High Plains are several subregions: the forested foothills of the Rocky Mountains, the parklands to the north, the lush prairies east of the Missouri River, and the near-desert to the south. These subregions were both naturally and culturally transition zones between the heartland of the Plains and the surrounding regions.

This vast expanse of grassland was inhabited by immense herds of bison, antelopes, elk and other deer. The Plains Indian, in colorful costume on horseback, his feather headdress streaming in the wind, has captured the imagination of the entire world. Yet, it is a curious fact that this Plains Indian emerged only as a result of the arrival of Europeans in America.

Small bands of nomadic hunters had roamed the Plains for thousands of years, with sturdy dogs pulling A-shaped wooden frames, or "travois," that served as carriers for their equipment. Their camps left behind the many circles of field stones, used to hold down the covers of their tipis. These "tipi rings" indicate that in summertime the Indians camped on the hilltops, so as to enjoy the fresh breeze and have a wide view to spot game from far away. With transport power restricted to dogs (and women), the tipi was a small affair; traditional native accounts mention that, long ago, two up-ended travois served as its frame.

Together with wolves and other scavengers, these people followed the buffalo herds out onto the open plains in summer, retreating into the timbered river valleys during the winter. Most of these early hunters may have moved in the fall to the forested fringes of the Plains. Their ancient origin in the northern and northeastern forests was evident in their use of the tipi, of dogs for transport, of communal hunting techniques developed in the exploitation of the northern caribou herds, in the quillworked and painted decoration of their skin garments, their Athapaskan and Algonkian languages, and in their worldview. Stylized animal images were painted on the tipi covers, with joint marks and certain internal organs in these pictures relating to an ancient circumboreal and shamanistic art tradition. This northern heritage was reinforced over the years by later immigrants. The descendants of these early Plains nomads are the Blackfeet, GrosVentre, Arapaho, Sarsi, Kiowa-Apache and other Plains Apaches, and from across the western mountains, some Shoshone and Kutenai people.

Each band recognized common ties of language, kinship and other customs with a number of other bands. For most of the year their camps were at a great distance from each other. Only in midsummer, when

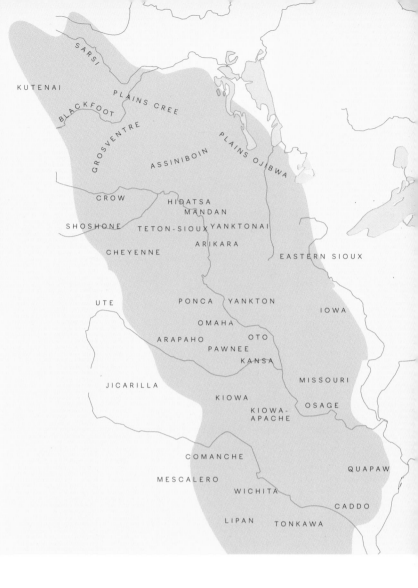

the buffalo assembled in large herds, did these bands come together in one large tribal camp. Drawing their members from all the bands, several fraternities and cult groups celebrated their annual summer ceremonies. After a few weeks, the hunters' quest for food forced the bands to separate and go their own ways again. In the fall some of the bands might cooperate in a buffalo drive hunt, involving the use of corrals on the plains or of steep cliffs called "buffalo jumps" in the foothills.

Thus a Plains Indian tribe consisted of a number of fairly independent bands, each with its own chief. The nature of the chief's leadership was reflected by his followers addressing him as "father." It was his custom to refer to his followers as his "children." Usually the chief ranked high in the ritual organization and was the owner or keeper of important medicine bundles, including a sacred medicine pipe.

Native creation myths convey the message that, unlike the animals, the people were latecomers without inherent spiritual power. They depended on gifts of such power, in dreams transferred by animal spirits from either Sky, Earth or Underwater. Native people still remember that "the old people survived by the power of their dreams." Success in hunting was believed to depend on an interaction with such spirits in dreams and mystical experiences. Respect for the animal spirits may have prevented the development of tailored clothing: hides used in making robes,

poncho-like shirts, and leggings were almost left in their natural shape.

Before a drive hunt, the spiritual ruler of the buffalo was honored in a night-long ritual to "call the buffalo." A medicine woman rubbed a stone or wooden buffalo effigy with red paint, and placed it on a layer of buffalo wool. Praying for help from the spirits in control of wind and weather, she blessed the "buffalo runner," a man with intimate knowledge of buffalo behavior. He might have already located a herd rich in cows, which were preferred above bulls for their meat. Dressed in his antelope disguise, he would leave in the dark of the night to start up the female leader of the herd. Followed by the animals, the runner would lead

Native American Clothing

them into a long V-shaped drive lane, accelerating his speed and swerving aside at the last moment. It was said that in the dawn of the early morning, the buffalo effigy in the ritual lodge would topple over when the herd stampeded into the corral or over the steep cliff.

Starting about AD 800, farming people from the east and southeast established their permanent villages on the major rivers of the southern Plains and along the Missouri and its main tributaries. Spreading northward, these colonists developed a nearly solid belt of riverine farming; for a short period in the 1700s, it reached as far as the South Saskatchewan River. Their Mississippian cultural heritage is revealed in shell carvings found in the Dakotas, in northern Montana and in Manitoba burial mounds. These immigrants were the ancestors of Caddoan-speaking tribes such as the Pawnee and the Wichita, and of the Siouan-speaking Mandan, Hidatsa, Omaha, Iowa, Osage and related tribes.

They lived in settlements overlooking the cornfields in the river valleys, in spacious dome-shaped lodges that were covered with heavy layers of earth along the Missouri or thatched with grass in the south. During the fall the villages were almost deserted when the people left on hunting expeditions. High-ranking families of hereditary chiefs and ritual leaders were the elite among these villagers, and in their annual cycle of ceremonials they preserved a memory of more complex societies in the middle Mississippi and Ohio regions.

Some of these traditions survived in their pottery, basketry, woven mats, twined-woven bags, finger-woven sashes, effigies carved on wooden bowls and stone pipes, the use of black-dyed skin and featherwork for ceremonial regalia, and other craft work. Many of these objects were kept in medicine bundles that were believed to protect and bless the community. It was the well-being of the community that inspired the highly organized life of these farmers. Aggressive ambition was not tolerated. Their annual cycle of elaborate ceremonies was intended to keep order in the universe and to promote the seasonal changes in nature.

Attracted by corn, craft work and the wonder of spectacular ceremonials, nomadic hunters from the western Plains frequented these riverine villages, which became centers of intertribal trade and the dissemination of new religious concepts, rituals and their regalia – and of new fashions in dress. Peaceful trade relations were established by means of the calumet ceremony, in which fictive kinship relations were created between individual strangers as well as between different tribes. To facilitate trade, the villagers adopted fathers and sons among otherwise hostile nomads. As a deterrent to warfare, this calumet ceremony spread in the 17th century beyond the Plains into the Great Lakes region.

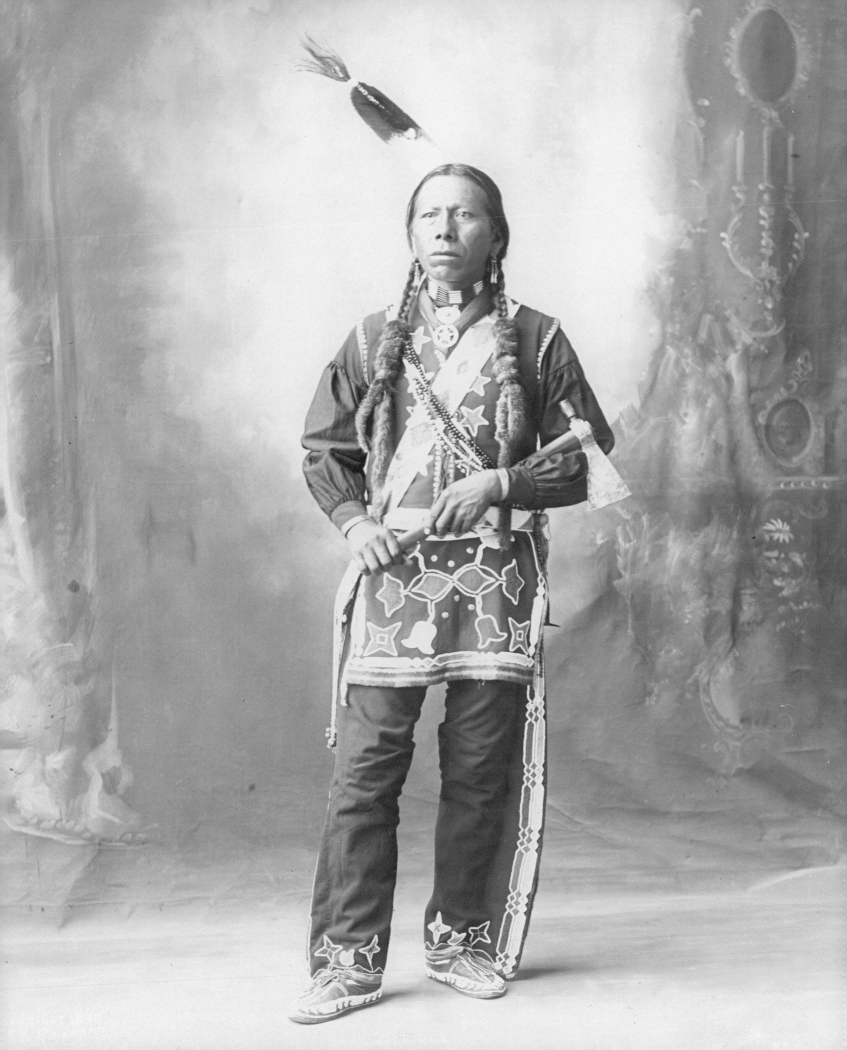

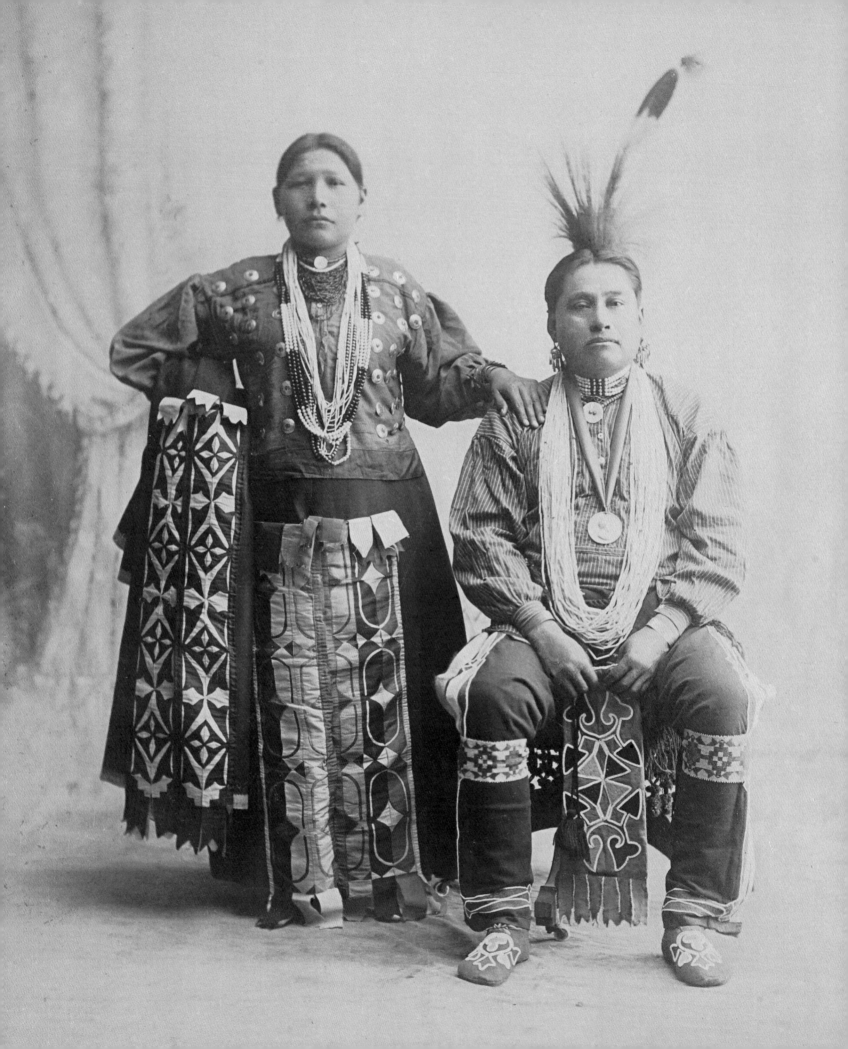

Facing page: **Oto Indian fashions in the 1890s.**
The festive costumes of this couple were typical of the tribes formerly living along the lower Missouri River and removed to present-day Oklahoma in 1880. Elaborate ribbonwork decorates the woman's skirt and robe. Beadwork is conspicuous in the man's regalia. His pipe bag is decorated with an Oto version of the fashionable "prairie style" beadwork. Courtesy Richard Pohrt, Jr., Ann Arbor, Michigan.

✳

Although some Spanish explorers had been there before, the first significant European influences reached the Plains through the native trade network in the 17th century. The use, riding, raising and trading of horses spread from the Spanish colony on the Rio Grande into the Plains, particularly when a Pueblo Indian revolt in 1680 made many horses available to the Indians. Attracted by these wonderful animals, the Comanche separated from the Shoshone in Wyoming and moved to the southern Plains. When the Blackfeet saw the first horse, they "did not know what name to give him. But as he was a slave to man, like the dog which carried our things, he was named Big Dog." In the late 1730s horses reached the villages on the Missouri River, where they were traded for the first European imports arriving from French trading posts in the Great Lakes region and Cree Indians from James Bay. From Montana the Kiowa moved south to become middlemen in the horse trade with the riverine villagers. Horses, the arrival of white traders and indirect colonial pressure motivated the Sioux tribes from the eastern fringe to become equestrian hunters on the Plains.

In the 1780s, the Hudson's Bay Company and its competition established their trading posts along the northern margins of the Plains, within reach of the northern trappers and the Saskatchewan River, which provided a means of transportation. Colonial rivalry between the French and Spanish led to the establishment of their trading posts in the Plains itself, followed by American posts in the 1820s. As a result, the old native marketplaces along the Missouri River lost their importance. Several of the farming tribes changed their way of life within only a few generations to become nomadic hunters; the Cheyenne and Crow are well-known examples. By 1800, the remaining riverine villages had become dwindling islands of an old world order. For more than a century the fur trade was the only contact between Euro-American society and the Plains Indians, and so a new world was allowed to emerge in which nomadic hunters adjusted to horse pastoralism and the fur trade. The increasing mobility of the native people helped level cultural differences; the development of a rich hand-sign language solved the problems presented by the many different languages. Along with horses and imported goods, however, diseases of European origin also made their devastating appearance. The Plains Indians lost more than half their population in a smallpox epidemic that swept across western North America from 1779 to 1782. Similar epidemics ravaged later generations.

While each family could produce almost everything it needed, certain individuals were known for

their exceptional ability in a specific craft. However, artistic production never became their exclusive occupation. Artistic expression was of a utilitarian and transportable type, each tribe according to its own standards of beauty. As with most tribal peoples, there was a clear sexual division of craft work. Women prepared the animal skins and made clothing, tipi covers and rawhide containers. They painted geometric designs on such containers and on tipi linings; skin garments on the southern Plains were monochrome colored all over. Quillwork was largely restricted to the range of the porcupine, so it never reached the southern Plains. The origin of quillwork was associated with certain female spirits such as Whirlwind Woman among the Arapaho, and Double Woman among the Sioux. Because of these spiritual origins and the involvement of ritual procedures, quillwork acquired a somewhat sacred status. The creation of certain symbolic designs was restricted to women who had acquired the rights to do this work through initiation. Among several tribes such women belonged to prestigious craft guilds.

The men produced equipment for the hunt, war and ceremonial use. They painted realistic and symbolic pictures on tipi covers, robes and shields; they carved wooden bowls, horn spoons and stone pipes. Catlinite, a reddish sedimentary stone primarily derived from a well-known quarry in southwestern Minnesota, was used most extensively for pipe bowls and widely traded throughout the Plains. Restrictions also applied to some crafts performed by men, particularly the paintings of a visionary origin and the construction of ceremonial regalia. Feather work was highly developed – it was made to be seen in movement, and no visual art form ever possessed a more dynamic quality. Feathers of eagle, hawk, owl and other associates of Thunder were believed to convey courage and protection to warriors. The famous "war bonnet" of the Plains Indian indicated the wearer's martial prowess. The right to wear such a headdress

required the accumulation of many war honors. As a result of Wild West shows and the movie industry, the war bonnet has become the prime iconographic symbol of the North American Indian.

After the coming of the horse, the life of the nomads lost much of its primitive harshness. Horse transport enabled the Indians to use more and longer tipi poles, increasing the size and comfort of their tipis. With greater mobility and firearms, hunting became easier. Beads, cloth and other imports encouraged the blossoming of colorful arts. The blue and white "pony beads" introduced by the early fur traders were fairly large and did not lend themselves to complex patterns in beadwork. Once steel needles became available in the 1840s, the women were able to use the smaller "seed beads" in colorful designs, many of which derived from the old quillwork designs. Without the designs developed in quillwork, beadwork on the southern Plains remained restricted to simple geometric designs run in narrow bands along the edges of monochrome-colored garments. More complex beadwork, including the netted "gourd stitch," was later adopted on Kiowa cradleboards. On the central Plains the "lane-stitch" prevailed in beadwork, producing a ribbed surface effect. The first bead-decorated cloth garments appeared there in the 1840s, and they gradually replaced painted and quillworked skin.

The flat surface of spot-stitch or overlay beadwork became characteristic of northern Plains art. This beadwork technique lent itself to the adoption of the floral patterns introduced by the Red River Métis. In the 1820s, many of these people had found employment at recently established trading posts on the upper Missouri River. The Métis specialized in the production of colorfully decorated horse gear, coats, moccasins, and a variety of "fire bags" and other pouches. Through trade in these crafts and through their intermarriage with the Indians, these Métis left their floral mark on the arts of practically every tribe of the northern Plains and the greater Northwest. Several

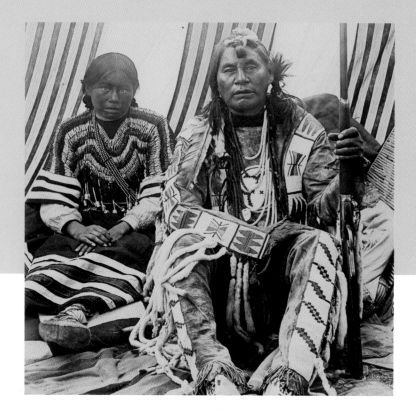

Chief Little Dog and daughter (?), Piegan-Blackfeet, 1910.
The heavy beadwork on Chief Little Dog's shirt and leggings
is a far cry from the narrow quillwork strips seen a century
earlier. The ermine fringes on his costume and his separately
tied hairstyle indicate his ownership of a medicine pipe. The
girl's dress shows the traditional pattern of a loose lane-stitch
beadwork and the use of thimbles as fringe pendants.
Courtesy Richard Pohrt, Jr., Ann Arbor, Michigan.

of the riverine villages remained trendsetters in
new fashions; quillworked costumes made by the
Mandan and Hidatsa were popular on the northern
and central Plains throughout the 19th century.
Trade in decorative apparel was not restricted to
the Métis and village tribes. Buffalo robes painted
by the Western Sioux were popular among all their
neighbors; quillwork and beadwork of the Assiniboin
found eager customers among the Blackfeet; loom-
woven beaded shoulder bags of the Minnesota Ojibwa
were traded all over the central Plains. Most popular
at intertribal "giveaway" festivities were the colorfully
painted containers made from folded rawhide and
known as parfleches.

Leisure time resulting from the use of horses was
devoted to more elaborate ceremonials, decorative
art and warfare. This new Plains Indian Culture was
strongly motivated by achieving honor in intertribal
warfare and the acquisition of material wealth, to be
displayed at festivities or given away in public acts of
"generosity." Chiefs had to be generous in order to win
the enduring support of their band members. The cap-
ture of horses became a major motivation in warfare.
Successful horse raiders proudly carried batons carved
with horse effigies in public ceremonies. In return for
horses and import goods, a man might become the
respected owner of medicine bundles without the
rigorous efforts of a vision quest to acquire such sacred

gifts. Elaborating upon the ritual concepts of some
riverine villagers, the Cheyenne and Arapaho seem to
have originated the annual ceremony usually referred
to as the Sun Dance. This complex ritual, which spread
on the Plains after 1750, was modified by each tribe to
suit its own ceremonial pattern.

Contacts made by the trade in horses across the
Rocky Mountains led to increasing Plains Indian influ-
ence in the beadwork and costumes of the Columbia
River tribes and, in return, Plateau influence in the arts
and crafts of the Blackfeet and Crow. Similar influ-
ences came from the east in the 1830s, when many
tribes from the southeast and Great Lakes were moved
to reservations in present-day Oklahoma and Kansas.
As a result of these contacts, the local village tribes
created their own style of ribbon work, contributing to
the emergent intertribal "prairie style" of beadwork.

For the American traders, the Missouri River
provided a fairly easy route into the central and north-
ern Plains. Using large keelboats, they shipped their
trade goods up the river and every year returned with
large numbers of buffalo hides, made profitable by

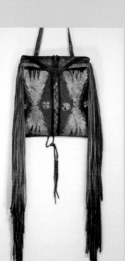

Right: **Parfleche. Lipan-Apache type, circa 1850.**
Parfleches are folded, envelope-shaped rawhide containers, used to store clothing, dried meat and other goods. Small versions with long fringes were used to store personal charms and items for ceremonial use. Parfleches were popular presents at intertribal gift exchanges, which took them great distances all over the Plains and Plateau, making it difficult to recognize their different tribal origins. The paintings on Plains Apache parfleches are remarkably similar to those on parfleches of the Kutenai and other Plateau people. Courtesy Charles Derby, Northampton, Massachusetts.

Facing page: **A Blackfeet camp, near Calgary, Alberta, circa 1885.**
Canvas replaced buffalo skin when the large herds vanished, but it did not change the construction of the tipi. Two poles on the outside of the tipi hold up the two smoke ears, which can be closed in bad weather. Tripods served to hang medicine bundles, of which several are visible right of center. © McCord Museum, MP-0000.14.189.

the growing demand for leather by the industries in the east. When buffalo hides became a major export product, the fate of the buffalo was sealed. Between 1830 and 1870, the buffalo herds dwindled from an estimated 30 million to a few thousand. Their subsequent near extermination was hastened by military efforts to subdue the desperate Indians. By 1850, the California gold rush was drawing long caravans of emigrants along the Oregon Trail; the discovery of gold in the Black Hills and the Colorado foothills attracted another wave of frontier people. Indian hostilities started the Texas Rangers on a prolonged war of extermination and initiated military actions in the Dakotas. Hostilities increased in the 1860s, when the Civil War forced the withdrawal of the U.S. military from the West and their replacement by local volunteer militia.

In 1870, the northern Plains, granted by royal decree to the Hudson's Bay Company in 1670, were transferred to the Canadian government. The army crushed the resistance of the Red River Métis to their loss of land rights. The buffalo were disappearing, and the railroad tracks extending west brought increasing numbers of white settlers. By a series of treaties, the Canadian and American governments restricted the native peoples to reservations (known as reserves in Canada) and set the path for their assimilation policies. By withholding rations, Canadian officials used starvation to enforce their directives; similar ruthless actions were common on the American reservations.

Treaties and the settlement of Indians in reservations marked the beginning of a half-century-long effort by paternalistic governments to force the Indians to adopt the customs of mainstream society and to remove the Indian from the general population's conscience by suppressing all expressions of native culture. Despite official disapproval, native resistance expressed itself in a tremendous production of festive apparel by Indian women; by the many notebooks filled by war veterans with nostalgic pictures of the past; and by a variety of short-lived messianic movements, including the Ghost Dance of 1890. Promising world renewal and the removal of the white intruders, several of these movements instigated the creation of specific ceremonial garments decorated with visionary designs. The painting of traditional designs originating from visionary dreams survived on the tipis of Blackfeet and Plains Cree.

On the southern Plains the adoption of the peyote cult gave birth to the Native American Church. Although many Indians attend Christian church services today, the annual Sun Dance has survived among some tribes and was revived among others; ancient medicine pipes have their rituals on several reservations. Funerals often reveal the eclectic spirituality of many Plains Indians: the church service is followed by traditional songs and prayers at the grave site.

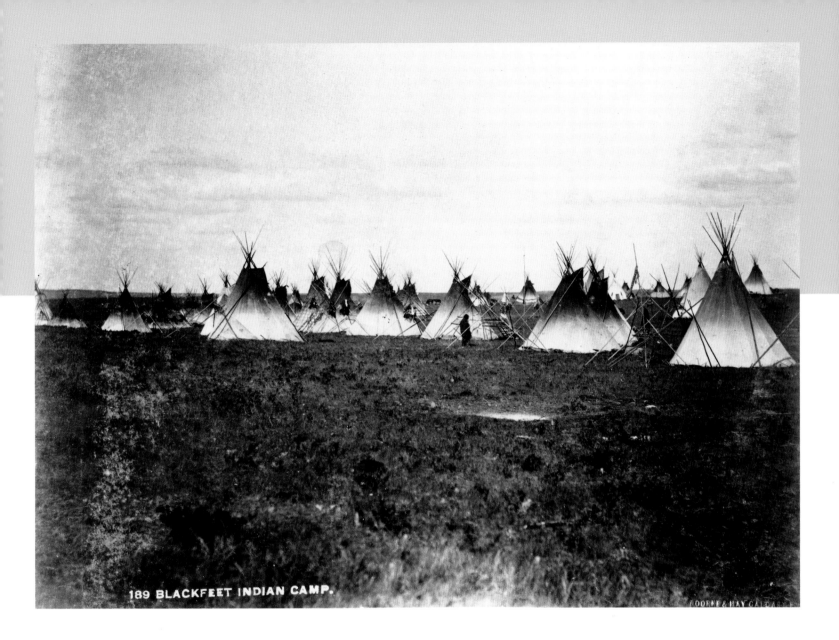

189 BLACKFEET INDIAN CAMP.

With its large and diverse Indian population, Oklahoma became a hotbed of new fashions in Pan-Indian dance costumes, which spread to powwows far and wide. Feather work blossomed in the creation of these dance costumes and in the beautiful fans used in peyote rituals. Giveaway ceremonies to honor relatives encourage the continuation of beadwork and the production of colorful quilts as vigorous art forms. Military service in the modern wars led to a revival of the warrior fraternities, and of rituals relating to warfare.

Living conditions on the reservations have gradually improved since World War II. Both rural and urbanized Indians spend the summer traveling the powwow circuit; the Crow Fair near Custer Battlefield draws Indians from Alberta to Oklahoma and beyond. More tourist-oriented are the All-American Indian Days at Sheridan, Wyoming, the Indian Days at Banff, Alberta, and the annual celebrations at Anadarko, Oklahoma. In many aspects Plains Indian Culture has changed, but it has fiercely maintained its basic values and remains fully alive.

"Little Bat," one of the most noted
scouts on the frontier from 1870
to 1890.

"Little Bat"

**Baptisto "Little Bat" Garnier, Sioux-Métis,
1870s.**

His beadwork-decorated costume was typical
for the "Flower Beadwork People," as they were
called by the Sioux. Half-leggings, or "botas," may
have originated from the Southwest, but on the
Missouri they became particularly popular among
the Métis as a way to protect their trousers.
Courtesy The Amon Carter Museum
Archives, Fort Worth, Texas. Unknown
artist, unknown date, gelatin silver print,
4⅝ inches x 3⅜ inches, DP1967.353.

Facing page: **Man's shirt, Blackfeet, circa 1840.**

Made of two hides. Length, 62 inches / 158 cm, sinew-sewn and decorated with paintings, quillwork
and pony beads. Long shirts with minimal tailoring were common before the use of horses made
shorter shirts more comfortable. As a conventional expression of respect for the animal spirits,
the leg skins were left as pendants at the bottom of such traditional shirts. The brown painted
stripes refer to hostile enemy encounters, indicating that the shirt owner was a distinguished
war veteran. Very few shirts with large quillwork panels on front and back have survived. Their
disappearance by around 1850 coincided with a change in the buffalo drive hunt because of the
use of horses. Before that time, special "buffalo callers" lured the herd into the corral. This buffalo
trap, called "bloody kettle" by the Blackfeet, is represented by the red designs on the panels of
these shirts. Most probably these shirts were restricted to ceremonial use by such buffalo callers.
Courtesy John and Marva Warnock Collection / www.splendidheritage.com

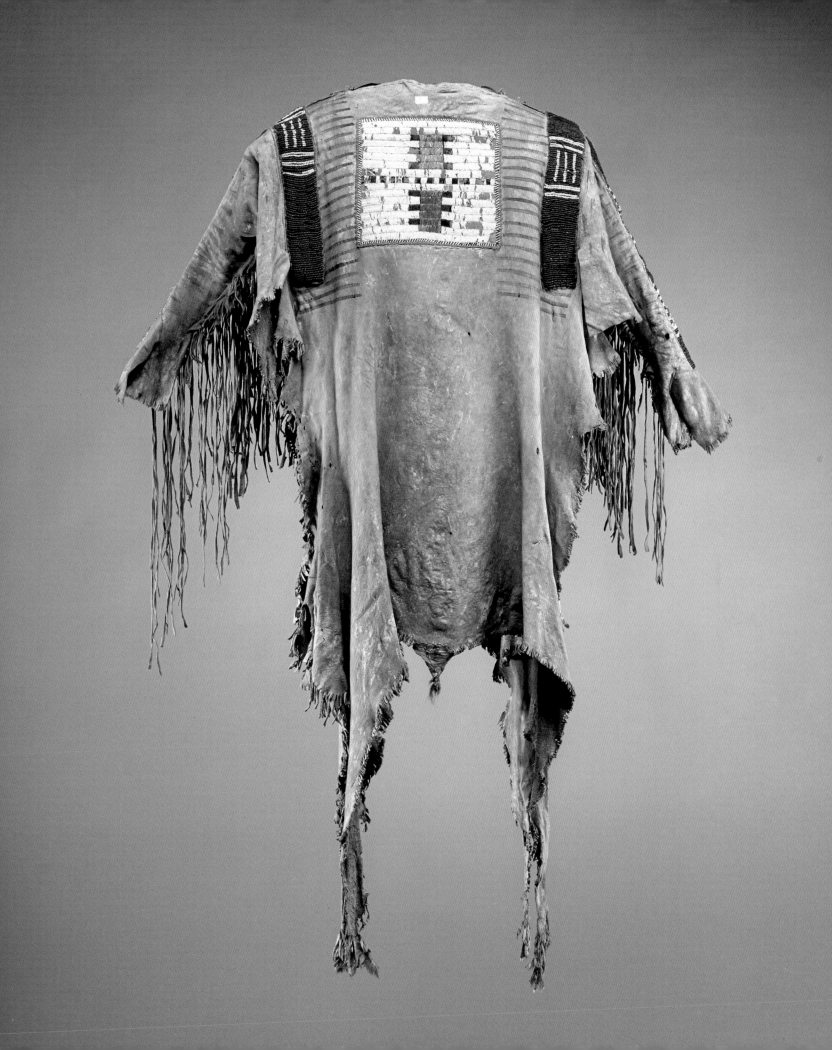

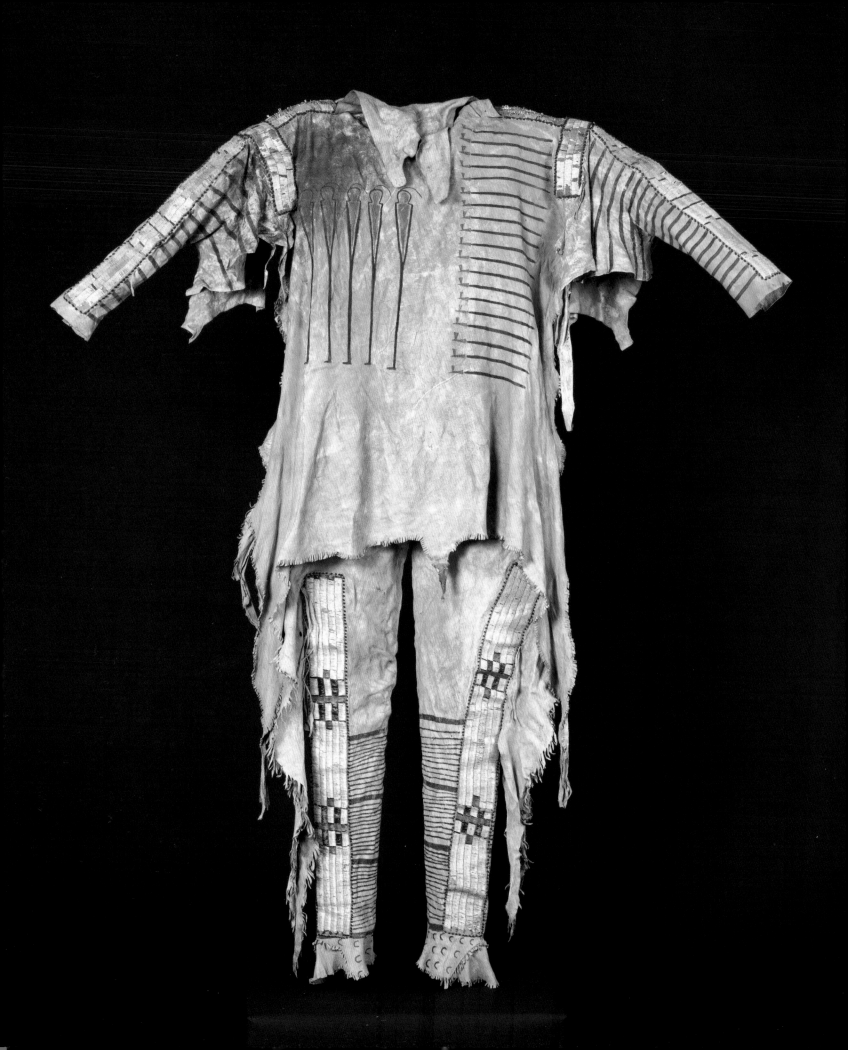

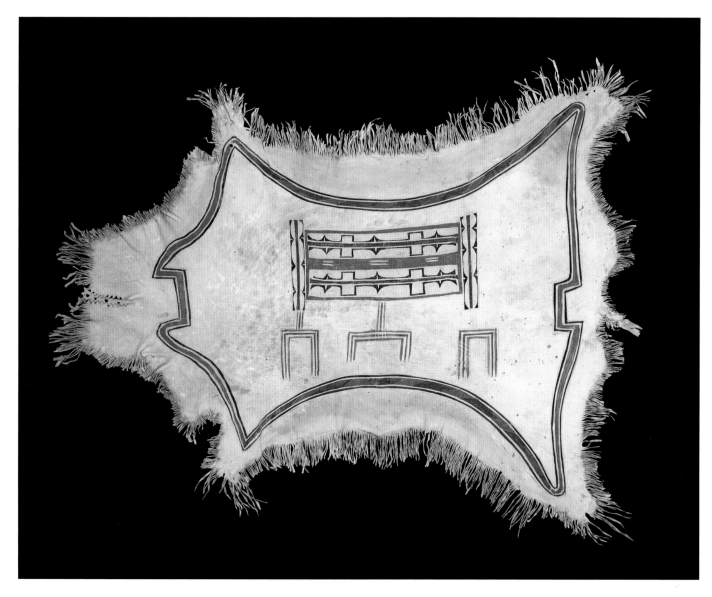

Facing page: **Man's costume, Yanktonai-Sioux type, circa 1830.**
Native-tanned skins (antelope?), sinew-sewn, decorated with paintings,
quillwork outlined in blue pony beads. Poncho-like shirt and leggings
of classic type, with minimal tailoring. Rows of tiny holes along the
quilled strips indicate the former presence of "scalp lock" hair tassels.
The paintings are marks of honor won in warfare, conforming to a
regionally understood system of symbols. Parallel stripes refer to
hostile enemy encounters; the column of pipes on the front stands for
the number of times that this man has led a war party, while the five
human figures may refer to enemies illstruck in "coup counting." On
the back of the shirt, a column of horse quirts register the number of
horses captured and given away. Captured horses are also indicated
by the horse hoofs or tracks pictured at the bottom of the leggings.
Courtesy Donald Ellis Gallery, Dundas, ON, New York, NY.

Painted hide robe, Arapaho, 1860s.
The hide of a buffalo calf or elk, 60 inches by 50 inches / 152 x 126 cm, with
a painted decoration. Explicit statements of native people indicate that these
geometric designs were of a symbolic nature, referring to the buffalo and "our
Mother Earth." This explains their exclusive use on robes of married, that is,
child-bearing women. However, the small size of this robe suggests that it
was made for a young girl, probably when she was honored by adoption in
a calumet ceremony. As such, it is a painted prayer for the girl's future.
Courtesy Donald Ellis Gallery, Dundas, ON, New York, NY.

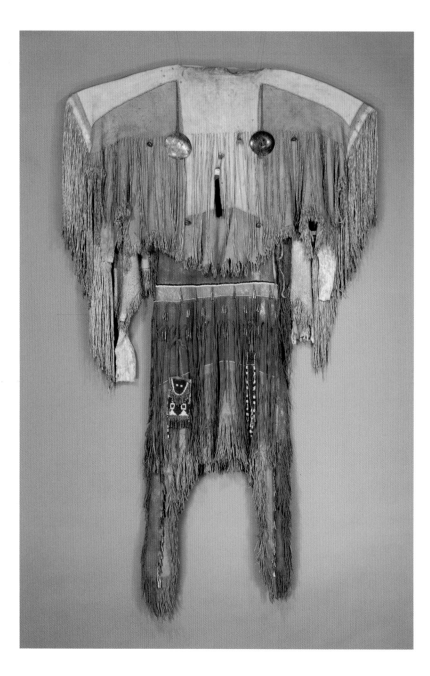

Woman's dress, Plains Apache, circa 1840–50.

A short poncho and skirt, made of deerskin; sinew-sewn, stained with monochrome yellow-orange ochre and decorated with silver disks, small brass bells and metal cones. Indian women of the southern Plains used to wear such garments, though in warm weather they dispensed with the poncho. After the 1850s most of the local tribes joined poncho and skirt into a one-piece dress, but the old two-piece fashion has remained typical for the Apache tribes. Crossing the shoulders, a large uncolored cross design stands out against the yellow background; similar designs decorate some early dresses assumed to be of Comanche origin. Several details suggest that this dress originated from one of the early Apache bands in Texas, of which the survivors joined the Lipan and the Jicarilla. Tied to the fringes of the skirt are a paint pouch and an awl case, both decorated with beadwork in Kiowa style of a later date; they may have been added by a later owner of this dress. Courtesy Charles Derby, Northampton, Massachusetts.

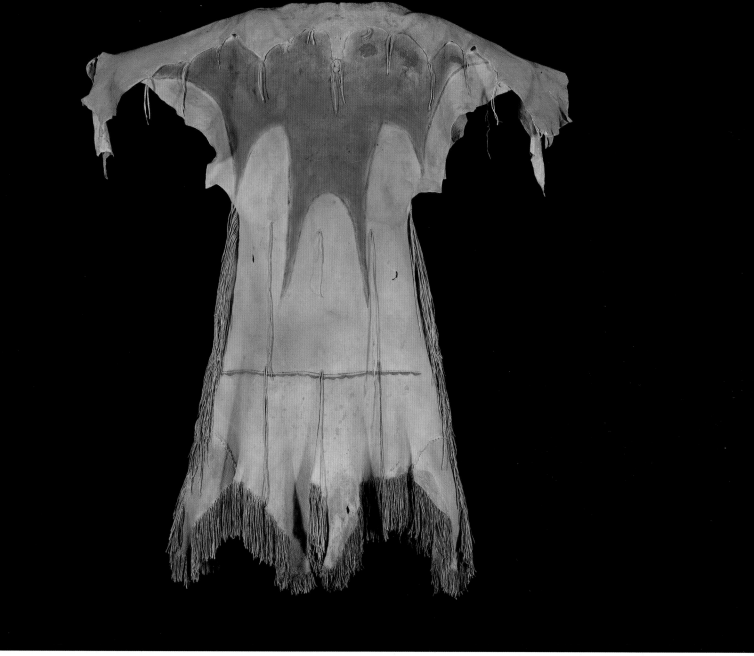

Woman's dress. Southern Plains, circa 1850–60.

Made of two large mule-deer or elk skins, stained a monochrome yellow, the upper part decorated with a reddish-brown design. The coloring and decoration of this dress unmistakably identify its origin as the southern Plains, but its shape is usually associated with more northern parts of the Plains. This dress was assumed to be of Comanche origin, but the most southern distribution of this dress type was among the Jicarilla Apache, and the painted decoration is reminiscent of the Plains Apache dress illustrated on the facing page.

The folded-over shoulders are the skins' hind quarters, the shoulder line formed by sewing the two hides together along this fold. The tails of the two hides were left at center front and back, while the head-skin and front legs are at the bottom of the dress. This position of skins in women's dresses is reversed in the men's shirts, which have the tails at the bottom and the head parts folded over at the neck opening. Courtesy GrimmerRoche, Santa Fe, New Mexico.

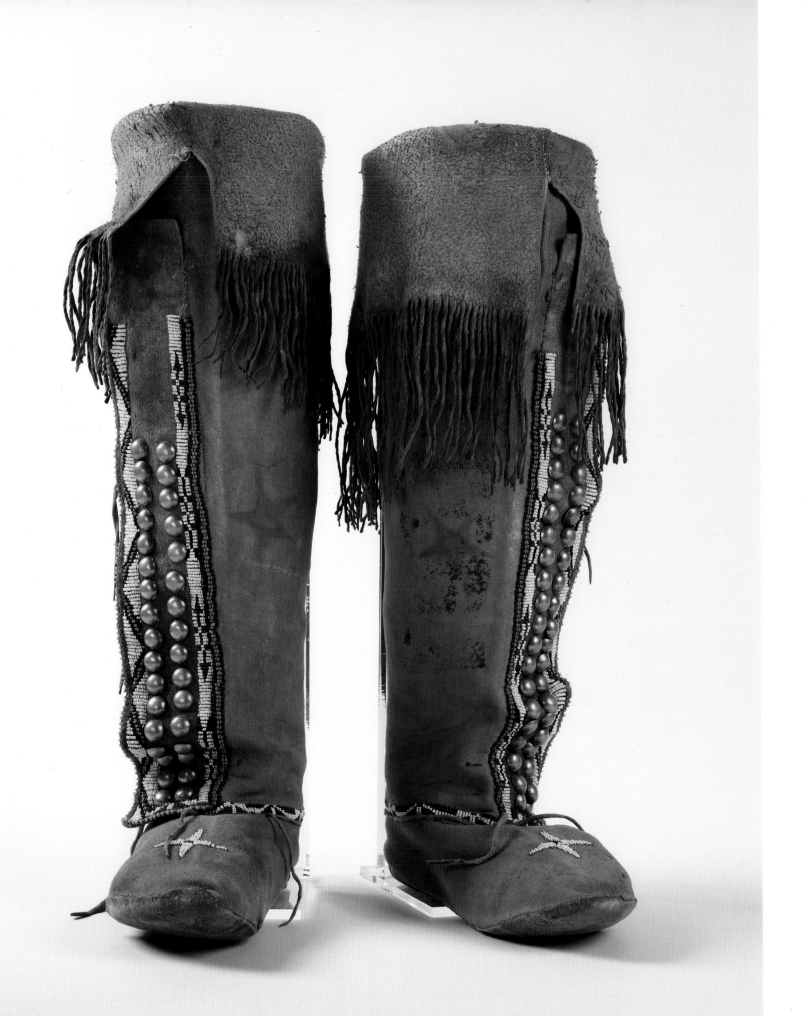

Facing page: **Woman's boot leggings, Kiowa, circa 1885.**
Native-tanned deerhide stained with yellow ocher, sinew-sewn onto
rawhide soles. Decorated with beadwork and German silver studs.
On the southern Plains, the women combined their leggings and
moccasins into one piece, presumably after the arrival of horses.
Long ago, they made these boot leggings from the upper parts of old
skin tipi covers that had been waterproofed by smoke. They were
held up with garters just below the knee, with the upper part folded
down. The use of twisted fringes was popular among the Kiowa.
© Bata Shoe Museum, Toronto, Ontario. Photo by Pete Paterson.

Woman's leggings, Yanktonai-Sioux, circa 1870.
Beadwork and paint on deerskin. Proud of their
husbands, women often painted on their garments
the war honor marks of these men.
© Museum Volkenkunde.

Native American Clothing

Shield with covers, Blackfeet, 1840s.

A concave rawhide disk, 19 inches / 50 cm in diameter, with two buckskin covers, each held in place by a drawstring along their borders, which were pulled across the edge of the rawhide disk. Painted on the innermost one of these covers is a picture of the mythical Thunderbird below an arch, representing a starry night sky. Originally this picture was hidden behind a fringe of feathers, of which only the short tie strings remain along the upper edge of this cover. In contrast to this reference to a major Sky power, the other cover shows four snake heads extending crosswise from the border into the black central part: reptiles, at night emerging from the underworld and raising their heads in defiance of their cosmic enemy in the sky. Revealed in visionary dreams, these pictures were believed to have more protective value than the rawhide shield itself. Courtesy John and Marva Warnock Collection / www.splendidheritage.com

Facing page: **Headdress, Plains Cree, circa 1840.**

Eagle feathers, decorated with quill-wrapped strips, placed in the fold of a double buckskin headband that is covered with loom-woven quillwork. Remnants remain of short black feathers, formerly standing between the larger feathers, and of white fur and red-dyed hair wisps at the tips of the eagle feathers. This type of "straight-up" headdress was probably the most common warrior's headdress before the spread of the well-known flaring war-bonnet in the 1820s. The older arrangement of upright feathers survived among the Blackfeet. © Museum Volkenkunde.

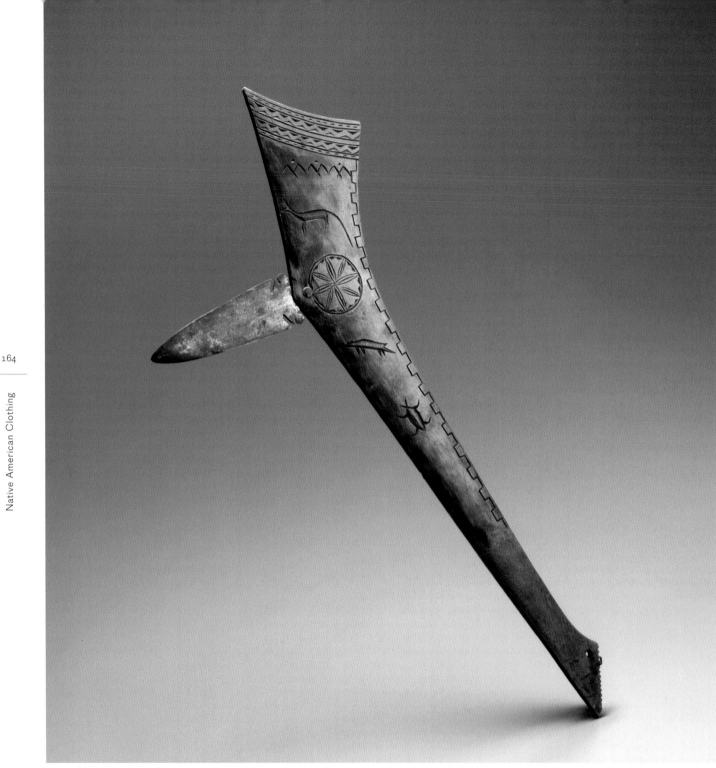

War club. Eastern Sioux, circa 1800–20.

War clubs of this "gunstock" type were common in the eastern parts of the Plains; metal blades were attached after their introduction by the fur traders. The decoration by chip-carving was typical for examples of the Eastern Sioux. The incised designs show a row of thunderbirds above the long-tailed Underwater Panther. On the other side of this club is a war record of seven human figures, of which six are without heads – that is, killed. This club may once have been in the collections of Governor William Clark in St. Louis. Courtesy John and Marva Warnock Collection / www.splendidheritage.com

Facing page: **Coat, Missouri River Métis, circa 1840.**

Made of smoked elk or moose skin, sinew-sewn, decorated with abstract and semi-floral designs in porcupine quillwork. White pony beads separate the quill-wrapped fringes. These coats were made in Dakota Territory by the Métis who had emigrated from southern Manitoba in the 1820s. The art style on these coats was derived from a northern Cree tradition, while the tailoring was adapted from the European redingote. After the 1850s, many of these Métis disappeared into the Sioux and other native communities. Courtesy John and Marva Warnock Collection / www.splendidheritage.com

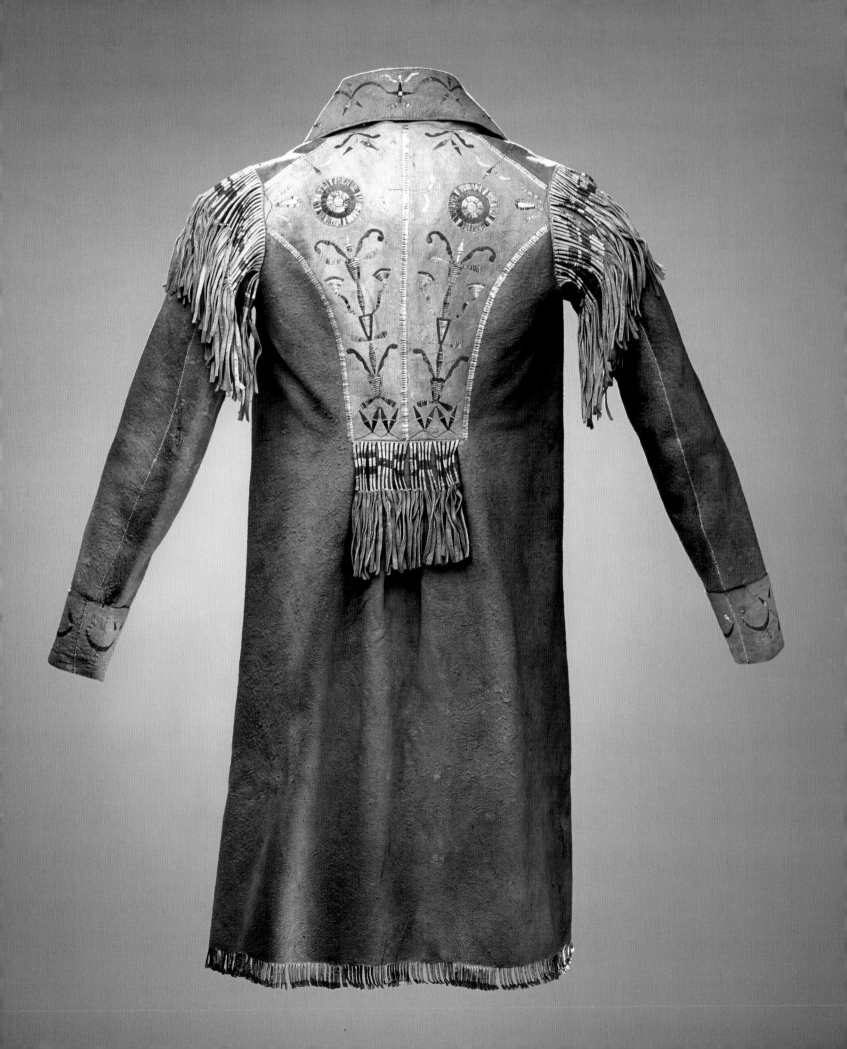

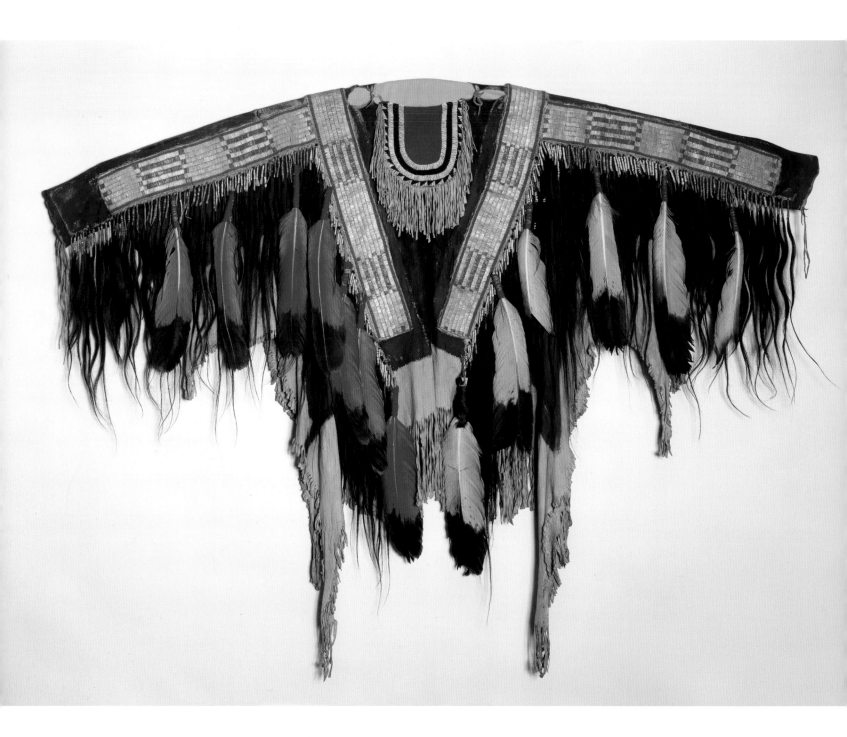

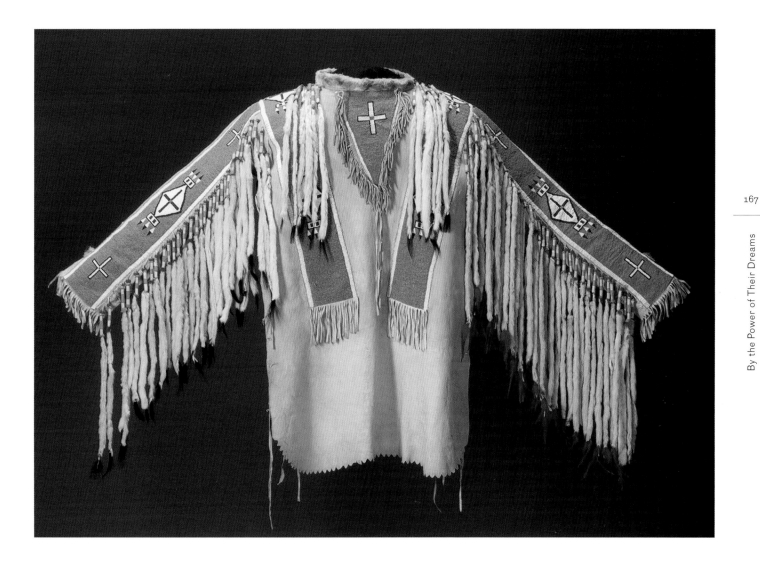

Facing page: **Man's shirt, Western Sioux, circa 1870.**
A classic central Plains poncho-style shirt, made of two hides. The blue and yellow paint, the fringes of human hair and the eagle feathers along the strips of quillwork identify this shirt as the regalia restricted to the Wicasa-Yatapikas, the "Shirt Wearers." They were the four supreme chiefs of the Lakota, chosen from the men who exemplified the virtues of generosity, courage, wisdom and compassion. After the people settled in reservations, these shirts lost their former exclusive function, but even today "war shirts" are worn only by important and well-respected Sioux men. Courtesy Charles Derby, Northampton, Massachusetts.

Man's shirt, Blackfeet, 1880s.
The last quarter of the 19th century saw a flowering of beautifully bead-worked costumes among the Blackfeet, of which this shirt is an excellent example. The profuse decoration with ermine fringes was formerly restricted to sacred "weasel tail shirts," but the absence of painted marks suggests that this shirt was made for festive occasions in general. This shirt was acquired in the 1890s by Walter McClintock, who illustrated it in *The Old North Trail* (London, 1910). The shirt's pristine condition suggests that it was not made long before 1890. Courtesy Skinner, Inc. Boston and Bolton, Massachusetts.

Cradleboards

Facing page: **Kiowa, circa 1870.**
Beadwork on native-tanned hide. Length, 42 inches / 106 cm, attached to wood frame. The Kiowa often used different colors and/or different designs in the beadwork on each side of the cradle. Fully bead-covered cradles became popular in the 1860s, when small "seed beads" became available. On this example, however, the beadwork is executed in the older and larger "pony beads." The wood frame served as a support to suspend the cradle from a horse saddle or in carrying it on the mother's back.
Courtesy John and Marva Warnock Collection / www.splendidheritage.com

Right: **Cheyenne, circa 1880.**
Beadwork in lane-stitch on buffalo hide, lined with parts of a painted parfleche; attached to wood frame. Stepped triangles with rectangular "tipi doors" enclosed were typical in Cheyenne beadwork of the late 19th century. The baby was wrapped in soft rabbit skins, and dry moss was placed between its legs as an absorbent diaper. Beautifully decorated cradles were often made by a female relative of the mother, since a new life was considered a blessing to the whole family.
Courtesy Skinner, Inc. Boston and Bolton, Massachusetts.

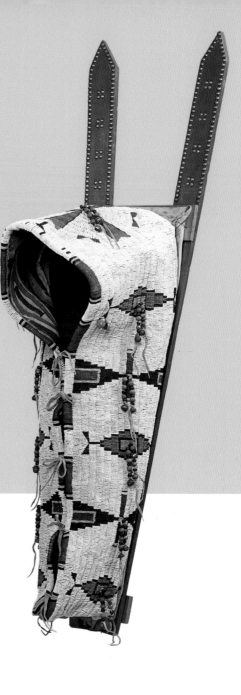

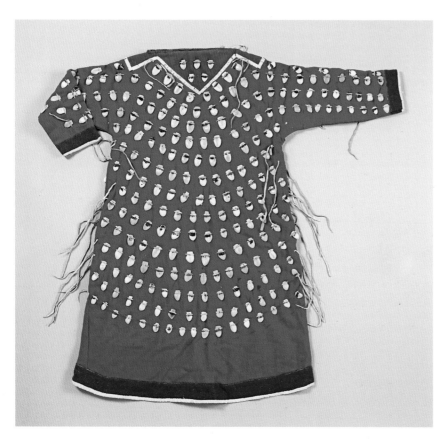

Left: **Girl's dress, Crow, circa 1900.**
Red trade cloth with green cloth trim, decorated with multiple rows of "elk teeth," carved of bone. Length, 35 inches / 98 cm. The V-shaped neck part, extending over the shoulders, was fashionable on the front and back of Crow women's dresses since the 1870s. On the central and southern Plains, the profuse decoration with elk teeth was a sign of wealth. The elk has only two upper canines, implying that many elk were killed to create such a dress. In 1852, 100 elk teeth were traded for a good horse. By the late 19th century, imitations carved of bone were often used.
Courtesy Skinner, Inc. Boston and Bolton, Massachusetts.

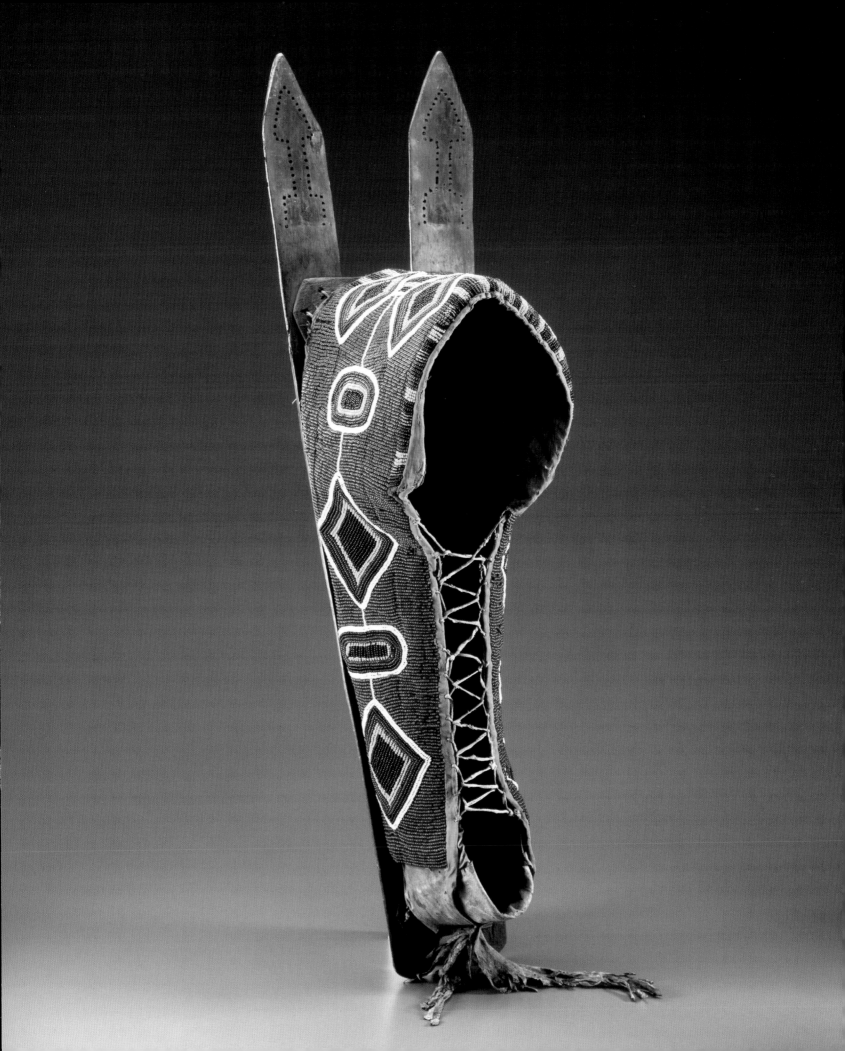

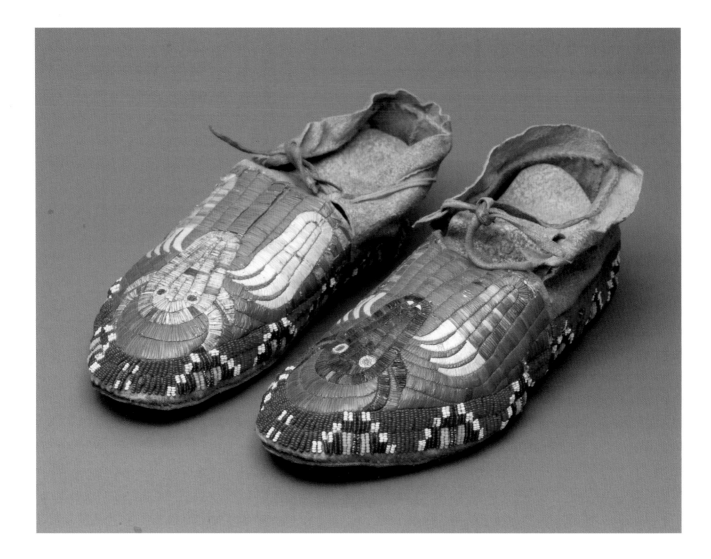

Moccasins, Western Sioux, circa 1880–1910.

Native-tanned cowhide, sinew-sewn and decorated with quillwork on the front; lane-stitched beadwork along the rim. Moccasins of the central and northern Plains were once made from one piece of soft-tanned skin; the side-seam type was most popular. Moccasins with a hard rawhide sole were gradually adopted by the mid-19th century, derived either from Apache / Navajo fashions or from the white man's boots. The quillwork on these moccasins illustrates native assertions that designs decorating moccasins are intended to be viewed from the wearer's viewpoint. The symbolic designs related to the owner's dreams or mystical experiences, and they served to focus the owner's thoughts during meditations. The sacred nature of these buffalo and bear symbols is emphasized by their execution in traditional quillwork; beadwork had become more fashionable by the end of the 19th century.
Courtesy John and Marva Warnock Collection / www.splendidheritage.com

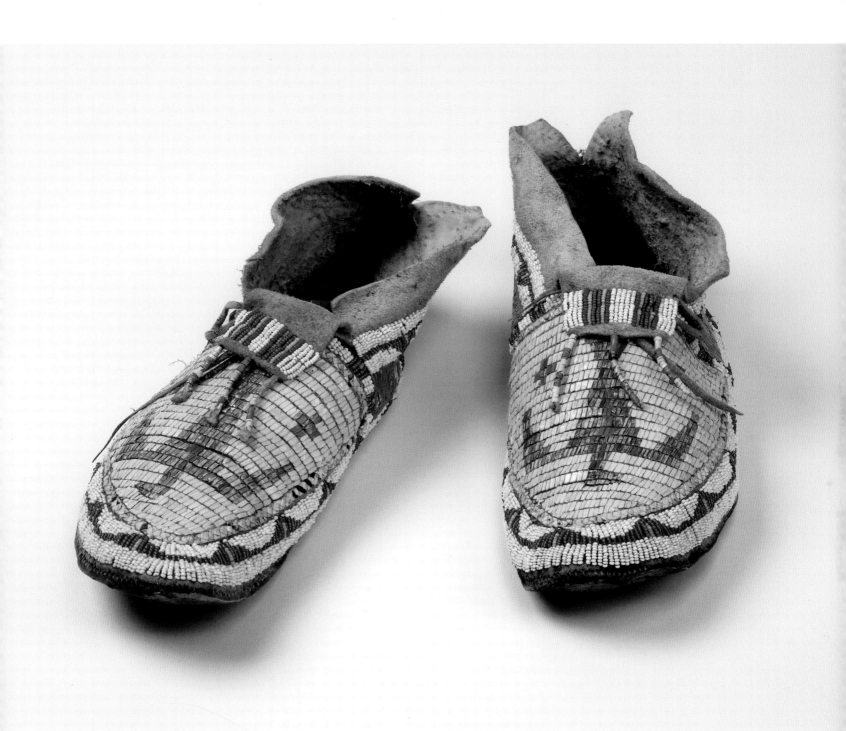

Moccasins. Cheyenne, circa 1880–1890.

Quillwork and beadwork on native-tanned skin; rawhide soles. Thunderbirds facing the wearer were very popular on Cheyenne moccasins, presumably owing to the support and protection expected from this mythical Sky warrior.
© Bata Shoe Museum, Toronto, Ontario. Photo by Pete Paterson.

Above: **Sole-decorated moccasins, Western Sioux, 1880–1900.**
Indians in the northeastern forests used to paint stripes
on the soles of their moccasins as a protection against
evil. Among the Plains Indians, prestige motivated such art
expressions. They wore sole-decorated moccasins to show
that, as wealthy horse owners, they did not need to walk.
Also, the "favored child" of such a wealthy family might have
moccasins like these, and girls made them for their lovers.
Courtesy Skinner, Inc. Boston and Bolton, Massachusetts.

Facing page: **Moccasins. Kiowa, 1870s.**
Beadwork on native-tanned skin; rawhide soles; long
fringes at the heels. Fully beaded moccasins were rare
on the southern Plains, where beadwork was usually
restricted to narrow bands on color-stained buckskin.
Apparently stimulated by the introduction of seed
beads in large quantities, some Kiowa women produced
elaborate beadwork on moccasins after 1870.
Courtesy Ned Jalbert, Westborough, Massachusetts.

Left: **Moccasins, Western Sioux,
circa 1900.**
Beadwork on native-tanned skin;
rawhide soles. The Ghost Dance
stimulated the revival of ancient
symbolic designs, including the
decoration of a pair with different
designs and/or different colors on each
moccasin. Abstract designs such as on
these moccasins were intended to be
viewed from the wearer's point of view.
© Bata Shoe Museum, Toronto,
Ontario. Photo by Pete Paterson.

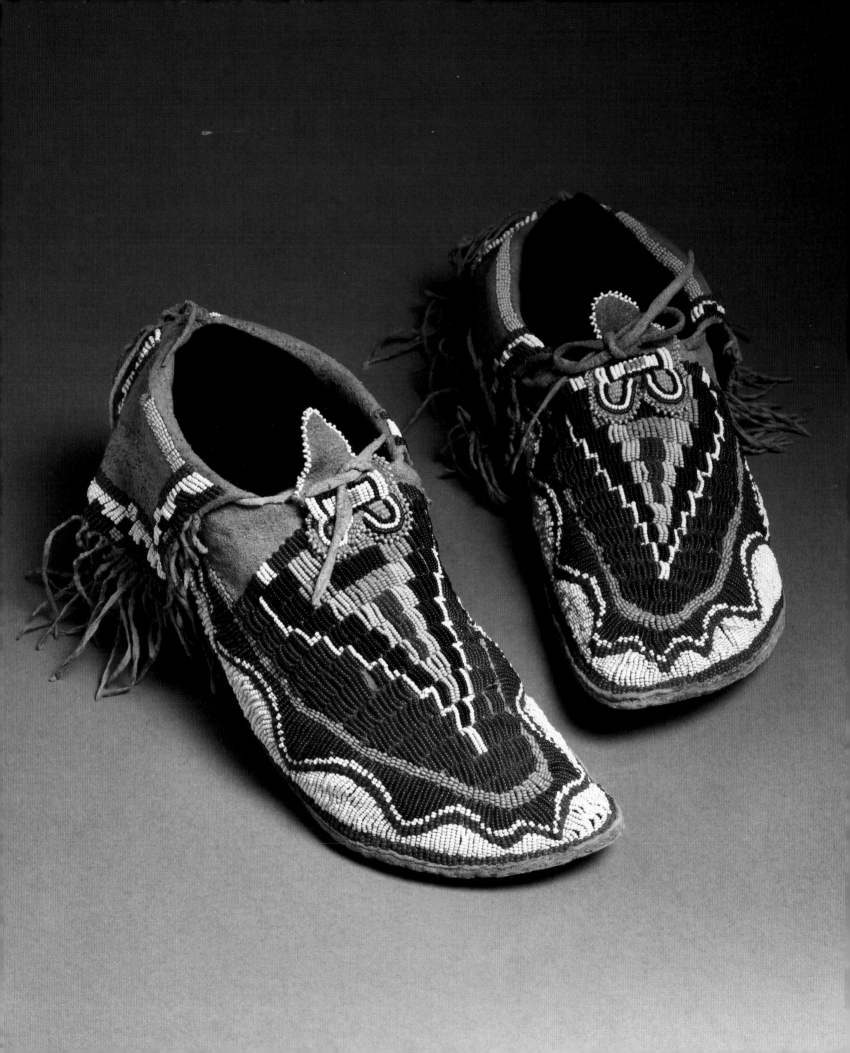

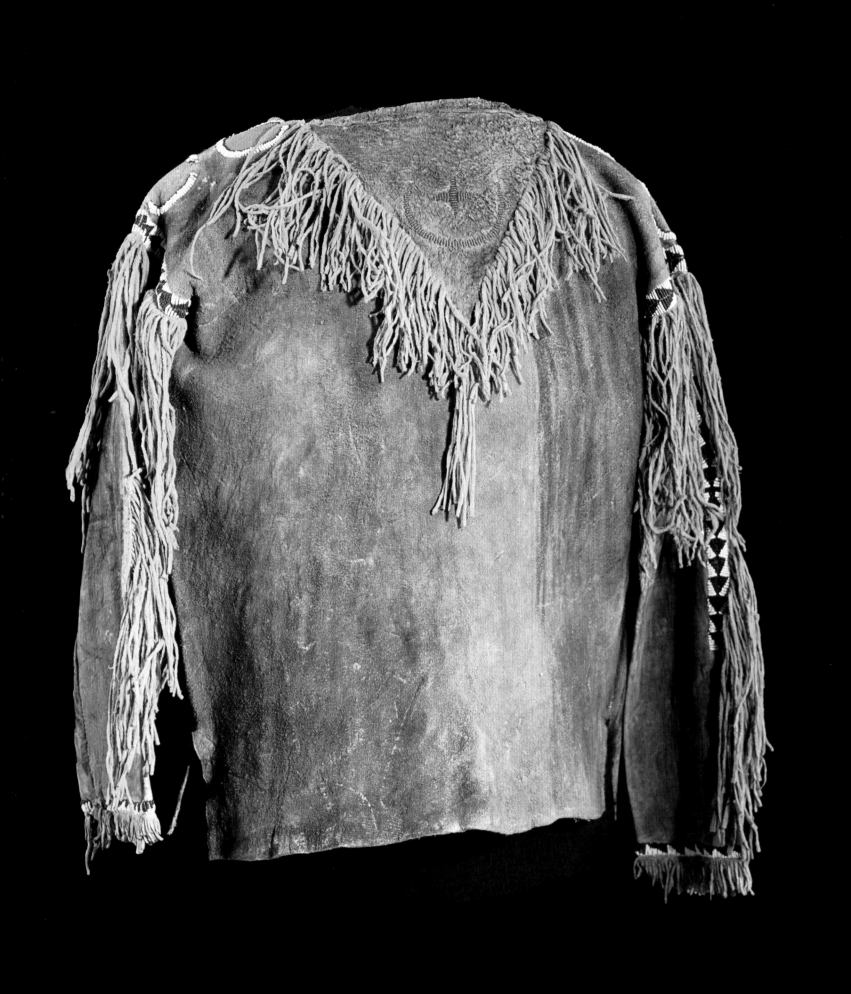

7 | Born from This Earth

The northern part of the culture area referred to
as the Southwest consists of present-day Arizona
and New Mexico, but the area extends south into
the northwestern parts of Mexico. The Rocky
Mountains come down through New Mexico,
continuing south as the Sierra Madre. Fed by heavy
snow melting in the spring, a few rivers and their
tributaries descend from these mountains through
deep canyons, making the higher northeastern parts
of the region more fertile. The forests and exten-
sive grassland of these higher elevations contrast
with the thorny shrubs and cacti of the steppes
and the hot desert to the south. The rain of sudden
thunderstorms in midsummer may rapidly change
the desert for a short while into a vast garden of
wildflowers. For most of the year water is scarce
everywhere, and for thousands of years the prayer
for rain has been a central theme in the people's
songs, dances and other art expressions.

Some 12,000 years ago, when the first people
were settling in this land, there was more water than
there is today. Nomadic hunters of mammoth and
other large animals, they disappeared when this
ancient fauna died out about 3,000 years later. Yet
these people left the deepest layers of debris in caves,
occupied by them and later generations for many
thousands of years. Faint memories of life in these
ancient rock shelters may have led many present-day
Indians to believe that their ancestors emerged from
the underworld.

By 5000 BC, these ancestors had spread in the
region as small bands who exploited a seasonal cycle
of gathering edible wild plants and their fruits and
seeds, supplemented by hunting deer, rabbits and
other small game. Their most vital tools were the dig-
ging stick, the atlatl or spear thrower, the boomerang-
like rabbit stick, the stone metate and mano used in
grinding seeds, and their baskets. Their expertise in
basketry was rivaled only by their great knowledge of
wild plants and their potential as food, medicine and
utility in the manufacture of rope, nets and basketry.
The diversity of languages among their descendants
indicates that these semi-nomadic hunter-gatherers
were of very different origins.

Aware of the germination of plants from seeds,
people in the Mexican south manipulated the growth
of a wild grass called teosinte, and that led to the first
domesticated maize. By 2000 BC, a trade in maize ker-
nels may have spread this new plant among the desert
people. It remained merely an addition to the menu
until about 500 BC, when cultivation produced larger
corncobs, followed by squash, beans, chili peppers
and cotton, and gourds that were used as containers.
In the wake of this increased gardening and a more
sedentary lifestyle, the making of pottery spread
from the south about 300 BC. Here, as elsewhere

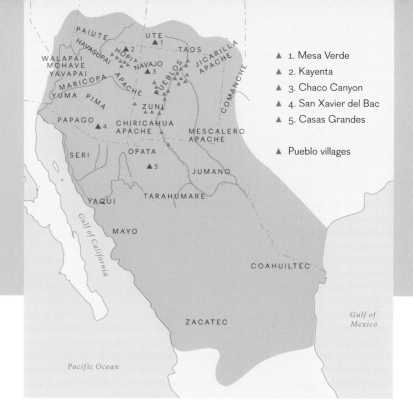

in aboriginal America, the potter's wheel was unknown; the clay was rolled into long strips, and the vessel built up by a coiling process.

In the adaptation of these novelties – agriculture, a sedentary life and pottery making – three major cultural traditions emerged, named by archaeologists as Mogollon, Hohokam and Anasazi. The Mogollon Culture, named after a mountain range in southwestern New Mexico, emerged among the local hunter-gatherers by about 300 BC. Their culture is distinguished by the adoption of agriculture on irrigated fields and by the settlement in small villages of pithouses, earth-covered wooden frames over a floor at least two feet below ground surface. Wild plants and game remained important sources of food for several centuries. Their pottery evolved from plain gray vessels starting in AD 200, to polished red ware, culminating, by AD 1000, in beautifully painted ceramics made by the people along the Mimbres River. The unique style of realistic designs on this pottery may have been created by only a few artisans. Painted ceramic bowls were inverted over the head of the deceased in burial ceremonies. A hole broken through the base "killed" the bowl and released the vessel's spirit. Masked or painted human figures carved of stone and wood may be prototypes of the Kachina effigies of the later Pueblo Indians.

By AD 1000 the Mogollon lived in adobe houses, in settlements built around a central plaza. Semi-subterranean rooms called kivas had a ceremonial function, and the pictures of masked dancers on the ceramics suggest that the people had developed a complex ceremonial life. It is perhaps no coincidence that by AD 1060 Mexican entrepreneurs had established Casas Grandes, a large trading center on the southern borders of Mogollon territory. Raw materials such as shell, turquoise, paint pigments and deer hides were exported by these traders to the Toltec empire in central Mexico. In return, they imported effigy-decorated ceramics, copper ornaments and the scarlet feathers of macaws, which were bred in large numbers at Casas Grandes. In addition, and perhaps more important, these Mexicans may have introduced the local natives to complex religious notions from central Mexico. Casas Grandes was a large town, attracting the settlement and labor of many people from the region. It was destroyed in 1340, during the upheavals of the Aztec wars and the collapse of the Toltec empire. The Mogollon Culture and its people were assimilated into the Anasazi Culture as it expanded from the north.

A burden strap and sandals, early Anasazi, circa 500–700.
Before the introduction of the loom, twined weaving undoubtedly
developed from expertise in basketry techniques. Yucca fiber and
native cotton was made into the thread for this finger weaving.
Piles of sandals, none of them forming a pair, were found in
several early Anasazi houses. When going out, apparently
anyone could take two sandals from this common store.
Courtesy American Museum of Natural History, New York.

The Mogollon people became the ancestors of some of
the later Pueblo Indians.

At about the same time as the Mogollon Culture
was active, the Hohokam Culture developed among
local hunter-gatherers of southern Arizona. Unlike
the Mogollon, the Hohokam revealed Mexican
contact from its very beginnings. By AD 1200, adobe
structures replaced the earlier pithouses in a growing
number of settlements along the Gila and Salt Rivers.
Irrigation canals providing the water to grow corn,
beans and other crops extended from these rivers into
the desert for hundreds of miles. Much of Hohokam
pottery was painted with geometric red designs, as
well as with figures of birds, lizards and dancing
human figures.

Mexican influence became particularly strong from
AD 500 to 1200, possibly caused by an actual influx
of Mexican immigrants. Ball courts reminiscent of
those among the Toltec and Maya were constructed;
platform mounds may have served as ceremonial
centers. Shell imported from coastal California was
carved into bracelets, and designs were etched in shell
ornaments with an acid made from the saguaro cactus.
Widely traded exotic objects may reflect common
religious ceremonies shared by the scattered villages.
Although Hohokam Culture declined in the 15th
century, the people were probably ancestral to the
Pima and Papago, nowadays referred to by their native
name O'odham. They remained farmers, "singing up
the corn" in night-long song sessions.

As the Mogollon and Hohokam cultures devel-
oped, corn-growing had spread farther north, where
hunter-gatherers were living in caves and pithouses.
The dry condition of these caves has preserved
many of their fine baskets. By AD 1, the cultivation
of gardens led the growing population to establish
many small farming communities, and the emergence
of the Anasazi Culture on the high mesas and in the
deep canyons in and around the present four states'
corner of Utah, Colorado, Arizona and New Mexico.
Although the people shared a common cultural
development, the several unrelated languages of their
descendants and the locally different art styles of the
Anasazi both suggest they were divided into several
politically independent societies.

The Anasazi adopted multi-room houses construct-
ed of adobe and masonry, turning the old pithouses
into ceremonial centers or kivas. A small hole made in
the kiva floor symbolized the entrance through which
the ancestors had emerged from the underworld in
mythical times. Murals decorating the interior walls of
these kivas depicted deities and masked dancers, sug-
gesting the existence of something like the Kachina
cult of historic times. Kachinas are a multitude of
spiritual beings, ancestors and messengers of the gods.
During the spring and early summer, they come down

Taos, New Mexico.
Taos is the northernmost of the Rio Grande Pueblos, established circa 1350 and still
inhabited. The four- and five-storied buildings, with outside ladders to reach the upper
floors, are the most photographed of all historic Pueblo villages. Taos is divided into two
groups of buildings by a creek running through the middle of the village. This picture was
made in the 1880s, but the place has not significantly changed since that time.
Courtesy National Anthropological Archives, Smithsonian Institution, neg. 1921a.

from their mountain residence to bring rain, fertility and bountiful harvests to the people. Impersonated by masked men, they visit all the villages to perform their dances, which are actually dramatized prayers that serve to maintain harmony in the universe.

The increasing Anasazi population required larger villages of multi-storied apartment buildings. Spectacular developments started about AD 600 in the region of the San Juan River. Access to or control of water may have instigated hostilities, which may explain why the San Juan Anasazi withdrew from the open mesa tops to establish the famous cliff dwellings in huge caves and on the ledges of high cliffs at Mesa Verde, Kayenta and nearby locations in around AD 1100. It is estimated that the regional population numbered about 30,000 people at that time.

Despite Anasazi expertise in water conservation, part of the growing population had been forced to move 70 miles south to Chaco Canyon. The population in Chaco Canyon was much smaller, yet by AD 900, they inhabited 13 large and well-planned towns and many small villages. Large kivas were constructed in the plazas of the towns, and there is some evidence that Pueblo Bonito was a ritual center or pilgrim's place, attracting continuous visitors from far and wide. Remarkably straight and wide roads were constructed, leading from Chaco Canyon to Mesa Verde, to the Mogollon country in the south, to turquoise mines near present-day Santa Fe, and in other directions.

Turquoise was processed in many workshops and traded with the Mexicans at Casas Grandes for imported copper bells, macaw feathers and ceramics. Other evidence of Mexican contacts are the Anasazi pictographs of the horned or feathered serpent, symbol of the Meso-American deity Quetzalcoatl. The women produced a great variety of locally distinct pottery, while the men wove blankets of native cotton on upright looms, as well as an older type made from twined yucca cords wrapped in rabbit fur or the feathers of domesticated turkeys. Belts and sashes were woven on a horizontal backstrap loom. Anasazi cultural influence expanded far to the east and south, affecting the Hohokam and absorbing the Mogollon. It was probably in this context that masked dances, reminiscent of the Kachina cult, were adopted by the ancestors of the Pima and Papago.

Shortly after AD 1100 a drought spread throughout the whole region, lasting for at least 50 years, as indicated by the analysis of tree rings. The crops failed, wild plants and game became scarce, and by around 1300 all the great towns had been abandoned. The ancestors of the Hopi Indians established new villages on the nearby mesas, but most of the Anasazi moved farther away, some to establish the Zuni villages, others to villages scattered along the Rio Grande in New Mexico. We recognize their descendants as the Pueblo Indians.

From the Grand Canyon down along the Colorado River, small bands of wandering desert people remained hunter-gatherers during all these centuries. After AD 500, under the influence of the Hohokam and Anasazi, they gradually adopted pottery making and some gardening, but they remained marginal to the cultural developments of the Southwest. Their descendants are the Yuma (or Quechan), the Mohave, Yavapai, Walapai and Havasupai, all speaking Yuman languages.

The forced migrations of the Anasazi were still well remembered by their descendants when bands of primitive hunters came down from the northern mountains. They were closely related in their language to the Athapaskan tribes of northwestern Canada, from whom they had separated about AD 1000. Students of their language, archaeology and history do not yet agree whether these snowbirds came down along the eastern or western sides of the Rocky Mountains, but they had arrived in the Southwest by around AD 1500. They called themselves Dineh or Nde, simply meaning "people," and their descendants are the Navajo and Apache Indians. Their northern origin was represented in the belief that the universe is

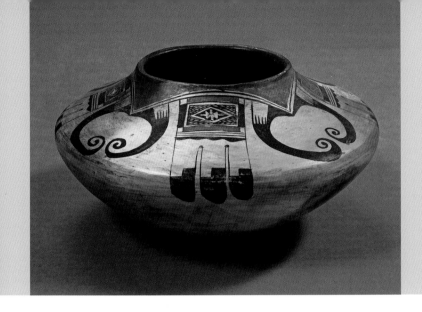

Polychrome pottery jar, made by Nampeyo, Hopi, circa 1900.
Diameter, 10.75 inches / 27 cm. Jars of this type were
formerly used to store seed or water. It is decorated with
a stylized bird motif, repeated in four directions.
Courtesy Skinner, Inc. Boston and Bolton, Massachusetts.

pervaded by spiritual forces, who might convey bless-
ings and powers to people in their visionary dreams.
It was from such personal experiences that most of
their public ceremonies originated. These rituals
included the girls' puberty celebration, in which the
girl was dressed to represent White Shell Woman
(Apache) or Changing Woman (Navajo), a prominent
figure in the mythology.

These people rapidly spread all over the region,
dividing into many local bands, some of them follow-
ing the buffalo herds into the southern Plains, others
more attracted by foraging on the cornfields of the
Pueblo Indians. Eventually some of these unwelcome
visitors adopted the rudiments of agriculture and
the production of a plain utilitarian pottery. They
settled in small villages in northeastern New Mexico
and traded dressed deerskins and meat for corn and
woven blankets from the nearby Pueblo villages.
Most of the other bands continued a nomadic life
as hunters, raiding farmer settlements as a profitable
sideline in their economy. Most probably, their aes-
thetic expressions were confined to symbolic designs
painted on their buckskin garments and rawhide
shields. The making of basketry was probably learned
from women captured from regional communities.

✳

Far beyond the southern deserts, centuries of human
sacrifices in Tenochtitlan of the Aztecs had culminated
in a wholesale massacre by the Spanish conquistadores.
Their plundering of Aztec Mexico in 1520 and Peru in
1532 had yielded incredible wealth of gold and silver.
Mexico City was rife with tales of other Eldorados.
Following up on rumors of golden cities up north, an
expedition led by Francisco Vasquez de Coronado set
out into the desert in 1540. That same year, Hernando
De Soto had started on his trail of destruction through
Florida and the Southeast. Coronado's golden cities
turned out to be the mud-plastered pueblos of the
Zuni Indians. Riding on four-legged beasts never seen
before, the white strangers explored the country and
committed bloody outrages, but they did not find any
gold. In the desert along the lower Colorado River,
the local Indians scraped the gravel aside to create
a picture of a huge horse and some gigantic human
figures. They are still there. It was half a century before
another attempt was made to introduce Spanish rule,
but the resentment and distrust of white people had
been planted, never to disappear.

In 1598, Don Juan de Onate led an expedition
of soldiers and settlers and 7,000 head of livestock
into New Mexico. In the mountains, Don Juan met
nomadic Indians whom he called "Apache"; later
he learned to distinguish some of these bands as
"Apaches de Navajo." Along the Rio Grande he found

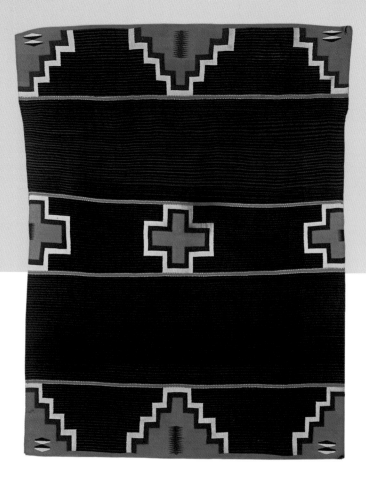

Woven blanket, Navajo, late 19th century.
Dimensions, 62 inches by 83 inches / 157 x 211 cm: circa 1890s. Designs of this type were made in the Ganado region of Navajo country. It is referred to as a Germantown weaving because it was woven of Germantown yarns from Pennsylvania, promoted by traders among the Navajo from around 1880 until 1910. Courtesy Skinner, Inc., Boston and Bolton, Massachusetts.

the Indians living in about 70 "pueblos," that is, villages. Farther west were Acoma and the Zuni pueblos, and in northeastern Arizona, the Hopi occupied six villages. As a whole, the Pueblo population had four distinct language groups, but each of their villages was an independent social and political entity.

The Pueblo villages consisted of rectangular, flat-roofed apartment buildings, made of stone masonry and adobe that blended with the surrounding landscape. Some of these houses were three or four stories high, constructed in a terraced or set-back style. The ground floor had no doors or windows; entrances on the second floor were reached by ladders, which could be pulled up when undesirable visitors were noticed in the distance. Each family occupied a single room in the building, although it might have other rooms for storage. These apartment buildings were arranged around a plaza or in parallel rows. In every village

were one or more underground kivas, which were entered by a ladder through the roof. Kivas served as ceremonial centers and as clubhouses where the men spent much of their time.

Confiscating land from the Pueblo Indians, the Spaniards established their headquarters at Santa Fe and settled villages, farms and ranches up and down the Rio Grande. They came to expand the Spanish empire and to make Christian Spaniards of the native people. A program aimed at this transformation was forcefully imposed. Farmlands were seized from the Indians, who were forced to work for the private ventures of colonial authorities. Annual tributes of corn and woven textiles were demanded. Supervised by the padres, churches were constructed by the Indians in many Pueblo villages, where missionaries were stationed. The kivas were raided; hundreds of masks and other ceremonial regalia found there were burned, and the people were forced to attend daily church services. The missionaries propagated a religion of which they themselves did not understand the essentials. Whatever genuine success they had depended very much on the personalities of the few who learned the native languages. Spanish became a lingua franca among the eastern Pueblos. Motivated by their desire for horses and corn, the Apache and Navajo contacts with the colonists were largely confined to periodic raids on the settlements and the occasional retaliatory

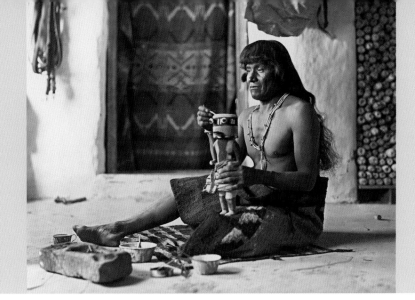

A kachina-doll carver at work, Hopi, 1920s.
Invariably carved from the roots of cottonwood trees, the dolls (see pages 196, 197–99) are painted and provided with the attributes that distinguish them among the several hundred different types. As children were taught that these dolls were made by the Kachina spirits, carvers used to work in secrecy and anonymity.
Courtesy Neil Judd / National Geographic Image Collection.

expeditions of the Spaniards. Some of these Spanish invaders were pictured by the Navajo in paintings on the rock walls of the Canyon del Muerto in Arizona.

The Pueblos, by nature peaceful and unaggressive, were slow to react to the injustices and abuse to which they were subjected. The burden of forced labor and tribute might have been tolerated if the Indians had been left the freedom of their own religion. Several local rebellions were brutally repressed, but in 1680 the Pueblos finally united in a general revolt. It lasted only for a few weeks, but at the end, 21 missionaries and 375 colonists were dead, while the other 2,000 settlers had fled south to the El Paso area. The mission buildings were destroyed and their furnishings burned in order to wipe out every vestige of the Christian religion. Before they could return to normal life, the Pueblo warriors went to the river to cleanse their bodies and minds from the evil of disharmony. The 80 years of missionary efforts had failed to destroy their traditional spiritualism.

The Apache and Navajo did not participate in the Pueblo Revolt, but it was the beginning of a gradual differentiation in the cultures of the two groups. The taking over of the Spanish horses increased their mobility and their devastating raids, but the herds of Spanish sheep were to enrich and change the Navajo way of life. The Navajo lived in hogans – conical lodges supported by three forked poles and covered

with bark and earth – in contrast to the tipis and dome-shaped wickiups of the Apaches.

A Spanish army reestablished Spanish control in 1693. Many Pueblos fled from the Rio Grande villages to escape Spanish reprisals. Some of these refugees established new villages among the distant Hopi; others joined the Navajo, who adopted them as separate clans. Pueblo Indian refugees brought elements of Pueblo life to the Navajo Culture, including agriculture and pottery. Adopting loom weaving from these Pueblo Indians, the Navajo used the wool of their Spanish sheep in the creation of their famous blankets. Cotton and woolen clothing replaced skin garments; the buckskin leggings of the men gave way to Spanish-style trousers, split from the knee down. Navajo women adopted a black woolen dress, made of two blankets fastened at the shoulders. Most significant was a considerable elaboration of religious ceremonials. Sand paintings, once used only in the Pueblo kivas, became very important in Navajo curing rituals. The Kachina cult of the Pueblos inspired the Navajo and Apache to adopt masked impersonators of spiritual beings, who would come every year to drive away sickness and bless the people. To some extent, the Pueblo religious focus on communal ceremonialism decreased the personal and visionary religious experience of the Navajo and Apache Indians.

After the Pueblo Revolt, Nuevo Mexico endured

Facing page: **Concha belt, Navajo, circa 1880.**
Derived from smaller Spanish-Mexican prototypes, Navajo conchas are made of sheet silver hammered into wooden forms. Designs are tapped into the silver with iron dies, copied from the dies used by Mexican leather workers. The scalloped edges are typical of early examples, when the conchas were still hammered out of silver dollars. Silverwork has become a major source of income for many Navajo. Courtesy Ned Jalbert, Westborough, Massachusetts.

as an outpost of the Spanish empire for another 130 years. Spanish settlement remained largely restricted to the valley of the Rio Grande, as all the surrounding country was controlled by the Apache and Navajo, who raided Spanish and Pueblo villages alike. Treaties and agreements with these Indians had little effect, as they were divided among a large number of independent bands, none of whose chiefs had authority beyond his own band. Due to the great distance through hostile country, the western Pueblos – Hopi and Zuni – remained beyond effective reach of the Spanish authorities.

In southern Arizona and adjoining Sonora, Father Eusebio Kino and other missionaries established several missions among the Pima and Papago Indians. They introduced horses, sheep and several new crops to these farmers, and they acquainted the native people with some notions of Christianity. After Father Kino's death, the Papago identified him with Saint Francis and developed a distinctly Indian cult of this saint. Supervised by the padres, the Papago built the church of San Xavier del Bac in 1783–1797. This building, located south of present-day Tucson, has been acclaimed as the finest example of Spanish mission architecture.

Of the 70 Pueblo villages on the Rio Grande, only 18 were left in 1700. The colonial government relaxed its oppressive policies, and the Church needed its priests to serve the increasing non-Indian population. This changing situation enabled the Indians to revive their ceremonials, though the more sacred dances and rituals remained concealed from all outsiders. Several societies relating to curing, hunting, war or the kachinas organized the dances. To appease the missionaries the eastern Pueblos adopted the externals of the new faith as an additional but separate cult. Over time, the Spanish-Catholic religion has become an integrated part of Pueblo Culture on the Rio Grande, but the two religious traditions have remained distinct. Within view of the mission church, the kiva continued as the hub of social and ceremonial life. Native people grow up with the understanding that no information about their religion is ever to be given to outsiders, even though some of the ceremonial dances allow the attendance of visitors. In contrast, there is no secrecy about the native version of Catholic ceremonials, the annual celebration of the patron saint's day of each pueblo, and its associated dances. The proper performance of both native and Catholic rituals is believed to produce the same results: health and well-being for all people.

The 18th-century farming economy of the Pueblos was enriched with new crops, cattle and sheep. New crafts included blacksmithing and carpentry and the weaving of sheep wool. Spanish floral motifs were adopted in the embroidery on woven textiles and in

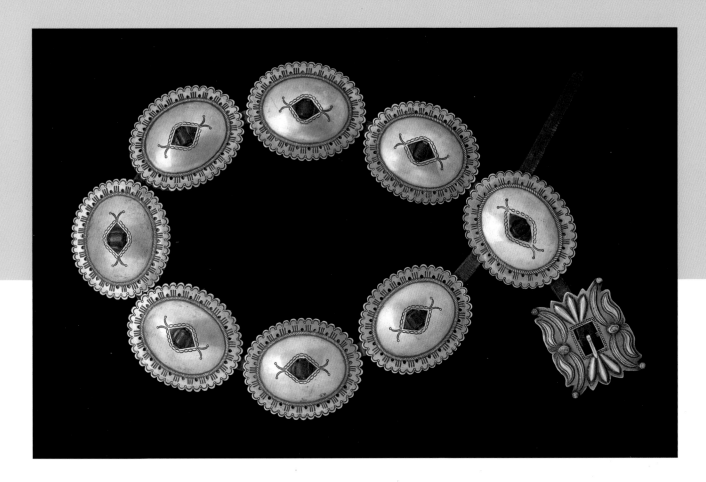

the painting of pottery. Pueblo architecture remained virtually unchanged, though doors were appearing on the ground floor of the houses. Those who married non-Indians were invariably forced to leave the native community. They and other Indians dissatisfied with the enforced adherence to traditional customs joined the growing Mestizo population.

Attracted by the Spanish horses, Comanche Indians of the southern Plains had long followed the Apache example in raiding the settlements. At the annual fairs at Pueblo Taos, they traded buffalo robes and slaves for corn and Navajo blankets. Plains Indian garments were adopted by the eastern Pueblos, and a "Comanche dance" became popular in their festivities. Comanche Indians may have played a role in the trade of Navajo blankets, which had reached the northwestern Plains in the 1830s. The water-shedding quality of these blankets made them highly prized among the Plains Indians.

Navajo silverwork has its roots in these growing intertribal contacts. Indians removed from the Great Lakes region to present-day Oklahoma had taught the craft to the Comanche Indians in the 1830s. The Plains Indians wore silver disks decorating their belts and their hair when they visited the market at Taos to meet with Navajo blanket traders. The Navajo were already acquainted with the silver buttons used profusely on Spanish-Mexican clothing and on the silver trim of Spanish saddles and horse bridles. These were the sources that inspired some Navajo blacksmiths to melt and hammer silver coins into buckles, silver-studded belts, rings, bracelets and necklaces. Starting in the 1850s, Navajo silverwork was an instant success among the Indians, and the number of silversmiths rapidly increased. Around 1870, some Indians at Pueblo Zuni learned the craft from Navajo friends, and shortly afterward, silverwork was taken up by the Hopi and Rio

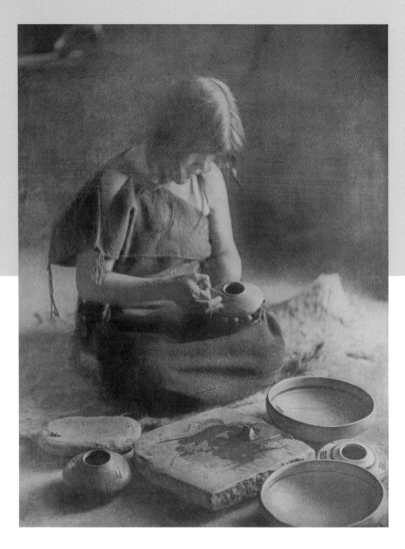

northern parts of New Mexico and Arizona.

In 1863, gold was discovered in western Apache territory, and the invasion of the miners set off bitter warfare with the Apaches until they were defeated by the American army in the 1890s. Government management introduced ranching and farming on the Apache reservations, but the same government allowed the many centuries of Pima Indian farming to come to an end in 1887, when a large canal diverted all the water from the Gila River to the farms of white settlers. Improving the life of Indians was tolerated only when it did not interfere with the interests of the white electorate.

The arrival of the transcontinental railroad in 1880 opened up the Southwest for the subsequent growth of the Anglo-American population and for increasing numbers of tourists. The Indians were waiting for them at the railroad stations with their products of traditional and innovative creativity: baskets, pottery, blankets, silverwork and a variety of dolls. The Arts and Crafts movement of the late 19th century made native crafts increasingly popular among the city people from the east.

The demands of this tourist market had a negative effect on the quality of Pueblo pottery, particularly now that the import of commercial china and metal cookware reduced the need for pottery making among the Pueblo women. The production of traditional

Grande Pueblos. Turquoise inlay became popular, particularly among the Zuni, who cover their silver with a mosaic of small turquoise stones.

In 1846, the Southwest was annexed by the United States, and that meant the beginning of drastic changes for the Apache and Navajo. Their raids on the settlements had reached enormous proportions; in the 1840s, they made off with more than 450,000 sheep. Their depredations came to an end in 1864 when the U.S. Army rounded up more than 8,000 Navajo, who were forced to make the "Long Walk" to a large concentration camp. After four years in dismal conditions, the survivors were released and made their way back to their homeland. Herding their large numbers of sheep, the Navajo spread all over the

ceramics continued in the more isolated communities, and it is mainly due to a few women from these pueblos that a revival emerged. Foremost among them was Nampeyo, a Hopi woman who was intrigued by the designs painted on pottery shards found in some prehistoric ruins. Around 1900, Nampeyo created the style called Sikyatki Revival Polychrome, and her superior pottery became the prototype for ceramic revivals among the other pueblos. Also famous were Julian and Maria Martinez of San Ildefonso; in the 1920s, they produced polished black vessels decorated with designs in matte paint. The high prices paid for their products encouraged other potters, and traders and art dealers promoted the revival of ancient designs from prehistoric Anasazi pottery. Today, scores of Pueblo artisans create fine pottery, but their products are not intended to replace the commercial pots and pans used in their households. Though originating from domestic ware and preserving traditional features, modern Pueblo pottery is a ceramic art produced for art galleries and native art fairs.

Weaving had declined among the Rio Grande Pueblos when Mexican serapes became popular in the 19th century. It was virtually abandoned when more and more Pueblo men took jobs in the cash economy of the Anglo-Americans. In their more isolated villages, only the Hopi men continued the weaving of blankets, kilts, breechclouts and sashes. By 1900, commercial American clothing had been adopted throughout the Southwest and traditional garments were primarily worn on ceremonial occasions. However, traditional embroidery patterns once restricted to ceremonial regalia now decorate shirts, skirts and jackets of native people.

In contrast to the Pueblos, the Navajo have always responded readily to trade opportunities with arts and crafts. White traders have operated among the Navajo, taking in wool, blankets and silverwork, since 1871. By the 1940s, there were 146 trading posts on and around the Navajo Reservation, which is the largest Indian reservation in North America. Traders promoted the quality and designs of the blankets woven by the native women, and various areas of the vast reservation have developed their own types of blankets. When the price of wool dropped in 1893, the traders pushed for a change from blankets to rugs for the growing market of Indian arts. Given the amount of time involved, the weaving of rugs is not very profitable and does not attract many of the younger women.

Non-traditional painting had its origins in the Southwest and the southern Plains after 1900. Anthropologists and schoolteachers encouraged native youngsters to put pen and paintbrush to paper to depict the scenery of their traditional life. Watercolors made in the Indian schools found a ready market among the urban intelligentsia and produced an entire generation of Indian artists. A flat, two-dimensional "Indian" style was developed and promoted by white patrons. In the 1950s, growing numbers of native artists renounced this "Bambi art" and moved into the mainstream of contemporary art.

Pueblo villages are still predominantly built of adobe, but the compact village structures have given way to single-family houses in new settlements near the old villages. Seasonal dances continue, calling tribal members living far away to return home to perform their traditional roles in the ceremonials. Pottery, basketry, rug weaving, silverwork and other crafts have become important sources of income for many southwestern Indians. Every year, the tourists are presented with the pageantry at the Gallup Intertribal Ceremonial, the Pueblo Indian Cultural Center at Albuquerque, the Flagstaff Powwow, the art fairs in Santa Fe, and at numerous celebrations in the Indian communities.

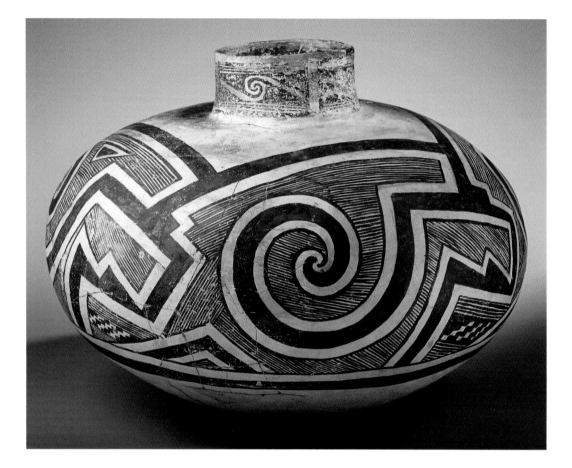

Jar, Tularosa black-on-white, circa 1100–1250.
Height, 12.75 inches / 32 cm. This type of pottery was popular throughout
the Anasazi region in the classic period of this culture. Fine hatching
and large spirals are characteristic in the decoration of this pottery.
Courtesy Heritage Auction Galleries, Dallas, Texas.

Effigy jar, Tonto polychrome, circa 1300–1400.
Length, 17.5 inches / 44 cm. Pottery of this type emerged in southern
Arizona when the local Hohokam Culture was strongly influenced by
the Salado Culture in central Arizona. Salado was related to the more
northern Anasazi, who made similar jars decorated with parrot effigies.
Courtesy Heritage Auction Galleries, Dallas, Texas.

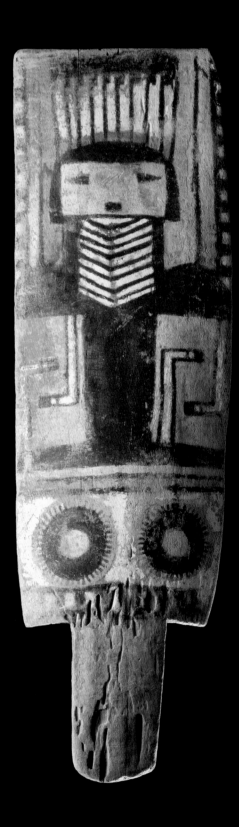

Facing page: **Ceremonial wands, Pueblo, circa 1700?**
Length, 29.5 inches / 75 cm. Almost flat boards made of cottonwood.
Reportedly found in the Largo Canyon near Blanco, northwestern New
Mexico. This is not far from the Aztec and Salmon Ruins, two Anasazi
settlements, circa AD 1200; these two wands may well be older than
the assumed date of circa 1700. The paintings on these wands may
represent masked Kachina deities, reminiscent of those pictured on
the wands carried by Hopi women in the Maraw ceremonies. The
handles of these two objects suggest their function as dance wands,
but they are much older and larger than the Hopi dance wands of the
19th century. Moreover, the "handles" may have functioned as a way
to place them upright in the ground as part of an altar arrangement.
Courtesy Donald Ellis Gallery, Dundas, ON, New York, NY.

Shield, Pueblo Jemez type, circa 1840.
A disk of heavy rawhide. Diameter, 22 inches / 56 cm
Strings along the upper half suggest the former presence of
a border of red cloth and/or feathers. The design painted on
this shield was almost exclusively used at Jemez; it may relate
to the Sun spirit, and it may have had a magically protective
quality. Shields of this type have a long history in the Southwest,
as indicated by many pictures of them in regional rock art.
Courtesy Donald Ellis Gallery, Dundas, ON, New York, NY.

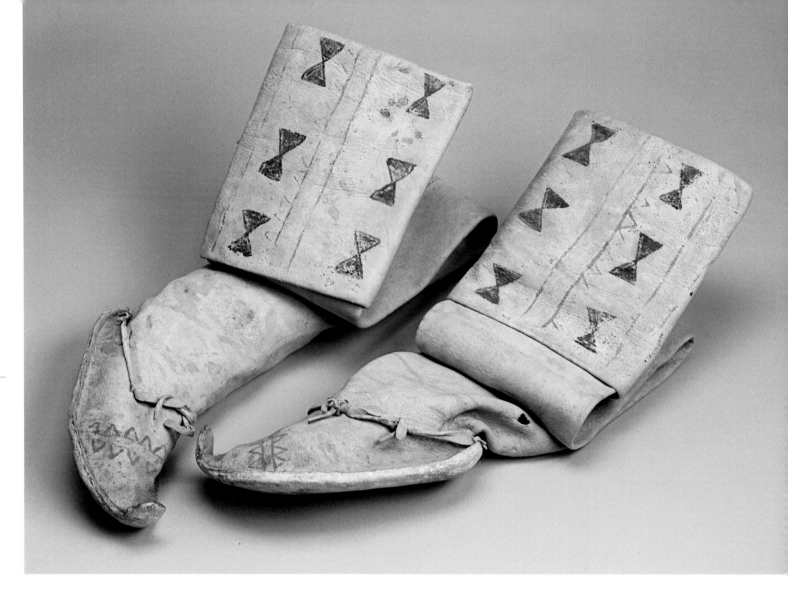

Above: **Painted boots, Western Apache, 1880s.**
Length, 41 inches / 104 cm. Made of soft deerskin,
sinew-sewn, with rawhide soles. Usually folded
down to knee-high, very long boots were worn by
men and women among the western Apache. The
pre-formed rawhide soles have upturned edges
and a toe extension, called a "cactus kicker."
Courtesy Skinner, Inc. Boston and
Bolton, Massachusetts.

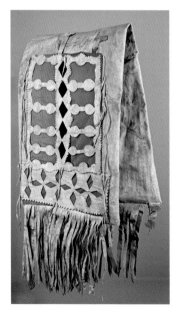

Left and facing page: **Saddlebag,
Western Apache, circa 1880.**
Length, 33.5 inches / 85 cm, excluding
fringe. Native leather with cut-out
designs exposing red cloth. This type
of leather decoration was popular
among the western Apache as well
as among the Spanish settlers in New
Mexico, but it is not clear where the
technique originated. Saddlebags open
through a slit on the halfway fold of
the bag, like the belt-pouches of the
Eastern Woodlands. Detail at right.
Courtesy Heritage Auction
Galleries, Dallas, Texas.

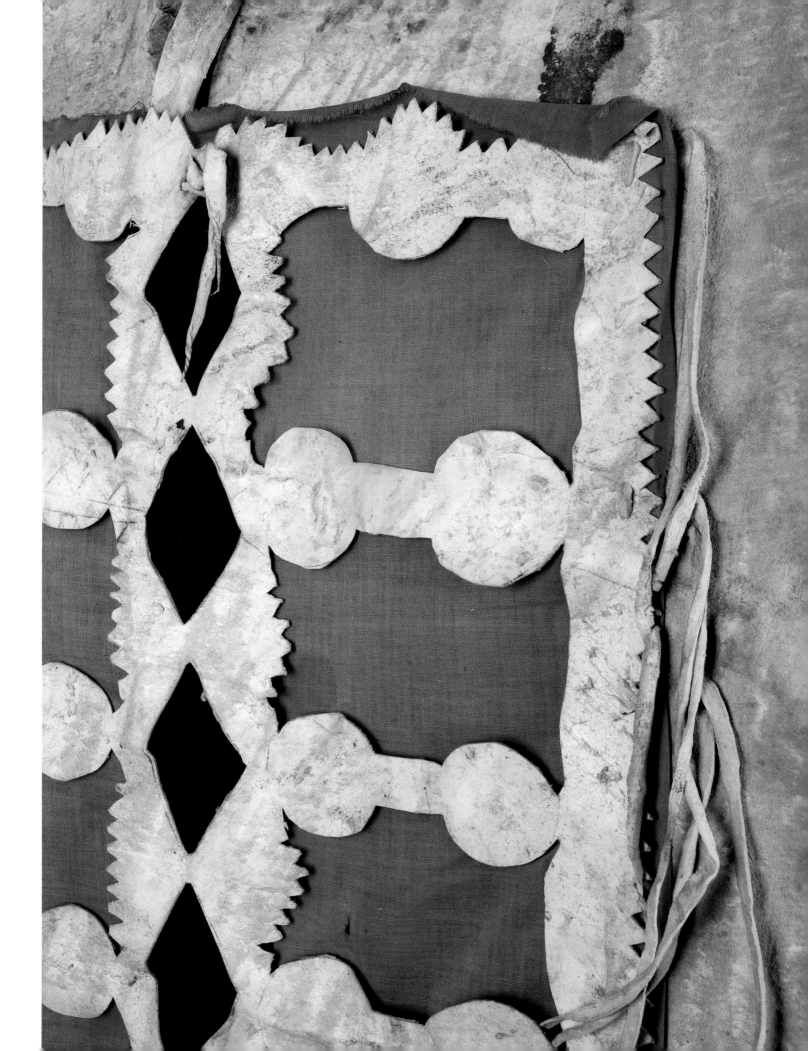

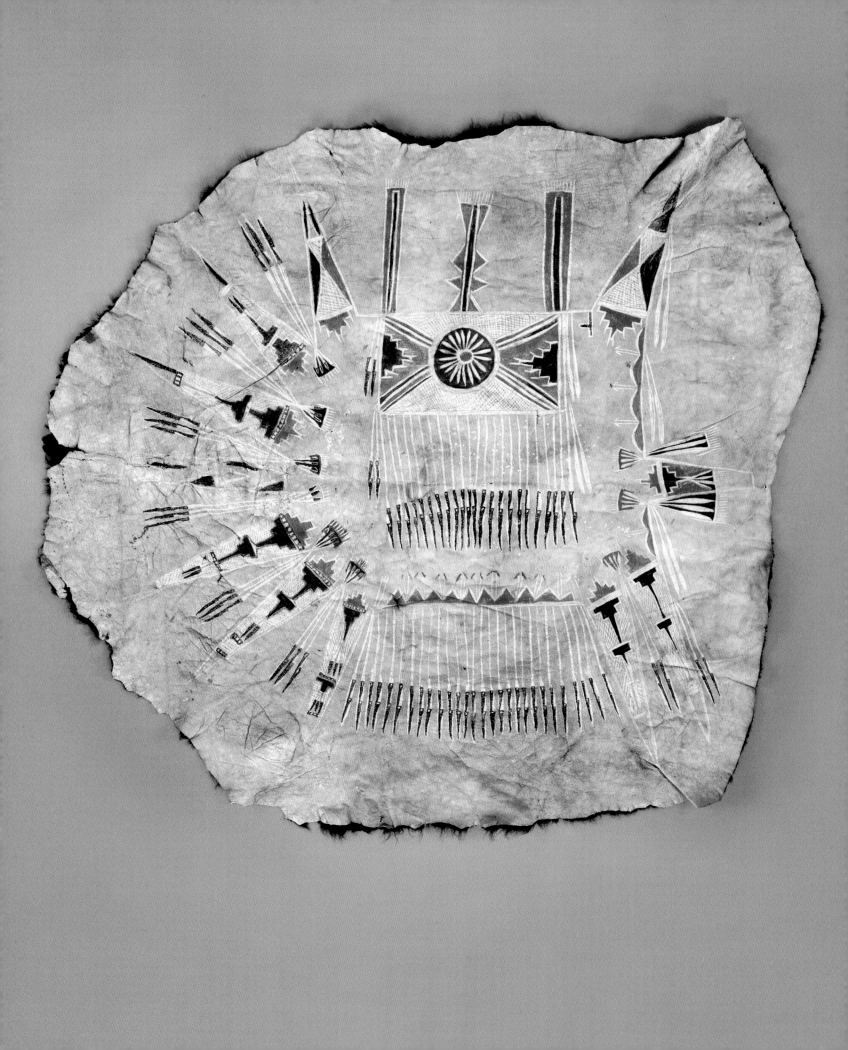

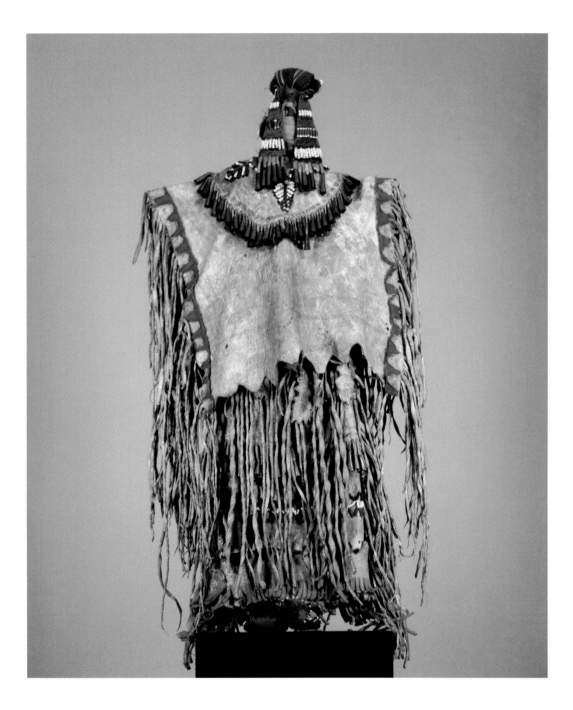

Facing page: **Painted robe, probably Mescalero Apache, circa 1840.**
A buffalo hide. Length, 70 inches / 172 cm. The painting consists of a vertical
column, crossing a design that is reminiscent of the abstract buffalo symbolism
on Plains Indian women's robes. In the vertical column, two rows of feathers
are recognizable. The many stepped triangles suggest Pueblo Indian influence.
Early hide paintings of the eastern Apache are very rare, and they do reflect
the marginal position of these people between Plains and Southwest.
Courtesy John and Marva Warnock Collection / www.splendidheritage.com

Doll, Apache, circa 1880. Length, 17 inches / 44 cm.
Representing a woman in traditional costume of poncho, skirt
and boots. Native tanned deerskin, painted yellow and pink.
Earhangers of beads and metal cones. This traditional dress
survived as the ceremonial dress worn by girls during their puberty
initiation rituals, hence the recent name "puberty dolls."
Courtesy Charles Derby, Northampton, Massachusetts.

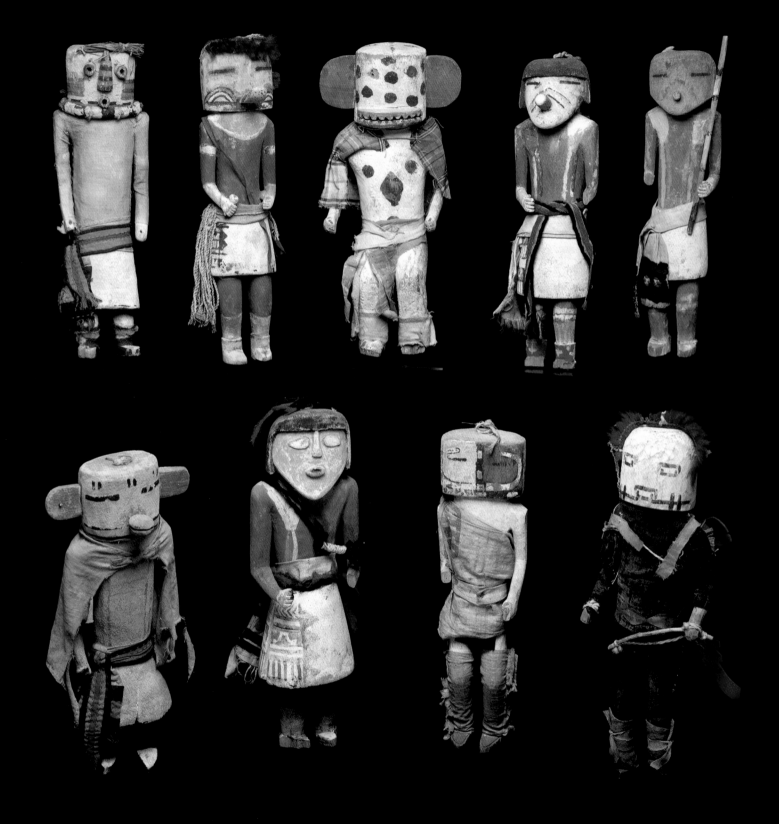

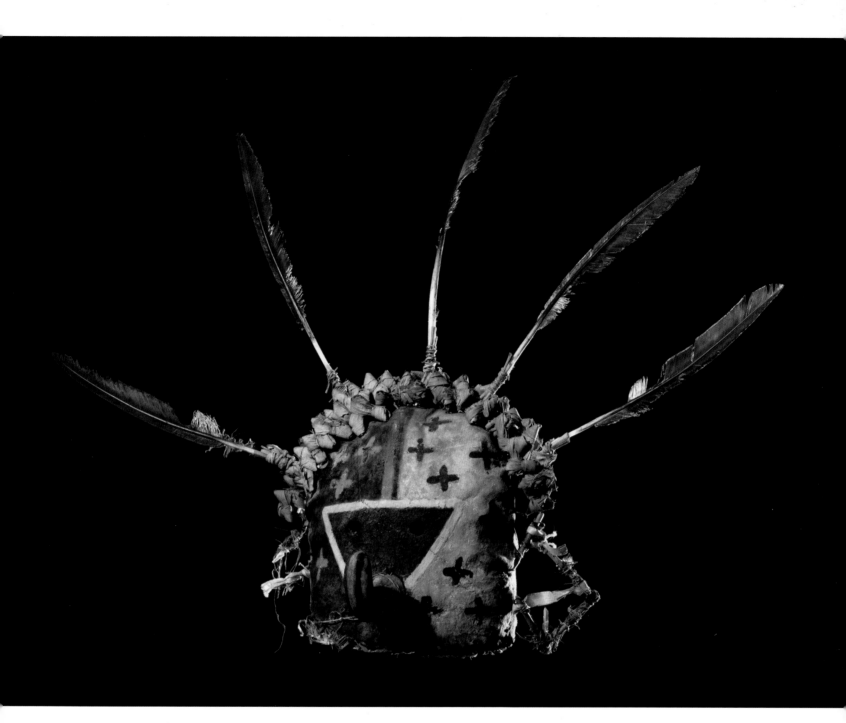

Facing page: **Kachina dolls, Hopi, circa 1900.**
Height, 13 to 14 inches / 33–35 cm. Girls receive such dolls from the Kachina
dancers in order to learn the distinguishing features of the many types of
Kachinas and their associated powers. Boys acquired this knowledge through
their initiation in the ceremonial societies or cult groups. This group of dolls was
acquired by Fredrick Volz at his trading post near the Hopi villages, between
1890 and 1910.
Courtesy Donald Ellis Gallery, Dundas, ON, New York, NY.

Kachina mask, Hopi, 19th century.
Painted buffalo hide, decorated with plaited corn husks and swan feathers.
This is the mask of Wuwuyomo, "Old Man" or Chief Kachina, in the Hopi
village Sichomovi. The mask is worn with a fox skin around the neck.
Wuwuyomo is the Sichomovi version of Ahula, the germinator of corn
seed in other Hopi villages. They appear in January or February, when the
people celebrate the return of the Kachinas to bring their blessings.
Courtesy Donald Ellis Gallery, Dundas, ON, New York, NY.

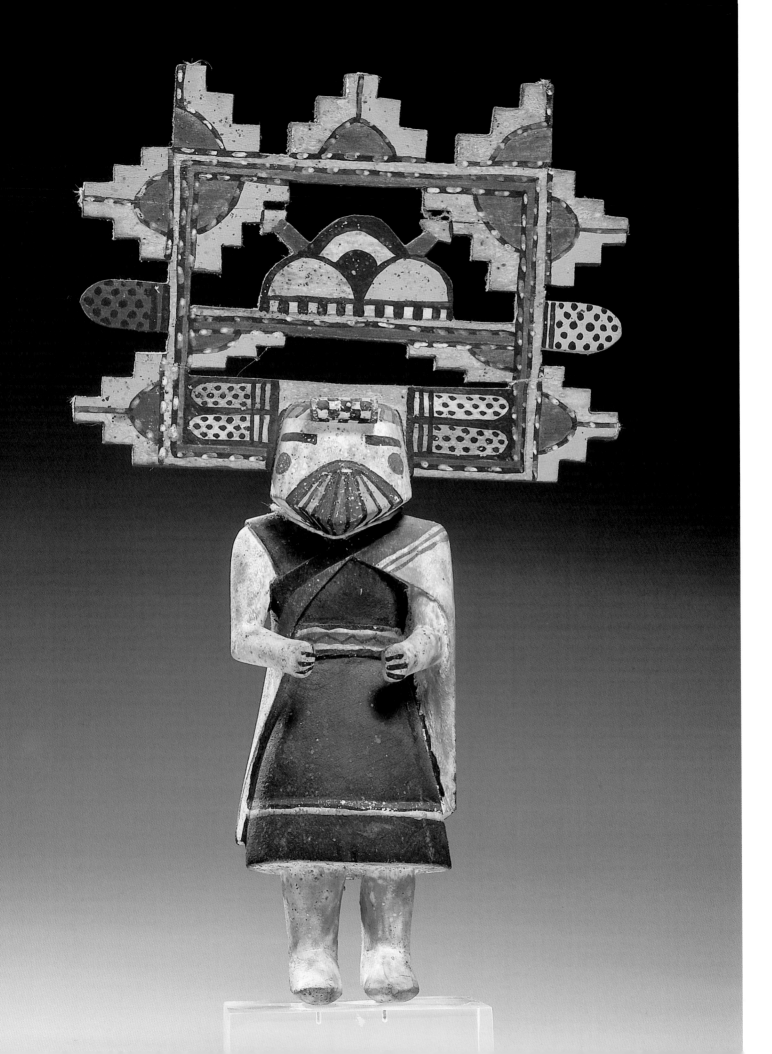

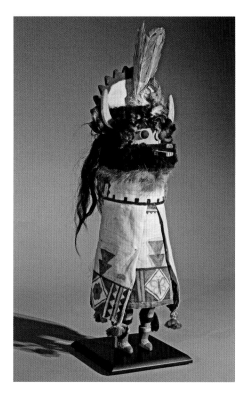

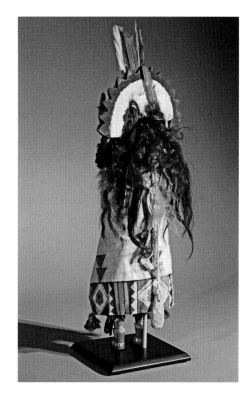

Two kachina dolls, Pueblo Zuni, 1900–50.
Owing to their limited sale, Zuni Kachina dolls are less common than Hopi examples. In contrast to the Hopi dolls, those of the Zuni are usually more slender, they have separately carved and moveable arms, and their costume is not part of the carving, but consists of leather or cloth garments.

Above: Height, 13 inches / 33 cm. Salimopaiya Kachina, one of the "Warriors of the Seed." They dash around on the outskirts of Kachina performances, waving yucca leaf whips. This doll was made between 1903 and 1906. Courtesy John and Marva Warnock Collection / www.splendidheritage.com

Right: Height, 15 inches / 38 cm. Shalako Kachina. In reality, the Shalako Kachina is over 10 feet tall, towering over the other Kachinas when they come to dance in the village once a year. This doll was made between 1925 and 1950. Courtesy John and Marva Warnock Collection / www.splendidheritage.com

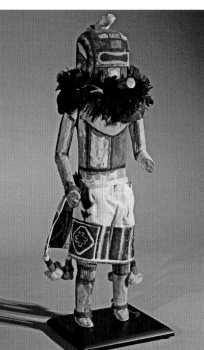

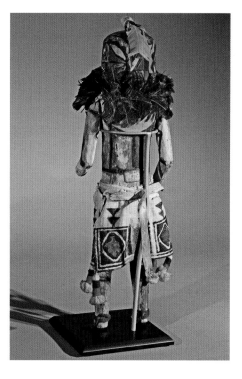

Facing page: **Kachina doll, Hopi, circa 1930.**
Height, 14.75 inches / 37 cm. This is Poli Mana, "Butterfly Woman," who appears in night dances together with a male Butterfly Kachina. Her tablita headdress shows pictures of rain clouds, lightning and corncobs, all references to fertility. During her performance, she carries evergreen branches in her hands as symbols of long life. Courtesy Cowan's Auctions, Inc., Cincinnati, Ohio.

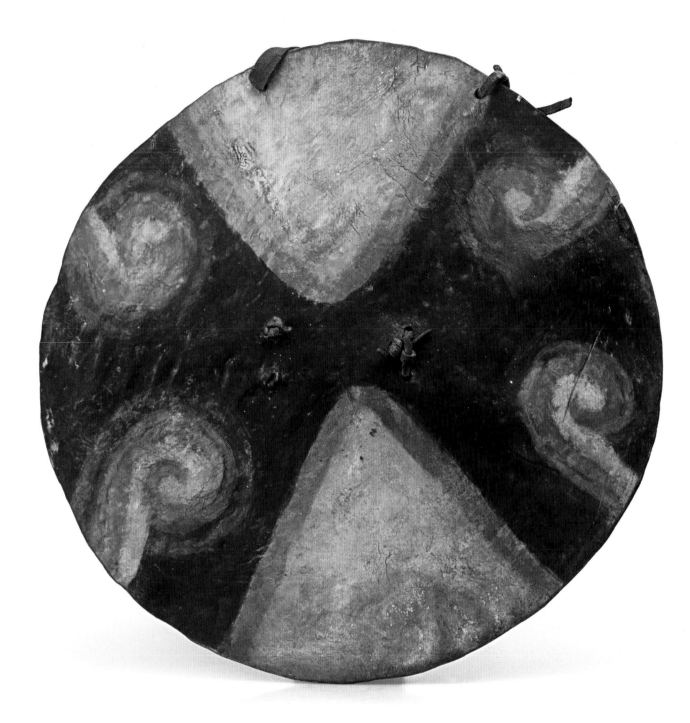

Shield, Pima (Akemorl-Oohtam), circa 1840.

A disk of heavy rawhide, 24 inches / 61 cm diameter, with a wooden handgrip that is attached
to the back with leather thongs. When the shield was held out at full arm's length and twirled
rapidly, the painted design was believed to confuse the enemy. Shields and war clubs were used
by Pima foot warriors. Their prolonged warfare with the Apache ended in the 1870s.
© Museum Volkenkunde.

Woven blanket, Navajo, late 19th century.

Dimensions, 72 inches by 47 inches / 183 x 120 cm; circa 1860–80. A so-called "Moki serape,"
that is, a type of Navajo weaving popular among their Hopi neighbors.
Courtesy Skinner, Inc. Boston and Bolton, Massachusetts.

Woven blankets, Navajo, circa 1840–60s.

Dimensions, 73 inches by 57 inches / 185 x 145 cm. Using the wool of Spanish sheep, the Navajo
women learned to spin and weave from the Pueblo Indians in the 1690s. In the development
of the early so-called "chiefs' blankets," four phases are recognized. This is an example of
the first phase: alternating white and dark horizontal stripes, with a wider central stripe.
This central stripe and the two border stripes consist of several narrow bands of different
colors. The term "chiefs' blanket" relates to their popularity among the Plains Indians.
Courtesy Donald Ellis Gallery, Dundas, ON, New York, NY.

Dimensions, 55 inches by 79 inches / 140 x 200 cm.
In the 1850s, a slight change in design led to the second phase of chiefs'
blankets, when blocks of contrasting colors appeared in the central and border
stripes. This particular example was acquired from the Ute Indians.
Courtesy Donald Ellis Gallery, Dundas, ON, New York, NY.

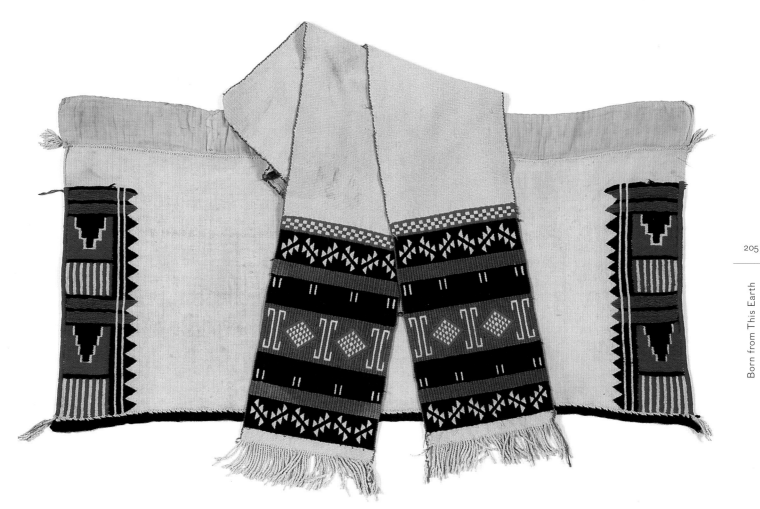

A kilt and sash of hand-woven cotton, Hopi, 20th century.
The kilt is decorated with embroidery on the finished fabric. The sash shows "Hopi brocade," a unique technique executed while the sash was being woven. Cotton fabrics were loom-woven by the Pueblo ancestors after about AD 1100, and Spanish embroidery (of native designs) was adopted when metal needles and commercial yarns became available. After 1880, weaving declined among the Rio Grande Pueblos, who have since depended on Hopi weavers for ceremonial garments. Neither Hopi nor other Pueblo weaving was ever done for sale to outsiders.
Courtesy Cowan's Auctions, Inc., Cincinnati, Ohio.

Facing page: **Gan dancers, Western Apache, 1925.**
Gan, or mountain spirits, used to visit the Apache camps every year to drive away evil and disease and bring blessings of good fortune. In more recent times, their annual visits have been combined with the girls' puberty rites and woven into a single event held every summer. The black masks of the Gan are made of the skin of deer that have been run down and strangled without the shedding of blood. On top of the mask stands a construction of colored wooden slats, reminiscent of the tablitas worn by some Pueblo Kachinas. Here, the impersonators of the Gan, like Kachinas among the Pueblos, are seen coming down from their mountain residence.
Photo by Forman G. Hanna. Courtesy Arizona Historical Society / Tucson. AHS 65206.

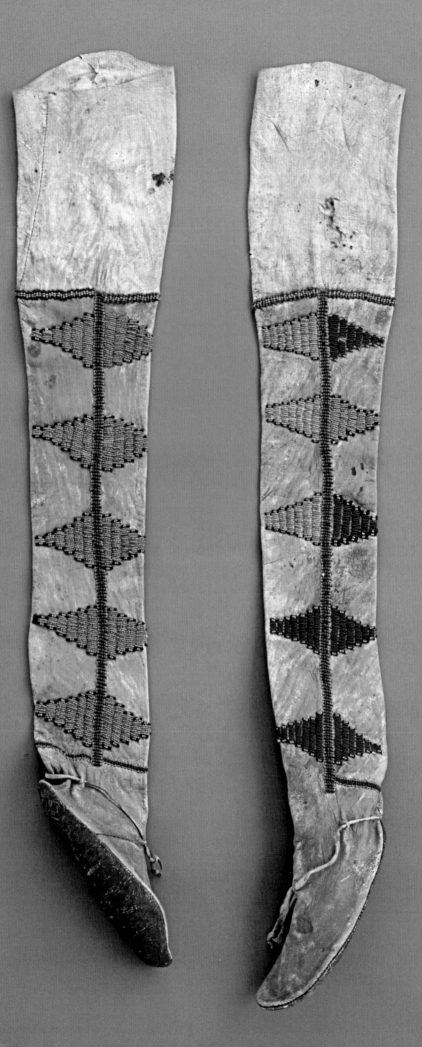

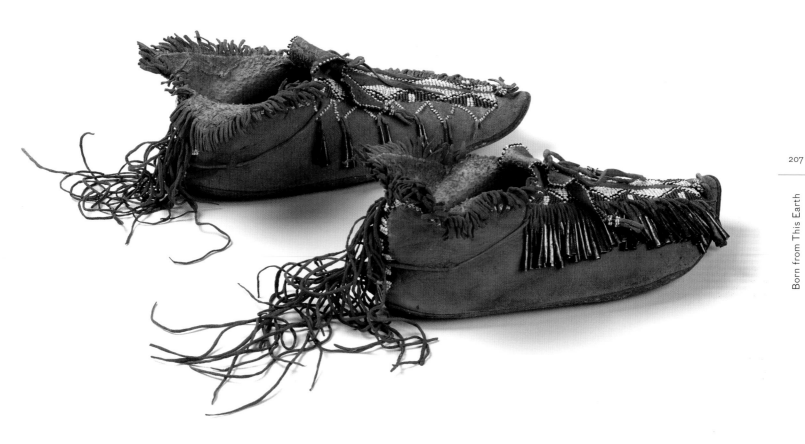

Moccasins, Jicarilla Apache, circa 1890.
These moccasins also show the strong Plains Indian influence,
particularly from the Comanche and Kiowa. When Jicarilla children
started to walk, new moccasins were put on their feet, and they
were led along a trail of corn pollen toward the eastern sunrise, a
journey that represented the wish of a long life for the child.
© Bata Shoe Museum, Toronto, Ontario. Photo by Pete Paterson.

Facing page: **Beadwork on boots, Jicarilla Apache, 1870s.**
Culturally intermediate between the Southwest and Plains, the
Jicarilla and Mescalero Apache once stained their buckskin garments
a monochrome yellow or blue, replacing painted designs with
beadwork in the 19th century. Jicarilla beadwork resembles the work
of their Ute neighbors. Their moccasins and boots have pointed
toes but lack the "cactus kickers" of their western relatives.
Courtesy John and Marva Warnock Collection / www.splendidheritage.com

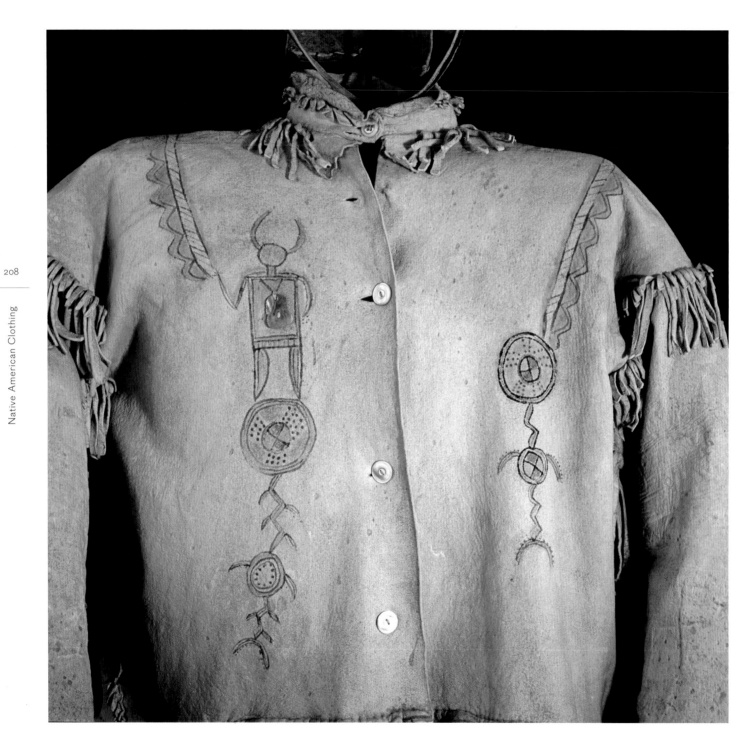

Painted leather jacket, San Carlos Apache, 1870–80.
Deerskin jackets patterned after the coats of the American military became popular among the western Apache during their wars with the U.S. army. The military uniform was perceived as a symbol of power, power that was claimed by the Apache warriors as well. The painted bands crossing the shoulders of this jacket probably imitate the shoulder straps on an officer's coat. Assimilation of foreign symbols did not dilute the owner's Apache identity: the painting of the horned figure has a piece of shell attached to it, suggesting that it represents Child of Water, the culture hero who exterminated giants and monsters in primeval times. The jagged lines stand for lightning and symbolize communications from spirits.
© Museum Volkenkunde.

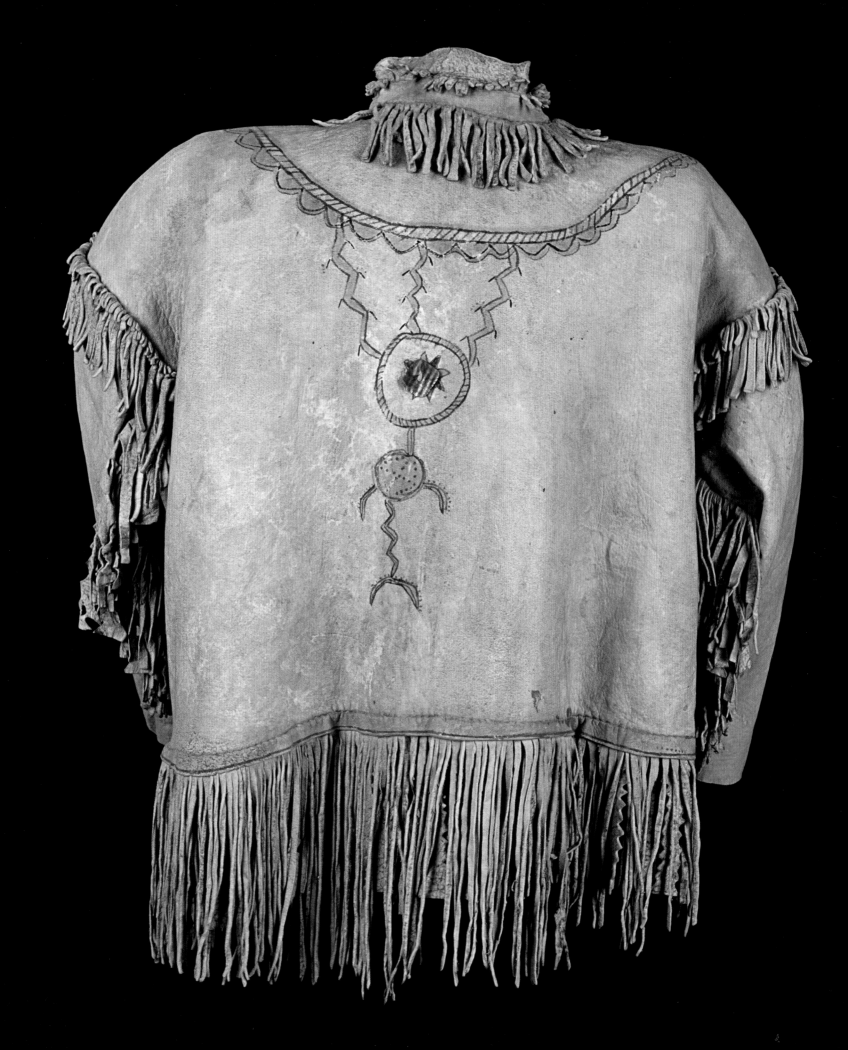

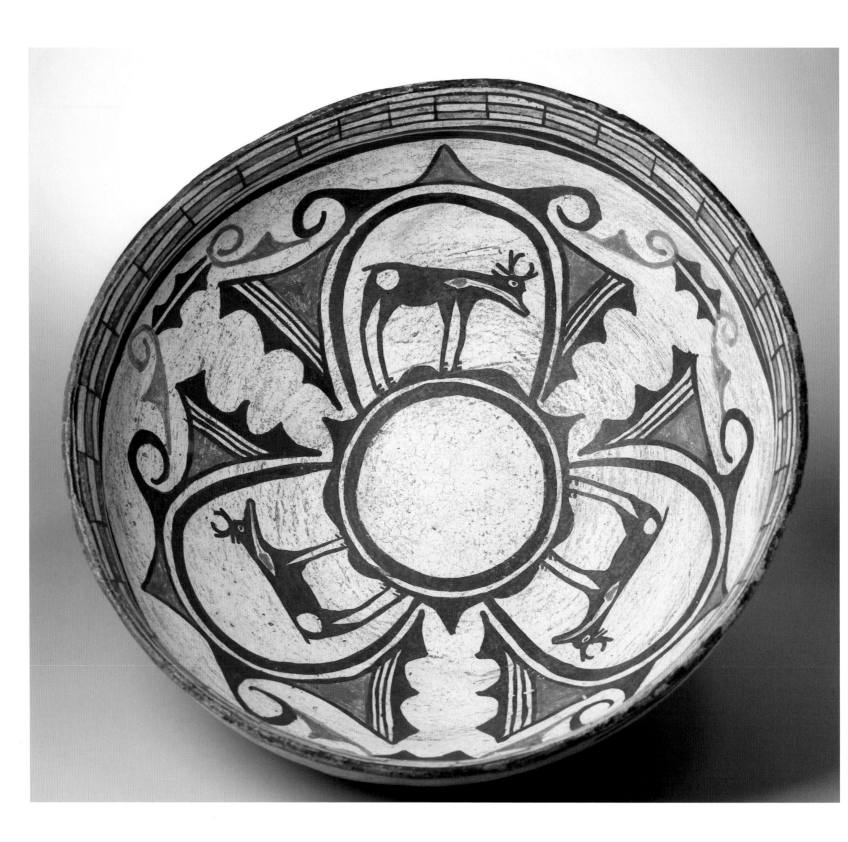

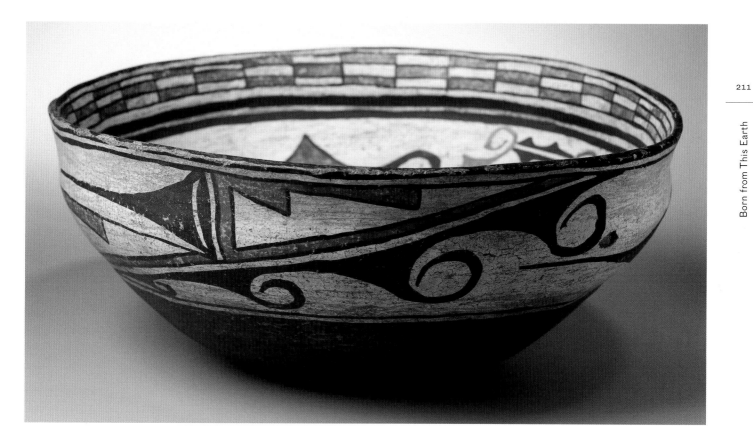

Polychrome pottery bowl, Pueblo Zuni, circa 1890.
Diameter, 15 inches / 38 cm. Deer standing under a scroll called the "deer's house"
is a popular design on Zuni pottery. The "life line" or "heart line" pictured in the animals
was introduced from the far north by the ancestors of the Apache and Navajo.
Courtesy Heritage Auction Galleries, Dallas, Texas.

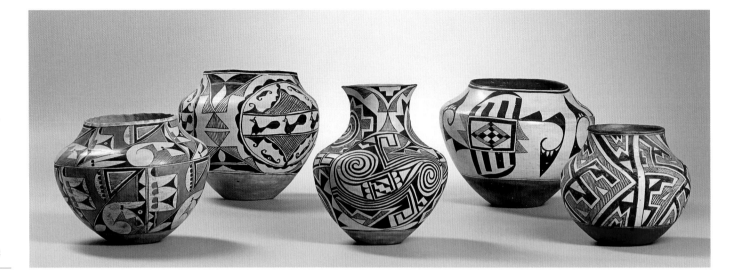

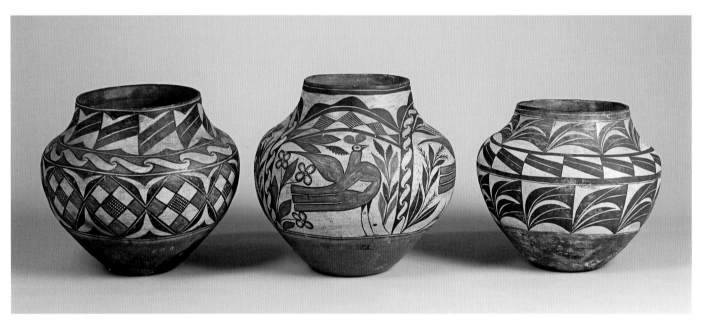

Polychrome pottery ollas, Eastern Pueblos, late 19th century.
Height, 10 to 12 inches / 25–30 cm. Lower left to right: Zia, Zia, Acoma.
Talented potters in Pueblo villages continue to produce beautiful ceramics.
Courtesy Skinner, Inc. Boston and Bolton, Massachusetts.

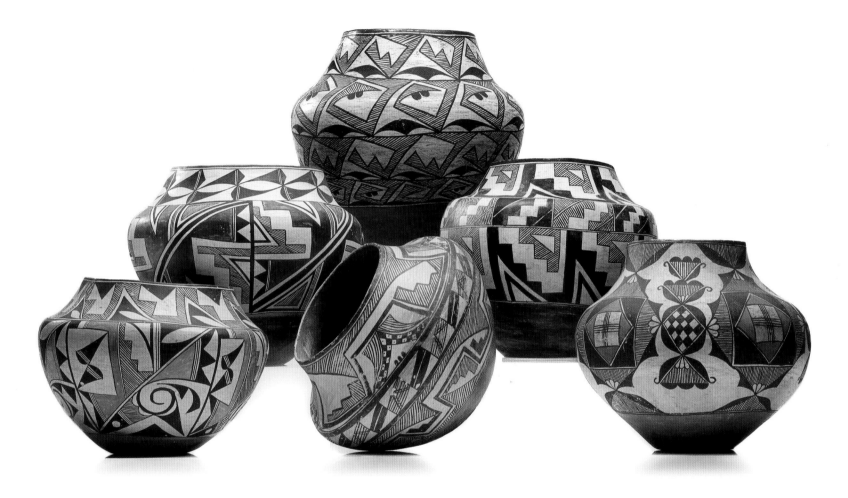

Polychrome pottery ollas, Pueblo Acoma, 20th century.
Height, 8 to 12 inches / 20–30 cm. Many of the designs
decorating this pottery can be traced back to Anasazi times,
though they now appear in different compositions and are
occasionally combined with floral elements of Spanish origin.
Courtesy Cowan's Auctions, Inc., Cincinnati, Ohio.

Basketry tray. Western Apache or Yavapai, circa 1900.
Diameter, 15.75 inches / 40 cm. Coiled basketry, made with the split shoots of willow, devil's claw splints for the black design, and yucca roots for the red details. In the 1880s, western Apache and Yavapai were placed together on the San Carlos Indian reservation; following this internment, their basketry has become indistinguishable. Literally thousands of baskets were produced by the women as a source of income during the early reservation period. Courtesy Skinner, Inc. Boston and Bolton, Massachusetts.

Basketry tray, woven by Peggy Black, Navajo, circa 1990.
Diameter, 17.5 inches / 44 cm. Coiled of natural and dyed sumac,
depicting the American flag swirling out from the center of the basket.
A far cry from the old utilitarian baskets, but a nice example of the
contemporary trend toward art for the galleries. Basket making is
attracting many young Navajo women, and several women in the Black
family are among the foremost innovators in modern Navajo basketry.
Courtesy Cowan's Auctions, Inc., Cincinnati, Ohio.

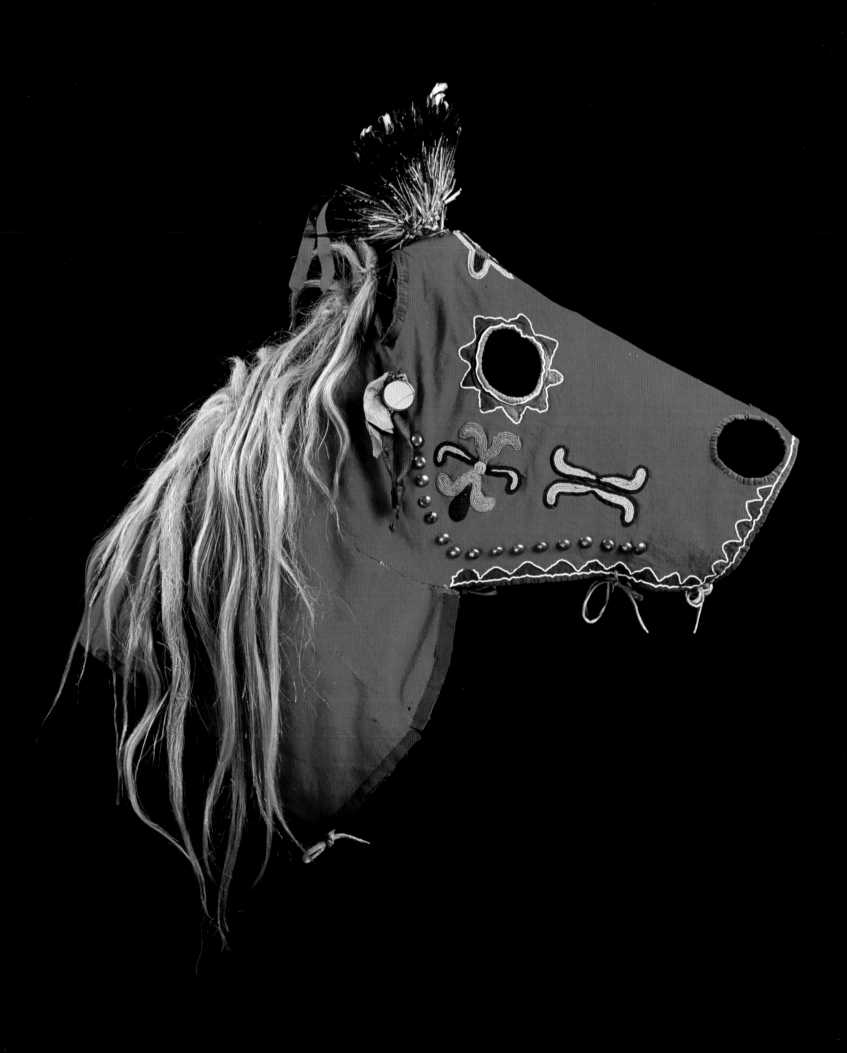

8 | Of Diggers and Prophets

Previous page: **Horse mask, NezPerce, circa 1875–1900.**
Beadwork on red trade cloth. Masks were part of the horse complex adopted from
the Spanish explorers of the southern Plains in the 17th century. They are known
from the Plains Indians, and horse masks were observed among the Plateau Indians
as early as 1844. The star design on front of this mask is emblematic of the prophet
Smohalla's Dreamer Cult. Clusters of flicker feathers are frequently attached on
top of Plateau horse masks; there may have been an association with war honors.
Courtesy Thaw Collection, Fenimore Art Museum, Cooperstown,
New York. Photo by John Bigelow Taylor, NYC.

The vast Intermontane region stretches from the Rocky Mountains to the east to the coastal mountains to the west, and from the interior of British Columbia down to the Mohave Desert in southern California. This region has been viewed as the underdeveloped hinterland of the Northwest Coast and California Culture areas. Usually, however, it is treated as two distinct culture areas, the Columbia Plateau in the north and the Great Basin in the south. Yet the cultural differences between these two areas were incremental and reflected primarily the gradual change in the natural environment. Beneath these cultural differences, we perceive a basically similar focus on the gathering of edible plants and seeds, fishing and hunting, in that order. Both areas had in common a great variety of basketry. Gathering, fishing, hunting and basketry were the basis of the economy of the ancient desert culture, and the common background of native life throughout the Intermontane. Observing the native women scrabbling daily for roots, white pioneers scornfully called them "Diggers," but these Indians had survived in a harsh environment for untold generations.

Thanks to the western mountain ranges, the whole Intermontane tends to be dry in terms of rain and humidity, and treeless sagebrush plains were not restricted to the southern parts. But two great river systems, the Columbia and the Fraser, and many lakes, provided the Plateau with water. Each spring these rivers and their tributaries were filled with salmon and other fish. Along the rivers, forests teemed with deer and elk, antelope grazed on the high plains, and edible roots and berries abounded in the valleys.

Much of this bountiful environment continued along the Snake River into southern Idaho and along the mountains in western Colorado. Extensive forests surrounded the Humbold River in northwestern Nevada, and groves of nut-growing pinon trees were spread along several mountain ridges in the Great Basin. Beyond these isolated locations, however, vast alkaline deserts extended southward. Except for the Colorado River along its eastern margins, water was restricted there to a few streams, which emptied into lakes and brackish marshes. Much of this water came from bitter cold snowstorms during the winter.

Still, Great Salt Lake was much larger, and there were more lakes when the first people appeared in the Basin, some 10,000 years ago. They may have come down from the Plateau, where long before, people already had fishing camps along the rivers. The ancestors of the Umatilla, Yakima, NezPerce and other Sahaptin-speaking tribes arrived along the Columbia River about 8,000 years ago; Shuswap, Okanagan, Spokane and other Salish speakers settled in their historic locations some 4,000 years later. Throughout the West, the native people followed a seasonal cycle

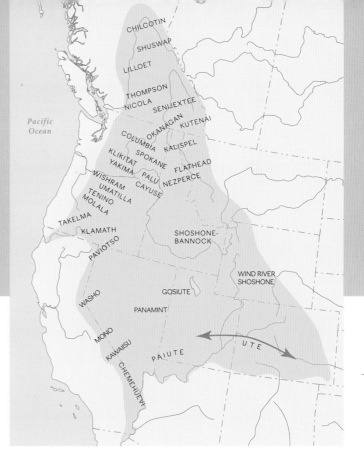

in gathering nature's resources. A detailed and extensive knowledge of wild plants and the habits of fish and game was passed on from generation to generation. The Indians spent much of the year on the move in small bands, fishing, hunting and harvesting the wild flora. Rudimentary shelters sufficed for the short periods spent in each location. Clothing was minimal, though the women used front and back aprons or skirts made of twined sage bark. In winter, robes made of rabbit pelts that had been cut into strips and braided together were worn. More protective clothing made of shredded bark and elk skin prevailed in the northern parts of the Plateau.

This was the ancient heartland of North American basketry, and the handiwork covered a range of objects, from twined and coiled utilitarian containers to bags, baskets and hats decorated in various techniques. The earliest baskets were made by twining double weft strands around vertical warps. Twined-woven hats protected the women's heads from chafing when they used burden straps to carry large baskets or cradleboards on their back. Water was stored in pitch-coated twined-woven bottles. False embroidery decorated the women's hats, and in different designs on both sides of soft flat bags. In coiled basketry a continuous coil of twigs, roots, other fibers and colored bird quills was wrapped and sewn together in a spiral. Baskets of tightly coiled

willow shoots were waterproofed by soaking them for some time, thereby expanding the willow coils. These baskets were used for cooking: fire-heated rocks were dropped into the stew. The Salish-speaking people were known for their coiled baskets decorated by imbrication, in which strips of colored bark were applied like shingles over the coils.

They adjusted indiscriminately to the available edible resources, which included nuts, berries, seeds, roots, rabbits, rats, lizards, locusts and other insects, fish, waterfowl and their eggs and, occasionally, antelope, deer and mountain sheep. Moving down the Columbia River in 1805, Lewis and Clark found the shores dotted with drying racks, all laden with salmon. Wooden weirs were constructed across the spawning tributaries of the main rivers, and platforms extended from the shores, from which the fish were dip-netted or speared. White stones were sunk below these platforms so the fish were easier to see, and paintings on the steep rocky shores were believed to attract the

Clay figurine, Fremont culture, Utah, circa AD 950–1200.
Length, 6.125 inches / 15.5 cm. Figurines made of clay, stone and wood, the majority of them representing females, were widely distributed in the prehistoric Southwest. Most elaborate are the examples created by the Fremont people, which detail hairstyles, jewelry, skirts and red face paint. Their function is unknown, though female figurines the world over were associated with fertility and procreation. In recent times, Indians have buried such figurines in their fields, presumably to promote the growth of corn. Courtesy N. Morss, *Clay Figurines of the American Southwest,* Papers of the Peabody Museum of American Archaeology and Ethnology, Harvard University, vol. 49, no.1, 1954. Reprinted courtesy Peabody Museum, Harvard University.

Facing page: **Petroglyph, Cottonwood Canyon, eastern Utah, circa AD 1000.**
Scraped in the sandstone wall, this drawing portrays several bowmen confronting a herd of bighorn sheep, a number of them followed by lambs. Standing among them is a horned being who may represent their guardian spirit, or the shaman who "called" the game. But why are the sheep all linked together? Courtesy Ira Block / National Geographic Image Collection.

fish. In the fall, nets half a mile long were strung in the southern deserts to enclose semi-circular areas for rabbit drives. If there were enough antelopes, a shaman might organize a communal drive hunt, using runways and corrals similar to those used by Plains Indians in buffalo hunting.

In late fall, the families came together in winter villages. They sheltered in sturdy lodges that were covered with earth or woven mats in the Plateau, and with brush in the Great Basin. Provided with dried meat and fish and storage pits and baskets full of nuts and seeds, the villages enjoyed a festive mood. Magpie feathers brightened the women's skirts during the harvest dances of the desert people. Winter was a time for dances, gambling and courtship. The impermanent communities precluded the development of elaborate ceremonials or great differences in social status. Existing rituals related primarily to birth, puberty initiations and death. Winter was also the time for night-long storytelling about Coyote and his brother Wolf, who created the world; of ancient times when people and animals still talked together; and about the spirits who owned and inhabited the land, lakes and rivers.

Warfare was largely restricted to the northwestern margins of the Intermontane, where coastal Indian slave hunters caused violence. Cultural influence from the Northwest Coast moved up the Fraser River after AD 1200, as evidenced by effigy bowls carved of

soapstone, war clubs made of whale bone, and a wooden mask found in Shuswap territory. Coastal influence was noticeable along the lower Columbia, and may have inspired the remarkable imagery in the art of the Wasco-Wishram people. Human and animal figures with skeletal details and human faces were carved on horn bowls and ladles, twined-woven on soft bags and pictured in the local rock art. Apparently, the meaning of these "X-ray" figures has never been recorded, but skeletal images were associated with a northern shamanistic ideology. Yet shamanism in the Intermontane was not overly dramatic. Shamans were believed to have the power to call the game, neutralize witchcraft and cure sick people. They acquired these powers from animal spirits in dreams, dreams like those in which many people acquired their guardian spirits.

The great rivers of the Plateau made possible travel in dugout canoes and a trade in surplus foods. A series of rapids in the Columbia River near present-day The Dalles created great fishing, attracting people from far and wide. As a result, the local Wishram villages became the greatest Indian market west of the Rocky Mountains. During the summer, the local population swelled to several thousand, and the continuous arrival of visitors was a cause of celebrations and endless gambling. Much of the trade was in the form of gift exchanges between established trading partners. Large quantities of fish were exchanged

for large baskets filled with roots, berries and meat. Ornamental dentalium shell from Vancouver Island was transported up the Columbia to the eastern Plains as early as 3,500 years ago; buffalo robes from the Plains were exchanged for twined flat bags and horn bows from the Plateau tribes; items traded at The Dalles have been found in prehistoric sites from California to Alaska. From The Dalles, major routes connected with similar trade centers on the lower Fraser River in British Columbia, on the Green River in western Wyoming and from the Green to the Mandan-Hidatsa villages on the Missouri River and with the Anasazi Pueblos in the Southwest.

As temperatures gradually rose in prehistory, the Great Basin became a poor and inhospitable country where the thinly spread population had to adjust to severely arid conditions. They did so by concentrating in the foothills of the mountains, near lakes, marshes and streams, and visiting seasonally productive locations in an annual circuit. They may have inhabited caves, which certainly served as storage places of surplus food, nets, duck decoys and other utensils. The abundance of prehistoric basketry is evidence of efficient harvesting and processing of edible roots, berries, seeds and nuts. Baskets, digging sticks and grinding stones, or "manos," were of major importance in this economy.

Since the Great Basin was lacking in resources,

beneficial contacts with neighboring regions remained rare for thousands of years, though black obsidian from the Basin reached the market on the Columbia River. By 500 BC, the spread of corn growing in the Southwest reached into the Great Basin as well, though it served merely as an addition to the harvest of the wild flora. Five hundred years later, increased agriculture had created the Anasazi Culture in the Southwest, and this development did not stop at the desert border. By AD 500, agriculture was adopted by some desert people in southern Utah and eastern Nevada. They established Pueblo-like settlements of adobe and masonry houses and made pottery, some of which was decorated with painted designs similar to those in basketry. This was the so-called Fremont Culture, well known for its rock paintings of tall ghostlike figures. Stylistically similar were enigmatic clay figurines of women with face painting, bedecked in shell necklaces; some wear fiber skirts similar to the regional female dress of early historic times. Anasazi influence was strong for a while, and its pottery has been found even in northern Utah. This Southwestern influence may have inspired the use of irrigation by the Paviotso of northwestern Nevada in the growing of certain wild plants, but they did not grow corn there.

From southeastern California, the Shoshone-speaking ancestors of the historic population of the

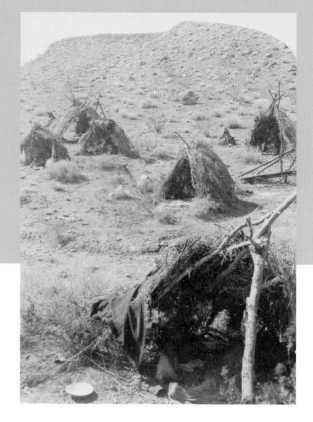

Great Basin were spreading throughout that region by AD 1000, some of them ultimately spilling across the Rocky Mountains. We know them as the Chemehuevi, Kawaiisu, Paiute, Panamint, Paviotso, Gosiute, Ute and Shoshone. They may have introduced the technique of coiled basketry, which spread northward about 700 years ago. Pecked into the rocks were pictures of bighorn and mountain sheep, often appearing near places frequented by the game and their trails, as a form of hunting magic. Rock art is always related to its environment, though the specifics may not be obvious to us anymore.

By AD 1000, a hunting group from the north associated with the Promontory Culture appeared in the Great Salt Lake region. They had disappeared by AD 1300 and may have been the ancestors of the Apache and Navajo in the Southwest. The removal of these nomadic hunters may have been related to the onset of a long period of widespread drought, which caused the Anasazi to abandon their great towns and cliff dwellings in the Southwest. The Fremont Culture also disappeared, the people probably reverting to their former desert culture. They may have amalgamated with the Paiute, among whom the growing of some corn survived into historic times.

❈

The dawn of history was recorded by the Intermontane Indians with pictures of horses and horsemen, painted on the rocks in Utah and Idaho. Unknown to the artists, their pictures were apocalyptic. They remind us of Albrecht Durer's engravings, made shortly after Columbus discovered the Americas, of the four horsemen bringing plagues, warfare and starvation in the end of times. The Ute Indians living on the southeastern borders of the Intermontane acquired their first Spanish horses in the 1650s. Many more horses reached the Indian trade center on the Green River after the Pueblo Revolt in 1680. When Lewis and Clark came down the Columbia River in 1805, they found plenty of horses at the trade center near The Dalles. Along the western slope of the Rocky Mountains, the arrival of horses brought about a dramatic change in the life and customs of the Ute, Shoshone, NezPerce, Flathead and all the tribes along the Columbia River.

Grassy plains in these regions offered good grazing, and large herds of horses became a prime form of

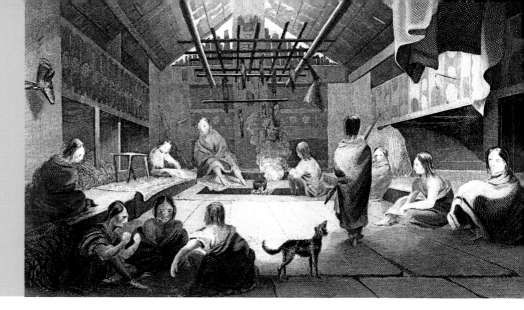

Mat-covered lodge, Umatilla, circa 1890.
The long, mat-covered lodge was the common winter dwelling in the Columbia River region. A narrow opening along the ridge allowed smoke to escape. The entrance was at one or both ends, depending on the length of the lodge. Some of these structures were up to 40 feet long and were inhabited by several families. Courtesy Oregon Historical Society, Portland, Oregon. Neg. 4466-A.

wealth on the Plateau. By means of selective breeding, the NezPerce and Palu developed the spotted Appaloosa horse in the 18th century, and horse racing became very popular. The horse enabled these people to form larger bands, which annually crossed the Rockies to hunt the buffalo on the high Plains. Warfare with Blackfeet and other Plains Indians made these expeditions dangerous, but in trading horses they adapted some of the customs of their rivals. The Ute, Shoshone and Plateau Indians adopted the use of tipis, Plains fashions in skin dress, and beadwork designs. Strong influence in these respects developed in particular with the Crow Indians in Montana. Several equestrian tribes adopted the Plains Indian Sun Dance.

Beyond the Plateau and western Colorado, the Intermontane was dry and lacked good browsing for horses. The desert bands continued their old way of life and treated the occasional stray horse as game. However, their peaceful existence was coming to an end. On horseback, Ute Indians raided the dispersed Paiute camps, capturing slaves for their trade with the Spanish in New Mexico; mounted warriors from the Columbia River also went slave-hunting, forcing the Paviotso to withdraw deeper into the desert.

✳

Rumors about white people in the Southwest may have spread in the late 17th century and given rise to the many prophesies later remembered by the Indians. It took another century before these strangers suddenly appeared from several directions. Spanish expeditions explored the southern Great Basin in the 1770s; British and American ships visited the mouth of the Columbia River in the 1780s and traded with the Indians; Canadian fur traders crossed the Rocky Mountains into the Plateau in the 1790s. Significant to the Indians was a volcanic eruption in the Cascade Mountains, which blanketed part of the Plateau with "dry snow," as they called the ashes, and set the stage for more prophets. Together with the first trade goods, venereal diseases and smallpox were imported. Starting in the 1780s, smallpox epidemics swept the native population several times during the 19th century.

When the Canadian traders established a string of trading posts along the Fraser and Columbia Rivers, they ran into some unexpected problems. Trade along the Columbia was subject to traditional regulations, and the local Indians did not accept the Canadian transports along their river. Native harassment forced the traders to hire native entrepreneurs for the transport of their goods. Unlike the Indians of the northern forests, many Plateau Indians initially refused to become trappers for the traders. The American traders along the Missouri had solved similar problems by

Facing page: **David Young Chief. Cayuse, circa 1900.**
The sturdy Cayuse horse was named for the Cayuse tribe, noted as horse breeders. As a prime form of wealth, their horses were elaborately decorated on festive occasions. After the Plateau Indians were confined to reservations, there were plenty of horse masks for use in parades and celebrations, such as the annual Pendleton Roundup. David Young Chief was the son of a prominent Cayuse leader. His shirt and extravagant headdress are richly decorated with ermine fur fringes. Courtesy National Anthropological Archives, Smithsonian Institution, neg. gn03073b68. Photo by Lee Moorhouse.

hiring frontier people as their own trappers, and they were now exploring the western mountains. Fearing the spread of these American "mountain men," the Canadian companies hired large numbers of Iroquois, Cree and Métis, and ordered them to exterminate the beaver in regions contested by the Americans. It was only in 1846 that the 49th parallel was accepted as the border between Canada and the United States.

Many Canadian trappers intermarried with the Plateau Indians, introducing the typical Métis "fire bags" and floral style spot-stitched beadwork. Traditional designs were adapted to woven beadwork by a few Indians on the Columbia River. The Iroquois trappers, who came from from Catholic missions in Quebec, spread the first notions of Christianity, which were rapidly assimilated as additional sources of "medicine power." Other versions of the new faith were spread in the 1830s by several Plateau Indians who had visited Fort Garry in Manitoba. As a result, a religious movement called the "Prophet Dance" spread throughout the northern parts of the Plateau. Prophetic movements may well have been common in the Intermontane, and this was certainly not the last one in historic times.

South of the Columbia River, the American trappers were penetrating Utah and Nevada, and they devastated the fragile resources of the native people. Competition with the "Diggers" was habitually settled with the gun. By 1825, these frontier people were coming every year to the Shoshone trade center on the Green River, changing it into their own boisterous and most famous "rendez-vous." Wagons from St. Louis delivered supplies and collected the beaver pelts from the mountain men. Many Indians joined in their horse races and festivities and traded their women to the trappers.

The Great Basin remained peripheral to the fur trade, but it became a thoroughfare for many thousands of emigrants to the West Coast. The Spanish Trail from Santa Fe to Los Angeles was established in 1830, followed by the Oregon and California Trails in the 1840s. The newcomers killed off the game, demanded grazing for their livestock and forced the native people to move away from the best natural resources. Their discarded garments were salvaged, and as a result, the desert tribes gradually adopted more clothing. In some areas, the native population was entirely eliminated because of reduced food supplies, hostilities and disease.

In 1847, Mormon pioneers arrived at Great Salt Lake and established their settlements wherever water promised success in farming. The Mormons believed that the native people were the descendants of the "lost tribes" of ancient Israel, which belief inspired their efforts to convert the Indians to the Mormon faith. Moreover, their leader, Brigham Young, was of the

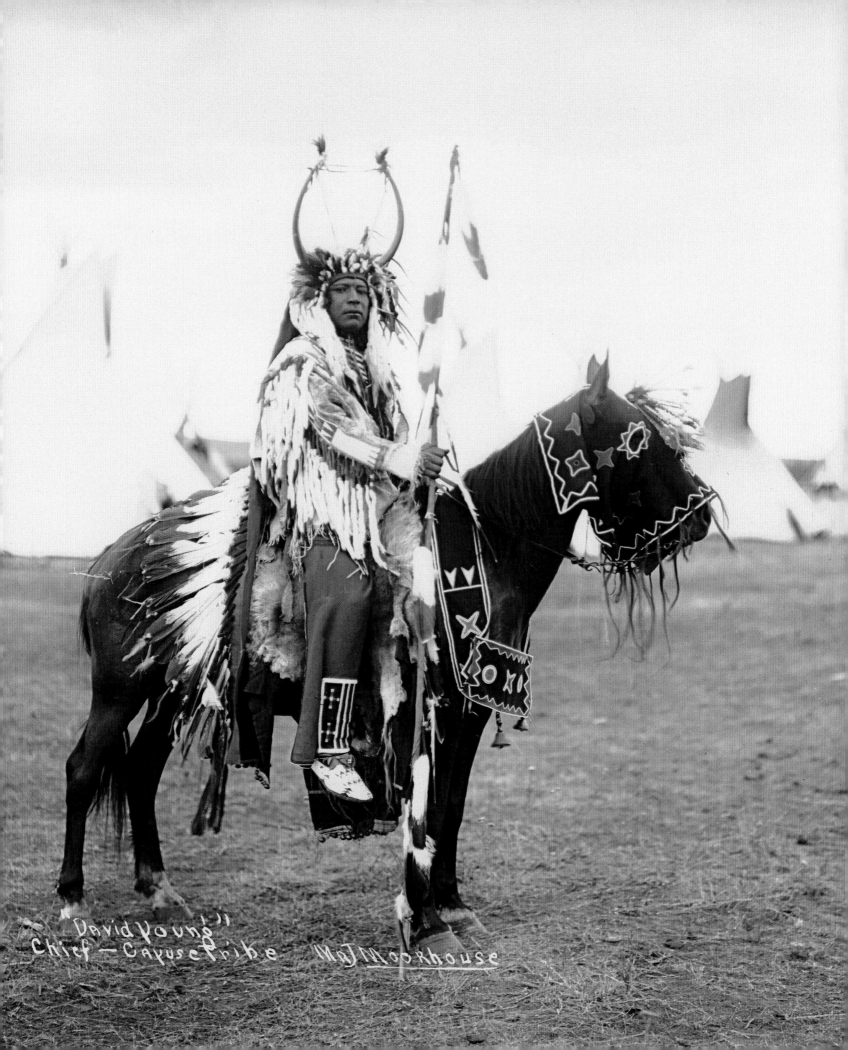

"David Young" Chief—Cayuse Tribe Maj Moorhouse

Plate 221

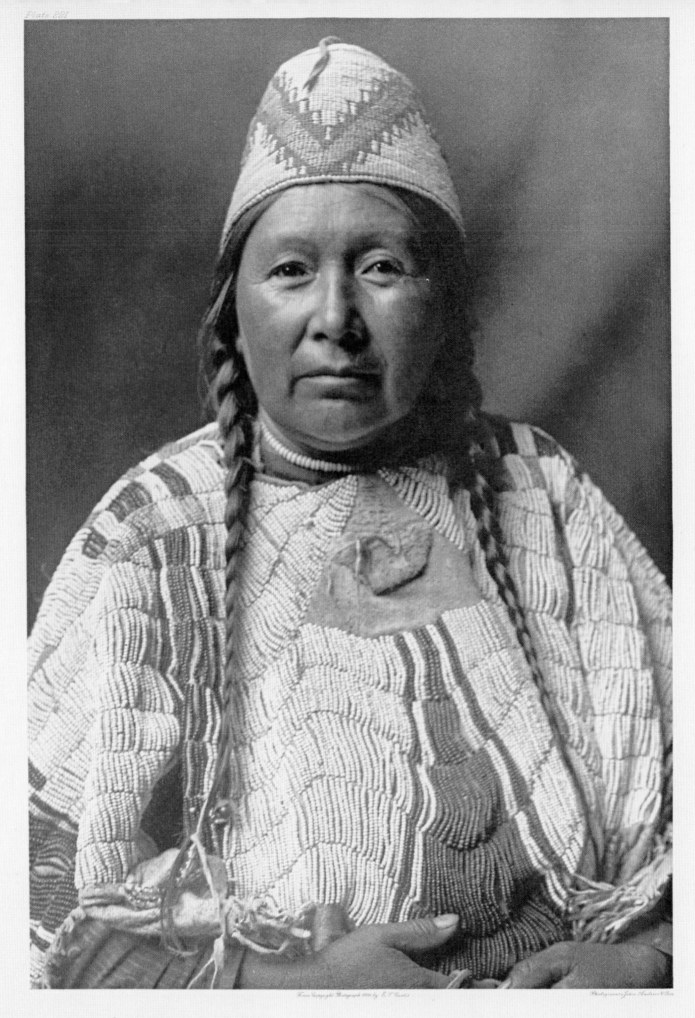

From Copyright Photograph 1910 by E. S. Curtis

Photogravure John Andrew & Son

WIFE OF MNAÍNAK - YAKIMA

Facing page: **"Wife of Mnainak – Yakima," circa 1910.**
Photo by Edward S. Curtis. The undecorated piece of skin
below the neck of this woman's dress identifies it as a "deertail
dress," of which the tail part of the deerskin is folded down
along the shoulder line. On Plateau dresses, this upper part
is always heavily covered with very long lane-stitches of pony
beads. Her hat also seems to be covered with beadwork.
Courtesy Northwestern University Library.

opinion that "it is cheaper to feed the Indians than to fight them." However, their settlements and protests against the Ute Indians' slave trade of Paiute children led to warfare. The defeat of the Utes finished their slave trade, but it started a long-continued and large-scale "adoption" of Indian children by the Mormons. This program of assimilation replaced the largely unsuccessful mission work among the desert Indians.

Whatever peaceful life was left for the desert Indians vanished in 1848 with the discovery of gold in California, and shortly after that, of gold and silver in Nevada. Prospectors swarmed all over the country; settlers cut down the pine-nut trees for fuel, and their horses and cattle trampled the wild vegetation on which the Indians depended for food. Indian camps were burned, and taking potshots on the "Diggers" was deemed "fun"; smallpox and other imported diseases killed even more Indians. The desert Indians were too poor and disorganized to offer effective resistance. After the destruction of their world, they became beggars, lingering in shantytowns and gradually finding employment as underpaid laborers and housekeepers on farms and ranches. Due to overgrazing and farming, the gathering of wild plant foods had been severely reduced, but basket making was to become a much needed source of income.

Probably in response to cultural deprivation, several religious dances spread among the desert Indians in the 1860s. Prophets and their promise of world renewal were not new in the native religion. In 1888, revelations came to Wovoka, a ranch hand known also by his employer's name, Jack Wilson. The Ghost Dance had originally been taught by the mythical Old Man Coyote as a ceremonial to drive out the ghosts of disease, but Wovoka's version promised the return of game and departed relatives, and the disappearance of the white people and their evil works. Thanks to the white man's communication systems, the movement spread rapidly beyond Nevada. Native pilgrims from Canada down to Oklahoma came, by train, to hear the message from the prophet personally. The religious frenzy of the Indians frightened the American people, culminating in the massacre of Sioux Indians at Wounded Knee.

In the Plateau region, prophecies about the coming of white missionaries had inspired delegations of Flathead and NezPerce Indians to travel to St. Louis in the 1830s, urging Catholic priests to come to their country. Protestant missionaries headed west immediately, but their efforts to introduce farming and harsh disciplinary methods met with resistance from the Indians. The native people lost interest when the hoped-for world renewal did not materialize, and their resentment increased with the waning of the fur trade and the arrival of more and more white settlers.

The murder of Protestant missionaries in 1847 started several decades of violence, which were

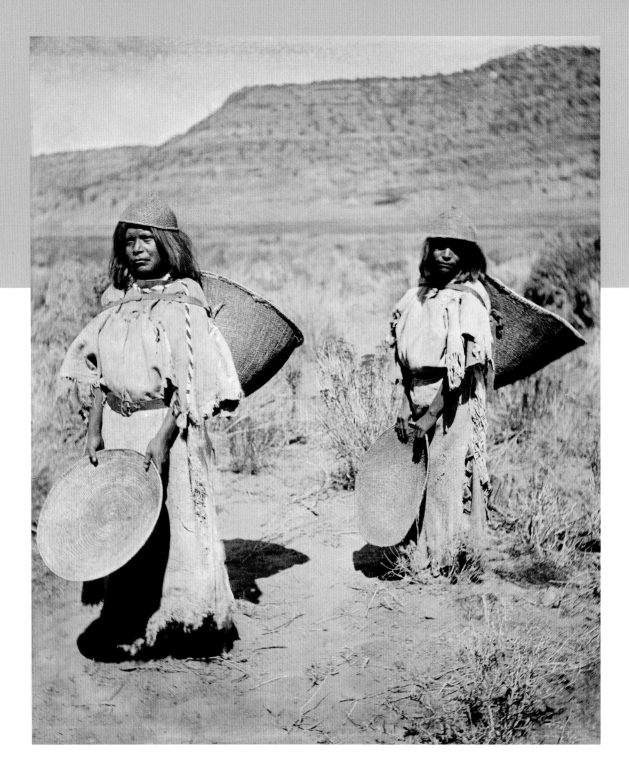

Southern Paiute women in 1873,
wearing twined hats and carrying twined burden baskets on their
back, and trays for gathering and winnowing seeds. This picture has
become stereotypical for the Great Basin Indians, but the photographer
came prepared for the actual lack of clothing: he brought along
some buckskin dresses from the Ute Indians in Colorado.
Courtesy National Anthropological Archives, Smithsonian
Institution, neg. gn1607. Photo by John K. Hillers.

worsened by the discovery of gold in the interior of British Columbia, in Idaho and in Colorado, and by the "pacification" methods of the U.S. Army. Well known is Chief Joseph's defiance of the American army in 1877; he led his 700 NezPerce families more than a thousand miles from Idaho toward Canada.

The Indians' refusal to settle in reservations and become farmers related to an intensely emotional bond of the people with their homelands, and the belief that plowing the land would hurt and insult Mother Earth. This opposition to agriculture was part of the visionary messages spread by the prophet Smohalla in the 1870s. Forced to accept reservation life, the native people were subject to policies meant to destroy their culture and identity. Religious movements continued as the major resistance of the Indians. The "Shaker" cult spread from Puget Sound all over the Plateau; organized as an independent church, it has still its adherents in the region. The peyote rituals of the Native American Church are attended by many Indians of the Great Basin.

The transition to the white man's lifestyle was gradual. Hunting, fishing and the gathering of wild plant foods continued wherever possible. By the late 19th century, store-bought pots and pans were replacing much of the basic basketry, but new incentives for basket making emerged as Indian baskets became increasingly popular among collectors and dealers. This transition from native utility to a non-Indian art market led to several changes and innovations, ultimately altering the indigenous art styles. Traditional baskets did not disappear, but smaller gift baskets decorated with pictorial designs were popular among tourists. Pictures of butterflies, birds, lizards, snakes and human figures began to adorn the coiled baskets of the Washo, Panamint, Paiute and Chemehuevi. Outstanding basket makers became known by name. Datsolalee, also known as Louisa Keyzer, was a Washo woman who created many baskets of great beauty from 1895 until her death in 1925. The twined and coiled baskets of the Paiute on the San Juan River in northern Arizona had long been popular among the Navajo. In recent years, innovative new designs have been created by a local trading post, and basketry continues to be a viable craft among these Paiutes.

Among the Plateau tribes, basket making declined as the people moved to reservations, though production continued for native use among several tribes. Traditionally used in gathering roots, twined soft bags became more colorful when their function changed to purses used at festive occasions. Bear grass was replaced by cornhusk and yarn in the false embroidery on these flat bags. Coiled and imbricated baskets are still made by the Lilloet in British Columbia; they replaced split roots by cedar slats as the foundation in their rectangular coiled baskets. There has been a modest revival of imbricated coiled basketry among the Klikitat, Yakima and other Indians in Washington and Oregon. However, beadwork has become a major art expression of the Plateau Indians, used to decorate their festive costumes, horse trappings and a variety of bags and purses.

Major change came in 1934, when the Indian Reorganization Act of the American government promoted self-government by the tribal councils. Along the rivers of the Plateau, fishing by the Indians is protected by treaty rights; root digging and berry picking still motivates women to load their family in the car for a day out in the country. Strong emotional attachment to this activity finds expression in the Root Festival of the Umatilla in late April, the Bitterroot Feast of the Flathead in May, and the Huckleberry Feast of the Yakima in August. Rodeos have largely replaced horse racing, and many traditional ceremonies have changed into powwows. However, the annual Sun Dance is a great celebration among the Shoshone, Bannock and Ute Indians; and shamans still lead the singing in winter spirit dances on the Columbia River.

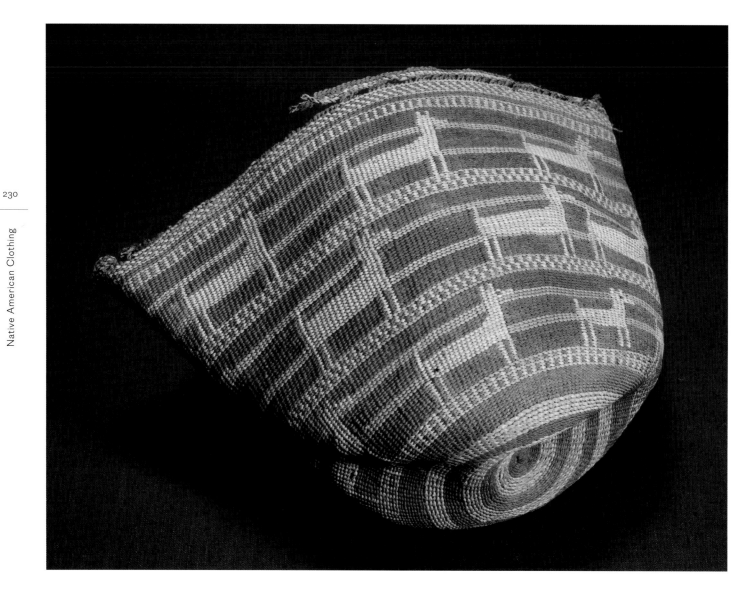

Twined-woven bag, Columbia River, Oregon, pre-1838.
Height, 7.875 inches / 20 cm. Woven of plant fiber. The
design of deer is executed in a decoration technique
called "wrapped twining." Designs of this type survived in
basketry of the Twana on Puget Sound until circa 1900.
Courtesy Historiska Museet, Lund University.

Facing page: **Flat twined bag. Spokane, mid-19th century.**
Dimensions, 29.75 inches by 23.5 inches / 75.4 x 59.6 cm. Often ascribed to the
NezPerce, flat twined bags were made by many Plateau tribes. Created without a
loom, these flat bags were decorated in false embroidery while twining the bags in
the round. Native hemp fiber served as the basic structural warp and weft; bear- and
rye-grass were wrapped around the weft to create different designs on on both sides.
Courtesy Northwest Museum of Arts and Culture / Eastern
Washington State Historical Society, Spokane, Washington.

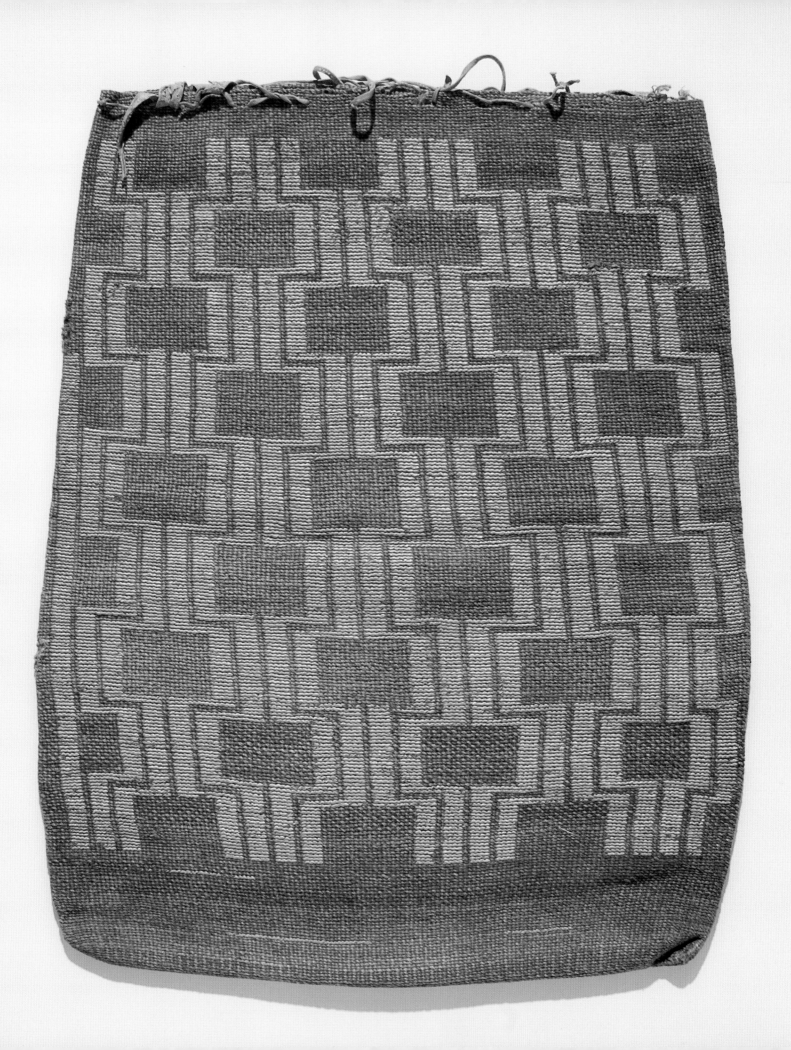

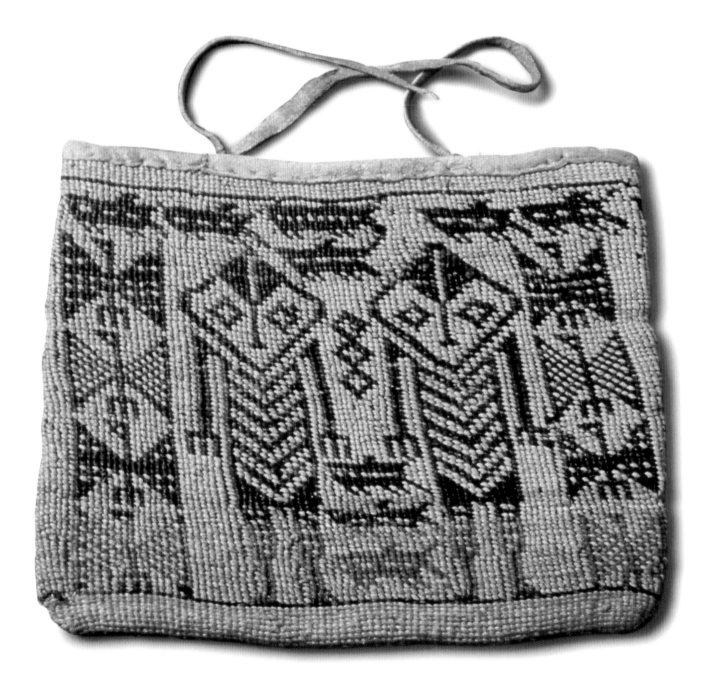

Flat twined bag, Wasco-Wishram, 19th century.
The false embroidery shows human figures in X-ray style,
birds and sturgeons; birds and mammals are on the reverse.
Courtesy Maryhill Museum of Art.

Facing page: **Horn bowl, Wasco-Wishram, circa 1800.**
Width, 6.25 inches / 16 cm. The curved horn of bighorn sheep was
boiled until soft enough to be carved and shaped into bowl form.
Horn bowls with slotted rim handles, decorated with X-ray figures,
have been unique for the Wasco-Wishram for many centuries.
Courtesy Trotta-Bono. Photo by Justin Kerr.

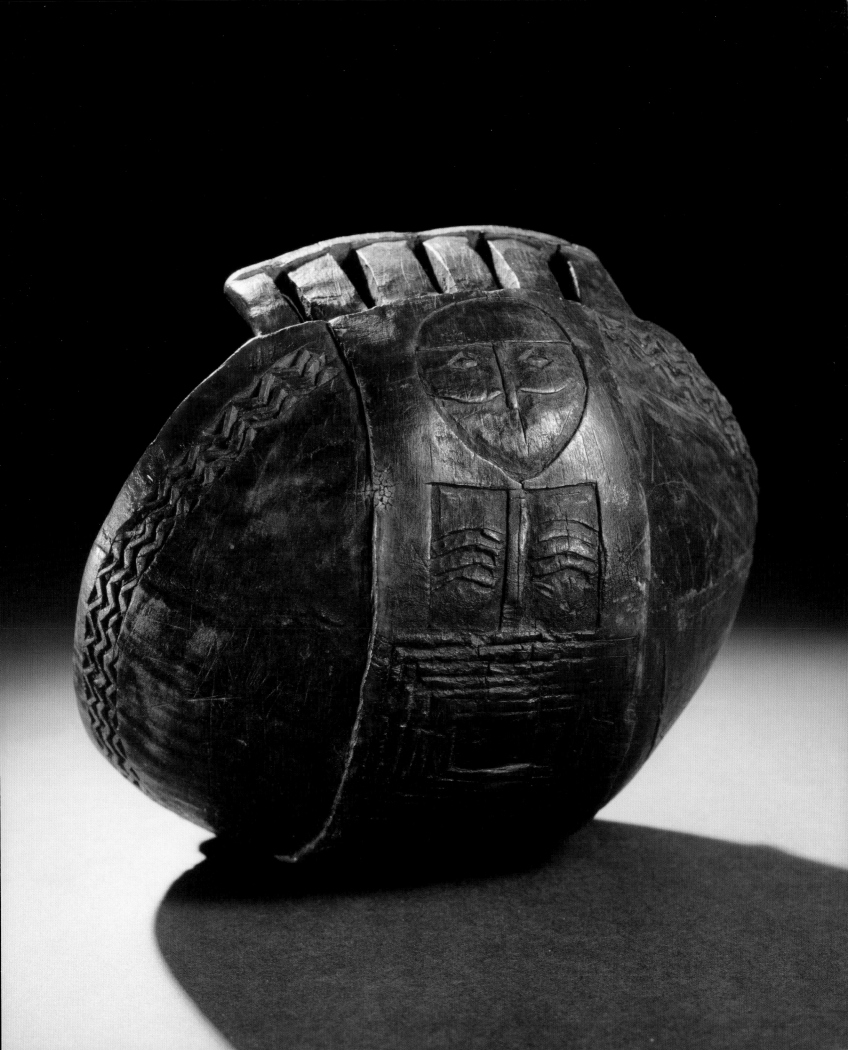

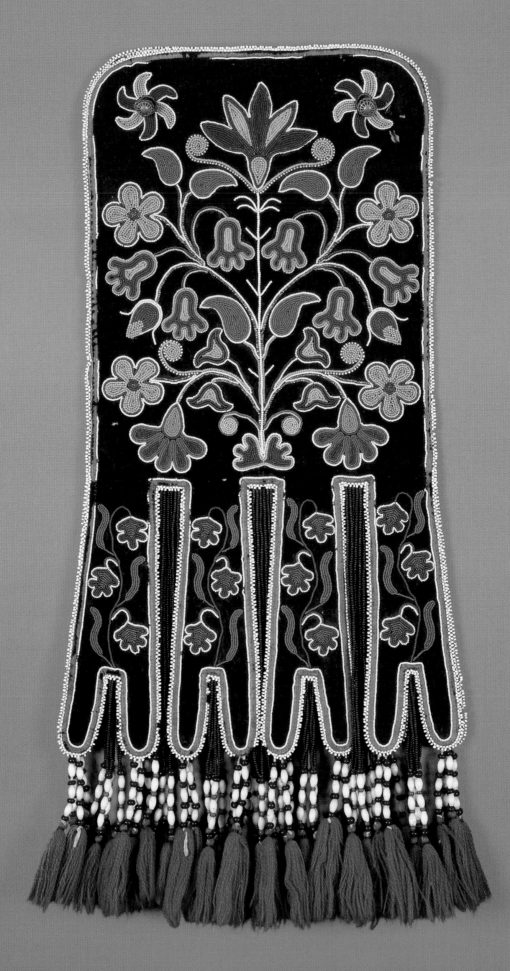

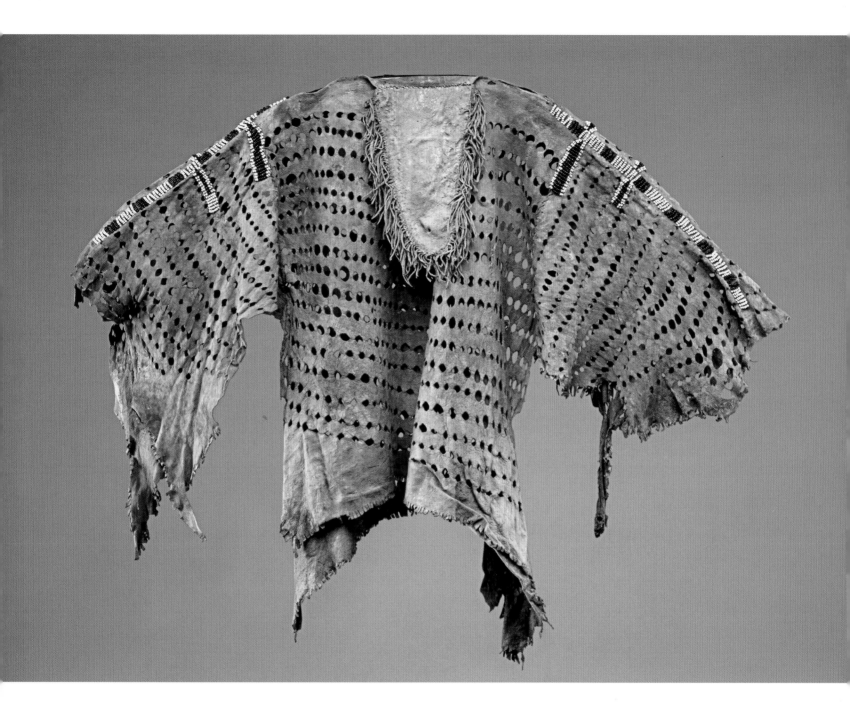

Facing page: **Fire bag, Plateau, circa 1860s.**
Employed in the Canadian fur trade, the Red River Métis introduced their distinct apparel and floral style of beadwork throughout the northwestern parts of Canada and across the mountains into the Plateau region. The large numbers and poor documentation of these pouches are the strength as well as a weakness in their identification. This example was once incorrectly attributed a more northern origin by this author. Actually, the beadwork designs are very similar to those on cradleboards of the NezPerce, Flathead and Kutenai. Called "fire bags" in the fur trade literature, they are commonly cataloged as "octopus bags" in museum vocabulary.
Courtesy Charles Derby, Northampton, Massachusetts.

Pierced shirt, Plateau, 1840s.
This type of shirt was associated with warfare among the Blackfeet Indians. An example of Plains Indian influence, the shirt was adopted by the equestrian Plateau tribes, though it is not known whether they also believed in the magical protection of these shirts.
Courtesy John and Marva Warnock Collection / www.splendidheritage.com

Man's shirt (front and back), Plateau, circa 1880.
A good example of the strong Crow Indian influence in the
beadwork designs, the rectangular neckpiece, or "bib," and the
use of long ermine fur fringes on the sleeves. Striking are the blue
and red painted bands in a style unknown from the Plains.
Courtesy the Doris Swayze Bounds Collection, High Desert
Museum, Bend, Oregon. Cat. no. 6.19.1.

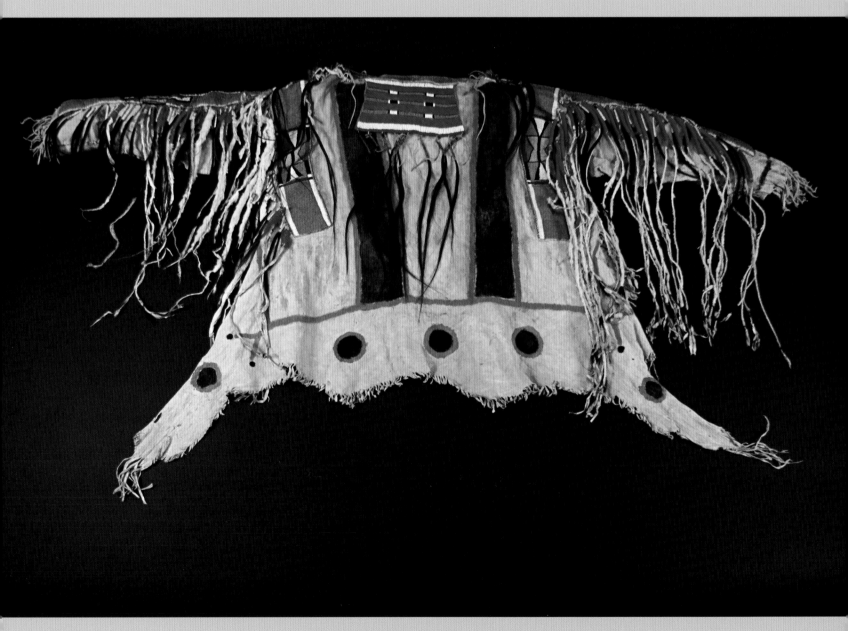

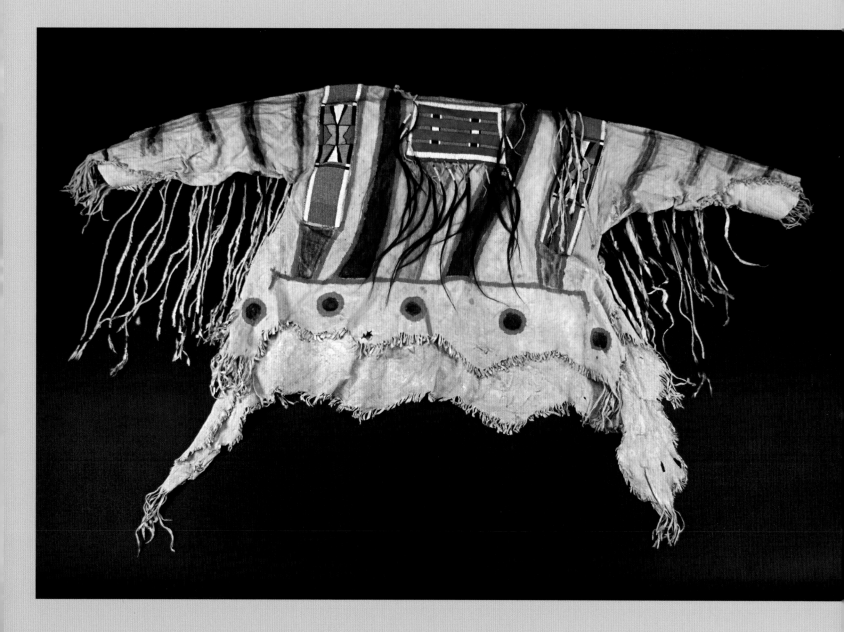

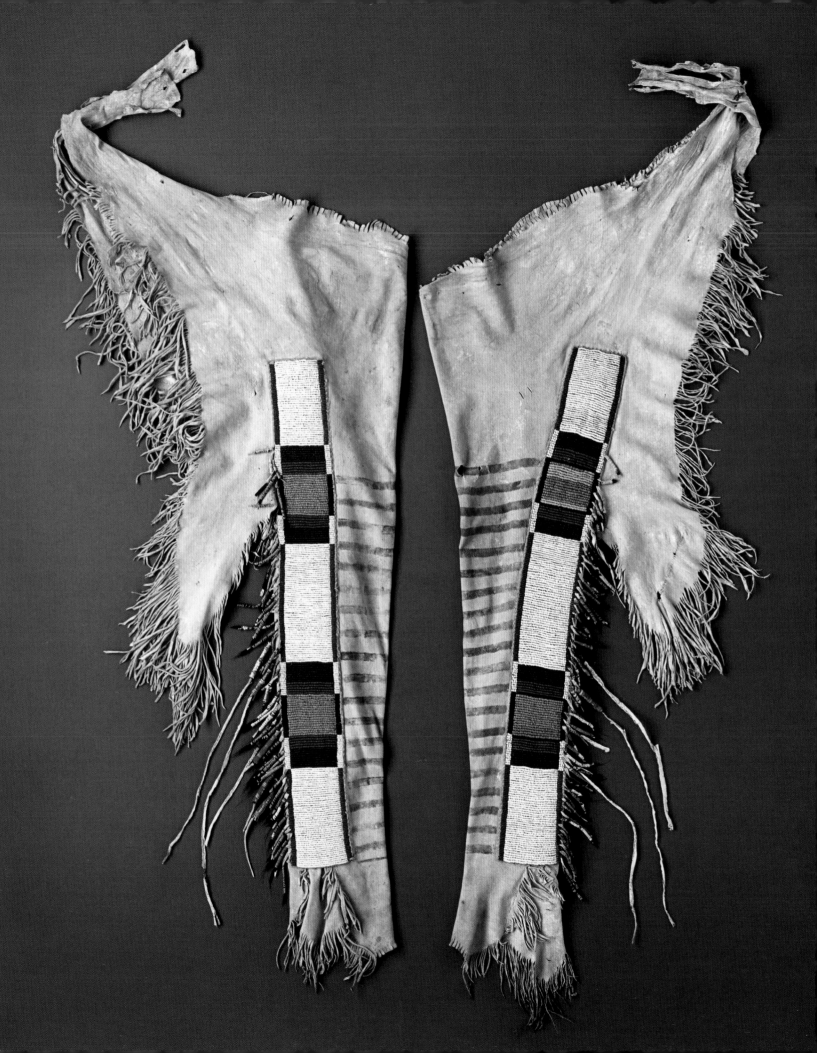

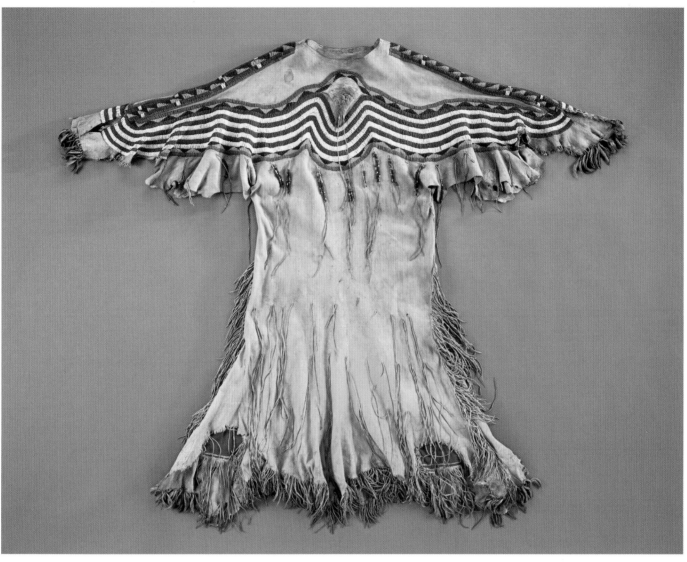

Facing page: **Man's leggings, NezPerce, 19th century.**
Popular in NezPerce beadwork, this blocked pattern
is a simplified version of a Crow Indian design, in a
different color combination. Also adopted from the
Plains were the battle stripes painted on the leggings.
Courtesy John and Marva Warnock Collection /
www.splendidheritage.com

Above: **Woman's dress, NezPerce, circa 1870.**
This is an example of the so-called "deertail dress," consisting of two large
deerskins. In order to form the shoulder line, the rear parts of the skins were folded
over and sewn together along this fold. The folded-down hindquarters form an
undulating line across breast and back, with the tails in the center. Along this curved
edge, a wide band of red and white lines was created in beadwork, very similar to
the standard decoration on Blackfeet dresses. Significantly, skins of female animals
were used for the woman's dress. The skin of the deer's udder is at the elbow
area of the sleeves, where a baby would have access to its mother's breasts.
Courtesy John and Marva Warnock Collection / www.splendidheritage.com

Native American Clothing

Coiled basket, Plateau, 19th century.

Alder bark wrapped around a core of split cedar root. In the process of coiling, extra filaments of bear grass and cedar bark are folded into the wrapping to create the designs. This "imbrication" technique is restricted to the native people of Washington and the interior of British Columbia. Attached is a twined-woven burden strap. Baskets of this type are traditionally used in berry picking. Even today, picking is not done with metal or plastic containers. Courtesy Cowan's Auctions, Inc., Cincinnati, Ohio.

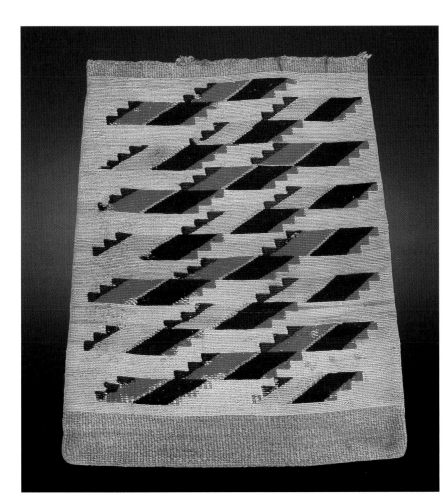

Flat twined bag, Plateau, circa 1880.
Length, 22.5 inches / 52 cm. Indian hemp, false embroidered with Germantown yarn. Formerly used in storing and trading edible roots, these bags continue to be prized as women's handbags at festive occasions. Invariably, the designs on both sides are different. Widely traded and used as gifts, their precise origin is seldom remembered. Though usually attributed to the NezPerce, these bags were made by several tribes of the Columbia River region. Courtesy Cowan's Auctions, Inc., Cincinnati, Ohio.

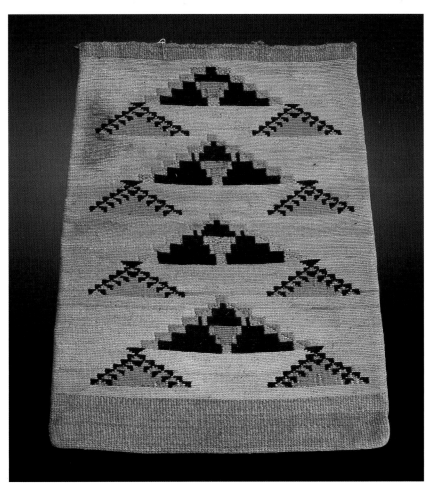

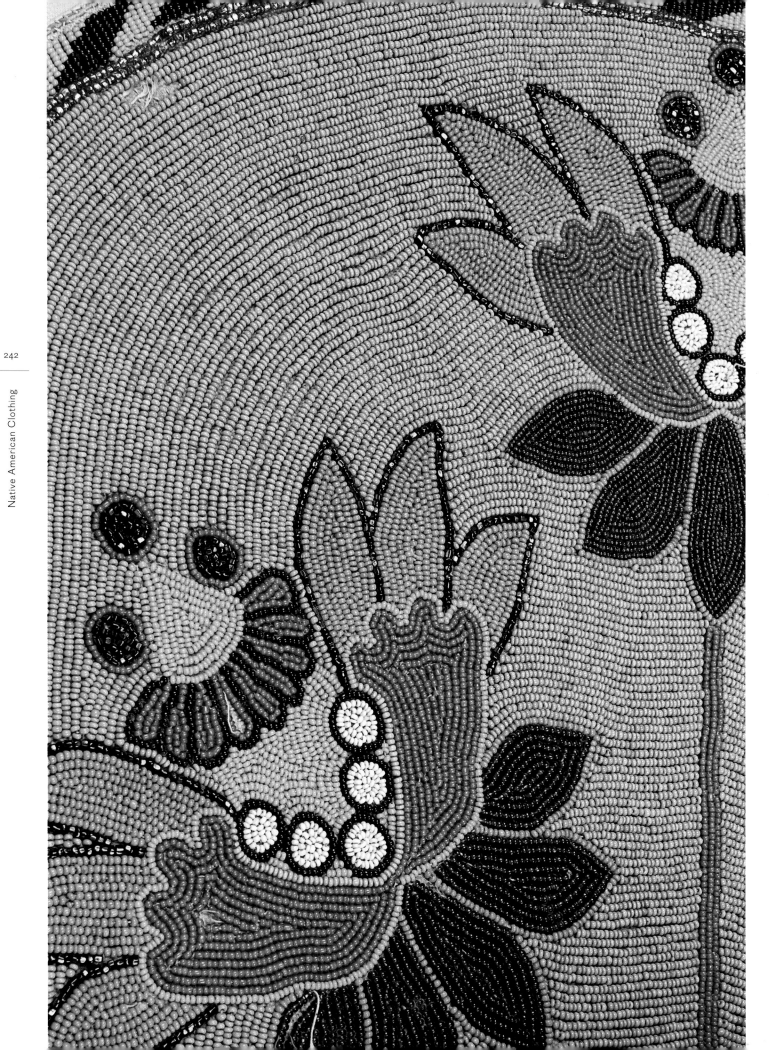

Cradleboard, Yakima, circa 1890.

Length, 41.5 inches / 105 cm. A flat wooden backboard, sewn into deerskin, with a protective bow of red and blue cloth around the baby's head. The upper part of the board is covered with floral designs in spot-stitch beadwork. Babies were considered a blessing, which is reflected in the careful construction and decoration of these cradleboards. When the baby was a few weeks old, it was swaddled in soft skins and laced into the cradle's bag. The latter was stuffed with dry moss, cattail down or similar materials to absorb the child's waste between changings. Usually attached to the head of the board was a small pouch containing the baby's navel string. Fastened to the back was a strap so the mother could carry the cradle on her back or hang it on her horse's saddle. Cradleboards of this type were used during the 19th century from the Ute in Colorado to the Kutenai in British Columbia.
Courtesy Heritage Auction Galleries, Dallas, Texas.

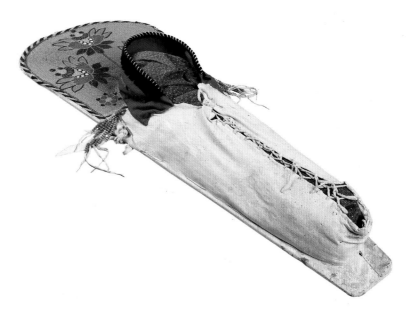

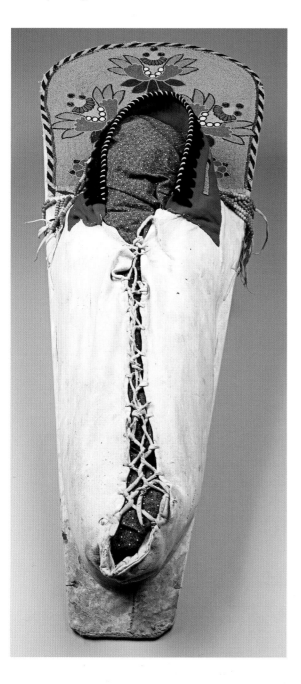

Women's hats, Cayuse, 19th century.
Twined of native hemp, with the designs created by dyed bear grass wrapped around the twining. In contrast to the bowl-shaped hats of the Great Basin and California, those of the Columbia River women are tall and fez-shaped. Used daily in the past, these hats are still worn on festive occasions. Most of the twined hats worn today are old and highly prized family heirlooms. Altogether, there are at most 10 weavers still active among the Yakima, Umatilla and other tribes.
© McCord Museum. Cat. nos. ME- 928.56, M-275.

Netted beadwork collar, Mohave, circa 1890.

Dimensions, 20 inches by 9 inches / 51 x 23 cm. The fringe is trimmed with American dimes, dating from 1875 to 1889. This collar would be worn by Mohave women around the neck, reaching across the chest and back to the ends of the shoulders. The restriction to dark blue and white beads is characteristic for early examples, when the designs were similar to those on Mohave pottery. Initially, these collars were the only apparel covering the upper part of the women's bodies; a skirt of shredded willow bark was their only other garment. However, when the use of these collars was first recorded in 1883, the women had already adopted cloth capes. Mohave women still wear these beadwork collars at celebrations. Netted beadwork of this type is rare in North America, restricted to the southern margins of the Great Basin and the Greenland Eskimo. This curious distribution suggests an outside, that is, European, introduction, but no relevant information has been uncovered.
Courtesy Cowan's Auctions, Inc., Cincinnati, Ohio.

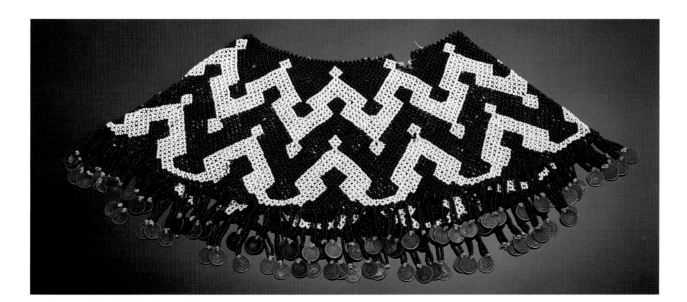

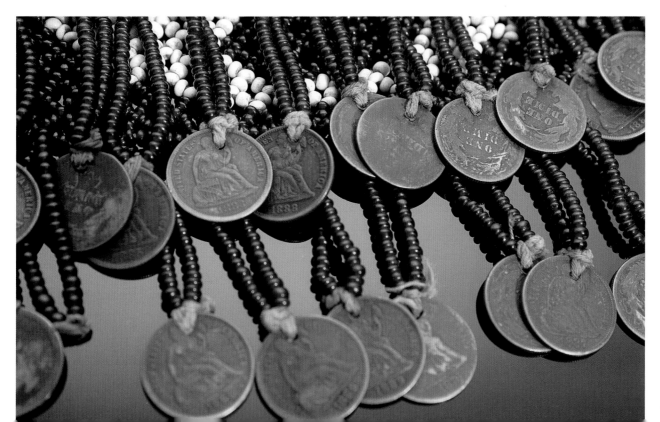

Coiled baskets of the Great Basin, 1900–25.
Left: Coiled willow, with designs in bracken fern.
Height, 5 inches / 12.7 cm. Washo Indians.
Courtesy John and Marva Warnock
Collection / www.splendidheritage.com

Below: Coiled willow, with designs in
bracken fern and redbud. Height, 4 inches /
10.2 cm. Probably made by Scees Bryant
Possok, relative and follower of Datsolalee,
the famous Washo basket maker.
Courtesy John and Marva Warnock
Collection / www.splendidheritage.com

Facing page: Coil made of split willow and
yucca root, wrapped around a core of grass.
Height, 4.75 inches / 12 cm. The design was
called "flight of the butterfly." Kawaiisu Indians.
Courtesy Clinton and Susan Nagy
Collection / www.splendidheritage.com

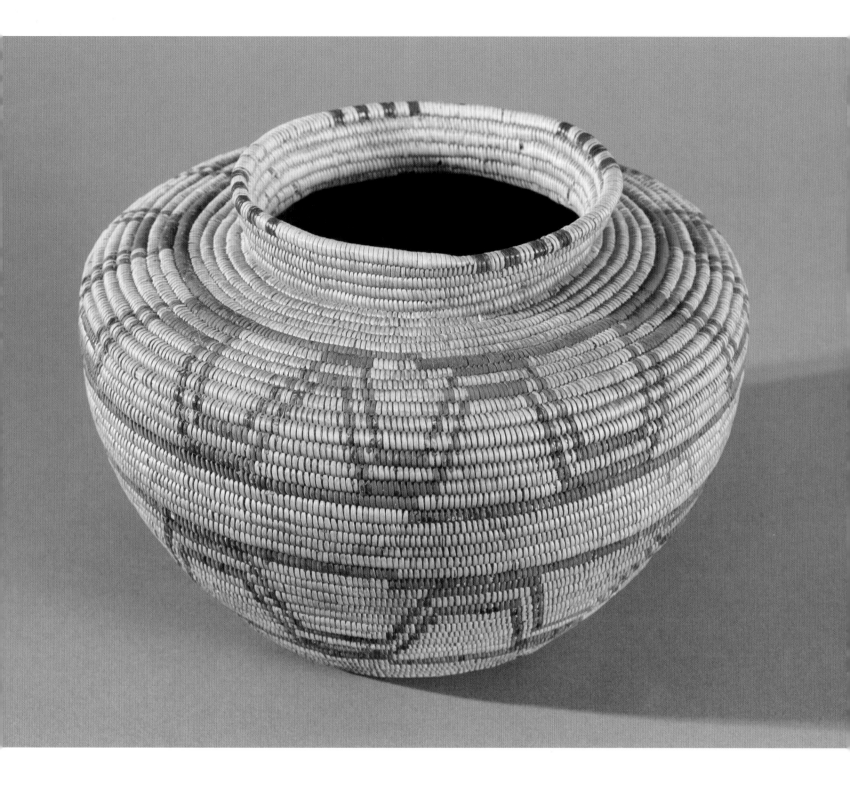

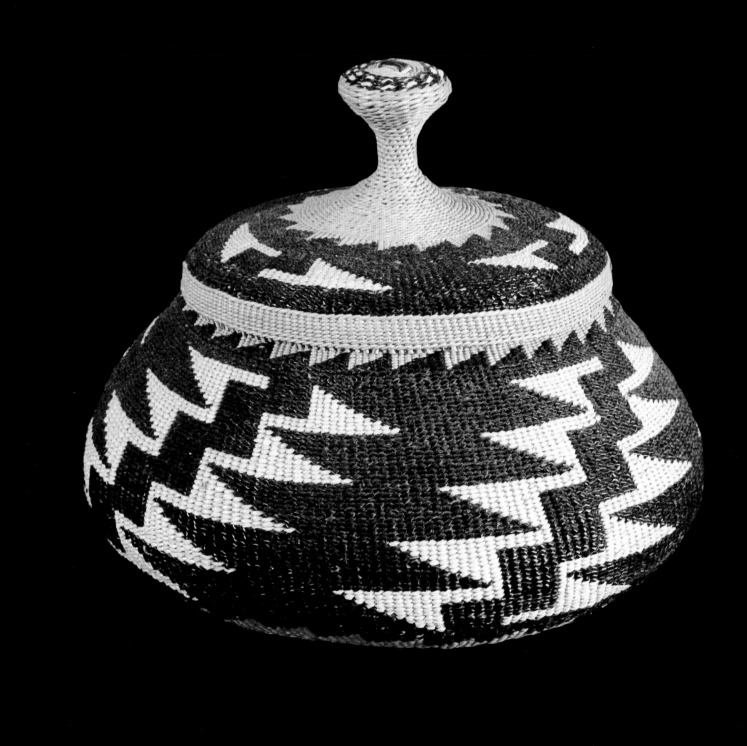

9 | Paradise Lost

Previous page: **California basketry for a non-Indian market, 1900–25.**
Diameter, 5.5 inches / 14 cm. Twined trinket basket with lid, the wefts of wild grape root overlaid with maidenhair fern and dyed porcupine quills. Made by Elizabeth Hickox, Karok.
Courtesy Clinton and Susan Nagy Collection / www.splendidheritage.com

A land of abundance stretched westward beyond the mighty Sierra Nevada to the Pacific Ocean, and from the mountainous region of southwestern Oregon down into Baja California. The central and most distinctive part of the California Culture area is a huge valley in which two large rivers join and drain through San Francisco Bay into the ocean. To the south, the westward-curving mountains divide this valley from the deserts that extend from the Great Basin into southern California. The rain, withheld from the deserts by the Sierra Nevada, falls generously on its western slopes and in the valley. As a result, California had everything that was lacking in the Great Basin. Yet in California, the people remained primarily gatherers, with hunting and fishing of secondary importance and varying from place to place. Presumably it was precisely because of this natural abundance of food (and its easy gathering) that more complex societies were not developed.

Forests extended along the western foothills and the coastal ranges; groves of oak trees produced massive amounts of acorns. Acorn flour was the staff of life, made by a process of pounding the acorns and leaching out the tannic acid. In addition, piñon nuts, roots, berries, mesquite beans and the seeds of various grasses provided a near-inexhaustible source of food. Along the coast the people gathered clams, mussels, abalone and seaweed. The annual migration of whales always left some stranded on the beaches to be butchered, together with seals and sea lions. Salmon traveled upriver to their spawning grounds far inland. California is on the western flyway of migrating geese and other waterfowl that spend the winter in the marshes. Chaparral shrubs covering the southern hills were regularly burned to create better grazing for deer, elk and rabbits. Favored by a mild climate, California was an unusually rich environment, in which the native people had a relatively easy life. Marveling at the varied food supplies, a Spanish missionary wrote that "for them the entire day is a continuous meal." The possibility of harvesting a whole winter supply of food within just a few weeks provided the time for artistic creativity and elaborate ceremonials.

Contacts with the Southwest introduced the growing of corn and beans to a few communities in southern California, but the sheer bounty of the natural food base prevented the further spread of farming. Despite this lack of agriculture, California supported the greatest population density in North America. An estimated 325,000 Indians inhabited this culture area at first European contact in the 18th century (including about 25,000 in Baja California). Nearly a hundred different languages were spoken here, representing six distinct language families. This linguistic diversity, and the evidence that these peoples had lived there for thousands of years, suggest that California was a

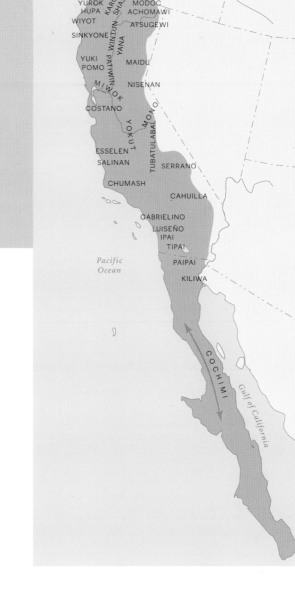

cul-de-sac along the major migration routes into the Americas.

Stone artifacts found in northern California indicate that hunters roamed there about 10,000 BC; they vanished together with the big game of the Ice Age. By 6000 BC, immigrants from the Great Basin were adapting their desert culture to the California environment; the growing importance of wild plant foods is indicated by the stone mano and metate used for grinding wild seeds. Ocean fishing and the hunting of sea mammals became common, and by 1000 BC the archaeology reveals a variety of specialized adjustments to local conditions. This local diversity and the village size of most socio-political units remained characteristic for most of the region. All over California, the people living in the valleys developed more elaborate arts, crafts and ceremonialism than the highlanders.

Most of the "tribal" names coined by anthropologists actually refer to language groups, but the speakers of any of these languages did not perceive themselves as a politically or otherwise separate group. Their world was the self-sufficient community, in which the children were taught with great precision the boundaries of their own territory. West of the Rocky Mountains, the gathering way of life promoted everywhere a strong emotional association with the

land, but this bond was even more intense in the small worlds of the California Indians. Due to the great linguistic diversity, the knowledge of several languages was common, but the relationships with neighboring villages were often brittle and ambivalent at best. Although trade was important, intertribal marketplaces as found elsewhere were absent in California. Contacts beyond one's own residence were limited to visitors invited to attend annual ceremonials, or more accurately, to be impressed by the wealth of the local elite. At such occasions, shell beads, colored bird

Facing page: **Bow, Yurok, 19th century.**
Length, 36.5 inches / 93 cm. Sinew-backed yew wood,
the hand grip wrapped with animal hair and skin. Painted
designs are primarily found in northern California and
were clearly related to the patterns used in basketry.
Courtesy Clinton and Susan Nagy Collection /
www.splendidheritage.com

feathers, baskets, salt and other gifts were exchanged and surplus foods bartered. Steatite was traded from Gabrieleno territory to all their neighbors, who used it in the carving of bowls and figurines of whales, seals and fish. Passed on from village to village, shell beads from the coast found their way across the mountains into Nevada for thousands of years. Travelers from beyond California operated whatever trade existed over longer distances. Large quantities of dentalium shell came from Vancouver Island to the Columbia River markets, to be transported into northwestern California, where these tubular shells served as money. In return, the Columbia River traders acquired obsidian implements. For many centuries, the Mohave of the lower Colorado River were middlemen in the trade between the Southwest and California. They brought some Pueblo pottery, cotton blankets, turquoise and many stone axe heads to the coast and carried shells and steatite into Pueblo country. These major trade routes undoubtedly played a role in the spread of cultural influence from coastal British Columbia into northwestern California, and in the adoption of pottery and other Southwestern practices by the Indians of southern California.

Beyond these marginal influences, native culture did not substantially change over the centuries, nor was the possibility ever imagined. According to widespread myths, the way things were had been worked out by a pre-human race of beings. When Old Man Coyote created the people, these beings had taught them everything they needed to know, after which they had turned into animals, plants, rocks and mountains. These beings no longer spoke with the people, except in dreams and mystical experiences.

Most receptive to such experiences were the shamans, male and female, who acquired their curative powers from spirits residing in the environment. As leaders in the annual cycle of ceremonials, they had more authority than the hereditary village chiefs, though the shamans often came from chiefly families. In songs and dance, the shaman achieved a trance-like ecstasy, in which his soul was believed to leave his body and communicate with spirits. In the southern regions, he might induce such experiences by means of a drink drawn from datura, or jimsonweed, a hallucinogenic plant. It is believed that the "visions" resulting from this drink inspired the remarkable rock paintings found in almost inaccessible caves in Chumash Indian territory. These polychrome paintings show human figures, animals and plants, in a strange combination with a variety of abstract elements. Their remote locations strongly suggest that the artists came there in search of a mystical experience.

Quite different are the many large murals found in the canyons and caves of central Baja California.

Some of these paintings are almost 500 feet long and 30 feet high, picturing running deer and other game, driven on by larger-than-life-size men and women with raised arms as in prayer. Many of the human figures are vertically split in red and black, whereas the animals are often split horizontally in the same colors. The emphasis on game animals suggests that these paintings served as a backdrop of rituals in honor of game spirits. The local Cochimi denied that they had made these paintings and ascribed them to giants who long ago had come from the north.

During the dry season, edible plants and their roots, berries and seeds were gathered; large quantities of fish were caught and dried, and people might temporarily move off to fishing sites or hunting camps. Ocean fishing was well developed among several coastal groups, and toggle harpoons were used in hunting seals. Dugout canoes were used in the northwest; bundles of tule rushes were made into canoe-shaped balsas by the Pomo and Miwok. America's only planked canoes were made by the Chumash. Carefully shaped with stone and shell tools, the planks were sewn together with fiber cord and caulked with a mixture of natural asphalt and pine pitch. Up to 25 feet long, these frameless boats were paddled across the 30 miles of open water between the mainland and the islands of the Santa Barbara Channel. The owners and captains of these boats were prestigious men, recognized by their short bearskin capes.

Save for festive occasions, other men seldom wore any clothing, and the women wore only a skirt, an apron and their round woven caps. Body paint and tattooing distinguished the different villages. After the acorn harvest in the fall, the people returned to their permanent villages, where the men prepared their dance regalia in the central ceremonial house. Piles of acorns had to be ground on the stone metate or in holes chipped into level rock surfaces. In chilly weather, feather cloaks and robes woven of rabbit fur strips were worn. Waterfowl were hunted, but the food stored during the summer usually lasted until spring.

All through the rainy season, a series of religious dances were performed in the villages of central California. These were the public ceremonials of several interrelated secret societies, together referred to as the Kuksu Cult. Appearing in elaborate costumes, the dancers represented divinities and other supernaturals visiting the villages to bring good health and prosperity. In its organization, performances and motivation, the Kuksu Cult was reminiscent of the Kachina Cult of the Pueblo Indians in the Southwest. If there had indeed been a relationship between the two, it would have required considerable direct contact, but it will be next to impossible to uncover such prehistoric evidence.

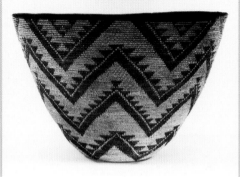

Since pottery was almost absent, baskets were indispensable in daily life. Developed far beyond utilitarian requirements, basketry served the women as a medium for the expression of talent, pride and prestige. Among the Pomo, the men also made some basketry, though restricting their efforts to wicker creels for trapping fish, seed-beaters and coarse open-work storage containers. Women roamed the fields and marshes, gathering shoots, fine roots, juncus grass, ferns and other fibers. They tended their wild gathering patches like crops, pruning the willow and sumac to encourage long, straight shoots. All this material had to be prepared by whittling and scraping, peeling and splitting, soaking and roasting. By convention and habit, only a small selection of the available materials was used, but each tribe tended to use a different selection of fibers.

Twining in various modes was the universal technique used in this basketry, until coiling spread from the Great Basin into central and southern California by about 1000 BC. Geometric patterns were part of the wrapping in coiled basketry, and they were executed in overlay techniques in twined ware. These patterns were referred to as animal tracks, mountains or clouds, but no symbolism was implied by these names. A break or interruption in the main pattern functioned as the entrance and exit of the basket's spirit, or as the signature of the weaver.

The Pomo and some of their southern neighbors used to decorate many of their coiled baskets with brilliantly colored feathers, with shell beads and pendants. It was in the colors of these feathers and shells that symbolism was recognized: red for courage, yellow for love and happiness, green for discretion, black for beauty, and the white shell for generosity. One feathered Pomo basket in the Smithsonian Institution is said to reproduce exactly the basket in which the legendary Oncoyeto stole a sun from the spirit world, hanging it up in the sky to light up the world of mankind. These feathered baskets were used in ceremonials and as gifts, though – the women also appreciated beauty in their utility ware – some were used in the household as well.

Baskets functioned in daily life and in the celebrations of birth, puberty, marriage and funeral rites. Babies were cradled in them, and, among the Pomo, fine baskets were given by the bride's relatives to the groom's family during the wedding feast. Well known are the elegant round caps, twined in the north, coiled in more southern regions, worn by the women. In a game played with dice, Yokut women used large coiled flat trays decorated with rows of human figures. Dancers carried their secret charms in tubular twined baskets in the annual Jumping Dance of the Hupa and Yurok. In central and southern California, the deceased were cremated while covered with all their

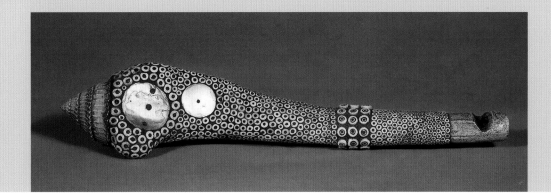

Bone whistle, Gabrieleno, pre-1500.
Inlaid with shell beads in bitumen. Found on San Nicolas Island, which was frequented by the Indians for gathering shellfish. Courtesy National Museum of the American Indian, Smithsonian Institution (214532). Photo by Carmelo Gaudango.

possessions, including many baskets, for it was felt that the dead would need these things in the other world. Mourners around the funeral pyre expressed their grief by adding still more baskets to the fire.

✳

After his conquest of Mexico in the 1520s, and intrigued by persistent rumors of another Eldorado, Hernan Cortez began exploration of the unknown northwest. Spanish ships surveyed the coast of Baja California in the 1530s and expanded their coastal explorations northward 10 years later. They claimed the country for the Spanish Empire, but there was no golden kingdom to loot, nor was there anything else that attracted the Spaniards. When in 1579 the English privateer Sir Francis Drake repaired his ship somewhere near present-day San Francisco, he noticed that the natives had baskets beautifully decorated with red woodpecker feathers. Collecting Indian baskets was not yet profitable, though, and Drake's interest was in capturing the Spanish treasure ships that plied the Pacific from the Philippines to Acapulco. Piracy of this type led the Spanish to search the California coast once more for possible ports of call for the annual Manila galleons. The Spanish tried to settle at the southern tip of Baja in 1597, but Indian hostilities forced them to abandon this location. The reception

they received suggests that earlier visitors, conforming to usual practice, had probably captured Indians for the Spanish slave trade.

After more than a century of fleeting contacts, the European interference in the native world began in earnest in 1683, when Jesuit missionaries came ashore in Baja California. They established a series of missions near Indian villages, since these were the only places where freshwater was available. This mission project was not destined to become a success. Arid Baja did not lend itself to the Mexican system of self-supporting missions. Conversion to the new religion and farm labor ideally required the resettling of native people in planned communities, and a population willing to accept the regimentation of daily work. Willing Indians were scarce, and so was water for farming. Several missions had to be abolished after a few years; the Indians were often hostile, and the rapid spread of new contagious diseases caused a high mortality rate among them. In 1767, by royal order, the Jesuits were expelled, and their missions were transferred to the Franciscan order. Within less than a century, the Indian population of Baja California had been reduced by probably about 50 percent.

Prospects did not look bright for the padres, but colonial politics changed their future and that of the Indians. Spain had neglected its claims of the West Coast for more than a century, but now Britain was

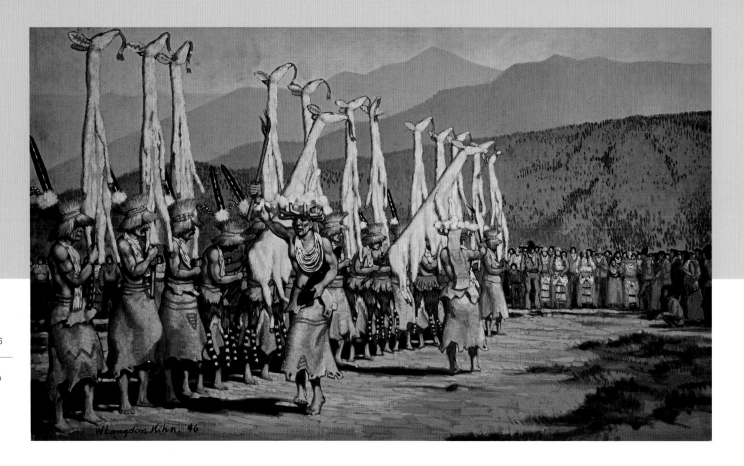

expanding the Canadian fur trade westward, and Russian traders might come south from Alaska. Forced to secure its colonial borders, Spain established a military outpost near San Diego. In keeping with Spanish tradition, the cross traveled together with the sword. Leaving the Baja Indians to oblivion, the Franciscans established a string of 21 missions from San Diego (1769) to San Francisco Bay (1823), accompanied by several military presidios and some cattle ranchos. They settled on the coastal plain and seldom penetrated the interior.

Within this coastal strip of colonial activity, the native way of life was drastically altered, though it took many years before all the missions were established. The Indians were induced into resettlement near the missions, where they were taught farm work, carpentry, masonry and other crafts. European ideas of bodily modesty and an unrelenting daily work program were among the first incomprehensible adjustments forced upon the Indians. The missions

were designed to become self-supporting reeducation centers, basically to change the Indians into Spanish peasants. Although they originated from different villages, when gathered at the missions, the Indians lost their tribal identities and became known by the name of their mission, such as Dieguenos at San Diego, Luisenos, Gabrielinos, and so on.

Many Indians accepted the new religion because the white people appeared to possess desirable powers that might possibly become available by conversion. For many years, native religious ceremonies persisted alongside Catholicism, often tolerated by the priests as "secular" entertainment. Confronting cultural breakdown, a Gabrielino shaman known as Chingichgish spread a reformation of traditional beliefs and practices. Unknown to the missionaries, this religion survived the mission period and is still alive in southern California.

Imported cloth replaced fur robes and feather cloaks, but much of the native craft work continued

Facing page: *The White Deerskin Dance*, Hupa, 19th century.
The White Deerskin Dance and the Jumping Dance were the two major events in the annual celebration of the World Renewal religion of the Hupa and Yurok Indians. Each of these dances lasted 16 days in September, culminating in the elaborate display of regalia shown in this painting. Chief dancers wear crowns of sea-lion tusks and carry sacred obsidian knives. The decorated hides of rare albino deer symbolized new life, masculinity and the beneficial deer spirit. Ceremonial regalia and food for the many visitors were provided by the local elite. Women in the background wear traditional skirts and aprons. Painting by W. Langdon Kihn in 1946, based on early photographs. Courtesy W. Langdon Kihn / National Geographic Image Collection.

in the mission villages. At San Luis Obispo and San Buenaventura, the Chumash women produced several coiled baskets decorated with the royal coat of arms copied from Spanish coins. Indian basketry was popular among the Spanish settlers: a collection of fine baskets acquired in 1791 is preserved in the Museo de America in Madrid, Spain.

Inevitably, the Indians realized that their acceptance of mission life came at a heavy price, particularly in the loss of personal freedom. Once they had entered the mission settlements, they were kept from returning to their old free lives by military force, though groups of converts might be given a few weeks off to gather their wild plant foods in the hills. Forced to wear clothing and crowded into dormitories and communal kitchens without sufficient bathing facilities, the people were bound to fall victim to the new contagious diseases. The collapse of the native society and the imposition of a foreign, rigidly disciplined and unsatisfying existence had a depressing and demoralizing effect, evident in a low birth rate and many deliberate abortions. The high mortality rate and many runaways meant there was a continuous search for and coercion of new mission Indians from more remote villages. However, many of these villages were found to be deserted. Fleeing from the spreading diseases, the Indians had moved into the foothills of the Sierra. They became

mounted bands, adopting feral horses and raiding the livestock of Spanish ranchos.

The Mexican Revolution finished this period in 1834, when the missions were "secularized," that is, confiscated by the government. Wealthy friends of the government took over the mission farms and dispersed the Indians. Some of them were hired by the new landowners; others returned to their former locations to become a slave labor force in the expanding colony.

As a consequence of the Mexican War, California became part of the United States in 1846. Two years later, on January 24, the discovery of gold on the Sacramento River started a nationwide stampede as thousands of adventurers raced for the diggings. That was a disastrous date for the Indians. The non-Indian population jumped from about 15,000 in 1848 to over 100,000 within two years. From this time on, the history of the California Indians in the 19th century is one long account of mistreatment and extermination.

Swarming all over northern and central California, many of the miners and settlers were ruthless and vicious men who considered raping and killing Indians an entertainment. Companies were formed for hunting Indians as a sport, their children to be sold as slaves. Desperate conditions forced several bands to go into hiding, and to live a primitive life in remote places, avoiding all contact with the invaders.

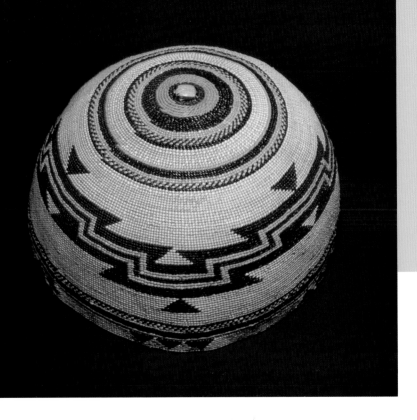

As the gold rush subsided in the 1860s, the government marked out reservations for the Indians, but few were large enough for economic development. In the northwest, the Hupa and Yurok were more successful in holding on to their homeland. Without giving up their traditions, they managed to take on lumbering and dairy farming. They used their large wooden houses and dugout canoes until the 1930s, and the women wore their shell-decorated skirts during the annual Jumping Dance and White Deerskin Dance.

Elsewhere, Indian "rancherias" developed on the outskirts of white settlements, their inhabitants eking out an existence by farm labor, begging and prostitution. In the early 1870s, a nativistic movement originated among the Nevada Paiute and swept through the demoralized native communities of California. Though the prophecy of a world renewal was not realized, it did cause a revival of faith in the traditional ceremonials. Dance lodges were built and dance costumes reappeared, though the timing of celebrations was adjusted to the work for white farmers. A new dance cult became popular, called the Bole-Maru. In 1911, Ishi emerged from the hills near Oroville, the last survivor of one of the hiding bands, his hair cropped short in mourning. By that time the native population of California was estimated at around 20,000, indicating a decline of over 90 percent of its original numbers.

In the 1880s, the Arts and Crafts movement led growing numbers of wealthy white citizens to collect Indian baskets. In visiting the native communities they created a much-needed source of income for many Indian families. Here as elsewhere, the transition from tribal to ethnic art fostered various innovations. Abstract geometric patterns remained common in basket decoration, but pictorial renderings became popular, including the typical snake designs in southern California. Pomo, Achomawi and other women developed colorful beadwork, completely covering some of their baskets with it. The establishment of Yosemite National Park created a major tourist market there in the 1920s, comparable to Niagara Falls in the east. The regional native women produced incredible numbers of beautiful baskets, and the park provided employment for the men. High-quality baskets are still produced, and for many California Indians they have come to represent their identity as Indian people. However, the future of the California Indians, with few exceptions, would seem to be one of assimilation into the general population.

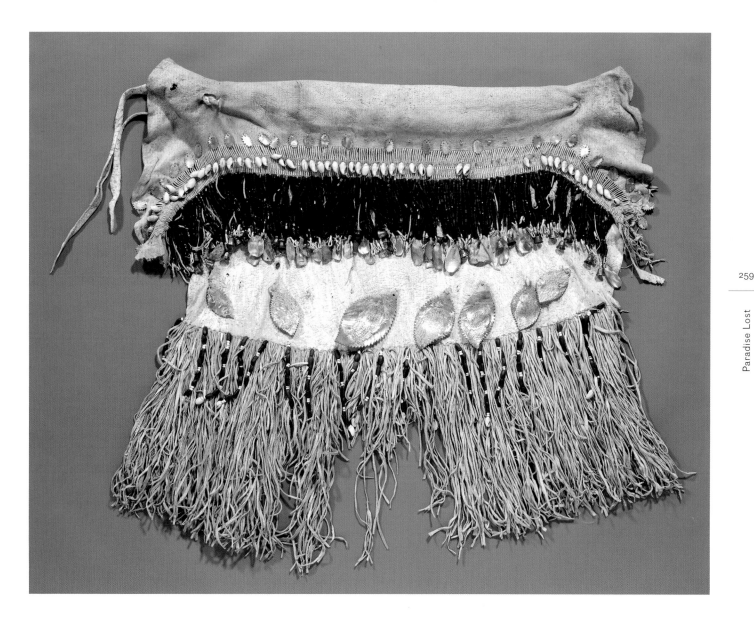

Hupa woman's skirt, late 19th century.

With Russian beads, abalone and Olivia shells.

With permission of the Royal Ontario Museum

© ROM. Acc. no. 977X1.1; image no. ROM2009_10546_7.

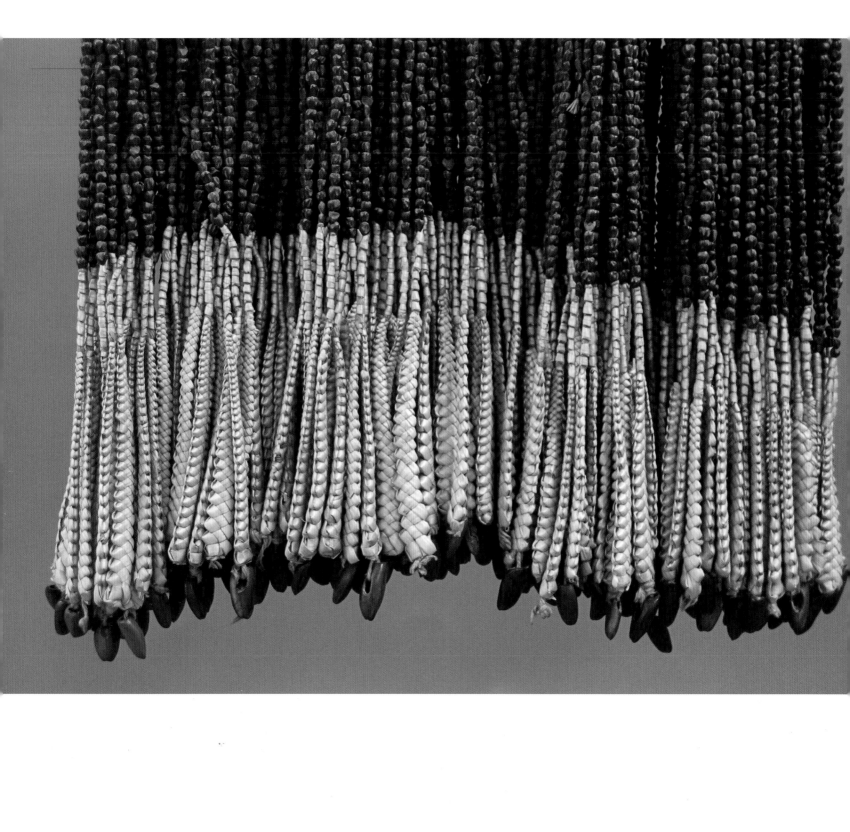

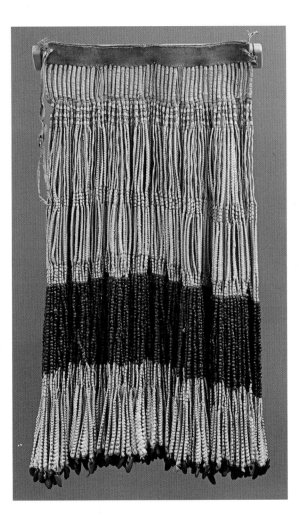

Left and facing page: **Woman's apron, Hupa, 19th century.**
Length, 22.5 inches / 57 cm. Made of braided bear grass and iris twine; the dark band is made of strings of juniper berries; pine nuts are used as a fringe at the bottom. Combined with skirts, such aprons were worn throughout California. Courtesy Clinton and Susan Nagy Collection / www.splendidheritage.com

Woman's skirt, Hupa, 19th century.
Width, 34 inches / 86 cm. Folded buckskin, the fringes decorated with white and blue glass beads and terminating in brass thimbles, interspersed with fiber-wrapped strands strung with seeds. These skirts formed the back and sides of the woman's dress. Courtesy Skinner, Inc. Boston and Bolton, Massachusetts.

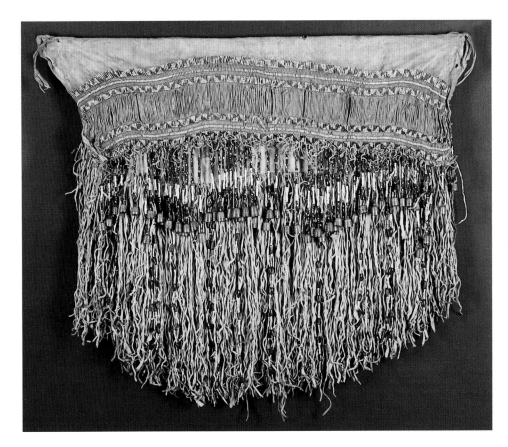

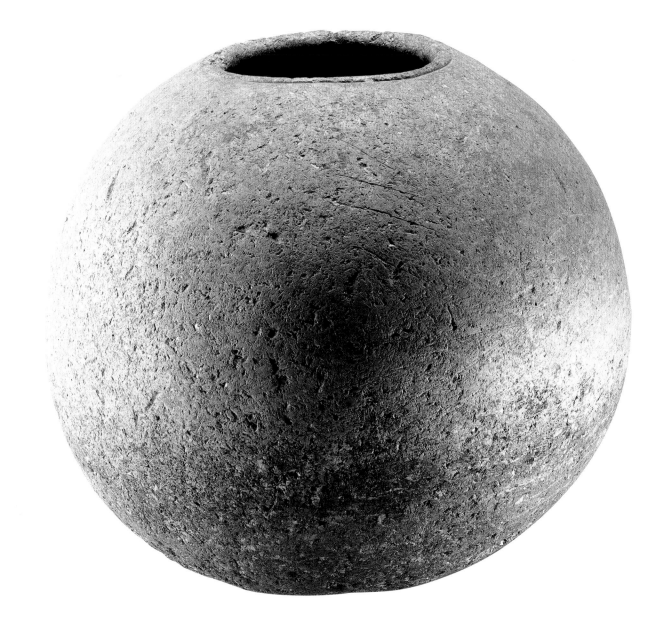

Stone bowl, Chumash, circa 1800.
Height, 13.5 inches / 34 cm. Steatite, or soapstone, quarries
on Catalina Island were controlled by the Gabrielenos, who
traded the soft stone to their neighbors. Bowls and figurines
carved from this material were often inlaid with shell beads.
Courtesy Donald Ellis Gallery, Dundas, ON, New York, NY.

Coiled basket, Chumash, circa 1800.
Diameter, 18.5 inches / 47 cm. Juncus stems and split sumac
roots wrapped around a grass coil foundation. Chumash
products are among the oldest surviving California baskets, but
their production had practically come to an end in the 1830s.
Courtesy Donald Ellis Gallery, Dundas, ON, New York, NY.

Native American Clothing

Spoons, Yurok, 19th century.

Length, 7 to 7.5 inches / 17.7–18.6 cm.

Carved of elk antler. Wood, antler and stone carving were highly developed in northwestern California. Wealthy people kept large numbers of such spoons in order to serve their male guests acorn mush at feasts. Spoons used by women were made of shell or animal skull bone.

Courtesy Phoebe A. Hearst Museum of Anthropology and the Regents of the University of California (cat. nos. 1-2032, -1943, -1239, -2069, l. to r.).

Women's ceremonial ear pendants, Maidu, 1908.
Crane wing bones, decorated with woodpecker scalps, abalone shell,
clam shell beads and glass beads. Worn by both men and women, bone
tubes pushed through a hole in the ears were a common adornment in
central California. Decorated versions such as this pair were worn by
wealthy Maidu women, who belonged to the tribal dance society.
Courtesy The Brooklyn Museum, Brooklyn, New York. Cat. no.
08.491.8826.1-2. Museum Expedition 1908, Museum Collection Fund.

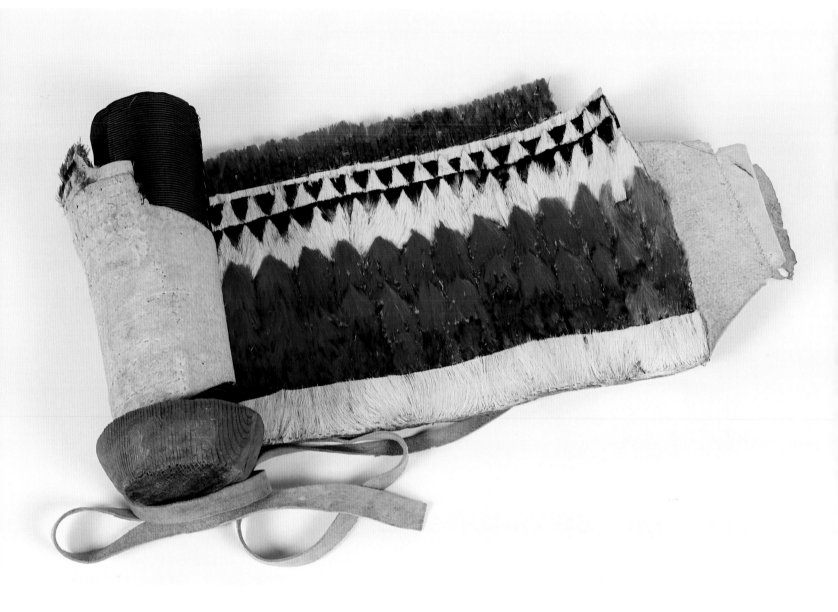

Dance headdress, Hupa, circa 1900.
Headdresses of this type are worn by all the men in the Jumping Dance. About 50 red scalps of the pileated woodpecker are sewn on a band of deer fur. All the dancers carry rectangular twined basketry containers, believed to hold various charms. Wealthy men possessed the right to sponsor these dances and owned all the associated regalia. The Jumping Dance is part of the annual reenactment of the death and rebirth of the world. Courtesy National Museum of the American Indian, Smithsonian Institution (122847). Photo by NMAI photo services staff.

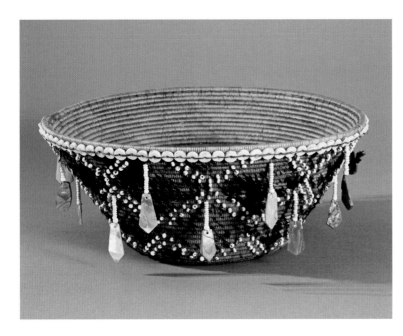

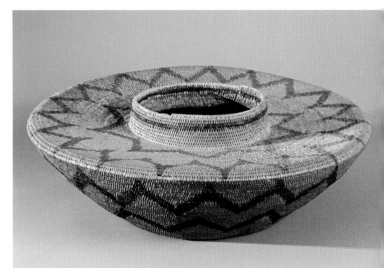

California basketry for a non-Indian market.

Left: Coiled basket decorated with mallard feathers, abalone pendants and threaded beads. Diameter, 8.75 inches / 22 cm; Miwok, circa 1875–1900.

Above: Coiled "bottleneck" basket, the foundation coil wrapped with split bull-pine and dyed bracken fern root. Diameter, 17 inches / 43 cm; Miwok; circa 1900–1925.

Courtesy Clinton and Susan Nagy Collection / www.splendidheritage.com

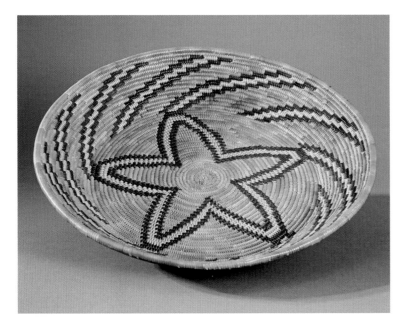

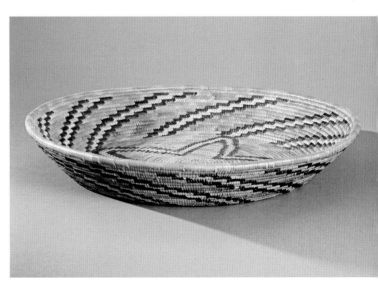

Above and right: Coiled tray of wrapped juncus and sumac. Diameter, 12.75 inches / 32 cm; Cahuilla, Morongo Indian Reservation, circa 1900–1925. Courtesy Clinton and Susan Nagy Collection / www.splendidheritage.com

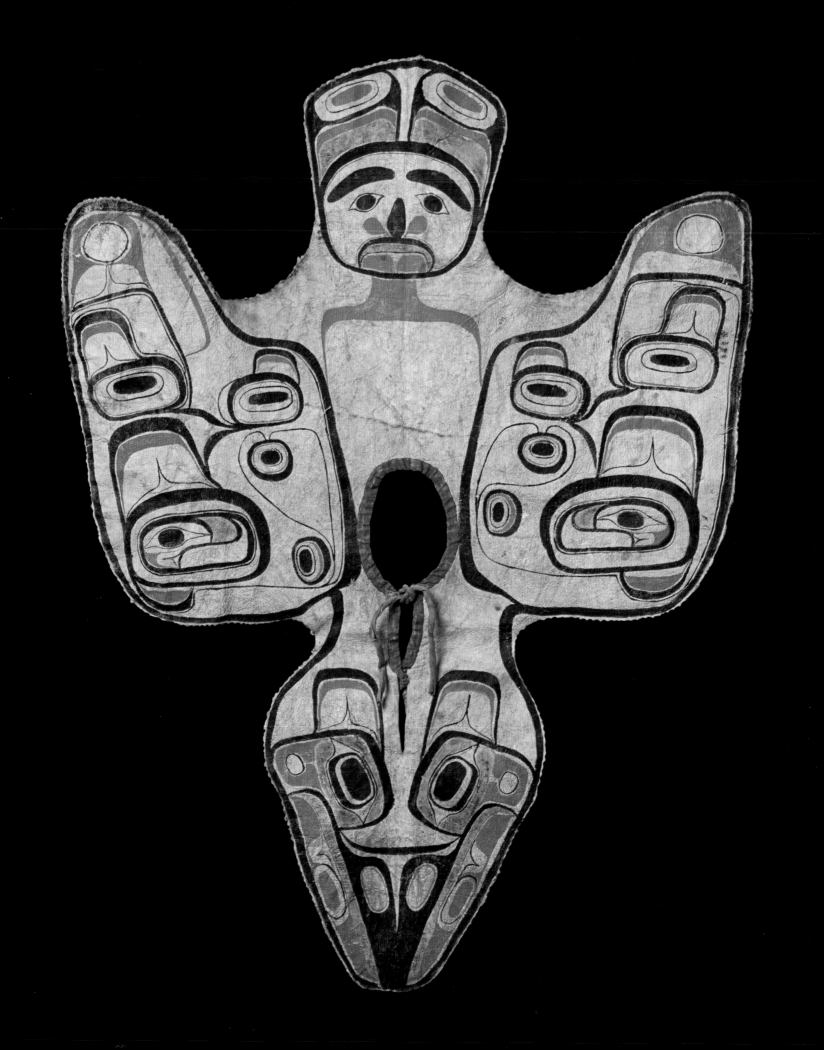

Previous page: **Shaman's tunic, Kaigani Haida, circa 1880.**
Length, 42.5 inches / 108 cm. Painted hide, shaped
and painted to represent a raven. Worn like a poncho,
with the bird's head on the wearer's chest.
Courtesy Donald Ellis Gallery, Dundas, ON, New York, NY.

Isolated from the interior by a chain of high mountain ranges, the Northwest Coast Culture area extends from southwestern Alaska to northern California. North from Puget Sound, the coastline is broken by many inlets and hides behind numerous islands. The Skeena, Fraser and a few other rivers break through the mountains here. Early travel was certainly easier by water than over land. South of Vancouver Island, the coast straightens out, broken only by the estuary of the Columbia River. Protected by the mountains from severe winter temperatures, dense rain forests were rich in straight-grained softwoods such as cedar, fir and spruce. A variety of berries and edible roots grew in the clearings, attracting bears and deer. Mountain goats and sheep inhabited the higher mountain slopes. Fish, whales, seal, sea lions and sea otters frequented the coast. Immense schools of salmon jammed the rivers each year as they crowded upstream to spawn.

Blessed with this abundance of natural resources, people have lived here for thousands years. While much of the interior was still covered by glacial ice, this coastal strip was a major migration route from Beringia. Five thousand years ago, a permanent population had moved in, some people coming down the coast from Alaska, others along the major rivers from the interior. Tracing the route of the annual salmon migration, these people discovered the good life on the coast. Initially their subsistence activities resembled those in the Intermontane region, in which harvesting wild plant foods was important. They gathered clams, mussels and other shellfish, creating vast shell middens along the beaches. By fishing and hunting sea mammals, they were able to produce a surplus of foods, thereby allowing time and energy to be devoted to the development of arts and crafts, a complex social organization and elaborate ceremonialism. Against the backdrop of the forests, the people spent the winters in sizable villages of multi-family houses facing the sea. These villages were virtually abandoned during the summer, when most of the people camped at fishing sites or gathered berries and other plant foods. About 200,000 Indians inhabited the coast when the first Europeans arrived in the 1770s. Athapaskan, Salishan and Wakashan were the three major language families, represented among 45 or so different languages in the region.

Probably reflecting a denser local population, cultural developments beyond basic needs became noticeable in and around the lower Fraser Valley and on nearby Vancouver Island in the period between 1500 and 500 BC. Surviving fragments of stone, bone and antler implements show engravings and carvings in an art style that subsequently spread south around Puget Sound, as well as northward along the coast. Some of these small figurines and engravings

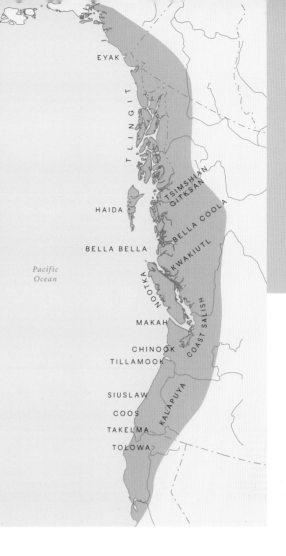

foreshadow elements and themes that were characteristic features in Northwest Coast art of the historic period. It is assumed that the development of this early art style reflected the emergence of basic characteristics of the regional culture, particularly of shamanism in religion, of masks used in ceremonials and of an elite class in society.

About 2,000 years ago, differences in the distribution of natural resources had created a lively trade among tribes all along the coast and in the interior. Important items in this trade were native copper, amber, obsidian, jade and dentalium shell. The oil made of olachen, or candlefish, was traded in large containers up and down the coast, and along the "Grease Trails" across the mountains into the interior. Specialization in specific arts and crafts produced additional trade items such as fine basketry and woven blankets made by the women; and large dugout canoes and implements carved of wood, stone and horn made by the men. Heraldic crest designs decorating some of these products indicate that a class system was well developed by this time.

By AD 500 there is growing evidence in the engravings of artifacts that a different art style was emerging on the lower Skeena River, possibly in reaction to a declining artistic activity in the old southern center of regional culture. The new art style developing in the north was of a formal and complex symbolism. The style was conventional in the sense that the symbols were subject to the principles of the so-called "formline," to symmetry and to a dislike of empty space. The formline structure consists of gently expanding and contracting curved lines of the design elements, merging into a continuous frame that outlines the subject. Bark templates were often used in outlining the conventional design elements. Symmetry in graphic and sculptural art included the depiction of animals split and opened out, so as to show both sides of the subject.

Centered among the Tlingit, Tsimshian and Haida, this dramatic northern style was fully developed by about AD 1000. A less formal and more relaxed version was adopted by the Kwakiutl to the

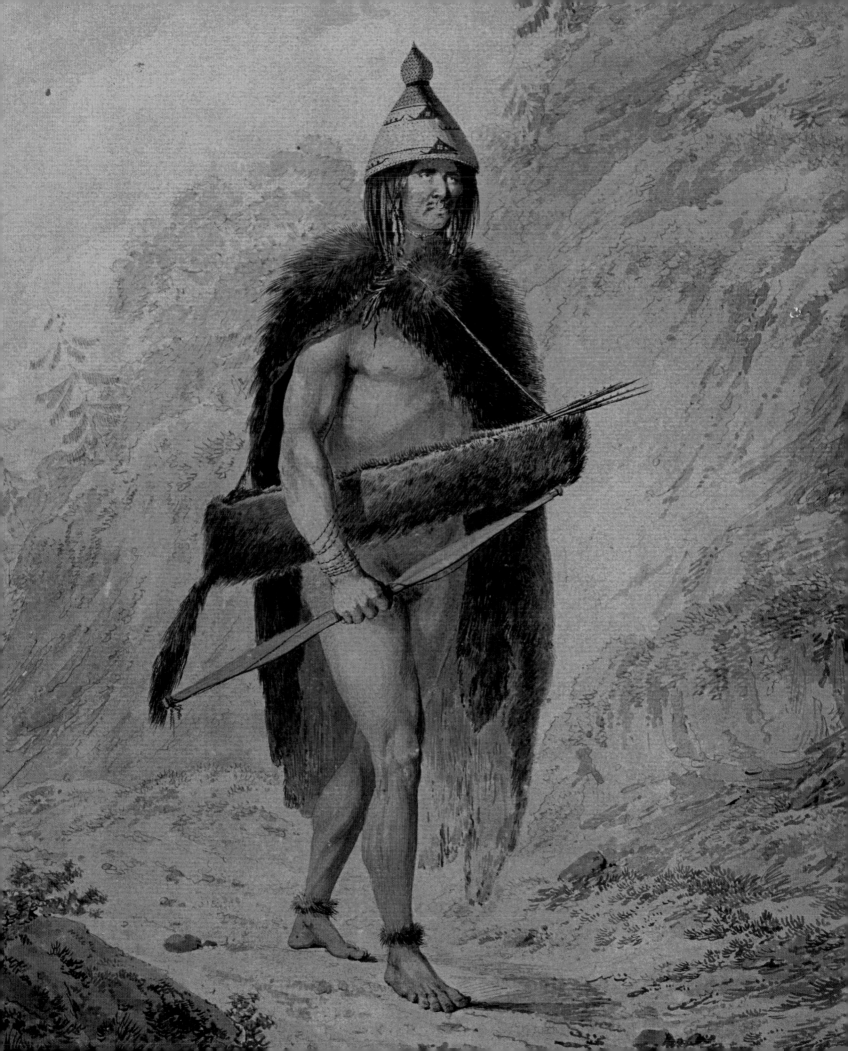

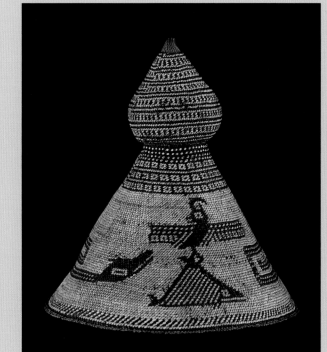

south and some of their neighbors, while the old coastal art style survived primarily among its Salish originators.

Admittedly, this is a simplified review of the complicated history of an incredibly complex art. Fundamentally, however, Northwest Coast art expressed religious concepts that were common throughout much of North America. It was believed that spirits or spiritual powers are potentially present in all natural phenomena; that these spirits may visibly reveal themselves in dreams or mystical experiences; that they may bless people in becoming personal guardian spirits, and give specific powers, magical charms, songs or rituals. As frequently mentioned in legends, animals or their spirits might assume a human appearance in a mystical encounter, or a medicine man might transform himself into an animal. As for game spirits, the bones of fish and

animals were returned to their natural habitat, where they were believed to regenerate new life.

Some people were considered more generously blessed, that is, more sensitive to such experiences than others. They became medicine men or "shamans," male and female, recognized by their long hair, which they never cut for fear of losing their power. They would work themselves into a trance so their souls might contact spirits who would help them to cure patients, locate and send game, or defeat evil. The crew of a war canoe usually included a shaman to catch and destroy the souls of enemies before an impending battle.

Specific symbols decorated the ceremonial regalia of shamans. Their spirit helpers were often pictured in "X-ray" style, displaying skeletal details to connote the regeneration of life. Joint marks, often pictured as faces, referred to the belief that the joints are activated

Sledgehammer, Haida, pre-1770s.
Stone hammers or mauls were used for pounding wedges in woodcarving or stakes for fish weirs. The stone head represents the Thunderbird, executed in the northern form-line style. Stone carving was abandoned when imported steel tools made woodcarving so much easier. Photo © Canadian Museum of Civilization, artifact II-B924. Photo by H. Foster, 1985, image S85-3333.

by a spiritual force residing in each of them. Shamans used wooden rattles carved in the shape of birds; these were pictured as early as 1,500 years ago on an antler carving from the lower Fraser River. Northern shamans wore a necklace on which small charms carved of ivory or bone represented the otter as their most powerful spirit helper.

Much of the regional art was inspired by this religious worldview, by the giants, sea monsters and ogres haunting the deep waters and dark forests and by the events in which legendary ancestors had encountered such terrifying creatures. In the forest was said to live Dsonoqua, the Wild Woman, who lived on roasted babies. She was represented by masks used in the Cannibal Dance of the Kwakiutl. The lightning snake was a powerful spirit, addressed for success by Nootka whale hunters and depicted on their harpoons. For similar reasons, the wolf spirit was pictured on the tools used in hunting and fishing. On the southern part of the coast, the Thunderbird was associated with whaling, war and wealth, its image carved on whalebone war clubs and on the spindle whorls used in weaving blankets. Painted on large screens in Nootka houses and woven on their twined hats, Thunderbirds were pictured grasping whales in scenes remarkably reminiscent of Thunderbird pictures of the Great Lakes region. Religious inspiration remained particularly strong in the art of the Coast Salish tribes.

Save for festive occasions, men seldom wore clothing. Men and women generally went barefoot. Both sexes tattooed their faces and bodies with designs relating to clan or lineage. Hats woven of cedar root were popular, and in chilly weather a robe made of fur or woven in spaced twining of shredded cedar bark might be thrown over the shoulders. Family crests were often painted on these hats and robes. Women wore skirts and capes, also woven of bark fiber.

In trade with the Dene people of the Yukon interior, the Tlingit acquired tailored skin garments and moccasins, decorated with porcupine quillwork. Such costumes were used at ceremonials, together with robes woven by the Tlingit women. These "Raventail robes" were made of mountain goat wool, twined-woven on shredded bark, the warp strings hanging loose from a horizontal bar. "Raventail" refers to the decoration of geometric patterns, similar to those used in basketry. Similar robes, plain or decorated with horizontal bands, were woven on standing loom frames by the Coast Salish people.

Arrival of Chiefly Guests.
Dressed in prestigious regalia and holding their speaker staffs, chiefs and their relatives arrive at a Haida village for a potlatch. The canoe in front, paddled by slaves, is of Haida origin, while the other is of a type more typical for the Nootka. The hull of such a large canoe was carved from a single log, but the high bow and stern were separate pieces, perfectly fitted in place. Several mortuary poles are visible among the many totem poles. Painting by W. Langdon Kihn, 1943, based on early photographs and artifacts. Courtesy W. Langdon Kihn / National Geographic Image Collection.

Whether inspired by religious themes or otherwise, the enormous production of art among the northern tribes was driven by a desire to proclaim social status and display wealth. Northwest Coast society distinguished an upper class of inherited nobility from a lower class of ordinary people. Below them were the slaves, captured in warfare or acquired in trade. Professional artists hired by the aristocracy were found only on the Northwest Coast (and perhaps in the prehistoric Southeastern parts of North America).

Every hereditary chief owned an ancestral house and occupied it with the core of several related families who formed his lineage. Massive cedar posts supported the roof beams. Constructed without nails or pegs, the wall boards were detachable and could be moved to another house frame standing at the summer fishing site. Some of these winter houses were large enough to hold several hundred people during celebrations. The winter house was the basic unit in the social organization of the northern tribes. Located on a site owned by the chief's ancestors since immemorial times, it was much more than just a shelter. It represented the family lineage, its exalted origin and history, and it had a name. House names went back for generations and were ceremonially transferred to a new structure when the old house had to be renewed.

The lineage members traced their origin to a common mythical ancestor, many of whom had come down from the sky, and were associated with supernatural creatures of great power, such as the spirits of bear, raven or killer whale. Pictures of their inherited symbols were carved on the heavy interior house posts and painted on the house front. Though of spiritual and religious origin, these symbols were treated as heraldic crests, visual emblems relating to status and certain privileges achieved in the family's history. Family privileges included claims of specific fishing sites and berry-picking areas, but also the exclusive rights to sing certain inherited songs or perform specific dances.

In the early 18th century, it became fashionable among the Tlingit, Tsimshian and Haida to carve their crest symbols on a tall post that was attached to the house front. A large hole at the bottom of the post served as the entrance of the house. It was from these house posts that the "totem pole" evolved in later times. The winter village consisted of rows of such houses, extending along a beach suitable for landing canoes. The location of the houses reflected the seating order of the house chiefs at ceremonials, the most prestigious lineage having its house in the center of the village. Village chiefs were treated with more than usual respect. A Russian observer visiting Alaska in 1812 noticed that the Tlingit chief of Sitka "made no use of his legs for walking, but was invariably carried on the shoulders of his attendants, even on the most

Tlingit Nobility, 1912.
Louis Situwuka Shotridge was of high-ranking family in the powerful Kagwantan clan, Chilkat division, in the village of Klukwan. He is wearing a carved wooden crest hat with several potlatch rings on top; a woven tunic and blanket of Chilkat type; and Athapaskan leggings. He holds a ceremonial dagger with carved handle. Courtesy Penn Museum, image no. 140236.

trifling occasions." Beyond the village there might be alliances with other villages, but warfare caused by rivalry among the chiefs did not make for long-lasting friendships.

Ancestral and inherited family crests, honorific titles and privileges had to be validated at the installation of a new chief, the initiation of his sons in dance societies, weddings and similar events. Such occasions required the chief to give a potlatch: a formal distribution of gifts to the guests, accompanied by lavish feasting, speeches and the display of rich regalia in dances. Masked dancers scattered showers of eagle down in token of friendship and goodwill. Chiefs were invited, seated and treated according to their rank. Formally, they served as witnesses to validate the proceedings, but in their competitive exchange of impressive gifts with the host, prestige was publicly increased or diminished, and rivalries resolved or renewed. Gifts consisted of beautifully carved canoes, bowls and chests, woven blankets and slaves. Bringing together all the food and these gifts might require the cooperation of all the chief's relatives. In view of these costly and time-consuming preparations, the potlatch was an infrequent and relatively modest celebration before the coming of the white fur traders. Having given a potlatch allowed a chief to add a woven ring on top of his hat; very few people had a stack of such rings on their hats.

Potlatches and other celebrations were confined to the winter period. Most important among the winter ceremonials were the initiations and masked performances of various dance societies, which apparently originated among the Coast Salish. In the Spirit dances of these southern tribes, members of a secret society performed their highly individual dance and songs, given to them in dreams by their guardian spirits. Accompanied by a chorus of singing women, masked dancers performed cleansing rituals to protect the members of elite families from witchcraft, evil or illness. The masks used in this ritual were unusual in not representing a spirit: they were powerful beings themselves. Carved wooden headdresses in the shape of wolf heads distinguished the Nootka chiefs who sponsored the initiation and dance of boys in the Wolf society.

In prehistoric times, dance societies and their use of masks spread northward among tribes who had a more elaborate art and were given to more dramatic public display. Their winter ceremonials included the reenactment of mythic events associated with the chiefs' ancestors. Masks ranged from realistic portraits to stylized representations of mythical monsters. Most ingenious were the transformation masks, which were manipulated with strings to split open and reveal another face in a metamorphosis from animal to human appearance.

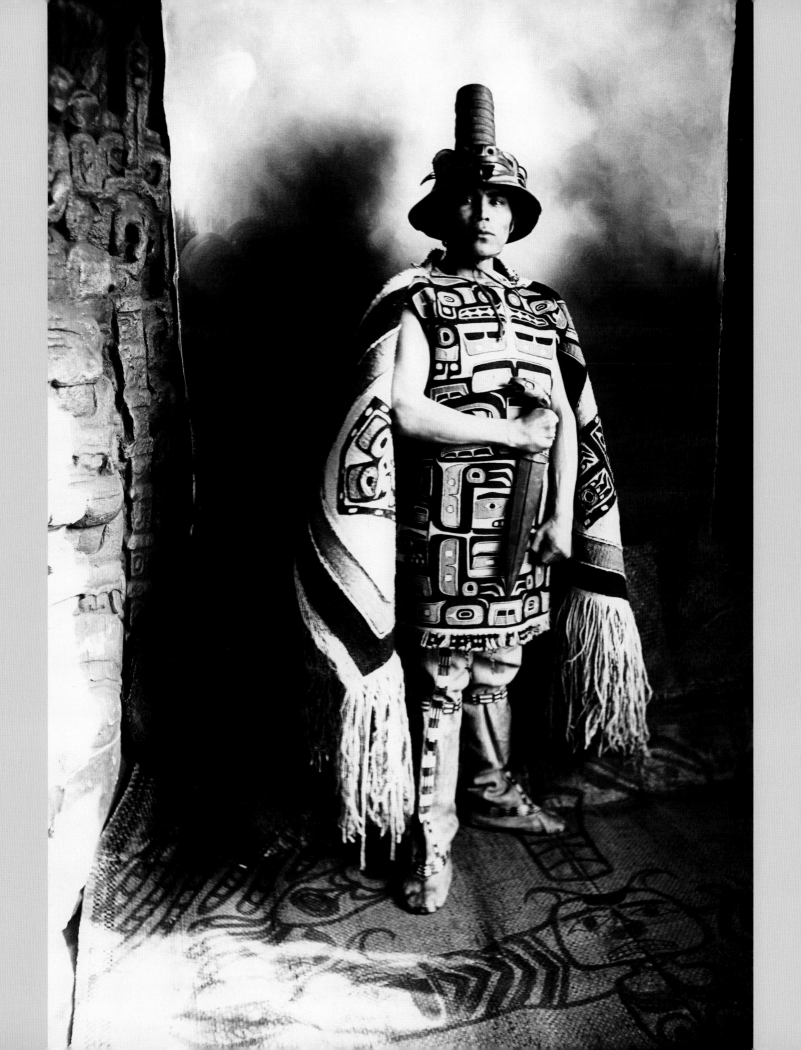

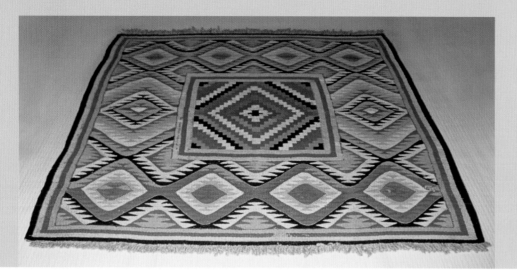

Woven robe, Coast Salish, circa 1870.
Yarn made of mountain goat wool and of raveled and re-spun trade cloth was used to create this blanket in a combination of tabby and twined weaving. After 1850, the Coast Salish women adopted this colorful pattern in their weaving, probably inspired by patchwork quilts of white settlers. In the 1960s, some Salish women revived the weaving of traditional plain robes. Photo © Canadian Museum of Civilization, artifact II-C-853, photo by R. Taylor, 1994, image S94-5679.

The dramatic performances of the Cannibal society originated among the Bella Bella and were adopted by the Kwakiutl and more northern tribes. The ancient origin of this cult is suggested by the similarity, except in size, between the large bird-monster masks used in the Cannibal dance and some antler carvings at least a thousand years old, found on southern Vancouver Island. Long ago, the people may have believed that cannibal spirits indeed possessed the frenzied initiates, but in historic times most of this ecstatic behavior was simulated for dramatic effect. Much of the associated pageantry was related to the display of wealth and the heraldic symbols of the elite, thereby gradually changing the religious ceremonies into secularized theater. Prestige, wealth and its ostentatious display were the main ideals in this extroverted society.

✳

Indians on the Oregon coast in the 16th century may have noticed on the western horizon Spanish ships. In 1707, one of them was shipwrecked there. Significant European contacts started in 1741, when Russians explored the coast of Alaska. They returned home with bundles of sea otter pelts, which bounty instigated the invasion of the Aleutian Islands by Russian fur traders and their expansion into Tlingit Indian country. News traveled slowly in those days, but the Russian activities along the northwestern borders of British North America eventually led the British admiralty to dispatch Captain James Cook to explore the northern Pacific. In 1778, he visited the Nootka on Vancouver Island and sailed north along the coast. A quantity of sea otter pelts received from the Nootkas brought high prices when Cook touched in at China on his way home.

The discovery of this Chinese market soon brought hundreds of European and American merchant ships to the Northwest Coast. From Europe and New England, they sailed around the southern tip of South America, traded their imports for sea otter furs along the Northwest Coast and moved on to Canton in China. It was estimated that, in 1780, for every shilling spent on Indian trade goods there was a return of about £90 in Chinese silks, porcelain, spices, tea and cash. Back home after two years, the merchants took in another supply of blankets, steel tools, rum and beads, to make the same voyage again and again. This circuit continued until the sea otters were seriously depleted in the 1830s.

During this period of maritime trade, the ships tended to return to harbors where they had established good contacts with the local chiefs. Representing the native communities in the negotiations with the ship captains, a chief would receive the major share of profits, and this accumulation of

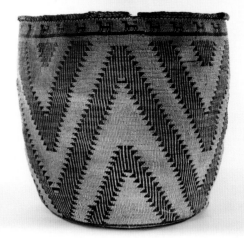

Storage basket, Skokomish-Twana, circa 1880.
Height, 13 inches / 33 cm. Wrapped twining of cattail and
cedar bark; the overlay designs of bear grass. The Twana are a
Southern Coast Salish people on Puget Sound in Washington.
Courtesy Charles Derby, Northampton, Massachusetts.

wealth increased his status and that of his lineage in the native social structure. Moreover, the local Indian village controlled the trade with more distant villages, which is how European imports had found their way up the Columbia River before Lewis and Clark arrived there in 1805.

Clothing received from the sailors became popular and even conveyed prestige among the elite. In 1792, a Haida chief met his white guests wearing two frock coats, one over the other, and decorated with Chinese coins and beads. Perforated Chinese coins also show up as eye inlay on early masks and on fringes of ceremonial regalia. Imported blankets became units of exchange in the intertribal trade, and piles of them served as a kind of money in potlatches.

Most important among the imports were hatchets, knives and other metal implements. More effective than the stone and bone tools, these steel utensils enabled the native artists to satisfy the increasing demand from the elite for beautifully carved regalia, masks and potlatch gifts. In addition to the carved house posts, free-standing totem poles became popular among the northern tribes. Some of these poles were erected by a new chief in memory of his predecessor; others were welcoming poles, placed on the beach to greet visitors. Mortuary poles supported boxes containing the ashes of the deceased nobility. Carved interior house posts remained more

prestigious among the Kwakiutl. Among the more southern tribes, sculptures were largely restricted to grave figures.

Despite great differences in customs and beliefs, the white traders and the coastal Indians shared many basic values, such as a passion for trade and a great interest in material wealth. The Indians were very discriminating in their selection of imports, though; if the trader did not have the quality of articles demanded by the Indians, there was no trade. During these years a trade language developed, based on Chinook and Nootka, combined with English vocabulary. Its use spread all along the coast in Indian-white contacts.

As contacts increased, greed caused increasing hostilities. Some visitors forced the trade at gunpoint, capturing chiefs and holding them for ransom in furs. Ships were attacked and destroyed by the Nootka and Haida, who enslaved the crews. The Tlingit were hostile from the start; in 1802 they destroyed the Russian fort at Sitka, looted the storage of furs and sold them to a passing British ship.

This situation changed with the establishment of permanent trading posts farther south along the coast. An American post founded on the lower Columbia River in 1811 was taken over by the Hudson's Bay Company (HBC) in 1825. Shortly after, the HBC established several other posts along the coast of British Columbia and in southwestern Alaska. As they had

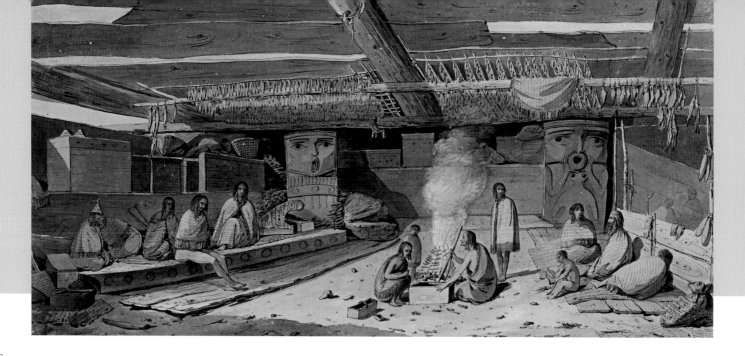

little interest in taking Indian land, the traders posed no threat and relationships were generally peaceful. Many old villages were abandoned by the Indians, who settled around the trading posts in order to create and protect a monopoly in the fur trade. The HBC responded by establishing more posts so as to make fair trade more widely available. After the decline of the sea otters, most of the furs were brought in from the interior. Vegetable growing was introduced by the Russians, so by 1825 the Haida were providing the trading posts with potatoes and trading the surplus with the Tsimshian.

Change was inevitable once the individual Indians could do their own trading, without supervision and control by the chiefs. The wealth derived from the maritime trade had enabled the chiefs to increase their humiliation of rival chiefs in more frequent potlatches with more lavish giving away of presents. As a substitute for traditional warfare, the potlatch had become a "fighting with property," as a Kwakiutl Indian saw it. But when the hereditary chiefs lost their control of the fur trade, a new rich emerged among the common people. More than ever before, public recognition of high social standing came to the man who was able to gather great riches and lavishly give them away.

To save their status, the chiefs boasted of their noble ancestry, hereditary crests and titles, but even these privileges were unexpectedly slipping away. Starting in the 1770s, smallpox epidemics stalked the coast, reappearing about every decade. Most severe was the effect of the first epidemic, in which one-third of the native population may have perished, including many aristocratic families. As a result, hereditary crests and titles came within reach of more distant relatives, particularly those who could validate their claims by giving a potlatch. Challenging the guests to respond with even more extravagant giveaways, smart hosts used such expectations as a means of capital investment. Large totem poles proclaiming all these achievements proliferated, forming dense rows in front of the houses. In the 1870s, about 500 carved totem poles stood in the 20 Haida villages, and comparable numbers decorated the villages of the Tsimshian and Tlingit.

The increased importance placed on the display of hereditary crests and related symbols was also reflected in the ceremonial regalia. Heraldic designs were cut from red material appliquéd on the imported blue blankets and outlined with mother-of-pearl buttons. In addition to these "button blankets," a new type of native-woven blanket appeared among the Chilkat division of the Tlingit in the 1830s. Because

Interior of a Nootka House, 1778.
Watercolor by John Webber. The carved house posts display figures relating to the ancestry of the chief who owned such a multi-family house. Dried and smoked fish hangs on racks from the ceiling. The people wear cloaks of twined bark fibers. A ceremonial object in the shape of a whale's dorsal fin is visible behind the people on the platform. It identifies the house owner as a whale-hunter chief.
© Presidents and Fellows of Harvard College, 41-72-10 / 499 T2360.

of the preference for the heraldic symbolism on these Chilkat blankets, the older Raventail weaving disappeared by 1850.

Indian artists had worked with native copper before, but their use of metals increased considerably when copper and iron became available in the fur trade. Copper masks and rattles were produced by Tlingit artists; coins provided the gold and silver transformed into bracelets and other ornaments, engraved with the usual prestigious designs. Shield-shaped sheets of copper, engraved or painted with crest designs, were symbols of great wealth. Such "coppers," each with a name or title, became the supreme gifts at potlatches.

Originally, most of the works produced by the native artists were commissioned by the tribal elite, but the arrival of white sailors and traders greatly expanded their market. From the earliest contacts, these visitors were sufficiently fascinated by the Indian arts to collect many examples, some of them now preserved in European and North American museums. Starting in the 1820s, Haida artists used a soft stone called argillite for carving hundreds of miniature totem poles, pipes, boxes and dishes for this curio trade. At first there was a noticeable influence of the sailors' scrimshaw work in the argillite carvings, but the traditional native style reasserted itself by about 1860. Wood carvings of the same type and

for the same market were also produced by the other northern tribes. The development of this curio market while the native arts and crafts were still fully alive prevented the corruption of these trade products into a poor tourist art. The curios were produced by artists who were well known among their own people for their outstanding traditional creations, and this quality is evident in the curios as well.

Among the Coast Salish and Nootka, the heraldic art style and its use in secular display had never overwhelmed the essentially religious motivation of their art. Their refusal to turn that art into curio products meant that sculpture on the southern coast simply disappeared when the region became heavily populated by white people.

The new population, however, offered a ready market for the imbrication-coiled and twined basketry of the southern tribes. Whaling scenes and other pictorial designs in wrapped twining and false embroidery became more popular than ever before on the basketry of the Nootka and Makah people, who also sold glass bottles completely covered with fine twined basket weaving. As well, Scottish immigrants introduced the knitting of woolen sweaters, which became an important cottage industry among the Cowichan of Vancouver Island.

In the second half of the 19th century, the declining fur trade and expanding white settlement led to

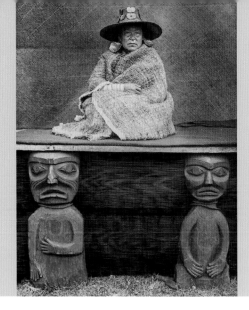

"A Nakoaktok Chief's Daughter," 1914.
Photo by Edward S. Curtis, showing how the eldest daughter of a Kwakiutl chief used to sit enthroned at ceremonial occasions. The carved posts of her seat represent slaves. The woman is wearing a robe twined of shredded bark fibers; large abalone shells decorate her ears and woven hat; and her nose ring also indicates status. Courtesy Northwestern University Library.

the breakdown of the native culture of the Northwest Coast and finished the golden age of its arts. The new diseases continued to ravage the native population, particularly after a gold rush in 1858 brought large numbers of unsavory intruders to the coast. On southern Vancouver Island, Victoria became a large city almost overnight, attracting many Indians as laborers. In the fall they returned home with large quantities of liquor and wealth, to celebrate in the winter ceremonials. At an 1895 Kwakiutl potlatch, 13,000 blankets were distributed, and this was not an exceptional event.

These excessive celebrations in the midst of social breakdown incensed the Christian missionaries. Following American prohibitions among the southern Salish tribes, the Canadian government banned the potlatch in 1884. This law was bound to undermine whatever still held the native society together, and force the Indians to change their value system. The results of this action were felt throughout the coastal area of British Columbia.

Without the potlatch and other winter ceremonials, the incentive to create new totem poles disappeared, and the production of masks and other sculpture dropped sharply. The weaving of the prestigious Chilkat blankets was abandoned by 1900. The Protestant missionaries demanded their converts to demonstrate full loyalty by giving up all aspects of the traditional way of life. Totem poles had nothing to do with religion, but many were destroyed as possible "idols." Churches were built with Indian support, and schools established, but many Indians searched for a compromise between the old and the new values and beliefs. Old traditions combined with Christianity created the Indian Shaker Church on Puget Sound in the 1880s, which spread to Washington and Oregon.

Fishing companies hired the native men for commercial fishing and the women to work in the canneries. Wage labor brought some independence for the individual families, but it undermined the traditional cooperation of the extended families. Old lineage houses might still be inhabited by a chief, but most were standing empty. By 1900, the native people had become a source of underpaid labor, many of them living in Vancouver, Seattle and other cities. Their fishing grounds were expropriated for commercial fishing operations, and the forces that pushed forward logging, mining and expanding white settlement ignored the native land rights.

From Alaska down into Washington, native organizations emerged and started the long and uphill battle for land and fishing rights. In Canada this struggle is still ongoing, but everywhere the native organizations have been leading forces in the revival of ethnic consciousness and tribal pride.

With the demise of the old wood carvers, the

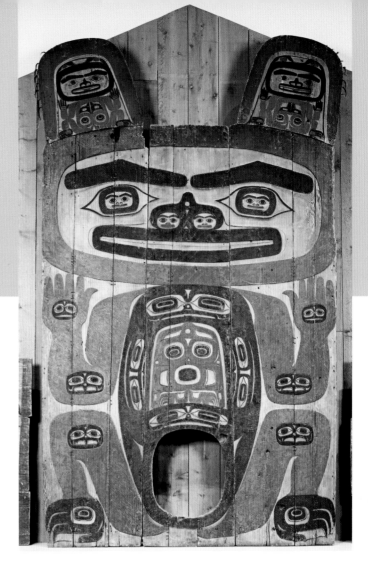

Interior house wall, Tlingit, circa 1840.
Height, 15.63 feet / 4.57 m. This partition separated the apartment of Chief Shakes from the other residents in the Grizzly Bear House at Wrangell Village, Alaska. Painted with the most important crest of the chief's family, the entrance and exit through the bear's belly symbolized the chief's descent from this mythical ancestor. Courtesy Denver Art Museum Collection: Native Arts acquisition funds. Photo © Denver Art Museum.

production of traditional art had been abandoned among most coastal tribes since 1900, and there was little interest in such things among the impoverished native people. The beautifully carved dugout canoes were replaced by motorboats in the 1920s, and the dwindling number of native artists worked primarily for a non-Indian market. A revived interest in native arts was led largely by anthropologists, starting with a major exhibition at the New York Museum of Modern Art in 1941. Projects were begun to preserve, restore and duplicate the old totem poles, which were rotting away in abandoned villages. The last few native carvers were hired for this work and to train younger apprentices. Bill Holm, Cheryl Samuel and other non-Indian experts continued to play a role, providing access to museum collections and supporting talented native students. With a renewed understanding of the concepts and principles of traditional art, this new generation of artists was able to go beyond duplication and create new interpretations of traditional themes. Traditional houses have been constructed for use as community halls, and a training center for the native arts was established at Hazelton in British Columbia. In addition to wood sculpture, the revival includes the weaving of blankets and hats, gold and silver work, and new art forms such as serial print making. After the Canadian government lifted the ban in 1951, potlatching was revived, with money and

modern consumer goods replacing the blankets and other items used in the past. The knowledge of dances and mask use is being transferred to young people.

Most of the native people have become staunch Christians, and so the underpinnings of this revived art have completely changed. Inherited rank and privileges still play a role, but the revived art functions primarily as an expression of ethnic pride. As in all other societies, these cultural activities involve only a small part of the native population, which has largely adopted the lifestyle of the dominant modern society. But as in other societies, it is this cultural core that has restored the identity awareness and pride of the population.

Soul catcher, Haida or Tsimshian, circa 1780–1820.
Length, 6.5 inches / 16.5 cm. Mountain goat horn, inlaid
with abalone shell and metal. "Soul catchers" were horn
or bone tubes, used by shamans to hold the souls of their
patients until these souls could be returned to their owners.
Courtesy Donald Ellis Gallery, Dundas, ON, New York, NY.

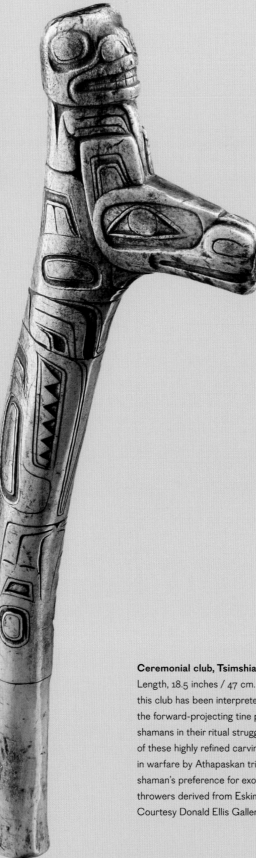

Ceremonial club, Tsimshian, circa 1750.
Length, 18.5 inches / 47 cm. Made of antler. The head carved at the top of
this club has been interpreted as the first owner of the wolf crest, pictured on
the forward-projecting tine part. Clubs of this type were used by Tsimshian
shamans in their ritual struggle with supernatural forces. The prototype
of these highly refined carvings was the sturdy caribou-antler club used
in warfare by Athapaskan tribes of interior Alaska. Other examples of the
shaman's preference for exotic weaponry are the beautifully carved spear
throwers derived from Eskimo prototypes and used by Tlingit shamans.
Courtesy Donald Ellis Gallery, Dundas, ON, New York, NY.

Raven rattle, Haida, circa 1860.

Length, 12.25 inches / 31 cm. A conventional type, carved in the form of the mythical Raven, holding a small piece in its bill, which refers to Raven's role in bringing light to the world by releasing the sun from captivity in the underworld. Sitting on Raven's back is a human figure, with his tongue receiving spiritual power from a bird. The shamanistic origin of the Raven rattle is evident in its iconography, but in historical times it became known as the "chief's rattle," popular all along the coast and used by wealthy people in winter festivities. This changing function from religious to secular ceremonialism is evident in the carving of the human figure. This is no longer merely a shaman, for his wolf's head identifies him as a Wolf clan ancestor. This rattle was probably carved by Albert Edenshaw, uncle and mentor of the great Haida carver Charles Edenshaw. Courtesy Donald Ellis Gallery, Dundas, ON, New York, NY.

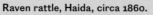

Shaman's rattle, Nootka, circa 1850.
Length, 14.5 inches / 37 cm. Carved of wood in two parts, tied together
with twine around the handle. This example also shows a human figure
receiving spiritual power, but the carrier of this scene is not a Raven. In
comparison with the more elaborate Raven rattles, this carving is typical
of the older and more naturalistic style of the southern tribes. The total
absence of any heraldic features suggests that this was indeed the rattle
of a shaman. Wolf spirits played an important role in Nootka rituals.
Courtesy Donald Ellis Gallery, Dundas, ON, New York, NY.

Ladle, Haida, circa 1860.
Length, 17 inches / 43 cm. A sheep-horn bowl
riveted with copper pegs to a goat-horn handle,
portraying mythical beings in a composition
similar to such arrangements on totem poles.
Courtesy Donald Ellis Gallery,
Dundas, ON, New York, NY.

Bowl, Haida, circa 1840–60.
Height, 4.5 inches / 11.5 cm. Made of mountain sheep horn, boiled and
steamed to soften the horn. This allowed the resilient material to be bent,
carved and formed into bowls, dishes and spoons. The high arched ends
and lower curving sides of these bowls are reminiscent of the shape of
the large dugout canoes. The entire outer surface was relief-carved in the
northern form-line style. Holding on to the mouth of a thunderbird (?) is
the figure of a frog, frequently involved in the transfer of spiritual power.
Courtesy Donald Ellis Gallery, Dundas, ON, New York, NY.

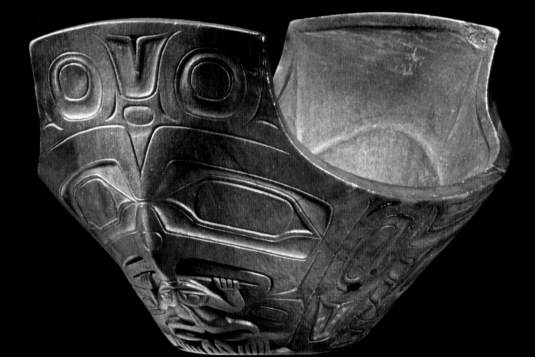

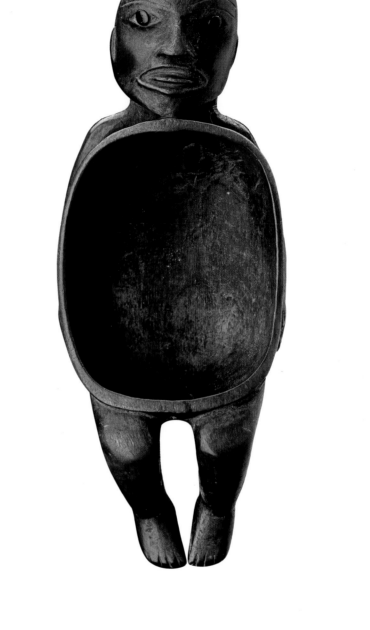

Bowl, Tsimshian, circa 1820–40.
Length, 6.5 inches / 16.5 cm. Carved
from mountain sheep horn; the eyes of
the human face are inlaid with mountain
goat horn. The simplicity of the carving
supports provenance information of an
early creation date for this bowl.
Courtesy Donald Ellis Gallery,
Dundas, ON, New York, NY.

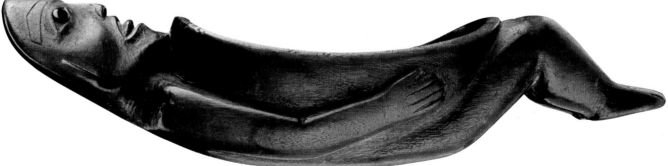

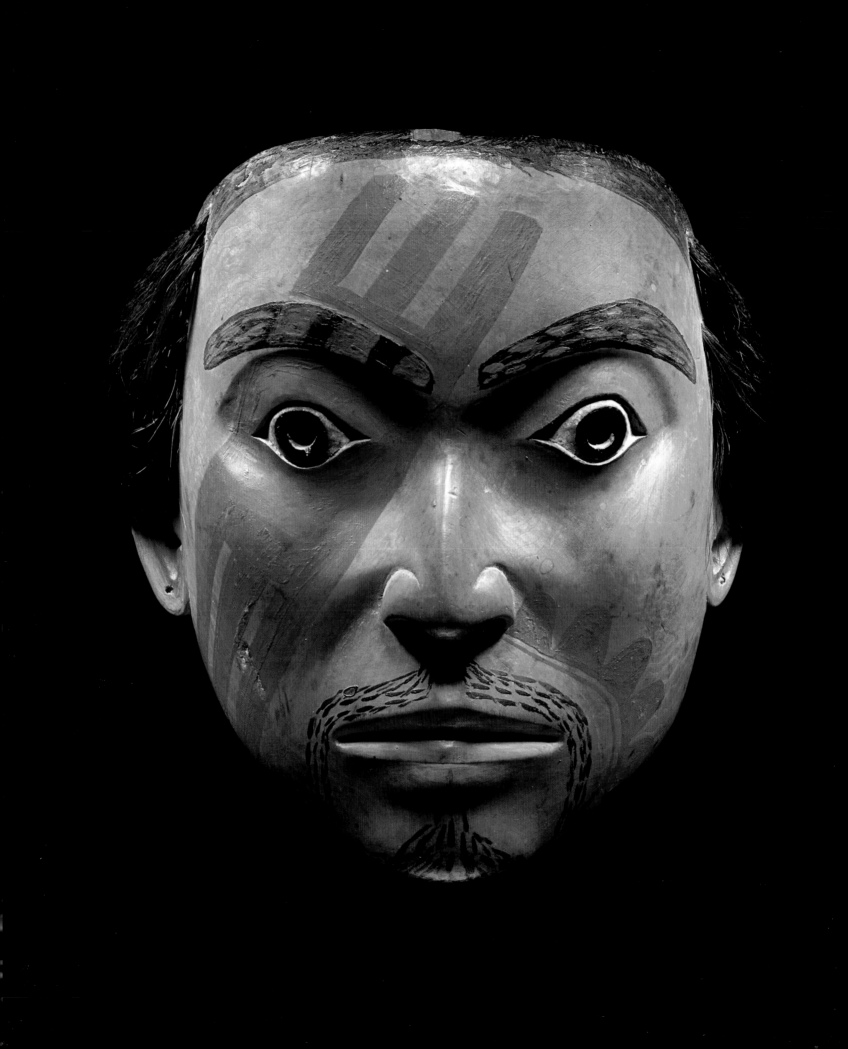

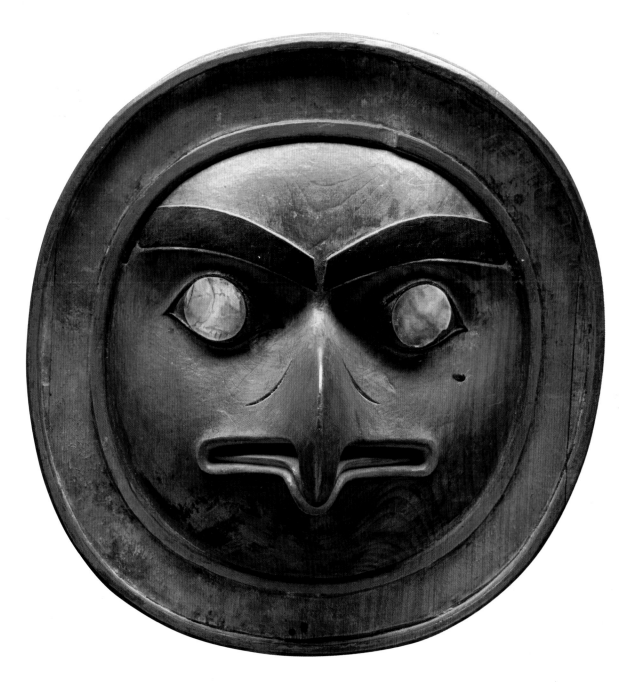

Facing page: **Portrait mask, Haida or Tsimshian, circa 1840.**
Height, 9 inches / 23 cm. Realistic woodcarving, with
the facial features and face paint identifying a specific
personality in a clan's history. Used in the reenactment
of heroic events in performances during the winter
ceremonials. The face painting suggests a Haida identity.
Courtesy Donald Ellis Gallery, Dundas, ON, New York, NY.

Frontlet of a chiefly headdress, Haida, circa 1870.
Diameter, 6.875 inches / 17 cm. Woodcarving representing
the chief's eagle crest; the eyes are inlaid with abalone
shell. Carved by Tahaygen, also known as Charles
Edenshaw, famous Haida artist (1839–1924).
Courtesy Donald Ellis Gallery, Dundas, ON, New York, NY.

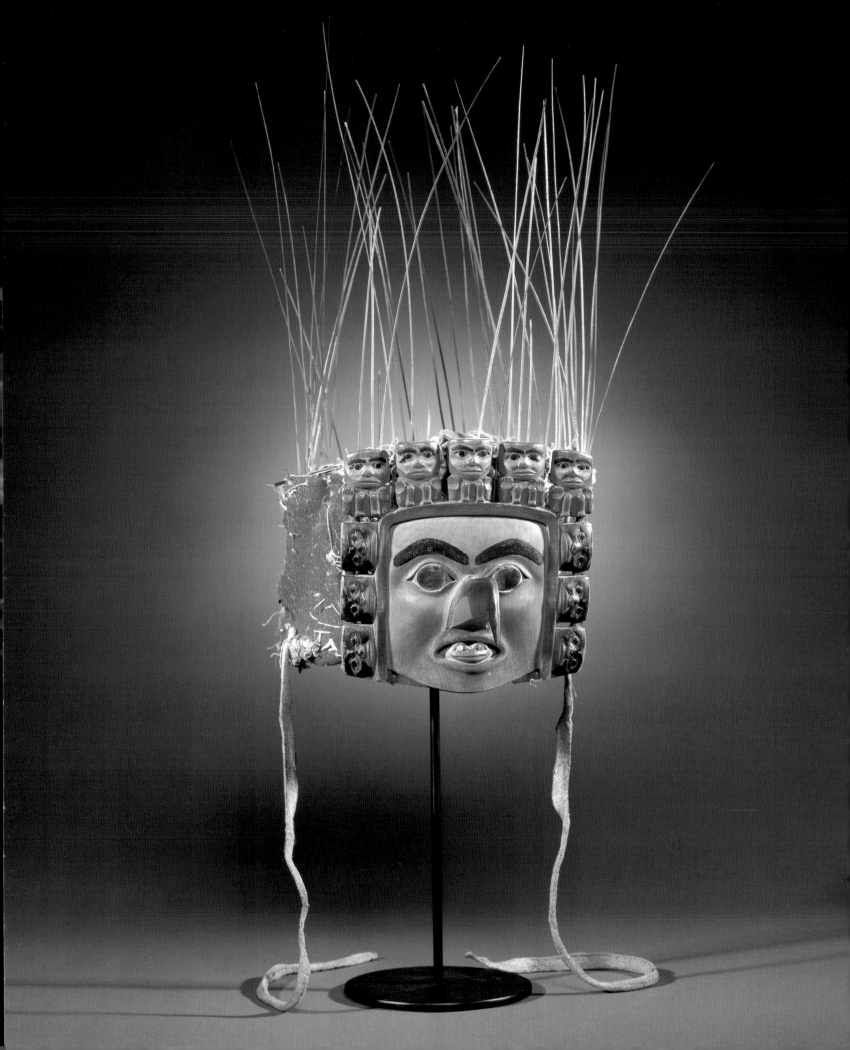

Facing page: **Frontlet of a Chiefly Headdress, Tlingit or Tsimshian.** The woodcarving represents a major character from the legendary origin of the owner's clan. Notice the frog emerging from the mouth. The images along the rim figure in related legends. Courtesy Donald Ellis Gallery, Dundas, ON, New York, NY.

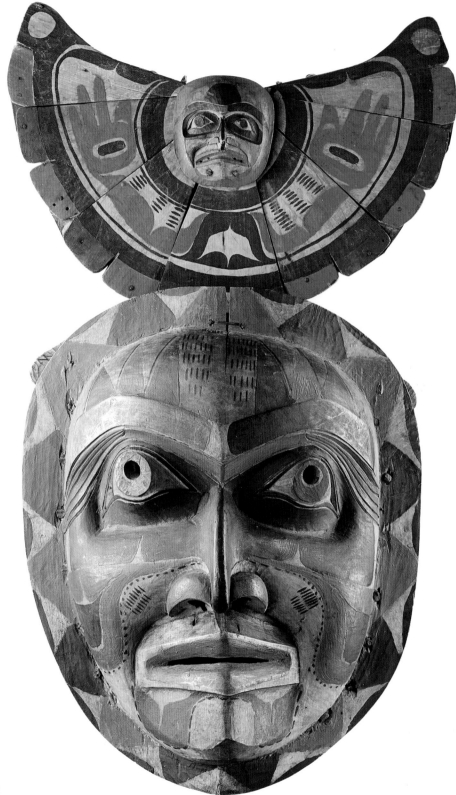

Sun mask, Kwakiutl, circa 1870.
Height, 22 inches / 56 cm (excluding attachment). The Kwakiutl were known for carving masks with a range of moving parts and appendages, enabling the dancer to change appearances. Transformation from animal to human frequently occurs in the mythic origin stories of families and ancestors. Transformation masks allowed the dramatic reenactment of such events. As a climax in the performance, the crescent-shaped piece on this mask could be moved down and changed into a series of sun rays around the mask. Courtesy Donald Ellis Gallery, Dundas, ON, New York, NY.

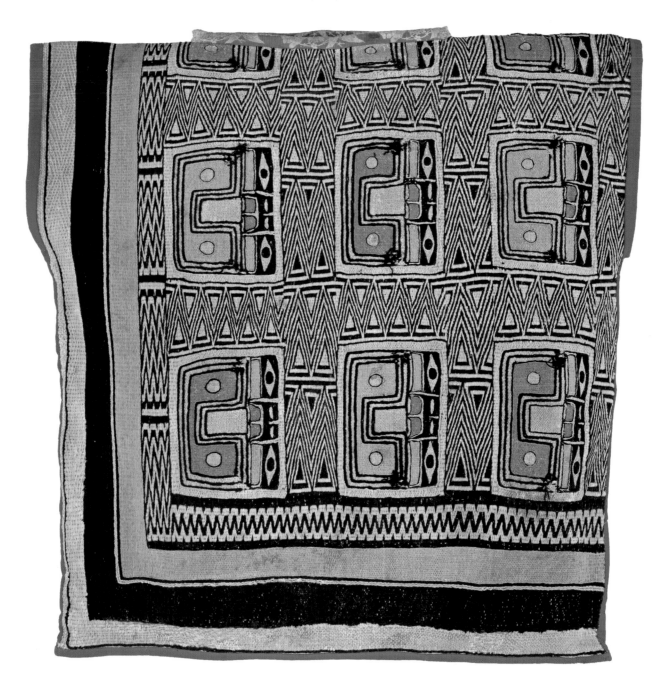

Woven tunic, Tlingit, circa 1850.
Length, 31.5 inches / 80.3 cm. A garment made from a
woven blanket, decorated with a combination of the old
Raventail patterns and the more recent Chilkat designs.
Photo © Canadian Museum of Civilization,
artifact VII-A-360, image s88-38.

Facing page: **Pattern board, Tlingit, circa 1860.**
The designs woven by the women on Chilkat blankets were copied
from pattern boards painted by professional male artists. The symmetry
of the design required them to paint only half of it on the board.
Courtesy Trotta-Bono.

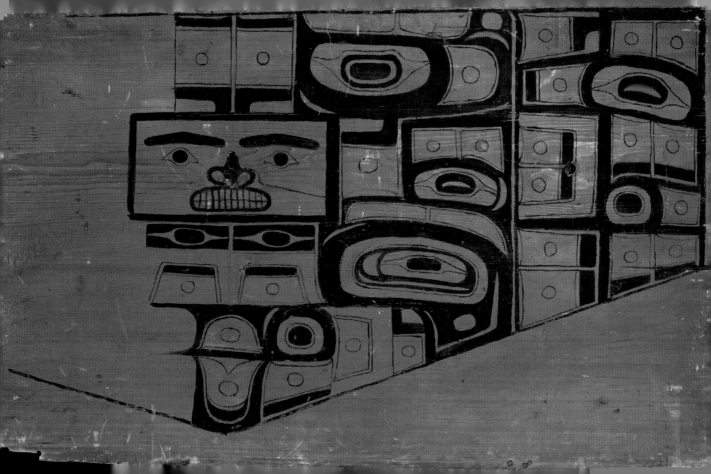

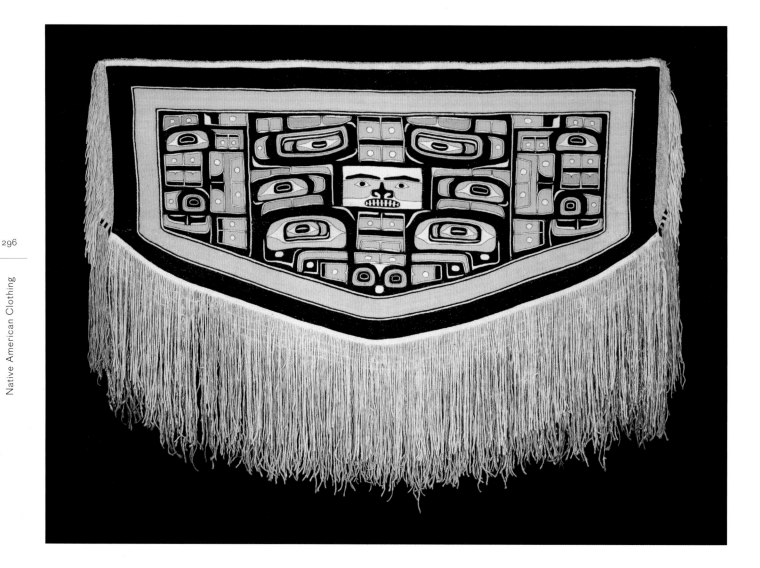

Chilkat blanket, Tlingit, circa 1860.

Width, 63 inches / 160 cm. Woven of mountain goat wool in a tapestry-twining technique. The designs on these blankets present perhaps the most extreme results of the traditional desire to cover all available space. This insistence led to modification and dislocation in the distribution of the human or animal design elements, thereby creating an almost abstract composition. Even native people often disagreed in their interpretation of the design subject. The identification as a heraldic crest symbol was apparently sufficient. These blankets were called "fringes around the body," referring to the pleasant movement of the long fringes during the dance. Courtesy Donald Ellis Gallery, Dundas, ON, New York, NY.

Facing page: **Model totem pole, Haida, circa 1900.**

Length, 15 inches / 38 cm. Argillite carving by Charles Edenshaw (1839–1924). The carving conforms to the arrangement of interlocking figures in deep relief carving on full-sized Haida poles. It is evident that many of these trade products were carved by talented artists, trained in the traditional form-line style. Argillite carving became a lucrative and dominant art activity for the Haida by the mid-19th century. Courtesy Donald Ellis Gallery, Dundas, ON, New York, NY.

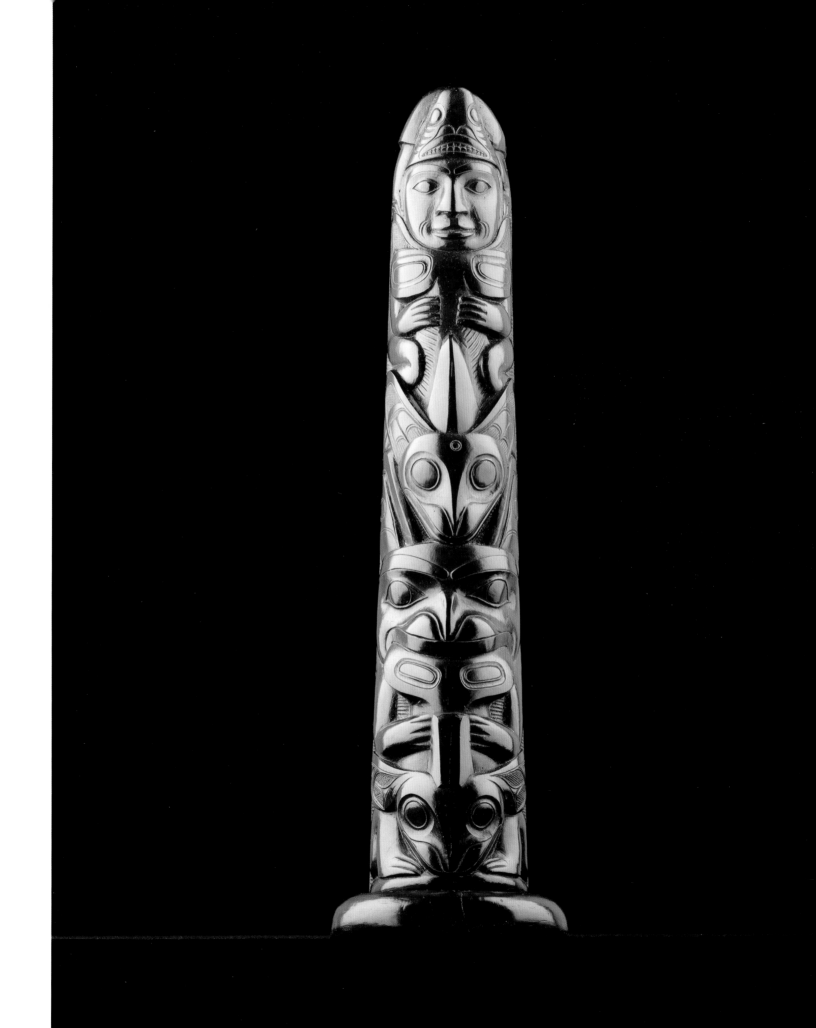

Native American Clothing

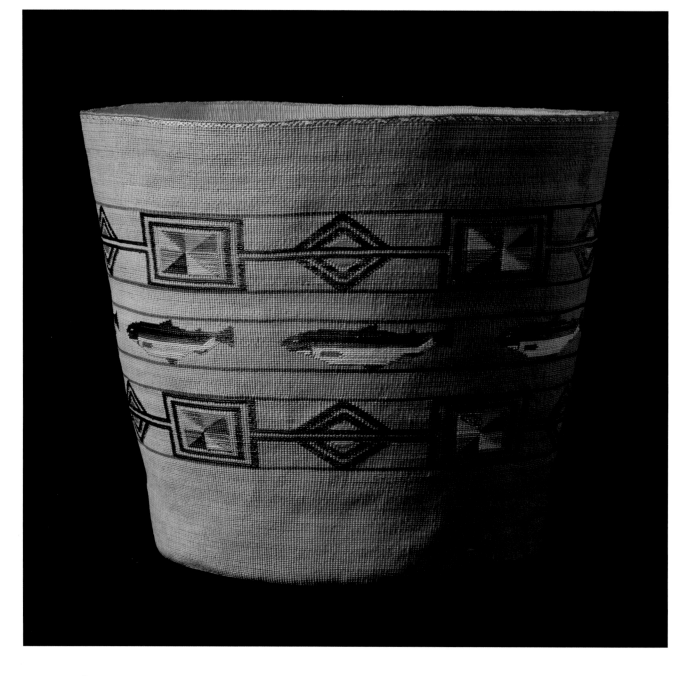

Storage basket, Tlingit, circa 1910.
Height, 11 inches / 28 cm. Twined-woven of split spruce root;
decorated with dyed grasses in false embroidery. The realistic fish
design is a pictorial innovation, usually promoted by a non-Indian
market. Basketry became a major source of income for Tlingit Indians,
who lost their land and livelihood in the gold rushes of 1880–99.
Courtesy Ned Jalbert, Westborough, Massachusetts.

Twined-woven hat, Haida, 1990s.

Width, 14 inches / 35.5 cm. Twined-woven by Isabel Rorick in 1991; painted by Robert Davidson, who is a grandson of Charles Edenshaw, the well-known Haida artist. Split spruce root is the traditional material for these hats, which were used by all coastal tribes for many centuries, presumably in response to the rainy climate. By crossing two warps at regular intervals, the weft created raised lines on the surface in a diamond pattern. The form-line painting on the front of this hat represents an eagle, while "Mouse Woman" is pictured on the back. The cylindrical rings attached to the top of the hat denote rank and status, each one said to stand for a potlatch given by the hat's owner. Courtesy Clinton and Susan Nagy Collection / www.splendidheritage.com

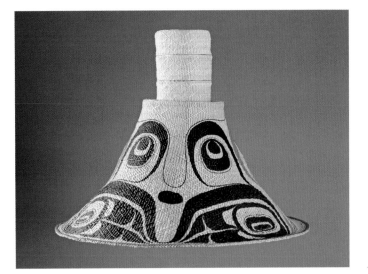

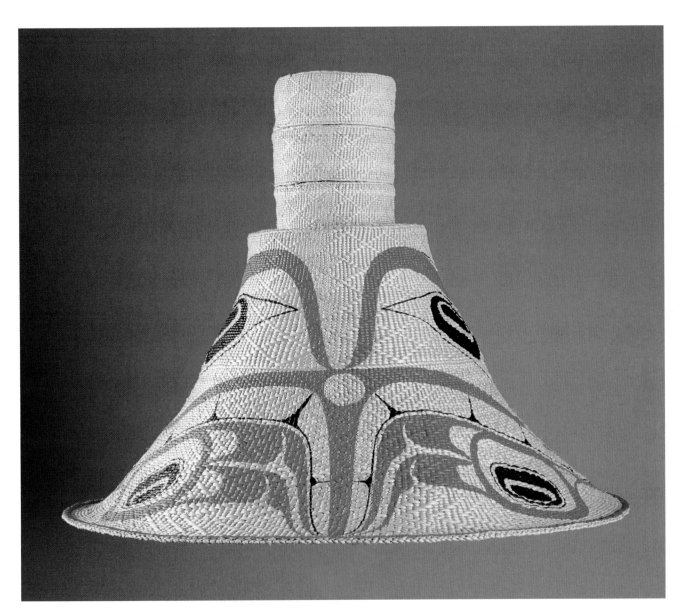

11 | Caribou

The western part of the great boreal forest, or taiga, starts north of the Plains and reaches north some 900 miles. Pine and spruce predominate in this forest, which is interspersed with open areas of muskeg and bog. A myriad of lakes and streams drain into a major river system formed by the Athabasca, Slave and Mackenzie Rivers and leading to the Arctic Ocean. Fish abound in these waters, which are also frequented by large numbers of migratory waterfowl. West of this river system, the land rises rapidly to the northern extensions of the Rocky Mountains, home of mountain sheep and goats. Behind these mountains, a complex array of other mountain ranges and plateaus protect the Northwest Coast from the long and bitter winter cold of the interior. This rugged country is drained by the many tributaries of the mighty Yukon River, which continues through the Alaska Plateau to the Bering Sea. Salmon fishing was important along these rivers and in rivers leading to the Pacific. Most of the Alaska coast was inhabited by Eskimo people. In contrast to the eastern lowlands, on which could be read the imprint of the last ice age, much of the Yukon country was not covered by glacial ice. The earliest ancestors of the American Indians lived here, probing for a route into the unknown.

Toward the north, trees grow smaller, and the forests give way to the windswept immensity of the open tundra, or Barren Grounds, where the musk-ox roamed. Indian and Inuit hunters may meet each other there, though in the past prepared for hostilities.

This is the land of the caribou, which offer life and survival for wolves and other scavengers, including man. The native people could not have survived here without the caribou. Equally numerous, caribou and stars were referred to by the same word by the Chipewyan Indians. Many thousands of these animals spend the winter in the protection of the northern forests. In the spring the herds gather and, led by the pregnant cows, start on their annual migration to the calving grounds and their summer range on the tundra. Across Alaska, Yukon and the Northwest Territories there are about 10 large herds, each usually following its own traditional migration route to its own calving ground. Tormented by clouds of mosquitoes, warble flies and black flies, the panic-stricken animals often stampede, but by the end of the short summer they are fat and ready to return and disperse into the forest. Throughout this country, each fall and each spring, thousands of these caribou are on the move in a storm of clattering hooves.

Deeper in the forest, in smaller herds, live the woodland caribou, which are not given much to traveling. They share the taiga with moose, deer and, in the south, buffalo. Bears, "snowshoe rabbits," muskrat and other small game are usually not hard to find.

The native people living in the western boreal

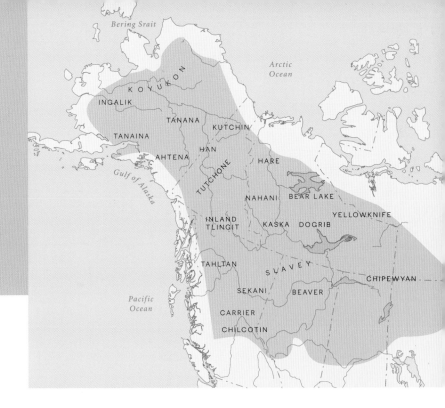

forest speak Athapaskan languages. Athapaskan is a poor choice as a reference to these people; it is a Cree word initially referring to the lake still called Lake Athabasca. In recent years, the native term Dene has come into use in reference to Athapaskan-speaking peoples.

Six thousand years ago, most of the Dene were still living on the upper Yukon River, though some had already wandered east to Great Slave Lake. Some 4,000 years later, the Dene spread into their historic locations in Alaska and the Northwest Territories. Presumably it was during these migrations that their speech differentiated into the 23 historic languages.

Tribal origin myths deal with a time when people and animals still understood each other and could assume each other's appearance. In order to distinguish themselves from these other "persons," the Indians called themselves Dene "people." Actually, the term implies "real people," and it is with that understanding that the term is never applied to the Inuit or any of the historic intruders. Instead, the Inuit and Cree were referred to as "enemies," though hostility was not restricted to these alien people. Considerable aggression was indirectly generated by the fur trade among the various Dene groups, but it was not unknown in traditional times. The earliest records mention the use of armor, wooden shields, war clubs and special daggers in warfare. Traditional hostility

was caused by blood feuds, the capture of women and the belief in witchcraft.

The Dene shared with the native people of the Eastern Boreal Forest a similar adaptation to the natural environment and an essentially similar spiritual worldview. This is most evident east of the western mountain ranges. The people lived a nomadic life in small groups of a few related families; moving on snowshoes and pulling their toboggans in the winter, traveling in bark- or skin-covered canoes in summertime. Women carried a child or luggage on their backs using shoulder straps and tumplines; dogs carried some equipment; the men carried only their hunting gear. Elderly men were recognized as leaders in specific activities, be it hunting, fishing or warfare. There were no tribal chiefs, because there was no recognition of community beyond the small family band. Self-reliance was supported by guardian spirits, who offered their assistance in dreams.

Charms of a general nature were the ptarmigan feet tied to the snowshoes to make them move lightly over the snow, bands of bird down on boys' legs to give them speed in hunting, otter feet tied to fishing nets

Facing page: **Dog blankets, Slavey, circa 1900.**
Length, 21 inches / 53 cm (including yarn border). Fancy
dog blankets, called tapies or tuppies, were used on festive
occasions by the Dene Indians. They were made in sets, usually
of four, often with rows of sleigh bells across the middle.
Courtesy Donald Ellis Gallery, Dundas, ON, New York, NY.

for success in fishing, and many other similar devices. Caribou and moose were foremost on their minds, but as a year-round dependable source of food, fish was important.

When the caribou gathered in large herds for their spring and fall migrations, the family bands of each region came together. They intercepted the herd at water crossings, where they speared the caribou from canoes, or they led part of the herd into fenced drive lanes that gradually converged at a corral. The leader of such a communal operation was a man who owed his expertise in "calling" the caribou to his good standing with the game spirits. The Kutchin Indians remember that the old people used to talk with the caribou when they followed the herd, and the caribou answered them.

Occasionally, however, the caribou changed their migration route. Even worse, caribou are subject to natural cycles of increasing and crashing numbers every so many decades. Such disastrous events were not "natural" to the Indians, though. They were convinced that the game spirits seldom failed to be generous to people who treated the game with respect. This assumed interrelation of human and animal populations was still noticed at Great Bear Lake in 1928. According to the local Indians, "now that there are fewer Indians, they do not think it strange that there is less game than formerly" (Osgood, 1933). Remarkably similar statements were recorded after 1781, when a smallpox pandemic with staggering mortality swept from the northern Plains into the boreal forest, coinciding with a mysterious and lethal disease that afflicts the game. Questioned by traders, the Indians "merely answered that the Great Spirit having brought this calamity [the smallpox] on them, had also taken away the Animals in the same proportion as they were not wanted, and intimating the Bisons and Deer were made and preserved solely for their use; and if there were no Men there would be no Animals" (David Thompson, 1784–1812).

Periodic starvation was part of the native way of life. Hunger was not experienced as a tragedy, but as a normal condition between periods of plenty. If there was game, the hunters killed as many animals as possible, in order to have food to share with less fortunate families. It was unthinkable for some people in the camp to eat while others went hungry. Without the facilities to transport much food, it was believed to be pleasing the game spirits to feast while the food lasted, without much worry about the future. Trusting in the goodwill of these spirits, the bones of game, waterfowl and fish were disposed of in their natural habitat, to ensure these would return to life, procreate and thus return as food. But it did not always turn out that way.

Game provided not only food, but also skins for clothing and shelter, antler and bone for tools

and sinew for thread. Caribou and moose hides were sewn together into tarpaulins to fit around conical lodge frames. A red ocher line was often drawn along the horizontal seam halfway up the lodge cover, and smoke penetrating the skin kept most of the mosquitoes out. Tanned caribou and moose skins intended for clothing were either smoked or hung outside to be bleached by sun and wind. White bleached skin garments were believed to attract the caribou. For summer garments, the hair was removed from these skins.

In historic times, the Dene south and east of the Mackenzie River used garments similar to those of the western Cree. The men wore sleeved, pullover shirts and leggings attached to a belt underneath the shirt. Garters with long fringes kept the leggings together below the knees. The dress worn by women reached below the garters that held up their knee-length leggings. Smoked moose skin was preferred for moccasins. Large hides served as robes, which might also be made of braided strips of hare fur. Fur caps, mittens and a knife sheath hanging on separate neck straps completed the outfit.

The name used by the Cree to refer to the southern Dene, Chipewyan, means "pointed skins," and alluded to the pointed bottom edge at the front and back of the Dene tunics. This name refers to a fashion predating the adoption of the Cree dress, probably similar to the type of dress that survived among the northern Dene tribes from the lower Mackenzie into western Alaska.

This older dress style was intricately tailored and of sophisticated design, providing maximum protection in the harsh climate. The pullover tunics indeed had a pointed lower edge front and rear. The panel for the back was cut longer and wider than the front so as to fold over the shoulders and around the sides, thus moving the seams away from the strain along shoulders and armpits. With these tunics were worn trousers with moccasins attached. Red lines were painted along the seams of these garments, and only the longer length of the tunic distinguished the female from the male's costume. Long fringes were quill-wrapped and strung with the seeds of the silver willow. Hoods, mittens and knife sheaths on neck-straps were used by the western Dene as well. White-bleached caribou skin was preferred, but native trade across the Bering Strait also made Siberian reindeer hides available in Alaska.

The skin garments were decorated with porcupine quillwork in various techniques. Bands of checkered and triangular motifs were created on the chest, back and cuffs of the tunics, and along the trouser seams and garters, hoods, mittens, bags and knife sheaths. Neither this quillwork nor any of the few other Dene art expressions carried explicit symbolism. Yet there

Facing page: *Winter Travelling in Dog Sleds,* **1846.**
Oil on canvas by Paul Kane, based on his sketches at Fort Edmonton.
The dog teams, decorated with "tuppies" and standing irons, draw
carioles, that is, toboggans, outfitted with wooden or canvas covers.
Introduced by the Red River Métis, these festive coverings were
adopted by the Indians throughout the Northwest Territories.
With permission of the Royal Ontario Museum © ROM.
Acc. no. 912.1.48; image no. ROM2005_1546_1.

was an intimate connection between the individual and his or her clothing. Garments were never loaned or borrowed, but those of successful hunters were desirable presents, expected to transfer such success to the new owner. An elaborately decorated dress was highly desired for burial, and on the lower Yukon River, relatives visited the grave a year later to replace the decayed clothing. Although the dress decoration was not explicitly symbolic, the costume as a whole was apparently intended to please the game spirits.

This traditional Dene dress style is of a unique design, incomparable to any other Indian fashions, but even more intricate variations of these tunics and footed trousers were made by the neighboring Eskimo women of northern Alaska. The Dene people of western Alaska have long interacted and intermarried with their Eskimo neighbors, in the course of which they adopted many features of Eskimo Culture. House construction, kayak and sled use, mythology and masks used in the winter festivals of these northwestern Dene are unmistakable evidence of Eskimo influence. Most probably, the unique dress style of the Dene people also originated long ago in this context.

The ease with which the Dene absorbed foreign influences is also noticeable among the Dene neighbors of the Tlingit, Tsimshian and other Northwest Coast tribes. Trade between coast and interior has a long history, in which coastal notions of clan organization, prestigious rank, heraldic crest symbolism, potlatch, masked dances and even the carving of totem poles was adopted by some of these western Dene tribes. In return, quillwork-decorated skin garments and knives made of native copper were highly prized by the Tlingit.

The invention and production of these copper knives by the Dene is rather mysterious and is apparently one of the very few items of Dene Culture not borrowed from other people. Tlingit and Central Inuit cold-hammered copper nuggets, but the Dene knives were made of a single piece of highly forged copper, revealing an advanced metallurgy most uncommon for nomadic hunters. These knives and other cutting tools were made by the Yellowknife Indians north of Great Slave Lake; knife handles made of musk-ox horn also point to that region as their place of origin. The Yellowknife or Copper Indians were named after the ore quarried by them near the Coppermine River. Native copper was used there as early as AD 1300, and the products were widely traded among the Dene tribes. In the 18th century, similar knives were obtained by the coastal Tlingit from the Tanana and Ahtena in Alaska. By that time, iron tools from Siberia had arrived at native trade fairs in western Alaska.

☀

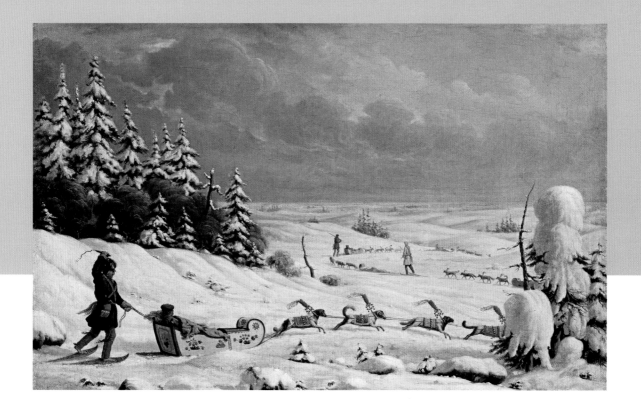

In the 1670s, the Hudson's Bay Company began its trade in furs with the Cree on James Bay and was slowly expanding its operations into the northwest. Rumors of the white people and their trade goods reached the southern Dene when York Factory was established on the lower West Coast of Hudson Bay in 1682. Acting as middlemen in the fur trade, the Cree offered metal implements and beads for exorbitant prices in fur to the natives in the distant interior and resorted to looting their camps when the Chipewyan tried to establish direct contact with the trading post.

In order to stop the violence and make trade goods available at a more reasonable price to the northern Indians, Fort Churchill was founded higher up the coast in 1717. As a result, the Cree redirected their aggressive trade westward to the Slavey and Beaver Indians, and the Chipewyan adopted the same activities in raiding their northern neighbors. Escaping from the turmoil, one band of Beaver Indians fled south into the northern Plains. Allied with the Blackfeet and adopting their culture, these fugitives became the Sarsi tribe. The frequent contacts between the western Cree and Dene tribes were not always hostile, though, as is evident in Cree influence on costume fashion, religious customs and the mythology of the Dene people in the Northwest Territories.

Nevertheless, the efforts to maintain a trade monopoly and the struggle for direct access to the white traders caused increasing warfare, mitigated only by the gradual expansion of trading posts into the interior after 1780. Earlier exploration by Samuel Hearne provided a remarkable picture of the Dene in this early period. Guided by Chipewyan Indians, Hearne left Fort Churchill in December 1770. Eight months later, they reached the lower Coppermine River, where Inuit were fishing. Hearne was unable to prevent his Indians from attacking the Inuit camp, and the ensuing massacre gave the place its current name, Bloody Falls. Returning to their own camp, the Chipewyans performed their ritual customs to cleanse themselves of spiritual impurity. On their way home, the party came upon unfamiliar snowshoe tracks, which led them to a small hut, in which they found a Dogrib Indian woman. Several months earlier she had escaped from a band of Cree,

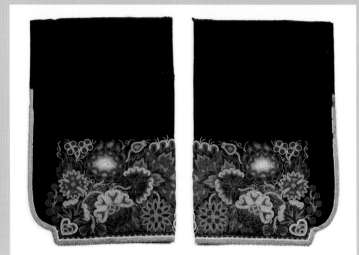

Woman's leggings, Great Slave Lake – Mackenzie River region, 1890–1900.
Floral beadwork on trade cloth. Floral designs of this complexity were primarily made by Métis women living at the trading posts, but comparable work was produced by the regional Indians after they settled in log cabins. Courtesy Walter Banko, Montreal, Quebec.

who had captured her in their attack on her people's camp. On foot, she had set out to rejoin her people several hundred miles away, but autumn found her still far away from her destination. Equipped with only a knife, an awl and a few caribou skins, she prepared herself for a long winter alone. Further travel would be too dangerous in the dark and bitterly cold season. She had built a small shelter, made a pair of snowshoes, a fish net and, from caribou sinews, snares with which she caught hares for food and clothing. Impressed by her courage and skills, Hearne's Indians spent the night in wrestling matches to determine who could take her as his wife.

What struck Hearne most strongly was the considerable effort made by this woman to decorate her new fur garments. What motivated her artistic creativity, without a reasonable expectation of human contact for months to come? Most probably, beautiful dress was part of her survival strategy: she had to please the game spirits and arouse their generosity. This notion is known from explicit statements by Cree; it is inferred from the Dene custom of decorating all garments and implements associated with hunting.

While the British traders followed the Mackenzie and Yukon Rivers into the northwest, Russians were exploring western Alaska, starting in 1741. Their trade was primarily focused on the sea otter, and they remained along the coast for a long time. Insofar as their trade reached the Dene tribes, it involved the coastal

Tlingit as middlemen, effectively barring Russian penetration into the interior of Alaska. Russian trade with the Dene of the interior also remained marginal because trade with the Hudson's Bay Company had reached Alaska by 1840. American traders moved in after the Russians sold Alaska to the United States in 1867.

In exchange for beaver, fox, marten and other furs, and by supplying the trading posts with meat and fish, the native people obtained guns, axes, knives, twine for nets, kettles, steel needles, scissors, beads, ribbons, blankets, cloth and cloth garments. All these imports made life easier and more comfortable, but the price included more than just animal pelts. In the early 1780s, smallpox wiped out nine-tenths of the Chipewyan people, soon to be followed by other epidemics.

The introduction of firearms did not change the native custom of killing as many animals as possible during the annual caribou migrations. Hunting with spears and arrows was balanced by the natural increase of the game, but the use of guns was going to test the assumed benevolence of the game spirits.

Christian missionaries had entered Dene country by the mid-19th century. They established mission schools near many trading posts, where the children acquired some command of the English language and where the women were taught domestic skills such as embroidery. Formal conversion to Christianity was accepted fairly soon, as a complement to the

traditional religious practices related to hunting. The native economy remained viable, in some places well into the mid-20th century.

The use of imported commercial goods was limited by the high costs of riverine transport. Nevertheless, the fur trade had its most obvious impact on the native arts and crafts, some of which disappeared rapidly. Waterproof basketry coiled from split spruce root, the rims wrapped with colored bird quills, was disappearing by 1850. Knives were no longer forged from native copper when steel imports became available, though the old technique was still used to make knives from imported steel files. Colorful glass beads competed with traditional porcupine quillwork in the decoration of garments, and the cut of those garments was influenced by European design. Beadwork was an indication of wealth, but traditional clothing became a mark of poverty. Coats presented to successful trappers in the early years of the trade inspired the creation of decorated "chief's coats" by the Indians of the Yukon and Alaska.

In the Great Lakes region, the early fur trade had created a large mixed-blood population, which acquired a culturally distinct identity once it concentrated in southern Manitoba. After their "rebellions" of 1870 and 1885, these Red River Métis started a virtual exodus to the Northwest Territories. By that time, a considerable number of the Dene had white people among their ancestors, but most of them remained Indian in their upbringing, worldview and attitudes. As elsewhere, then and now, lifestyle rather than genetics or government registration determined a person's ethnic identity. And here, as elsewhere, the Métis played an important role as cultural intermediaries between the Europeans and the Indians.

The most visible manifestation of Métis Culture was undoubtedly their colorful clothing, which was decorated with floral patterns. This style had its beginnings in the 1820s with small and stylized designs in multicolored quillwork. As these people

moved north, their art evolved, taking on increasingly naturalistic and flamboyant designs in beadwork and silk embroidery. French embroidery patterns used by the nuns in mission schools combined with Cree and Great Lakes Indian influences in the development of this Métis art style.

Métis art had a strong trade orientation, making it very popular among the Indian population. Métis women made jackets, moccasins, mittens and a variety of bags and pouches for this trade. On festive occasions, the dog teams pulling the toboggans were now decorated with "tuppies" – beadworked dog blankets with rows of bells on top and ribbons and pompoms on standing irons. At Christmas and Easter, these bells could be heard from far away as the native people were coming to the settlements. The introduction and adoption of this floral art style caused a total change in the decorative art of the Dene, particularly in the Northwest Territories. Its influence was less strong in the Yukon and Alaska, where more abstract patterns prevailed in beadwork. Much of this colorful apparel was used on festive occasions only; by the end of the 19th century, native style clothing had virtually disappeared from daily life.

※

Change had come very gradually until 1875, when a succession of gold rushes hit the Yukon and Alaska. Gold prospectors arriving by the thousands represented the first direct contacts with white people for some of the more remote native people. Living conditions changed rapidly for the regional Indians, who derived their first cash income from meat and fish sold to the new population. A curio market developed, mostly of basketry made by the coastal Tlingit, but with some production of beadwork, moccasins and jackets by the Dene people. Most interesting was the sudden revival of the production of old-fashioned traditional costumes by Kutchin women. Catering

to romantic notions of visiting sport hunters, these women created garments that were no longer used by their own people. Never worn and in pristine condition, these costumes became respectable in museum collections. In the same period the decorative art of moose-hair tufting developed in the mission school of Fort Providence and became popular among the Slavey Indian women. In tufting, a small bundle of hair is fastened onto the hide or cloth with a single stitch around the bundle. When the stitch is pulled taut, the hairs stand up and are trimmed with a scissor into a small dome-shaped dot. These colored dots are arranged into floral shapes.

By 1910, the gold rush had petered out and most of the white people left again, but there was no return to the old way of life. The nomadic lifestyle of the native people was disappearing. Many of them settled in log cabins near the trading posts. Hunting, trapping and fishing remained important, but some seasonal wage labor became available in lumbering and commercial fisheries.

Starting in the late 19th century, the Canadian government had negotiated treaties with native peoples in order to settle land issues and legalize the expansion of government control in the northwest. In the 1930s the international fur market began to decline, and by 1940 commercial fishing produced more regional export than furs. The increasing poverty of the Indians led the Canadian government to assume responsibility for local schools, medical centers and welfare services. Access to these services promoted permanent settlement of the Indians, as well as an increasing dependence on store-bought commodities. All-weather roads were extended northward, bringing lumbering, mining and other large-scale industrial activities, primarily run by a transient white work force. Employment for the Indians was restricted by their lack of education. The exploitation of the northern Alberta tar sands has destroyed the environment and poisoned the rivers; airborne pollutants from mining operations are covering the lichens on which the caribou feed; pipelines interfere with their migrations. Welfare has gradually become a way of life for many Indians, undermining incentives to provide for themselves.

In Alaska, unlike in Canada, native land rights were virtually ignored until 1958, when Alaska acquired statehood. Industrial development and population growth had become a source of conflict for the traditional economy of the native people. For the native people, caribou hunting means the difference between independence and a subsistence living on government handouts.

In Alaska, the construction of oil pipelines spurred the adoption of the Alaska Native Claims Settlement in 1971, which granted the native communities 44 million acres of land and close to a billion dollars in exchange for the extinguishment of all land claims. A distant bureaucracy established regional corporations and gave them control of timber, fisheries and mining, ignoring the existence of tribal groups.

Realizing, however, that perpetual ownership of the land was not assured under this arrangement, the tribal groups reasserted their rights under their own governments. This tribal movement has inspired a cultural revival that is spreading beyond Alaska into the Yukon as well. Traditional ceremonials promote arts and crafts, and young people attend cultural camps in which they are immersed in traditional customs. Thus the continuing political negotiations have become a rallying point to ensure the survival of native cultures.

In the Northwest Territories, the Indians have demanded "the right of self-determination as a distinct people and the recognition of the Dene Nation." In order to take into consideration regional differences, the Northwest Territories were divided into Nunavut, inhabited by the Inuit, and Denendeh, of the Indians, both terms meaning "our land." Unresolved claims of land and resources continue to dominate the political development of the North and may drag on for decades to come.

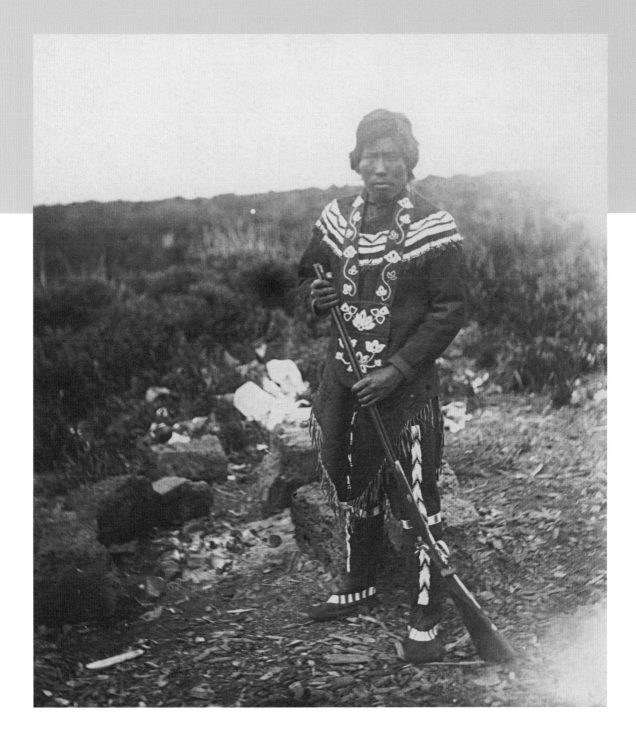

Ingalik Indian, lower Yukon River, circa 1880.
Tanned hide and quillwork were replaced by cloth and beads, but the
style of festive clothing remained traditional in western Alaska in around
1900. Beadwork in floral style decorates the shot pouch of this man.
Courtesy National Anthropological Archives,
Smithsonian Institution, neg. 6362.

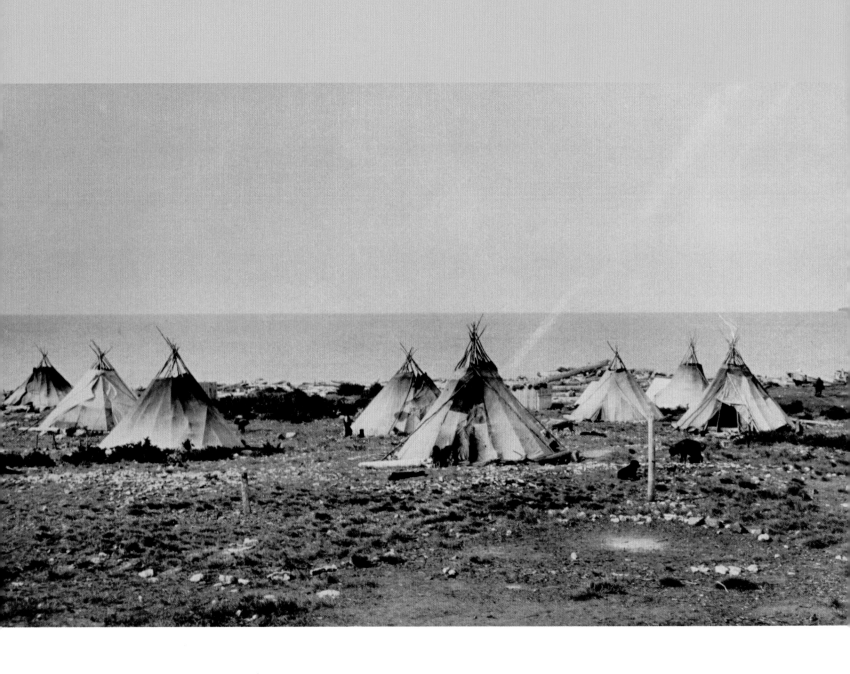

Indian camp near Fort Resolution on Great Slave Lake, 1913.
In the early 20th century, native peoples began to use
canvas as coverings in place of caribout hide.
Photo © Canadian Museum of Civilization, photo
by J.A. Mason, 1913, image 26098.

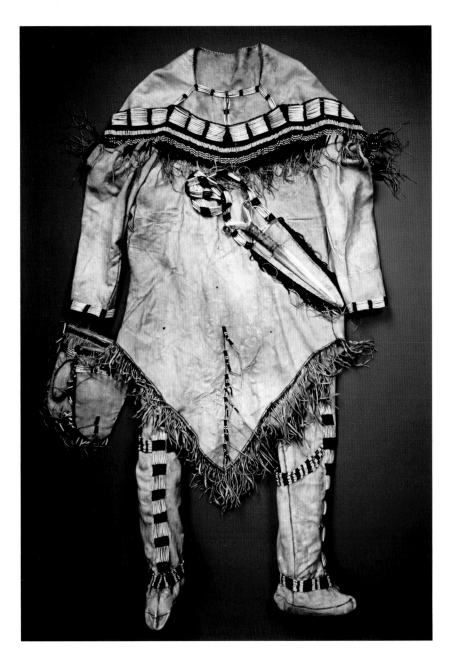

Man's costume, Kutchin, 1862.
Shirt length, 53 inches / 135 cm. Caribou skin, decorated with beads, dentalium shells and red ocher paint. The abundant use of dentalium shell indicates the prestige and wealth of the costume's owner.
© The Trustees of the National Museum of Scotland.

Birch-bark container, Fort Simpson, pre-1868.
Height, 5.25 inches / 13 cm. The rim is reinforced by a wooden hoop, wrapped with split spruce root. When reversed, the bark offers a brown surface on which designs can be scraped. In the eastern boreal forest, the background rather than the designs were scraped out. Birch-bark containers are part of a circumpolar tradition, dating far back into prehistory.
©The Trustees of the British Museum. All rights reserved.

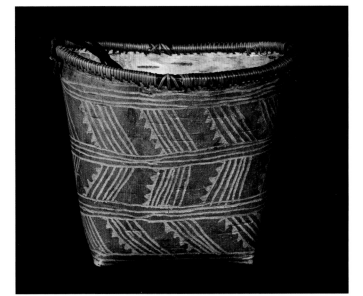

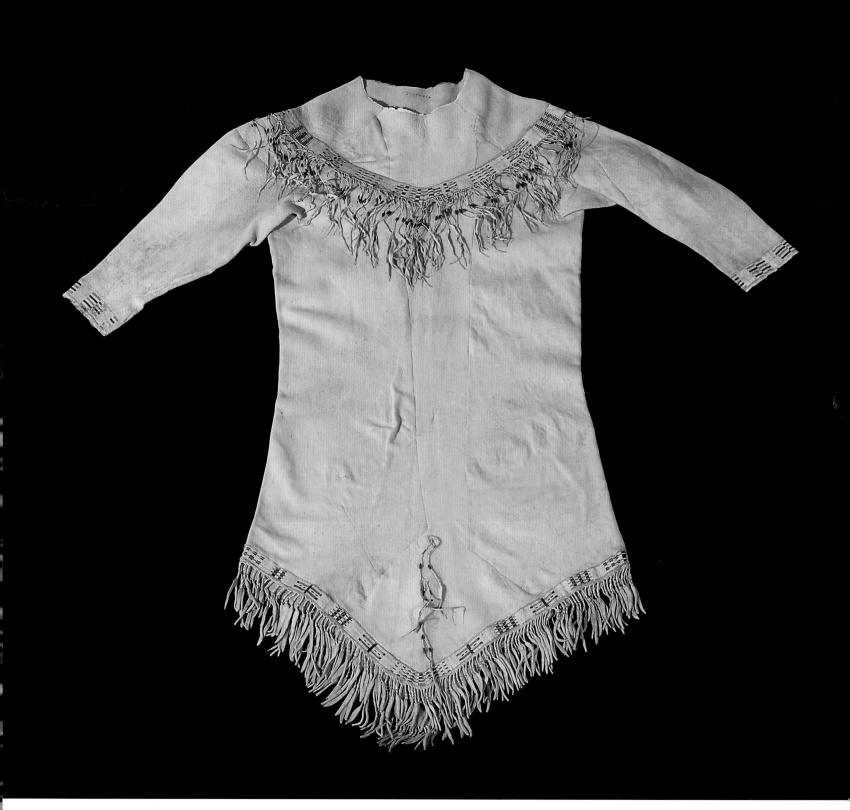

Long tunic, Ahtena, 1840s.

White caribou hide, decorated with fine woven quillwork;
silver willow seeds strung on the fringes.
Courtesy Phoebe A. Hearst Museum of Anthropology and the
Regents of the University of California (cat. no. 2-19045).

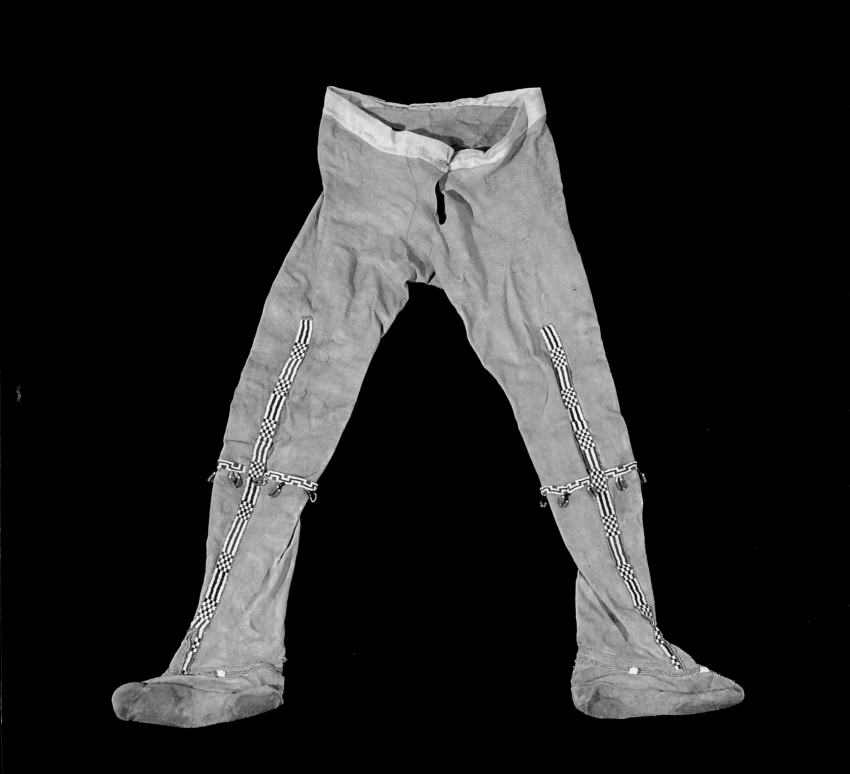

Moccasin trousers, Tahltan?, 19th century.
Dene trousers were essentially footed leggings, joined by a central gusset.
They were worn by men and women. The beadwork on this example
suggests an origin from the Tahltan in northwestern British Columbia.
Courtesy Phoebe A. Hearst Museum of Anthropology and the Regents of the
University of California (cat. no. 2-6722).

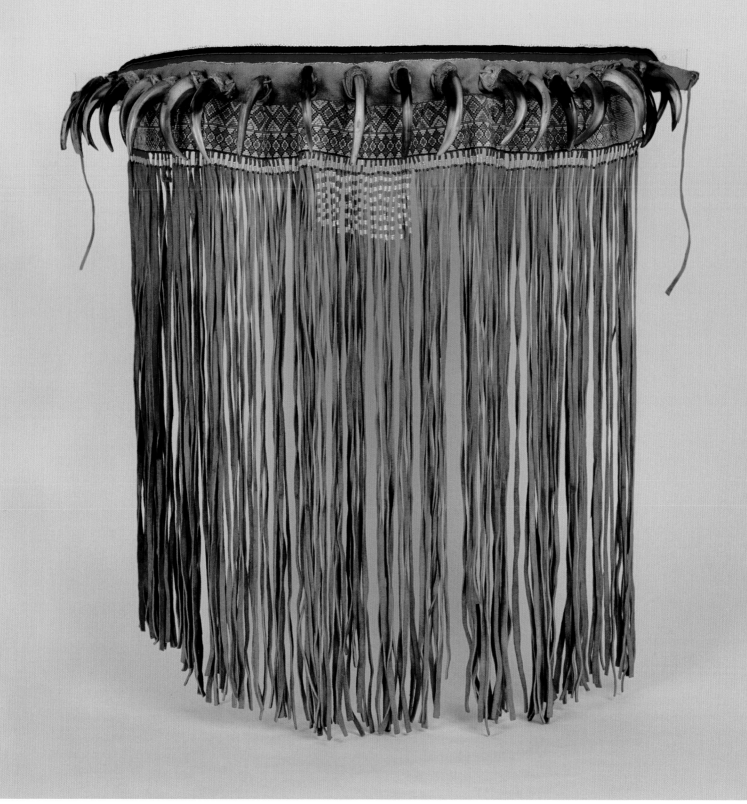

Belt, Tahltan, 19th century.
Woven quillwork and long fringes were popular on belts and garters. The bear
claws on this example most probably relate to the owner's guardian spirit.
Courtesy National Museum of the American Indian,
Smithsonian Institution (151696). Photo by David Heald.

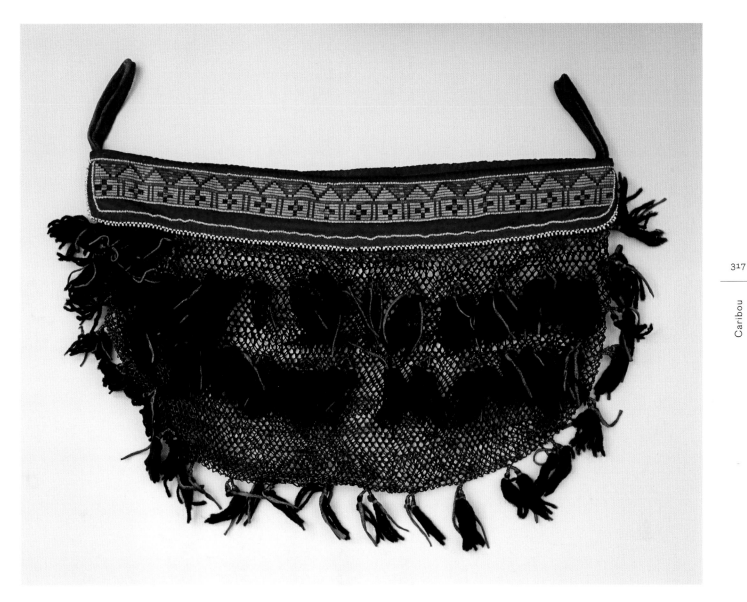

Game bag, Slavey type, 19th century.

Width, 17.25 inches / 44 cm. Open netting of skin thongs
called babiche, decorated with yarn tassels; attached to a
woolen border that is covered with loom-woven quillwork.
© The Manitoba Museum, Winnipeg, Manitoba.

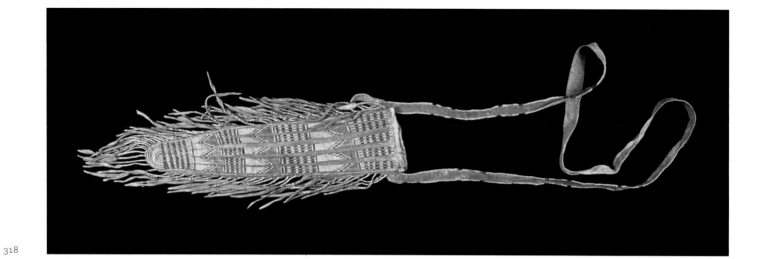

Top: **Knife sheath, Tanaina, pre-1821.**
Length, 12.5 inches / 32 cm. Woven quillwork on tanned hide.
Includes a strap with which to hang the sheath on the chest.
Photo © Canadian Museum of Civilization, artifact VI-Y-1,
image S86-1326.

Bottom: **Knife, Yukon River, circa 1800.**
Length, 15.75 inches / 40 cm. Native copper, forged and cold-
hammered. Acquired from Han Indians on the upper Yukon River,
but probably made by the Ahtena in southwestern Alaska.
Photo © Canadian Museum of Civilization, artifact VI-F-16,
image D2003-11361.

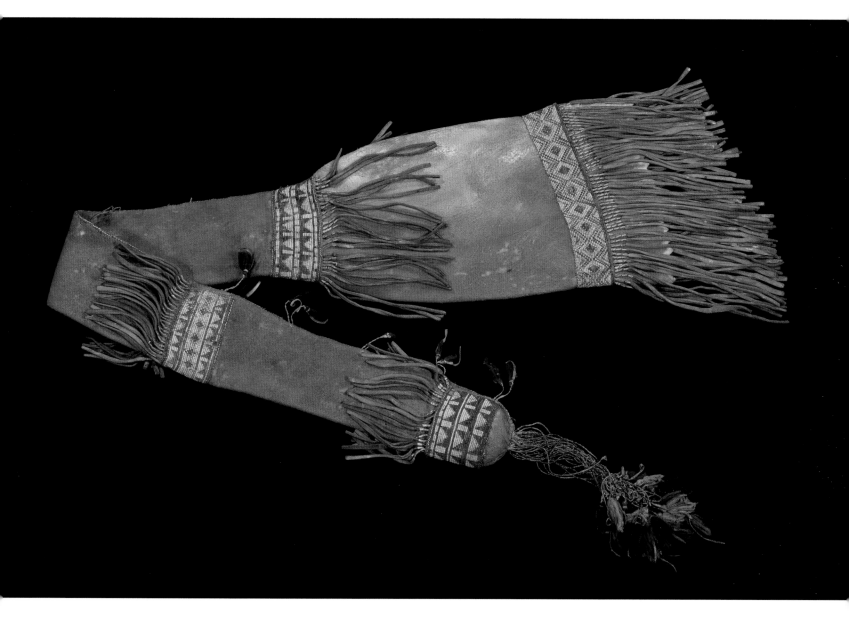

Gun case, Kutchin, 1890.

Length, 48.5 inches / 123 cm. Smoked hide, ornamented
with bands of woven quillwork; yarn tassels on top
fringes. Guns were kept in their cases to protect them
from snow and water. Native-made skin gun cases were
copied from cloth cases imported by the traders.
Courtesy Haffenreffer Museum of Anthropology,
Brown University.

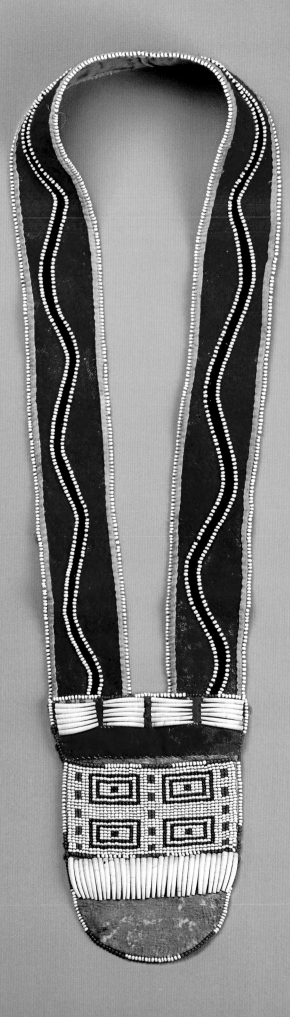

Right and below: **Woman's leggings, Dogrib, circa 1910.**
The Dogrib shared a predominantly floral style of beadwork with the other Mackenzie River Indians. For a short while at the end of the 19th century, bands of intersecting circles and spirals became popular in their beadwork. Photo © Canadian Museum of Civilization, artifact VI-E-3 a-b. Photo by M. Toole, 1992, image S93-747.

Facing page: **Shot pouch, Tahltan, circa 1900.**
Length, 33.25 inches / 84 cm. Beadwork and dentalium shells on smoked hide; the neck strap is covered with wool fabric. The use of dentalium as a signifier of prestige and wealth was introduced by Indians of the Northwest Coast. By 1850, these shells were imported by the Hudson's Bay Company. Courtesy Royal British Columbia Museum, image. no. BCPM 14817.

Native American Clothing

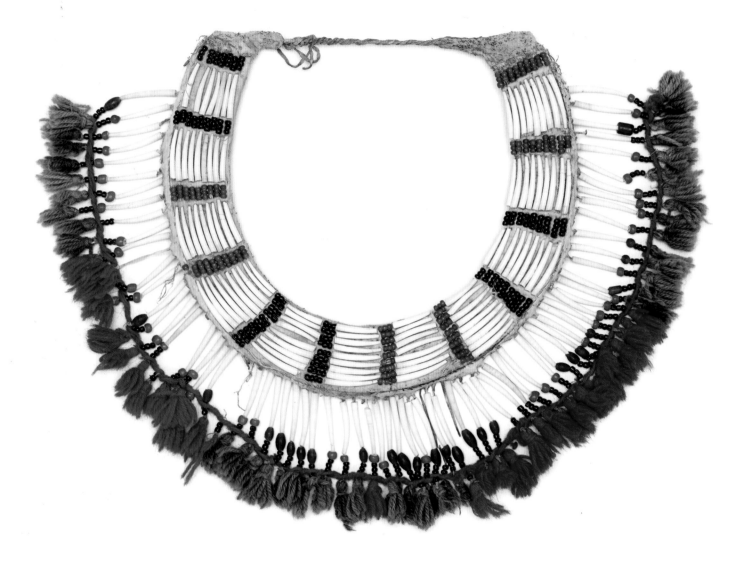

Girl's neck ring, Tahltan, circa 1900.
Wood base, covered with tanned skin; dentalium shells, glass beads
and yarn tassels. Neck rings of this type were worn by girls after their
puberty seclusion, indicating their maturity and readiness for marriage.
Prestigious dentalium shell was acquired in trade from coastal Indians.
Courtesy Department of Anthropology, Smithsonian Institution,
cat. no. E248388. Photo by D.E. Hurlburt.

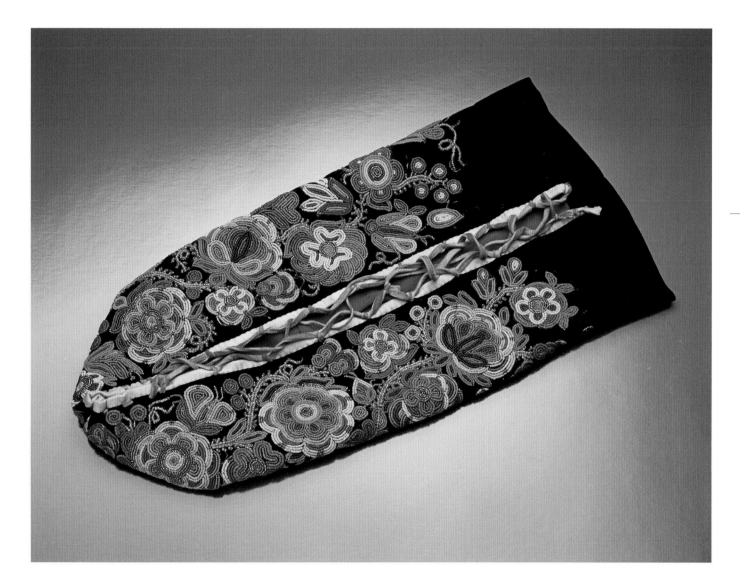

Baby bag, Kutchin, 1900.

Length, 21.5 inches / 55 cm. Beadwork on black velvet. This type of "moss bag" is of James Bay Cree origin and traveled with the fur trade into the Northwest, where it replaced birch-bark cradles.

Photo © Canadian Museum of Civilization, artifact VI-I-5, image S84-5992.

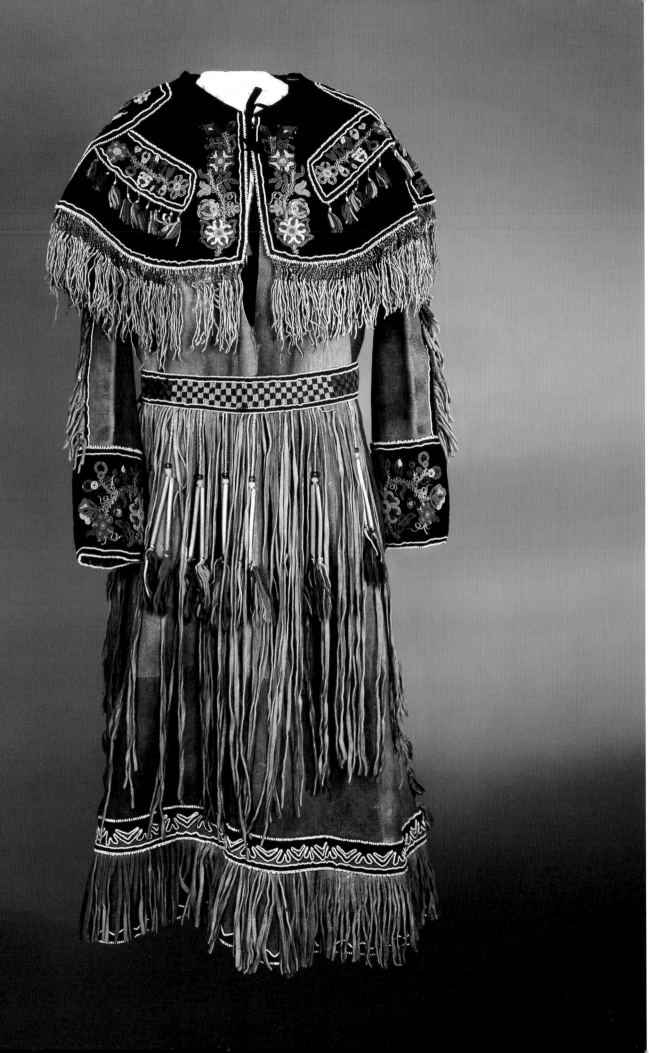

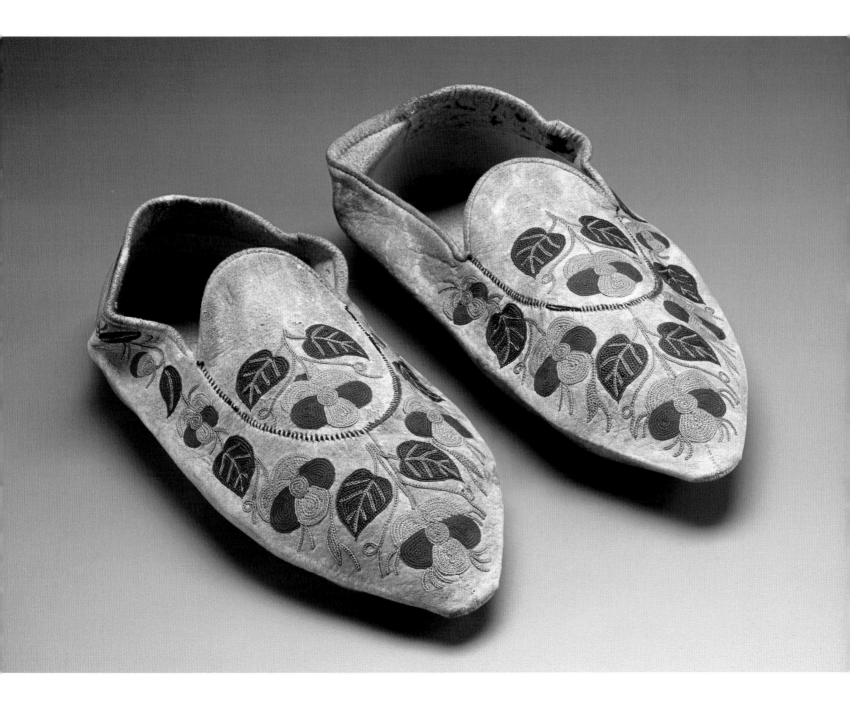

Facing page: **Woman's dress, Fort Chipewyan, circa 1900.**
Length, 46.8 inches / 118 cm. Beadwork on black velvet parts of a smoked-hide dress. Perhaps originating with the mission schools, native versions of white people's fashions became popular in the late 19th century. Only the generous use of long fringes is reminiscent of the old Dene dress. Courtesy the Royal Alberta Museum, Edmonton, Canada. Cat. no. H 73.55.1a-c.

Moccasins, Métis, 1880s.
Length, 10 inches / 25.7 cm. Silk embroidery on smoked skin. Unusual decorative design on slippers for indoor use, probably originating in northern Alberta. Courtesy John and Marva Warnock Collection / www.splendidheritage.com

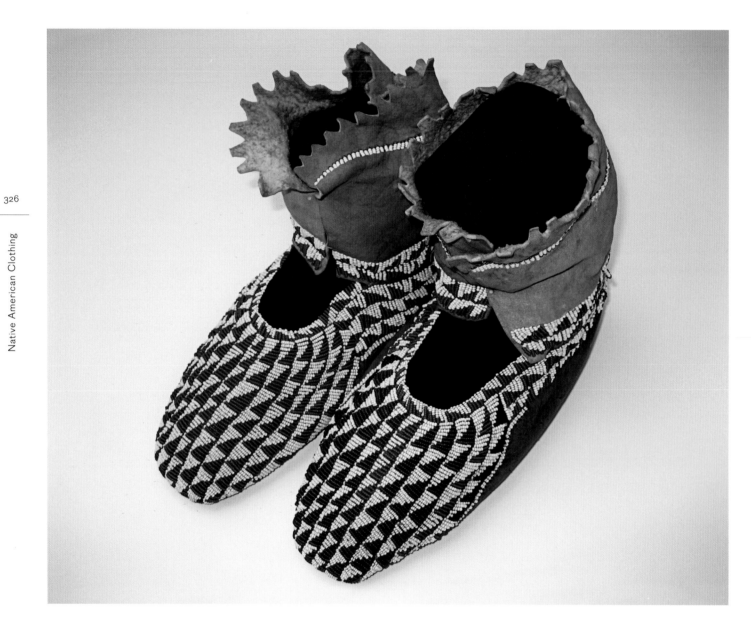

Moccasins, Inland Tlingit, circa 1900.
The Inland Tlingit, living along the border of Yukon Territory and
British Columbia, is a Dene group that adopted the Tlingit language
during the early history of trade between coastal and interior Indians.
Their lifestyle and clothing remained typically Dene, though in the
late 19th century some rather unusual beadwork was created in
their region. These moccasins are an example of that trend.
Courtesy Charles Derby, Northampton, Massachusetts.

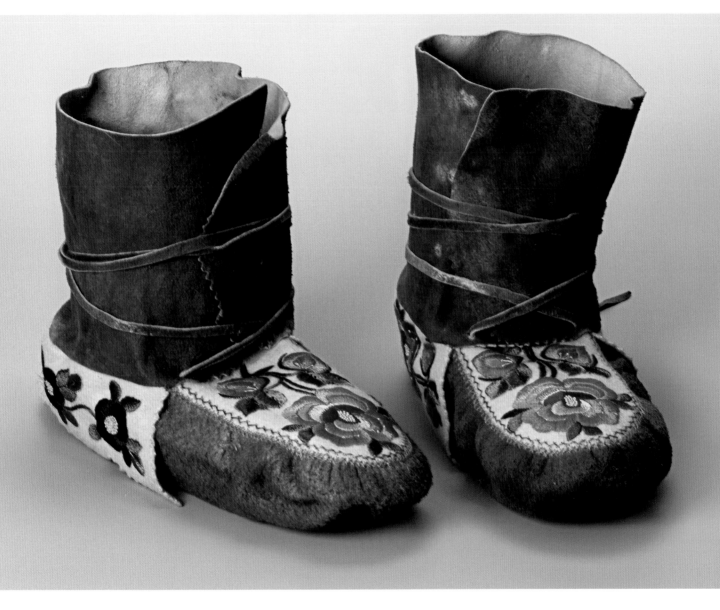

Moccasins, Dogrib, 1967.
Silk embroidery on white cloth on the front and cuffs of smoked-hide moccasins. Silk and floss embroidery became popular on the Mackenzie River by the 1950s, though it remained less common than beadwork. Courtesy Milwaukee Public Museum. Photo by Joanne Peterson.

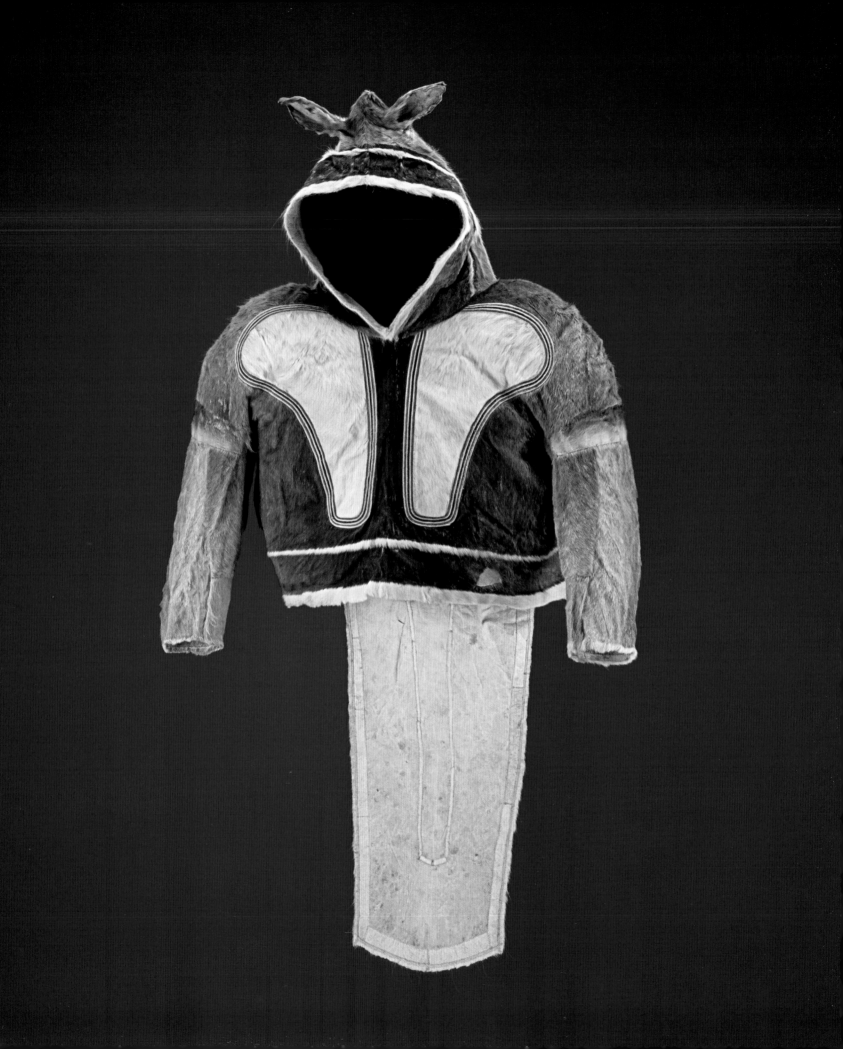

12 | Hunters of the Arctic Coasts

The young woman was living with her father by the
sea. Proudly she had rejected all suitors, until one
day, a man passed by in his kayak and called out that
he wished to marry her. He appeared to be strong
and handsome, and the girl joined him as his wife.
Paddling on, they came to an ice floe where the man
pulled up and revealed himself as an ugly fulmar, a
sort of petrel bird. The girl was shocked by this trans-
formation, but life could be worse, for her husband
provided ample food and a warm shelter.

The girl and her father missed each other, though,
and when one day her father found her, she left with
him. Returning from his daily hunt, the bird husband
found his wife gone, and he flew all over the ocean
in search of her. When he found the fugitives, he
pleaded to see his wife, who was hidden in the kayak,
but the father only mocked him. Angry, the fulmar
raised a furious storm with his wings, and water
began to fill the boat. This frightened the father, and,
to quiet and satisfy the bird, he threw his daughter
overboard. But the young woman desperately held on
to the kayak and refused to let go. Her father took his
knife and cut off the top joints of her fingers. As they
fell into the sea, they changed into ringed seals. The
woman still held on, and he cut off the second joints,
which turned into bearded seals. Still she held on, and
when her last finger joints were cut off, they became
walruses (or, in another version of this story, whales).

No longer able to grasp the boat, the girl sank to the
bottom of the ocean. There she lives as the mother
and guardian spirit of all sea animals.

Sedna, as she is called on Baffin Island, is known
by different names across the Arctic. She rewards
the hunter who honors the taboos out of respect for
the sea animals, but she is easily offended by a more
casual attitude. To those lacking respect, Sedna does
not release any game, causing hunger and starvation
for the hunters and their families. That is why the
Iglulik Inuit call her Takanakapsaluk, "The Terrible
One Down There."

Sedna was honored with a ceremonial every year
when the sun began to disappear for the long and dark
winter, starting a period in which the people depend-
ed on hunting her sea animals. All the oil lamps would
be extinguished when the shaman went into a trance.
His soul was believed to go down into the deep to find
Sedna, her long hair made dirty by taboo trespasses of
the hunters. Despite all her power over life and death
she could not clean herself, since she had no fingers.
The shaman would wrestle with her until she allowed
him to clean and dress her hair. He would flatter her
until, appeased, she sent out the sea animals again.

During this fall ceremonial, marriages were
temporarily dissolved, and the men and women were
matched in pairs to spend a day and night together.
Native statements are vague; one can only speculate on

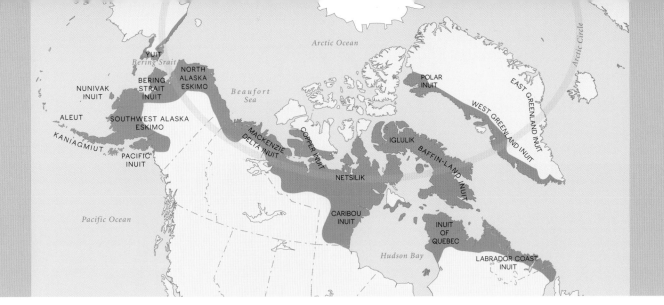

how far the shaman went in flattering Sedna. The celebration of fertility, looked upon with favor by Sedna, was supposed to be a forceful expression of hope that light and life would someday return again to the world.

At the end of the winter, the sun returned and heralded new life. Large flocks of waterfowl returned to lay their eggs; the caribou would gather on the tundra to drop their calves; and pregnant women ritually lit new fire in their oil lamps. This spring ceremonial was in honor of the master and guardian spirit of the land animals. Residing in the sky, this spirit was also known by different names, but regional legends do not, or no longer, agree on his or her identity.

Storytelling was recognized as an art, allowing imaginative entertainers to enrich or change their story with elements from other myths. Thus a Dene Indian myth was used to tell that Sedna was first married to a dog, by whom she had both the Indians and whites as her offspring.

The master of the land animals was named Pingna by the Caribou Inuit; the Netsilik identified him with the moon. Moon Man is surrounded by innumerable caribou souls, visible as stars in the night sky. He guards and regenerates the land animals and becomes angry if more are killed than are needed for food and shelter. In northern Alaska, this major game spirit is "Eagle Mother," who returns north with the birds in spring. The story is that long ago, she had taught a boy

to drum and dance, and he had introduced the first drum dance to his people. They had danced all night, but as they left in the early morning they fell forward on their hands and changed into wolves, foxes and all the other ancestors of land animals.

Eagle Mother was unusual, though; the lord of the land animals was usually believed to be masculine, and women are associated with sea animals and waterfowl in several myths. Due to the antagonism between Sedna and Moon Man, a strict set of rules and regulations was observed to keep the products of land and sea separated. At the end of winter residence on the ice and before the move inland, all implements associated with maritime hunting were cached on shore. New caribou skin clothing could not be sewn with thread made of seal sinew; meat of maritime and land animals were neither cooked together nor eaten on the same day. Most important, caribou antler had to be used to make arrowheads and other tools used in hunting land animals, and caribou blood, not seal blood, was used as a glue in the preparation of such arrows. By the end of the summer, caribou meat could not be stored beside the first seal meat; sealskin garments had to be made, but not before the people moved into their igloos on the ice. Yet caribou fur, which provided the best protection against the cold, was indispensable during the winter. Walrus ivory was the preferred material for harpoon heads and all

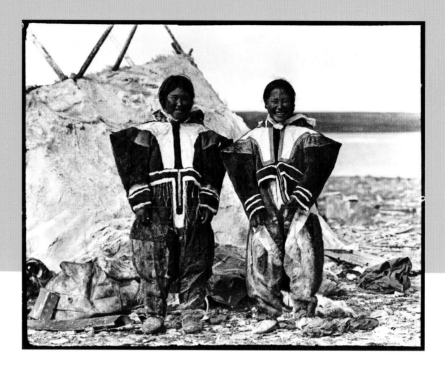

Right and facing page: **Copper Inuit Women, 1916.** The woman's parka shown here was made from the thin summer fur of the caribou, and its design features allude to her maternal role. The bulky leggings were abandoned when women adopted cotton skirts. Photo © Canadian Museum of Civilization. Photos by G.H. Wilkins, 1913-16, images 51250 and 51251.

other implements associated with maritime hunting. These rules and related observances reflected a basic dichotomy in the Inuit worldview, in which female, winter, sea and underworld stood in opposition to male, summer, land and sky.

Related to the mythological charter of this system was the belief in Greenland that the souls of the deceased go either to a land in the sky or to another one below the sea. Those in the sky have plentiful caribou, whereas the dead in the underworld have many sea animals as their food. As an effort to "explain" the social and economic aspects of summer and winter, this worldview prevailed in the Canadian Arctic and Greenland. In western Alaska, a different environment and many centuries of Siberian influence created other cultural configurations.

For many thousands of years, immigrants from Siberia have crossed the Bering Strait and lived in western Alaska before migrating southward into the Americas. Archaeologists have excavated scores of their ancient campsites, presenting a complex puzzle in which the recognition of specific cultures does not yet identify the people involved as Indian or Eskimo. As the last major group of immigrants before the

arrival of Europeans, the Eskimo-Aleut ancestors may have arrived some 10,000 years ago. But it is only from about 3000 BC that some coastal Alaska people appear to have begun a sequence of developments that connect them with the present-day native population of the Arctic.

The first people in this sequence were distinguished by their production of a specific type of small hunting tools made of flint, which stand out among the stone tools of other people for their artistic quality. Selecting multicolored flint, these Paleo-Eskimos chipped their spear and arrowheads with a degree of precision that went far beyond functional need. Most probably we have here the earliest evidence of a long-continued custom to honor and please the game spirits by the decoration of hunting tools. Tiny flint points are evidence that these Paleo-Eskimo were the first immigrants to Alaska to introduce the bow and arrow. As a major improvement in hunting techniques, the use of bow and arrows spread into the Americas.

From their beachhead on the Bering Strait, nomadic bands of the Paleo-Eskimo hunters trekked across the Canadian Arctic, apparently without the help of watercraft. Walking over land and ice, they reached

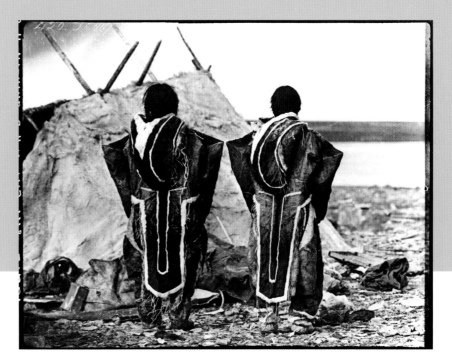

Greenland by about 2000 BC. Not yet wary of human predators, the caribou and musk-ox, seal, walrus and fish made these regions most attractive for the hunters. Skin, bone and walrus ivory were the materials used for most implements, because wood was scarce and came only as driftwood. Bone needles found in the campsites of these travelers suggest that furs and skins were made into tailored garments.

In the same period, the Aleut people became culturally visible in the long chain of storm-swept treeless islands stretching far into the Pacific from Alaska. Related in language to the Eskimos, the ancestors of this maritime people may have already separated from what was to become the main population of Alaskan Eskimos before they moved out of Siberia. Settled in permanent villages of large multi-family houses, the Aleuts developed a distinct way of life based on fishing and the hunting of sea otters, whales and seals.

About 1000 BC, the Norton Culture emerged among the Paleo-Eskimo who had remained in western Alaska. They used kayaks and umiaks, and developed efficient techniques to harvest the vast numbers of walrus and whales that passed through the Bering Strait in spring and fall. To intercept these migrations, large permanent villages were established, some of them remaining occupied well into the 19th century. Of major importance in this maritime specialization was the harpoon, with an ivory head designed to detach from the shaft and anchor itself in the wound while still tied to a long line. Some of these harpoons were large enough for whaling.

Inside the partly underground houses of the villages, a relatively comfortable temperature was maintained by a new invention: the stone oil lamp. The flat bowl, often made of soapstone, was filled with oil derived from whale blubber. All along the edge of the bowl, wicks of dry moss were placed in the oil. The row of burning wicks produced a smokeless flame, sufficiently hot to cook meat in a pot hanging above it. The stone oil lamp became indispensable in every family household, and the rapid spread of this invention throughout the Arctic is evidence of frequent contacts between neighboring and more distant settlements and camps. Examples of the Pacific Eskimo show carved human and animal figures emerging from the bottom of the bowl. The rudimentary knowledge of ceramic technology, sufficient to make cooking pots, was of Siberian origin.

Ivory carving of a swimming bear, Dorset Culture, Canadian Arctic, circa AD 500.

Length, 5.2 inches / 23 cm. The picturing of basic skeletal details and the marking of joints indicate that this bear figure once served as a hunter's amulet, promoting a good relationship with the animal spirits. Photo © Canadian Museum of Civilization, artifact NhHd-1:2655, image S90-3293.

Much of the ivory and bone hunting gear in Norton and successive Alaskan cultures was elaborately decorated with relief carving and engravings, the animal images ranging from realistic to complex abstract designs. The engraving was apparently done with metal tools, which began to arrive from Siberia in small quantities. The art style itself reveals strong links with Siberia and its ancient traditions, particularly in the Old Bering Sea Culture after AD 1. The animal art style related to the honoring of the bear and other animal spirits in shamanistic rituals. Some people, presumed to have been powerful shamans, were interred with ivory burial masks or with their eyes replaced with ivory imitations. Ivory chains were undoubtedly copied from the metal chains on Siberian shaman costumes. Before AD 100, there was a period of several centuries in which female figurines were carved from ivory, with most attention given to their long, oval faces. Famous is the "Okvik Madonna," unusual in that a small animal is held at the breast. The sculpture may refer to a widespread myth, in which a woman gave birth to a bear-like child that later devoured its mother. Given the focus in Eskimo art and culture, however, the devotion to a female figure reminds us of Sedna, the mythical Mother of All Sea Animals.

Reverberations of this shamanistic art style became noticeable in the Dorset Culture, emerging in the Canadian Arctic by 600 BC. Carved wooden figures and the remains of masks and drums suggest that these people had a ceremonial center on an island at the northwestern corner of Baffin Island. Ivory and bone carvings of bears and waterfowl were engraved with "X-ray" references to their skeletal structure, related to the idea that new life was generated by the bones of game. Here, as elsewhere, artistic expression was motivated primarily by the perceived need to maintain a good relationship with the powerful spirits of game and the environment. Enigmatic are the clusters of human faces carved on caribou antler, reminiscent of a group of such faces carved on the rocks of the Labrador coast in the same period.

The earliest documentation of arctic clothing fashions is in Dorset-carved human figurines, which show that these people used high collars instead of hoods on their parkas. They hunted seal during the winter, and they may have invented the domed snow house called igloo for living on the frozen sea. While hunting caribou during the summer, Dorset hunters built the first stone cairns called inuksuit, "like men." Standing in rows, these cairns form converging drive lanes, still used by caribou hunters in more recent times. Possibly following ancient custom, the people used to howl like wolves when they drove the caribou up to the hunters waiting in ambush. By AD 1, the Dorset Culture had spread all over the eastern Arctic, including Greenland, Labrador and even northern Newfoundland. Their wooden masks have been found in some of these regions, and mask use survived until recent times in eastern Greenland and Labrador.

Shortly before AD 1000, strange happenings may have made the Dorset people aware of dramatic changes to come. A prolonged period of warmer climate was starting, which opened up the sea ice for increasing numbers of whales, walrus and seals. A tremendous meteoric shower illuminated the sky along the northwest coast of Greenland, and strange people had beached their large boats farther down that coast. Fourteen ships of Scandinavians arrived there about AD 986.

These Norse colonists established two settlements in southwestern Greenland, which included churches, a small monastery and convent, and several farms in the green fjords. Cows, sheep and goats were imported; hunting and fishing provided additional food and skins for the manufacture of clothing. As skilled sailors, these Scandinavians explored the coast of Greenland and ventured across the Davis Strait, where they found Baffin Island, Labrador and Newfoundland. Norse artifacts found in Eskimo campsites indicate that there was sporadic trade, and

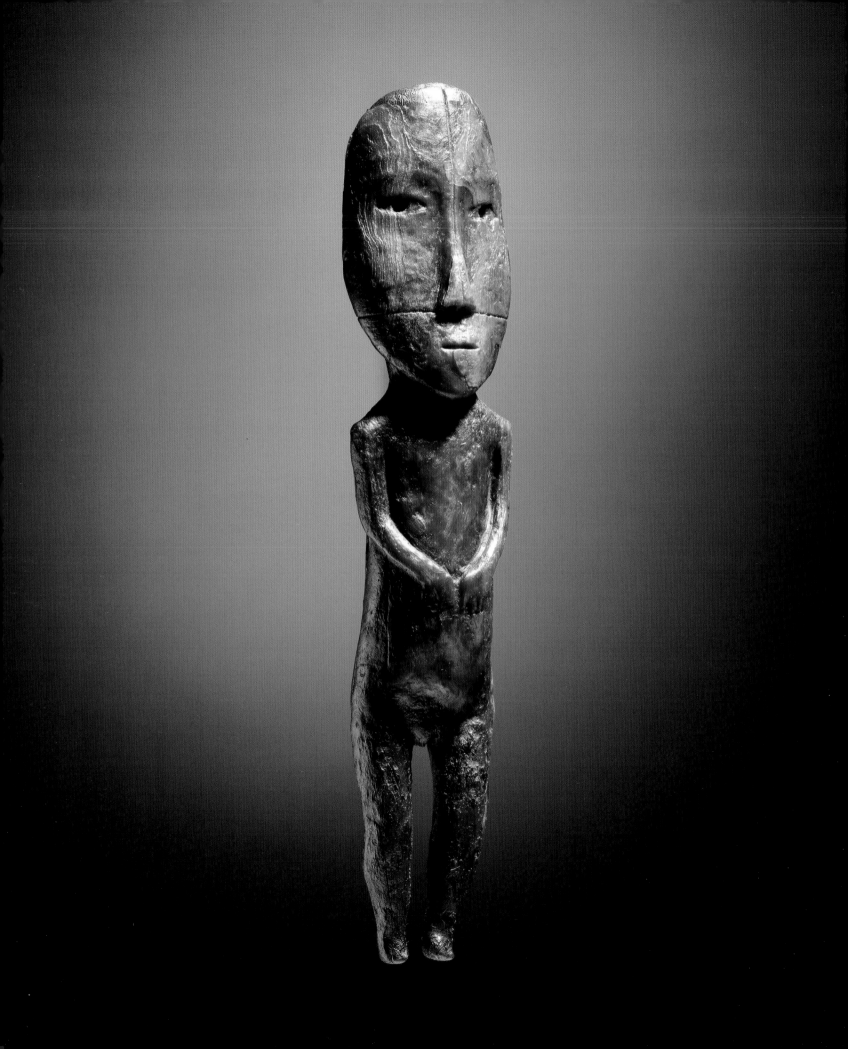

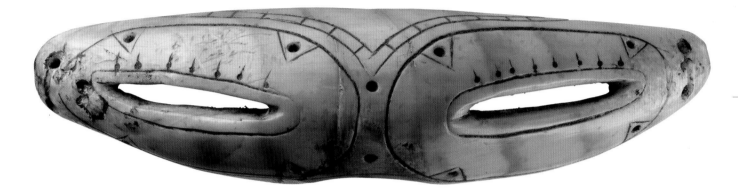

Facing page: **Female figure, Kodiak Island, Alaska, 200 BC–AD 100.**
Carved of walrus ivory, darkened by age. Height, 6.5 inches
/ 22 cm. This figure, particularly the elongated head, is
stylistically related to similar figurines of the Old Bering
Sea Culture. The carving of separate legs is unusual.
Courtesy Donald Ellis Gallery, Dundas, ON, New York, NY.

Snow goggles, Punuk Culture, Western Arctic, AD 500–1000.
Because they cut down on the amount of sunlight entering the eyes,
snow goggles were – and are – used as a protection against snow
blindness. The engraved decoration is typical for this early period,
though the style survived until the late 19th century in Alaska.
Courtesy Donald Ellis Gallery, Dundas, ON, New York, NY.

a short-lived settlement was founded in northern Newfoundland. With annual contacts, the Greenland colony became well known in Iceland, Denmark and Norway. Walrus ivory arrived from Greenland and became a popular material in Scandinavia for carving chessmen and other pieces about AD 1150.

The warmer climate and the annual migrations of large numbers of whales were noticed all over the Arctic. Encouraged by this development, expert whale hunters from northwestern Alaska were spreading eastward, introducing the Thule Culture. They were the ancestors of the present-day Inuit population of the Canadian Arctic and Greenland. Their legends tell of hostile encounters with the "Tunnit," the Dorset people, described as strong spear-wielding hunters, but still without bows and arrows. In several locations Thule-Inuit and Dorset people were neighbors for many decades, but the total lack of any borrowings from each other is significant. In comparison to the Thule immigrants, the Dorset were technically primitive and conservative in their religion. In the 12th century, the Dorset disappeared. Many were apparently killed; others were absorbed by the Thule-Inuit, who reached Greenland by circa 1200.

Shortly after 1200, the cold climate returned, with disastrous consequences for the Norse colony in Greenland. The total population never exceeded about 3,000, and it rapidly declined after 1200. Farming became increasingly difficult, and supply shipments from Denmark became irregular and finally failed to come. Starvation may have been one of the factors leading to the gradual disappearance of the colony. The last recorded contact with Europe was in 1410. Rumors of hostilities with the native people were later confirmed by the oral traditions of the Greenland Inuit, who may have adopted some of the Norse survivors.

One of the first things rapidly adopted by later European explorers was the superior native dress, but the Norse colonists preferred to weave their own fashions from the wool of their sheep. Presumably carved by local Inuit, some wooden figurines may represent Norse people, given their non-Eskimo style of dress. Despite almost 500 years of the colony's existence, there is no evidence of any significant influence on the regional Inuit society, or vice versa. By the time the Norse colony had come to its end, Columbus rediscovered the Americas.

The Thule-Inuit people had a superior technology for whale hunting and a vastly enhanced mobility with umiaks, kayaks and dog sleds. Dorset hunters had made use of some of the meteoric iron that came down near Cape York on the Greenland coast, but the Thule people had knives and arrowheads made of Siberian metal and later acquired iron from the Norse settlers in Greenland. In contrast to the Dorset, the Thule-Inuit no longer had highly decorated hunting gear, though they were strict in reserving ivory for tools used by women and for hunting sea animals and antler for spears and arrows for caribou hunting. After around 1200, western Thule people developed a pictographic art style of hunting narratives engraved on ivory implements. Fairly common were small ivory carvings of waterfowl, which perhaps functioned as pieces in a game. Human figurines carved of bone and driftwood often depict women with their hair tied in a topknot, a hairstyle that remained the custom in Greenland well into the 20th century.

Indications of tattooing on these female figurines were already noticeable on earlier carvings in Alaska, and this ancient art form continued among Canadian Inuit until recent times. The permanent grayish blue marks were created by drawing a needle threaded with soot-coated sinew under the surface of the skin. The tattooing on the women's thighs ensured that the first thing noticed by a child at birth would be something of beauty, and the same idea may have motivated Greenland women to tattoo their breasts. Throughout the Arctic, women

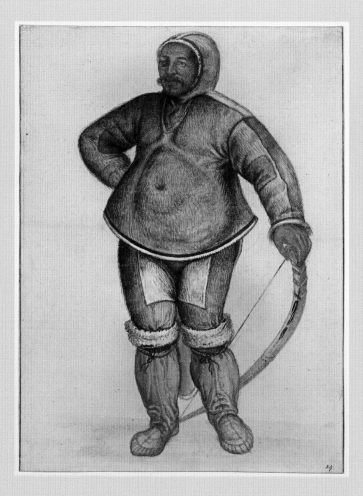

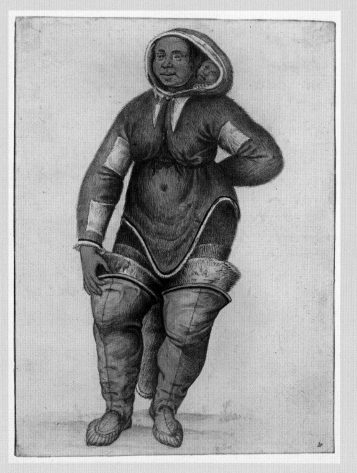

An Eskimo Man and **An Eskimo Woman,** Baffin Island.
Watercolor by John White, 1577. The woman wears a
sealskin parka with long flap down the back, and an enlarged
hood for carrying her child. Between the long sealskin boots
and their liners of caribou fur, a layer of insulating grass was
added in winter.

 The man's parka also has a long flap down the back,
which disappeared from men's clothing in the 19th century.
The indication of the navel beneath the thick fur in both portraits
is a European artistic mannerism of the period. This man, like
the woman and her child, were captured by Martin Frobisher.
They died within a short time after arriving in England.

Facing page: **Female tattooing, Netsilik Inuit, circa 1940.**
Courtesy National Film Board of Canada. Neg. 86893.

had their faces tattooed; in the central and eastern regions, arms and legs were also thus decorated. Only beautifully tattooed women were believed to join the hunters in a happy afterlife. Perhaps it was only in tattooing that the Eskimos expressed aesthetics purely for beauty's sake.

Symbolism may have survived in the location of tattooed patterns on shoulders, elbows and wrists, corresponding to the location of color-contrasting bands of fur in the parka construction. Joint marks are a well-known and ancient feature in Eskimo and Indian art, originating from the belief in a spiritual power activating the joints. In the cut of their garments, the people paid respect to the animals who gave their skins and without whom survival would have been impossible. Ideally, the men dressed in caribou fur when hunting the caribou, and in sealskin while hunting seals. The hoods of their parkas were made of the caribou's head skin, often with the ears left on. Hanging from the back of parkas, weasel pelts appealed to the weasel spirit for success in hunting; loon skins appealed for the loon's help in fishing. Inuit parkas used to have a long tail-shaped extension at the back, perhaps in imitation of a wolf's tail, but these also provided comfort when worn while sitting on the cold ground.

The woman's parka had a similar but shorter extension on the front. As a short narrow flap in some regions, it referred to the vulva; wider and decorated with an oval outline of white fur in other regions, it referred to the uterus – in both cases honoring procreation and maternity. The woman's parka featured a hood-like pouch at the back in which a child could be carried; the wide shoulders allowed the child to be moved to the front for breastfeeding. In some eastern regions, the woman's long boots were wide enough to hold a baby.

In the western Arctic, men and women used longer parkas, often elaborately decorated with inserted bands of geometric patterns. On the man's parka triangular gussets of white fur came down on both sides of the neck in an allusion to the tusks of the walrus. Another such reference was in the ivory disks fitted in perforations of the man's skin at either end of his mouth. They expressed the hunter's appeal for the power of the walrus. In these western regions, parkas were often made from feathered bird skins or fish skin, and strong walrus intestines provided gut skin for waterproof overgarments. With an obvious sense of style and beauty, women all over the Arctic prepared, cut and sewed animal skins into the complex patterns of their families' clothing, characterized by the stylistic differences of each region.

Most beautifully decorated were the costumes worn during the annual winter ceremonials. In the Alaska villages, these events were celebrated in the

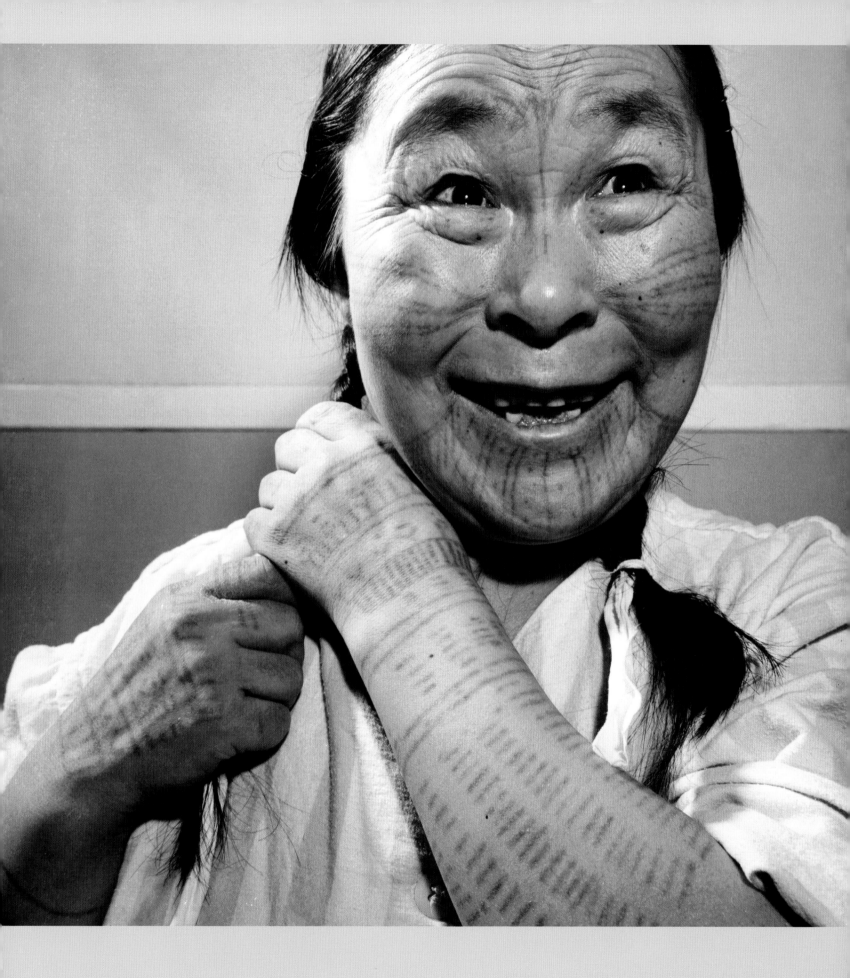

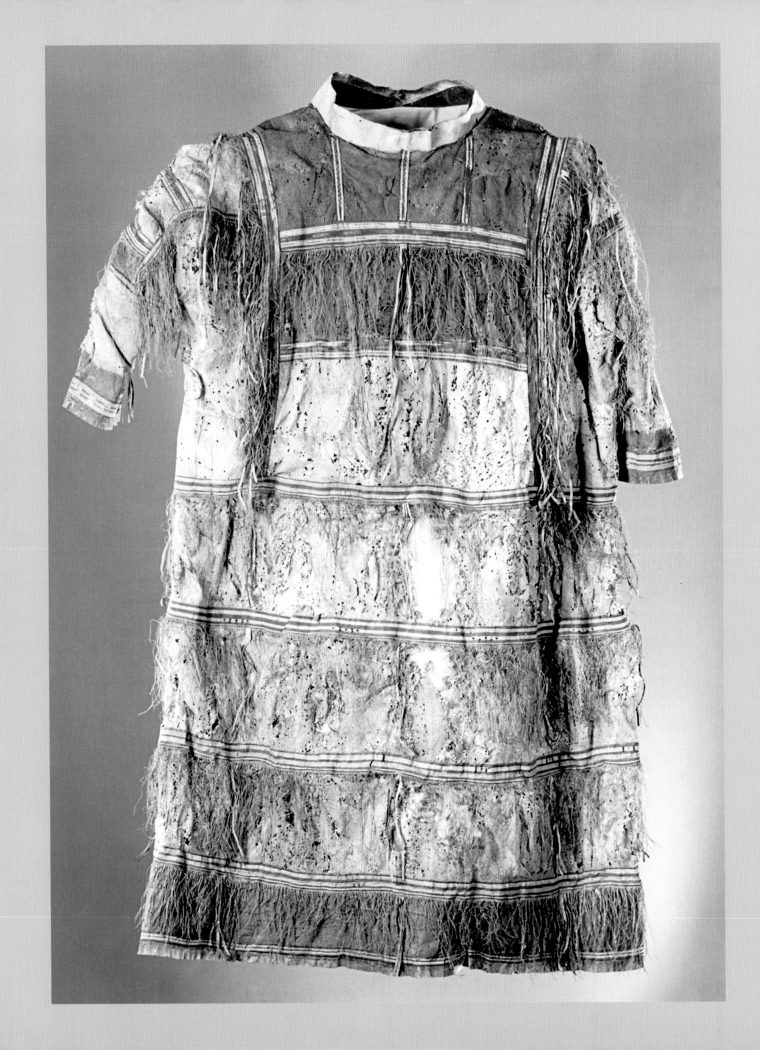

Facing page: **Birdskin parka, Kodiak-Eskimo, Alaska, circa 1800.**
Bird skins sewn together in horizontal rows, with the feathers on
the inside. Around the neck the skins are painted red, and the
horizontal seams are covered with red and white strips of leather.
© DLM-Ledermuseum, Offenbach.

kasgick, the community house otherwise used as the place where the men spent much of their time. The ceremonial season of the Yupik Eskimos started with the Bladder Festival. Believed to contain the animals' souls, bladders of game animals were saved during the summer. Now they were inflated, painted and, after a week-long ceremonial, released into the sea to return to their spiritual masters for reincarnation. During the "Inviting In" ceremonial, these animal spirits were invited to a feast and to enjoy the dances and songs performed in their honor. Other ceremonies focused on shamanistic performances, the recital and pantomime of traditional legends and enjoyable song sessions and drum dances. Potlatches among the southernmost Yupik revealed their close affinities with the Northwest Coast Indians.

Many of these celebrations involved the use of carved and painted masks. They ranged from realistic to distorted faces, to totally abstract creations. Miniature versions of the masks danced by the men served the women as finger masks in their pantomime dances. Mask carving may have increased when iron tools from Siberia became more common after AD 1000, but examples predating the 19th century are rare because masks were usually destroyed by the end of each winter season.

Over the course of centuries, the Aleuts developed a class-conscious society that was more reminiscent of the Northwest Coast Indians than of their Eskimo relatives. Aleut village chiefs were persons of wealth and prestige, and at death their bodies were mummified and placed in caves, their faces covered with painted wooden masks. In winter festivals, the Aleut used masks that in their shape and decoration suggest ancient Japanese influence. Aleut women were highly skilled in twining basketry of beach grass decorated by means of false embroidery.

Aleut hunters, who spent all day in their kayaks, wore waterproof gutskin costumes decorated in honor of sea animal spirits. Conical hats made of steamed bent-wood and decorated with sea lion whiskers protected their eyes from glare on the water. In hunting sea otters and birds, the hunters used spear throwers, or atlatls, to propel the darts. The Aleut kayak was of skillful construction and became the prototype for a popular modern sportscraft. Larger skin-covered boats, similar to the Eskimo umiak, were used on trading voyages and war raids. Both men and women wore long, ankle-length fur shirts, but they went barefoot all year round.

At the dawn of the historic period, the spread of the Thule Culture had created a linguistic unity from the Bering Strait to Greenland. This eastern Eskimo language is called Inuit, after the people's name for themselves. From the Bering Strait south along the coast, the language and people are called Yupik. The

Following two pages: **Dance masks, Yupik-Eskimo, Alaska, 19th century.**
Inspired by visionary experiences, masks were carved by shamans or by talented carvers under the shaman's supervision. Masks represented personal guardian spirits, animal spirits, demons ranging from dwarfs to giants, the most powerful rulers of the weather, the sea, and similar forces of nature. Their legendary ability to transform their own appearance is often referred to by different faces on the same mask. Concentric hoops attached around the mask symbolized different realms of the universe. Page 345, courtesy Trotta-Bono; page 346, courtesy Donald Ellis Gallery, Dundas, ON, New York, NY.

term Eskimo is no longer current, but it is unavoidable in a general overview. Though it shares a remote common ancestry, Aleut has always been recognized as a separate language of a culturally distinct people. The habitat of these maritime peoples is almost entirely restricted to the coastal regions. In western Alaska, their settlements extend up the lower courses of some rivers; in northern Alaska and Keewatin, some bands were exceptional in their almost exclusive focus on caribou hunting.

※

By 1500, Basque and Portuguese fishermen from the Newfoundland Banks had discovered the annual arrival of large shoals of whales into Davis Strait. This prompted the seasonal arrival of increasing numbers of European whaling ships in the eastern Arctic, and they continued their trade for almost four centuries. The Inuit of western Greenland and Baffin Island soon acquired their first metal pots, knives, fishhooks, glass beads and European garments, in return for sealskins, blubber and baleen. Several British expeditions explored the region in search of the fabled Northwest Passage to China and India. Many of these early visitors returned home with abducted Inuit people and their kayaks. After 1700, trade contacts developed along the coasts of Hudson Bay thanks to seasonal

visits of ships of the Hudson's Bay Company from its posts on James Bay.

The surviving knowledge of their former colony in Greenland initiated the establishment of a Danish colony in western Greenland in 1721. A government-controlled trading company was granted a monopoly in order to protect the native people from exploitation by the whalers. Throughout the history of Danish Greenland, a protective, rather paternalistic policy was instituted in government programs.

There is some evidence of the former existence of a complex ceremonial life among the Greenland Inuit, including winter festivals in community centers, comparable to the kasgicks in Alaska. Due to the energetic activities of the missionaries, however, public expressions of the native religion disappeared rather quickly, and drum dances and tattooing also met with austere Protestant disapproval. By 1782, most of the Inuit in west Greenland had formally accepted Christianity, which was undoubtedly related to the widespread and rapid intermarriage with Danish settlers. Their children played a major role in the development of a distinct west Greenland society. Firearms replaced the bow and arrows in hunting, but the kayak and umiak remained useful in an economy increasingly focused on commercial fishing. Traditional Inuit life continued in the remote and isolated northwest and on Greenland's east coast.

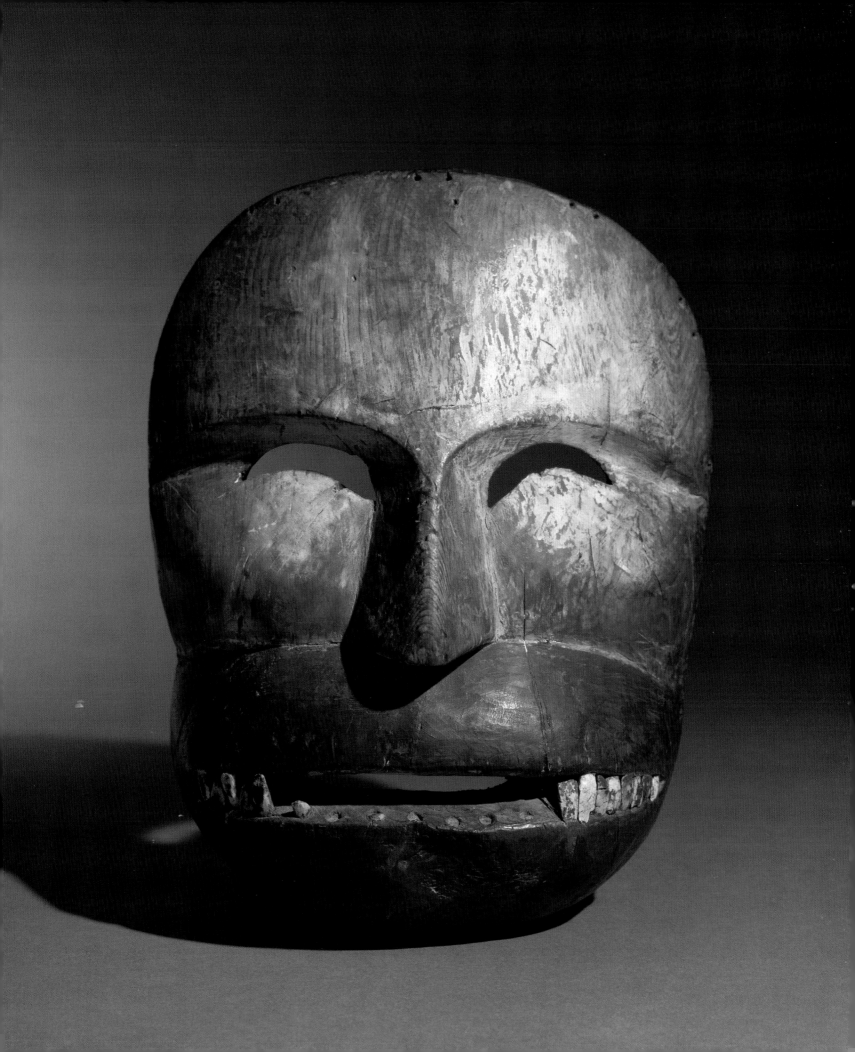

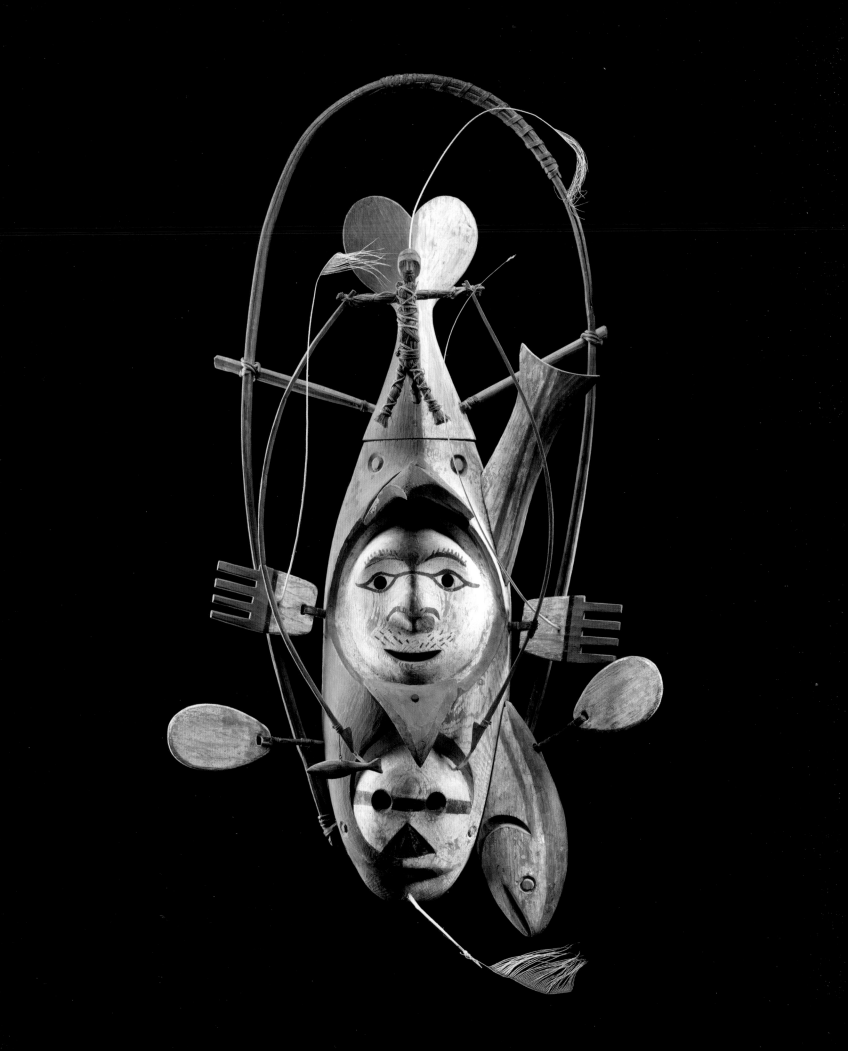

The early historic era in Alaska was very different from the peaceful colonial development of Greenland. In the 1740s, Russians explored the region, and their discovery of incredible numbers of sea otters, walrus and seals instigated the invasion of the Aleutian Islands by Russian traders and trappers. Once the local game was depleted, Aleut and Kodiak hunters were taken on ships all along the West Coast as far south as California. On the Alaska coast the Eskimos were forced to deliver an annual tribute in furs until 1800, when the Russian government finally took some control of the ruthless traders.

Russian Orthodox missions and schools supported by the Czar were established. Increasing numbers of native people were employed in the colonial bureaucracy, explored the interior for the government trade or were trained as clergymen. The Orthodox priests were instructed to convert more by example of their behavior than by proselytizing, and with the help of the native clergy the new religion spread rapidly. Russian influence did not lead to noticeable innovations in the Alaskan Eskimo way of life, but the Aleuts adopted Russian fashions in the cut of their parkas, in the painting of stylized floral designs on their bent-wood hats and with floral designs in their fine basketry. Popular among the Russian Navy officers were capes made of gut skin by Aleut women, tailored in the style of the officers' greatcoats and sewn with waterproof seams.

The Inuit of Alaska's northern coast were relatively unaffected by Europeans until the mid-19th century, when American whaling ships expanded their operations beyond the Bering Strait into the Beaufort Sea. For the next 60 years, life in the coastal Inuit villages was disrupted by lawless sailors, the introduction of whiskey, guns and epidemic diseases. When the Russians sold Alaska to the Americans in 1867, the future looked bleak for the native population.

Between Alaska and Greenland, the Canadian Arctic stretches for some 2,400 miles. Until World War II, European contacts affected the native way of life only very gradually. Apart from Fort Chimo in northern Quebec, traders occasionally visited the west coast of Hudson Bay before 1900. Some Russian imports reached the Mackenzie River delta before a Canadian trading post was established there in 1799. In general, however, there was little evidence of culture change; as late as the 1920s, the Inuit in the central Arctic had not even acquired rifles. Anglican and Roman Catholic missionaries arrived on the lower Mackenzie in 1860; in other parts of the Canadian Arctic, only by about 1912.

Significant change started with increased whaling in Davis Strait by 1820, followed by the arrival of American whalers in Hudson Bay and the Beaufort Sea. They employed native people as pilots, hunters and trappers, and to make winter clothing for the crews. In return, the Inuit received metal tools, guns, European clothing, tobacco and the liberal import of liquor. In northern Quebec and west of Hudson Bay, the Inuit women developed an elaborate style of beadwork on their parkas, while commercial fabrics were replacing skin use in summer clothing. The women abandoned their bulky skin leggings when cotton skirts of the "Mother Hubbard" type became popular.

The introduction of firearms and the demand by the many ships' crews for meat decimated the caribou herds. Alien diseases spread and exterminated several native communities, including the Inuit of the Mackenzie River delta. They were replaced by an immigration of Inupiat-Eskimo from northern Alaska. These immigrants introduced a longer caribou-skin parka, a style that soon replaced the customary parkas with tails for the men.

By 1900, whales and whalers were disappearing, and the Hudson's Bay Company moved its trading posts into the region. These posts and the trapping of foxes for their pelts signaled the emergence of permanent settlements and the gradual demise of the nomadic lifestyle. Thousands of waterproof skin boots (mukluks) were made by the Inuit of the eastern Arctic, to

be sold by the Hudson's Bay Company to the Indian trappers in northern Manitoba and elsewhere. Trade encouraged the replacement of native technology with imported firearms and other tools, increasing thereby the Inuit's dependence on the industrial world. Carved and engraved decorations that used to add magical efficiency to hunting gear disappeared together with those implements. Given modern equipment, the hunters apparently no longer felt the need to please game spirits.

In the 1930s, the collapse of fur prices caused widespread poverty and even starvation. Missionaries offered much in terms of advice, education and medical service to help the natives adjust to the rapid changes. It was only after World War II that the Canadian government began to assume its responsibility in these matters. Though the Inuit way of life changed entirely, hunting and fishing has remained important, and the native dress did not disappear. Appliqué decoration of cut-out designs on sealskin and designs in contrasting fur inlay became popular on boots. Geometric patterns of colored bias tape replaced similar designs of colored skin strips on the boots of the Mackenzie Eskimos. Floral designs in beadwork and silk embroidery were introduced among these people by intermarried Kutchin Indians. In the late 1940s a Canadian artist, James Houston, noticed the small ivory figurines that the Canadian Inuit had started to carve as souvenirs for the whaling crews in the 19th century. He motivated the Inuit to attempt carving larger figures from soapstone, which had been formerly used only for carving the bowls of the ubiquitous oil lamps. The immediate market success of these stone carvings led Houston to then introduce the production of prints. Government officials took charge of the promotion of these activities. Despite occasional bungling and misdirection by bureaucrats, some great artists have emerged. Though strictly modern arts, these sculptures and prints are mentioned here because they are internationally recognized as symbols of Canada itself.

Weather stations, airfields and the Distant Early Warning (DEW) line of radar installations preceded the development of oil exploration and mining in Canada's Arctic. Small Inuit groups were relocated to remote places on the northern islands where hunting promised to be better. For some time snowmobiles threatened to replace dog sleds, but due to the high maintenance costs of these machines, the more reliable dog sled is making a comeback.

A large part of the Northwest Territories became Nunavut in 1991, but the budget of its all-Inuit government is almost entirely provided by Ottawa. Despite oil and mining developments, the Arctic is not self-supporting. The Inuit are becoming part of Canada's lower class, and whether they will manage to maintain a cultural identity is questionable.

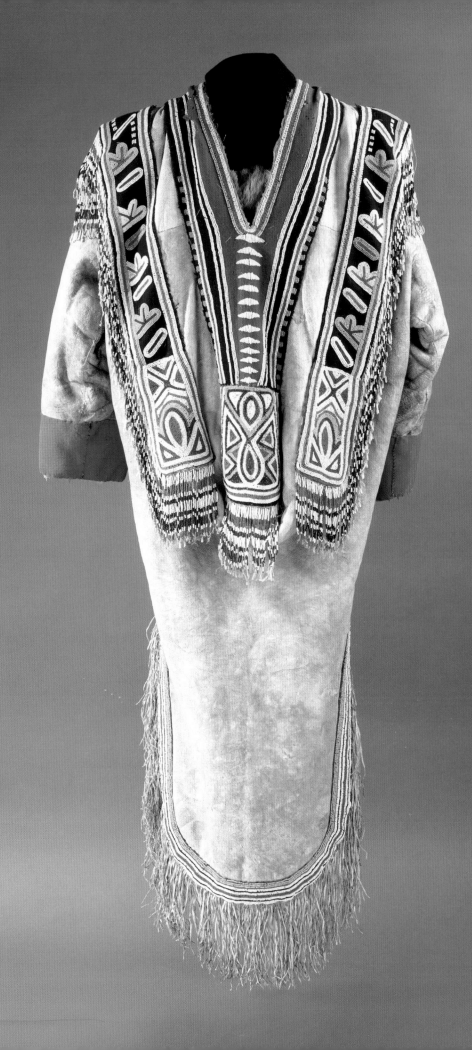

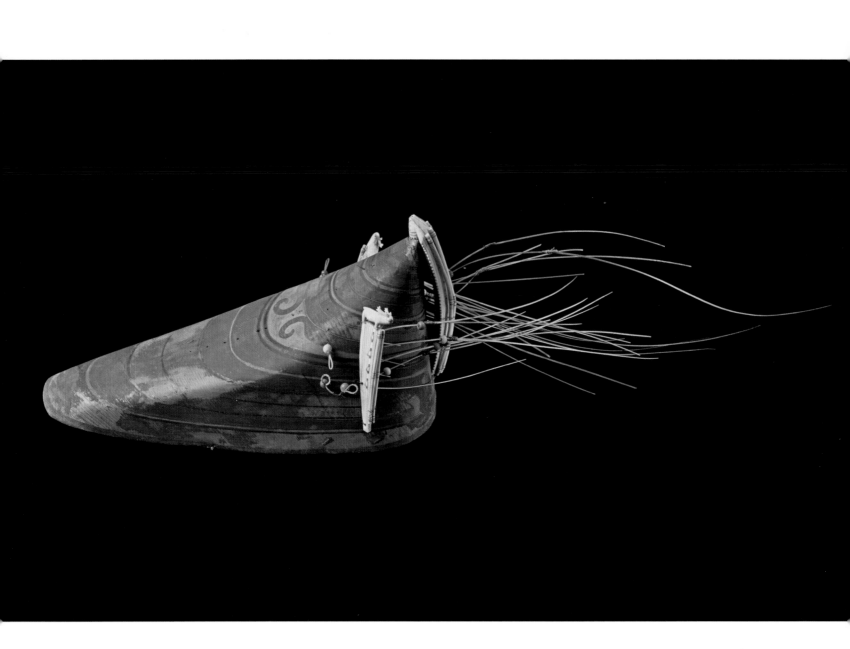

Hunter's hat, Aleut, Alaska, 19th century.
Wooden visor, decorated with ivory attachments,
seal bristle and glass beads.
Courtesy Presidents and Fellows, Harvard College,
69-20-10 / 1263 T558.

Festive woman's costume, West Greenland, circa 1970.
On Greenland's west coast the Inuit women developed a colorful costume that is still seen at festive occasions. A cape, or "timiak," of netted beadwork with a collar of black fur covers much of the parka, or "anorak," which is made of fabric without a hood. Black fur and beadwork decorate the cuffs of the anorak as well. Short sealskin pants, decorated with intricate patterns of colored skin appliqué, fit into hip-length boot linings that have an upper rim of black fur, lace and floral embroidery. The boots, or "kamikken," are made of bleached sealskin. These fairly expensive costumes confer prestige, and emphasize the ethnic pride of their owners. Courtesy collection of the author.

꙳

From 1867 until 1900, the American government was represented in Alaska by the captain of one Navy steamship that every year cruised along the coast. Fishing and the hunting of whale, walrus, seals and caribou continued as the basis of Eskimo life. However, these resources had considerably declined, prompting a missionary to arrange the import of Siberian reindeer in 1891. Laplanders were hired to instruct the Eskimos in herd management. Initially the program was successful, and the herd increased to over 6,000 until 1938.

A gold rush brought thousands of adventurers to Nome in 1900, initiating the emergence of a thriving souvenir market for traditional and innovative Eskimo crafts. Masks, formerly destroyed after the winter festivals, now found eager buyers. Ivory objects, including cribbage boards, were decorated with three-dimensional carvings and engravings of native scenery. The old pictographic style of these engravings became increasingly realistic, particularly when the engravers started to copy photographs. Basketry ranged from fine grass-twined Aleut work to the coiled basketry recently adopted from Siberia. By 1914, a new type of basketry appeared, woven of thin strips of whale baleen, with a carved ivory knob on the lid. Shortly after, the native population was ravaged by an influenza epidemic from which the souvenir industry never fully recovered.

Knowledge about the workings of modern society spread with the establishment of schools in the native communities. As American contacts intensified, "needs" increased, and the living conditions of the Eskimos changed. The Eskimos lost interest in reindeer herding, primarily due to its interference with their hunting culture, but the general use of firearms caused an excessive waste of game.

World War II brought military people into many native communities that had been relatively isolated before, and several thousand Eskimos served in the local home guard units. In 1942, the Aleut society fell victim to the war. Japanese invaders of the westernmost islands deported the local people to a camp in Japan; all the other Aleuts were hastily removed to the Alaska mainland, many of them never to return.

After the war, native cooperatives active in the marketing of native products and the purchase of imported goods created successful stores in many villages. The last nomadic groups settled in 1951, and town councils introduced a measure of self-government to the Eskimo villages.

The emerging sense of ethnic identity and the first native claims to mineral and land resources fostered the birth of a native political movement. Traditional celebrations, abandoned with the adoption of

Christianity, marked a cultural revival in the 1970s. Drum dances and masked performances have returned to the traditional village community halls, and once again whale hunting has ritualistic overtones. Developments following the Alaska Native Claims Settlement of 1971 have been mentioned in Chapter 11.

❋

From an early start, Inuit Culture change in Greenland continued at a quiet pace, assimilating many European features. For more than a century, this development remained confined to the population of the southern part of the West Coast. Only over the course of the 19th century did people became aware of the small group of Polar Inuit, living beyond the glaciers and massive pack ice in the extreme northwest, and of another isolated community on the east coast of Greenland. The Polar Inuit had lost all memory of former contacts with other Eskimos, and they believed themselves to be the only people in existence.

In Greenland, European fabrics were combined with sealskin and furs in the native dress. The men's parka lost its front- and back-tails; the men's trousers grew longer when they adopted shorter boots, while the women adopted long boots with shorter pants. For holidays and festive occasions, the women developed a more colorful version of the regular dress. A form of appliqué of fine, colored strips of sealskin in intricate geometric patterns was used to decorate festive garments. Very similar work is produced in Alaska, suggesting that this art form was once used in the Canadian Arctic as well. Remarkable as well is the similarity between the riveting of ivory figurines on wooden containers and spear throwers in eastern Greenland, and the figures on wooden hunting hats and containers in western Alaska. Surviving from the shamanistic past in eastern Greenland was the creation of figurines

from a combination of human and animal bone and skin. Made alive by magic incantations, these "tupilaks" were sent off to harm the maker's enemy. Carved from ivory, these bizarre figurines had entered the souvenir market by the 1930s.

By the mid-19th century there was a regularly published newspaper printed in the Inuit language, and native authors were contributing to a growing national literature, in Danish as well as in Inuit. Native people were employed in the government, commercial fishing, farming, sheep raising and service occupations. By the 1920s, the declining importance of seal hunting led to the gradual replacement of kayaks and umiaks by larger fishing boats.

World War II severed supervisory control by the Danish government, and after those years of isolation it was generally understood that a return to the old establishment was not a viable proposal. Actually, it was primarily the anti-colonial attitude of the people in Denmark that inspired political change. In 1953, Greenland's colonial status changed to that of a Danish province, represented in the Danish parliament by two elected Greenlanders. Native frustration with the continuing and even increasing Danish involvement in various programs led to further demands by educated younger Greenlanders. Home Rule was granted in 1979, and Greenland changed its name to Kalaallit Nunaat, "Land of the Greenlanders." Though not fully independent and requiring massive financial aid from Copenhagen, Kalaallit Nunaat is now a self-governing native state, with Inuit as its principal language.

Obviously, the development in Greenland was most intriguing to the Inuit of Canada and Alaska, who meet with their Kalaallit relatives every so many years at the Inuit Circumpolar Conference. However, problems relating to global warming and its noticeable effects on the Arctic environment have become at least as important as the fostering of the native culture.

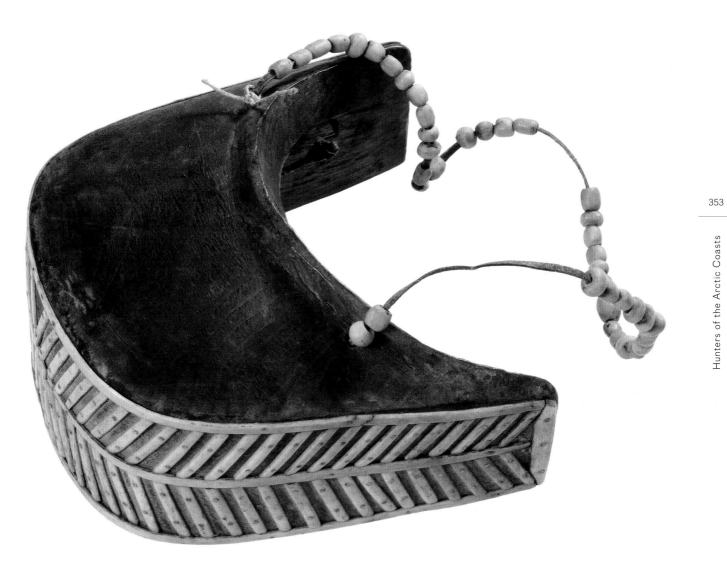

Hunting visor, East Greenland, 19th century.
Wooden shade decorated with ivory strips; worn by
hunters to protect their eyes against snow blindness.
Courtesy Department of Anthropology,
Smithsonian Institution, cat. no. 168939.

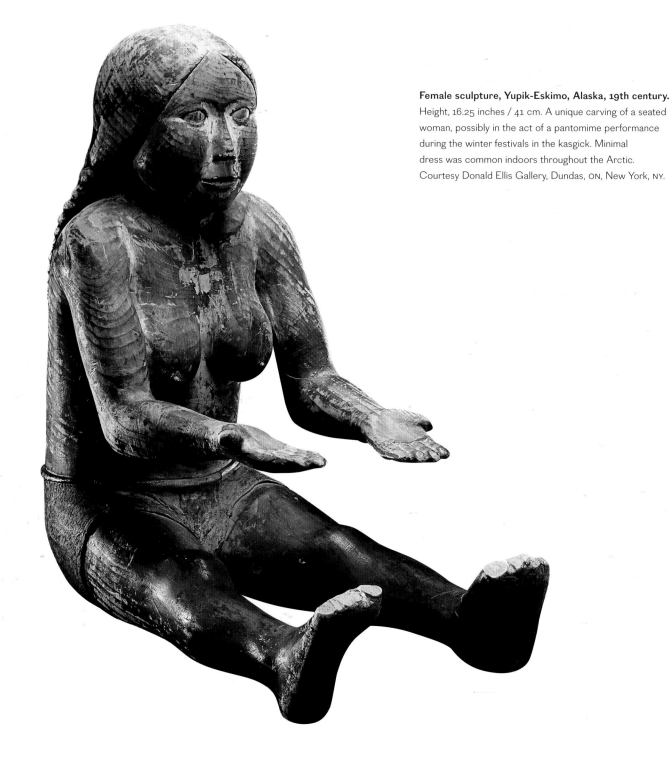

Female sculpture, Yupik-Eskimo, Alaska, 19th century.
Height, 16.25 inches / 41 cm. A unique carving of a seated
woman, possibly in the act of a pantomime performance
during the winter festivals in the kasgick. Minimal
dress was common indoors throughout the Arctic.
Courtesy Donald Ellis Gallery, Dundas, ON, New York, NY.

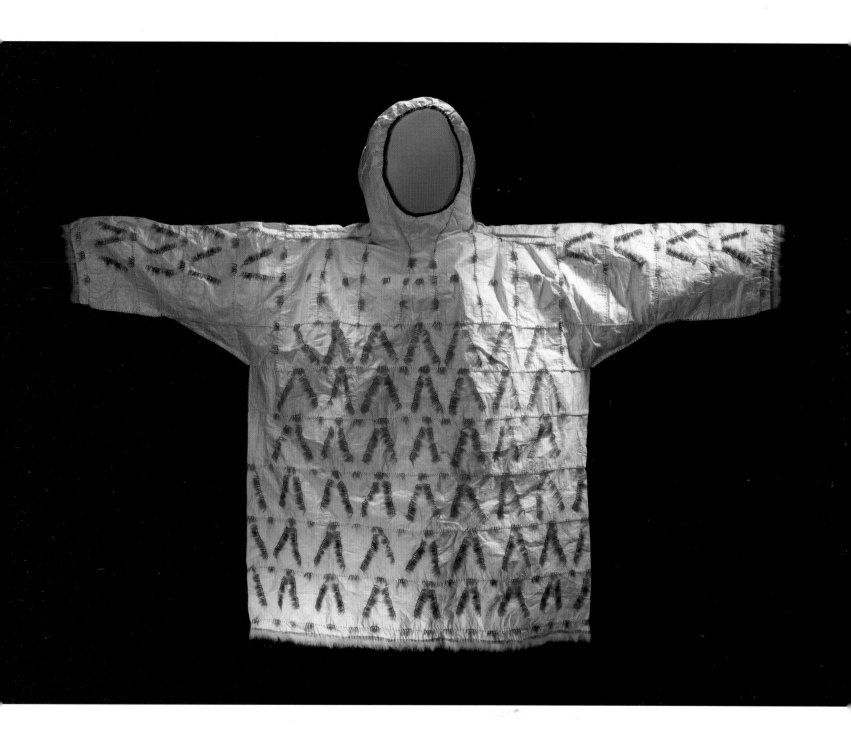

Gutskin parka, Yupik, St. Lawrence Island, Alaska, circa 1900.
Made of seal intestine and decorated with color-dyed walrus
fur in a triangular pattern, which may stand for harpoon heads.
Men wore such waterproof garments when hunting in kayaks.
Courtesy Donald Ellis Gallery, Dundas, ON, New York, NY.

References

Principal Sources

Please refer to the bibliography below for the full citations.

Chapter 1: Blackard, 1990; Brose, 1985; Fogelson, 2004; Hudson, 1976; Townsend, 2004.

Chapter 2: Brasser, 1975; Harrison, 1987; Leach, 1966; Newcomb, 1956; Trigger, 1978; Whitehead, 1982.

Chapter 3: Engelbrecht, 2003; Kent, 1993; Tooker, 1964; Trigger, 1978.

Chapter 4: Bishop, 1974; Brasser, 1976; Burnham, 1992; Harrison, 1987; Helm, 1981; Oberholtzer, 1994; Speck, 1935; Tanner, 1979.

Chapter 5: Brasser, 2003; Tanner, 1987; Torrence & Hobbs, 1989; Townsend & Sharp, 2004; Trigger, 1978; White, 1991.

Chapter 6: DeMallie, ed., 2001; Ewers, 1986; Brasser, 1987; McLaughlin, 2003; Brasser, 1985; Torrence, 1994.

Chapter 7: Dittert and Plog, 1980; Dozier, 1961; Ortiz, ed., 1979–1983; Tanner, 1976; Whiteford, in Vincent et al, 2000.

Chapter 8: D'Azevedo, ed., 1986; French, 1961; Opler, 1971; Schlick, 1994; Turney-High, 1937; Walker, 1998.

Chapter 9: Bates, 1982; Heizer, 1978; McClendon & Holland, 1979; Underhill, 1941; Whiteford, 2000.

Chapter 10: Brown, 2000; Holm,1965; Suttles, ed., 1990; Wardwell, 1996.

Chapter 11: Brasser, 1985; Duncan, 1989; Helm, 1981; Thompson, 1987, 2001.

Chapter 12: Damas, ed., 1984; Driscoll, 1987; Fitzhugh & Kaplan, 1982; Fitzhugh & Crowell, 1988.

Further Reading

Bates, Craig. "Wealth and Power: Feathered Regalia of Central California." In D.C. Ewing, ed., *Pleasing the Spirits: A Catalogue of a Collection of American Indian Art*. New York: Ghylen Press, 1982.

Bean, Lowell J. *California Indian Shamanism*. Menlo Park, Calif.: Ballena Press, 1992.

Bishop, Charles A. *The Northern Ojibwa and the Fur Trade*. Toronto: Holt, Rinehart and Winston, 1974.

Blackard, David M. *Patchwork & Palmettos*. Fort Lauderdale, Fla.: Fort Lauderdale Historical Society, 1990.

Brasser, Ted J. *A Basketful of Indian Culture Change*. Ottawa: Mercury Series, National Museum of Man, 1975.

——— *Bo'jou, Neejee! Profiles of Canadian Indian Art*. Ottawa: National Museum of Man, Ottawa, 1976.

——— "In Search of Métis Art." In J. Peterson and J.S.H. Brown, eds., *The New Peoples: Being and Becoming Métis in North America*. Winnipeg: University of Manitoba Press, 1985.

————— "By the Power of Their Dreams." In *The Spirit Sings: Artistic Traditions of Canada's First Peoples.* Toronto: McClelland and Stewart, 1987.

————— "The Plains." In G.T. Vincent et al, eds., *Art of the North American Indians: The Thaw Collection.* Cooperstown, NY: Fenimore Art Museum, 2000.

————— *Turkey River: Native American Art of the Ohio Country.* Canton, Oh.: The Canton Museum of Art, 2003.

Brose, David S. et al. *Ancient Art of the American Woodland Indians.* Detroit: Detroit Institute of Arts, 1985.

Brown, Steve C. "Northwest Coast." In G.T. Vincent et al, eds., *Art of the North American Indians: The Thaw Collection.* Cooperstown, NY: Fenimore Art Museum, 2000.

Burnham, Dorothy K. *To Please the Caribou.* Toronto: Royal Ontario Museum, 1992.

Damas, David, ed. *Arctic.* Vol. 5, *Handbook of North American Indians.* Washington, DC: Smithsonian Institution, 1984.

D'Azevedo, Warren L., ed. *Great Basin.* Vol. 11, *Handbook of North American Indians.* Washington, DC: Smithsonian Institution, 1986.

De Mallie, Raymond J. ed. *Plains.* Vol. 13, *Handbook of North American Indians.* Washington, DC: Smithsonian Institution, 2001.

Dittert, Alfred E. Jr., and Fred Plog. *Generations in Clay: Pueblo Pottery of the American Southwest.* Flagstaff, Ariz.: Northland Press, 1980.

Dozier, Edward P. *Rio Grande Pueblos.* In E.H. Spicer, ed., *Perspectives in American Indian Culture Change.* Chicago: University of Chicago Press, 1961.

Driscoll, Bernadette. *Pretending To Be Caribou.* In *The Spirit Sings: Artistic Traditions of Canada's First Peoples.* Toronto: McClelland and Stewart, 1987.

Duncan, Kate C. *Northern Athapaskan Art: A Beadwork Tradition.* Seattle and London: University of Washington Press, 1989.

Engelbrecht, William. *Iroquoia: The Development of a Native World.* Syracuse, NY: Syracuse University Press, 2003.

Ewers, John C. *Plains Indian Sculpture.* Washington, DC: Smithsonian Institution Press, 1986.

Feest, Christian F. *Native Arts of North America.* London: Thames and Hudson, 1992.

Fitzhugh, William H., and Susan A. Kaplan. Inua: *Spirit World of the Bering Sea Eskimo.* Washington, DC: Smithsonian Institution, 1982.

Fitzhugh, William H., and Aron Crowell. *Crossroads of Continents.* Washington, DC: Smithsonian Institution, 1988.

Fogelson, Raymond D., ed. *Southeast.* Vol. 14, *Handbook of North American Indians.* Washington, DC: Smithsonian Institution, 2004.

French, D. "Wasco-Wishram." In E.H. Spicer, ed., *Perspectives in American Indian Culture Change.* Chicago: University of Chicago Press, 1961.

Heizer, Robert F., ed. *California.* Vol. 8, *Handbook of North American Indians.* Washington, DC: Smithsonian Institution, 1978.

Helm, June, ed. *Subarctic.* Vol. 6, *Handbook of North American Indians.* Washington, DC: Smithsonian Institution, 1981.

Holm, Bill. *Northwest Coast Indian Art: An Analysis of Form.* Seattle and London: University of Washington Press, 1965.

Howard, James H. *The Southeastern Ceremonial Complex and its Interpretation.* Memoir. Columbia, MO.: Missouri Archaeological Society, 1968.

Hudson, Charles. *The Southeastern Indians.* Knoxville: University of Tennessee Press, 1976.

Kent, Barry C. *Susquehanna's Indians.* Harrisburg: Commonwealth of Pennsylvania, The Pennsylvania Historical Commission, 1993.

Leach, Douglas E. *The Northern Colonial Frontier, 1607–1763.* New York: Holt, Rinehart and Winston, 1966.

MacKenney, Thom. L. and J. Hall. *History of the Indian Tribes of North America.* 6 vols. Philadelphia: E.C. Biddle, 1838–1844.

McLaughlin, Castle. *Arts of Diplomacy: Lewis & Clark's Indian Collection.* Seattle and London: University of Washington Press, 2003.

McLendon, Sally, and Brenda S. Holland. "The Basketmaker." In A.C. Roosevelt and J.G.E. Smith, eds., *The Ancestors: Native Artisans of the Americas.* New York: Museum of the American Indian, 1979.

Newcomb, William W. Jr. *The Culture and Acculturation of the Delaware Indians.* Ann Arbor: University of Michigan Press, 1956.

Oberholtzer, Cath. "Together We Survive: East Cree Material Culture." PhD thesis, McMaster University (Hamilton, ON), 1994.

Opler, Marvin K. "The Ute and Paiute of the Great Basin." In E.B. Leacock and N.O. Lurie, eds., *North American Indians in Historical Perspective.* New York: Random House, 1971.

Ortiz, Alfonso, ed. *Southwest.* Vols. 9–10, *Handbook of North American Indians.* Washington, DC: Smithsonian Institution, 1979–1983.

Schlick, Mary D. *Columbia River Basketry.* Seattle and London: University of Washington Press, 1994.

Speck, Frank G. *Naskapi.* Norman, OK: University of Oklahoma Press, 1935.

Suttles, Wayne, ed. *Northwest Coast.* Vol. 7, *Handbook of North American Indians.* Washington, DC: Smithsonian Institution, 1990.

Tanner, Adrian. *Bringing Home Animals.* St. John's: Institute of Social and Economic Research, Memorial University of Newfoundland, 1979.

Tanner, Clara L. *Prehistoric Southwestern Craft Arts.* Tuscon: University of Arizona Press, 1976.

Tanner, Helen H., ed. *Atlas of Great Lakes Indian History.* Norman, Okla.: University of Oklahoma Press, 1987.

Thompson, Judy. "No Little Variety of Ornament: Northern Athapaskan Artistic Traditions." In *The Spirit Sings: Artistic Traditions of Canada's First Peoples.* Toronto: McClelland and Stewart, 1987.

————— "Athabaskan Studies." In *Fascinating Challenges.* Hull, PQ.: Canadian Museum of Civilization, 2001.

Tooker, Elizabeth. "An Ethnography of the Huron Indians, 1615–1649." *Bureau of American Ethnology Bulletin 190.* Washington, DC: Smithsonian Institution, 1964.

Torrence, Gaylord, and R. Hobbs. *Art of the Red Earth People: The Mesquakie of Iowa.* Iowa City: University of Iowa Museum of Art, 1989.

Torrence, Gaylord. *The American Parfleche: A Tradition of Abstract Painting.* Seattle and London: University of Washington Press, 1994.

Townsend, Richard F., and R.V. Sharp, eds. *Hero, Hawk, and Open Hand: American Indian Art of the Ancient Midwest and South.* Chicago: The Art Institute of Chicago, 2004.

Trigger, Bruce, ed. *Northeast.* Vol. 15, *Handbook of North American Indians.* Washington, DC: Smithsonian Institution, 1978.

Turney-High, H.H. *The Flathead Indians of Montana.* Memoir. American Anthropological Association, No. 48, 1937.

Underhill, Ruth. *Indians of Southern California.* Lawrence, Kan.: U.S. Department of the Interior, Bureau of Indian Affairs, Haskell Press, 1941.

Walker, Deward E., ed. *Plateau.* Vol. 12, *Handbook of North American Indians.* Washington, DC: Smithsonian Institution, 1998.

Wardwell, Allen. *Tangible Visions: Northwest Coast Indian Shamanism and its Art.* New York: The Monacelli Press Inc., 1996.

White, Richard. *The Middle Ground: Indians, Empires, and Republics in the Great Lakes Region, 1650–1815.* Cambridge: Cambridge University Press, 1991.

Whiteford, Andrew H. "Southwest." In G.T. Vincent et al, eds., *Art of the North American Indians: The Thaw Collection.* Cooperstown, NY: Fenimore Art Museum, 2000.

Whitehead, Ruth H. *Micmac Quillwork.* Halifax: The Nova Scotia Museum, 1982.

Photo Credits

We gratefully acknowledge the cooperation of the following dealers, private collectors, museums and institutions. Particular thanks are extended to Donald Ellis Gallery, John and Marva Warnock, Charles Derby, Richard Pohrt, Jr., Ted Trotta and Anna Bono, Clinton and Susan Nagy, Ned Jalbert, H. Malcolm Grimmer, Walter Banko, James and Elaine Kinker, Cowan's Auctions, Skinner, Inc., and Heritage Auction Galleries.

Complete credit information appears on the pages shown.

Afton Press / The W. Duncan MacMillan Foundation: 133
Alabama Department of Archives and History: 25
American Museum of Natural History: 178
Amon Carter Museum: 154
Archives of the City of Montreal: 53, 71, 89
Arizona Historical Society: 204
Ashmolean Museum, University of Oxford: 36, 95
Author's collection: 21, 27, 82, 351
Bata Shoe Museum: 105, 160, 171, 172, 207
The British Museum: 20, 40, 41, 273, 313, 339
The Brooklyn Museum: 265
Canadian Museum of Civilization: back cover, 83, 274, 278, 294, 312, 318, 321, 323, 328, 332, 333, 334,
Charles Derby: 131, 152, 158, 166, 195, 234, 254, 258, 279, 326

Christie's Images Ltd.: 29
Clinton and Susan Nagy Collection: 246, 247, 248, 253, 260, 261, 267, 299
Cowan's Auctions, Inc.: 34, 118, 119, 198, 205, 213, 215, 240, 241, 245
DLM-Ledermuseum Offenbach: 88, 342
David Cook Fine American Art: 8
Denver Art Museum: 283
DesBrisay Museum: 59
Donald Ellis Gallery: 1, 2–3, 5, 48, 66, 98, 99, 102, 103, 106, 108, 120, 121, 156, 157, 190, 191, 196, 197, 202, 203, 262, 263, 268, 284, 285, 286, 287, 288, 289, 290, 291, 292, 293, 296, 297, 305, 336, 337, 346, 354, 355
Edinburgh University Library: 45
Fenimore Art Museum: 56, 75, 79, 81, 216
Frank H. McClung Museum: 16
GrimmerRoche: 159
H. Malcolm Grimmer: front cover, 9
Haffenreffer Museum of Anthropology, Brown University: 319
Heritage Auction Galleries: 188, 189, 192, 193, 210, 211, 242, 243
High Desert Museum: 236, 237
Historiska Museet, Lund University: 230
James and Elaine Kinker Collection: 28
John and Marva Warnock Collection: back cover, 6, 32, 33, 78, 80, 82, 84, 113, 122, 124, 127, 128, 137, 141, 142, 155, 162, 164, 165, 169, 170, 194, 199, 206, 235, 238, 239, 300, 325

Photo Credits

The Joseph A. Skinner Museum, Holyoke College: 54

Library and Archives Canada: 68, 91, 132

Livrustkammaren / The Royal Armoury: 76, 90

The Manitoba Museum: 317

Maryhill Museum of Art: 232

McCord Museum: 153, 244

Memorial Hall Museum, Pocumtuck Valley Memorial Association: 97

Messiter Collection: 100

Milwaukee Public Museum: 327

Museum of Art, Rhode Island School of Design: 46

Museum Volkenkunde: 77, 161, 163, 174, 200, 208, 209

Museo de América: 126

National Film Board of Canada: 341

National Geographic Image Collection: 35, 73, 92, 183, 221, 256, 275

National Museums of Scotland: 313

Ned Jalbert: 30, 130, 138, 173, 185, 298

The New Brunswick Museum: 47, 52, 53, 56, 57, 58, 59

Northwest Museum of Arts & Culture / Eastern Washington State Historical Society: 231

Northwestern University Library: 186, 226, 282

Onondaga Historical Association: 24

Oregon Historical Society: 223

Peabody Museum of American Archaeology and Ethnology, Harvard University: 220, 272, 280, 350

Penn Museum: 277

Phoebe A. Hearst Museum of Anthropology, University of California: 264, 314, 315

Richard Pohrt, Jr.: 111, 116, 123, 134, 135, 139, 148, 151

Rochester Museum and Science Center: 74

The Royal Alberta Museum: 324

Royal British Columbia Museum: 320

The Royal Ontario Museum: 43, 72, 96, 100, 104, 259, 307, 349

Skinner, Inc.: 35, 73, 140, 167, 168, 172, 181, 182, 192, 201, 212, 214, 261

Smithsonian American Art Museum / Art Resource: 23, 129

Smithsonian Institution, Department of Anthropology: 322, 353

Smithsonian Institution, National Anthropological Archives: 26, 50, 115, 117, 147, 179, 222, 225, 228, 311

Smithsonian Institution, National Museum of the American Indian: 76, 136, 255, 266, 316

Trotta-Bono: 33, 55, 62, 233, 295, 345

University of Oregon Museum of Natural and Cultural History: 10

The Virtual Jamestown Archive: 65

Walter Banko: 100, 101, 308

Woolaroc Museum: 31

Index